The Color Line

ALSO BY IGIABA SCEGO

Beyond Babylon
Adua

The Color Line

Igiaba Scego

Translated from the Italian by John Cullen and Gregory Conti

OTHER PRESS
New York

Originally published in Italian as *La linea del colore*
in 2020 by Bompiani, Milan
Copyright © 2020 Igiaba Scego
Published in agreement with Piergiorgio Nicolazzini
Literary Agency (PNLA)

Translation copyright © 2022 Other Press and Gregory Conti

This book was translated thanks to a grant awarded by
the Italian Ministry of Foreign Affairs and International Cooperation.

Production editor: Yvonne E. Cárdenas
Text designer: Jennifer Daddio /Bookmark Design & Media Inc.
This book was set in Marcia by Alpha Design & Composition
of Pittsfield, NH

1 3 5 7 9 10 8 6 4 2

Library of Congress Cataloging-in-Publication Data
Names: Scego, Igiaba, 1974- author. | Cullen, John, 1942- translator. |
Conti, Gregory, 1952- translator.
Title: The color line : a novel / Igiaba Scego ; translated from the Italian
by John Cullen and Gregory Conti.
Other titles: Linea del colore. English
Description: New York : Other Press, [2022] | Originally published in Italian
as La linea del colore in 2020 by Bompiani, Milan.
Identifiers: LCCN 2022010840 (print) | LCCN 2022010841 (ebook) |
ISBN 9781635420869 (paperback) | ISBN 9781635420876 (ebook)
Subjects: LCGFT: Novels.
Classification: LCC PQ4919.C373 L5613 2022 (print) | LCC PQ4919.C373 (ebook) |
DDC 853/.92—dc23/eng/20220411
LC record available at https://lccn.loc.gov/2022010840
LC ebook record available at https://lccn.loc.gov/2022010841

Publisher's Note
This is a work of fiction. Names, characters, places, and incidents
either are the product of the author's imagination or are used
fictitiously, and any resemblance to actual persons, living or
dead, events, or locales is entirely coincidental.

For Rome, anywhere she may be,

and

with gratitude to Edmonia Lewis

and

Sarah Parker Remond.

Go thou to Rome,—at once the Paradise,

The grave, the city, and the wilderness;

And where its wrecks like shattered mountains rise,

And flowering weeds, and fragrant copses dress

The bones of Desolation's nakedness

Pass, till the spirit of the spot shall lead

Thy footsteps to a slope of green access

Where, like an infant's smile, over the dead

A light of laughing flowers along the grass is spread . . .

—Percy Bysshe Shelley, *ADONAIS*

PROLOGUE

T HE FIRST NEWS of the massacre appeared in the French-language *Journal de St.-Pétersbourg*, closely followed by *The Times* of London.

Meager information, scanty details. A few hackneyed words. The darkness of unexpected loss.

The news came out of East Africa and was received in Rome with ever-increasing dismay.

Italians had died.

They had died in battle, or maybe in an ambush. Neither the *Journal* nor *The Times* was definitive on this point.

The only certainty was that Italians had died far from home, and that they had died most horribly.

One hundred corpses on the battlefield. Two hundred corpses, and then three hundred.

No, five hundred. Five hundred Italian corpses. A round number.

Five hundred dead in East Africa.

But how had they died? And what had they been doing down there in Africa, among the palms and the baobabs? Among the mirages and the mermaids?

And then a name suddenly leaped out of the pages of those European newspapers.

The name was Dogali.

A name known, before the tragedy, to very few people in Italy.

The incident seemed just as obscure in Rome as anywhere else. There hadn't been any official communication yet. Politicians were keeping quiet, and journalists were awaiting confirmation of what *The Times* and the *Journal* had reported in brief, third-page articles.

In the city, the name of Dogali was pronounced through clenched teeth. People in the highest military circles were especially concerned about the general bewilderment that would soon afflict the country.

Rome, however, was not daunted.

Nothing could bring her down. Decrepit millenarian that she was, Rome had seen some troubles in her life: arrogant condottieri, avid Landsknechte, corrupt clerics, young girls sacrificed for reasons of state. By now, the city was used to the rot.

Dogali. The name menaced the City of Seven Hills like a pack of mad dogs.

IT WAS February 1, 1887, and Rome was enveloped in cold, crystal-clear air, in a great icy bubble. And so rich aristocrats took from their armoires their satin cloaks and their pure woolen overcoats, while poor people cast about desperately for some rags to cover their unhealthy limbs, prematurely aged by toil and rancor.

Rome, in the first hours of that first day of February 1887, was clad in hope. With a smile, she tried to defeat the icy air that had taken possession of her inhabitants' fragile souls.

It was in such moments that the city shone like an Indian emerald. It was in such moments that Rome became Rome again.

But it didn't last long. A vexing rain, an insidious wind, a crowd in tumult could suffice to undo all the magic. And on that day, the spell had been broken by a name: Dogali.

Dogali, an Eritrean city one hundred two meters above sea level and around twenty kilometers from Massawa. In Dogali, the sand was soaked with blood.

In Dogali, an invading army—the invaders were Italians—had been surprised by wily Abyssinian

patriots, who defended their land with honor and the sword.

But before Dogali, there had been Sahati. There, inside a stronghold, a small fort, were some Italians.

They were tattered and besieged, parched and starving.

Their skimpy provisions were almost gone. Their food would last two days at most. Their condition was critical. They needed reinforcements, which they urgently requested in a telegraph to Massawa.

The Italians were desperate. They were all reciting the Lord's Prayer, giving each other extreme unction, confessing their sins before it was too late.

"When will the reinforcements come?" the frightened soldiers asked. But nobody knew. Nobody had enough strength to hope. And more than one wondered, "What am I doing here, with broken boots and a torn uniform?"

They were Italians, the officers had told them before they left Italy. They'd told them, "Go and win the fatherland a place in the sun."

And they, they had believed that lie about the sun. They'd even believed in the Italy that Cavour and the House of Savoy had crudely cobbled together. Only forty years earlier, Italians had been Bourbons and Papists. They'd been *abruzzesi* and *piemontesi*, from Abruzzo and Piedmont. And now they were all supposed to acknowledge their union in "a single hope,"

according to the lyrics of the song "Fratelli d'Italia" ("Brothers of Italy") by Goffredo Mameli, who had died defending the Roman Republic in 1849.

But "a single hope" wasn't something anyone in the little redoubt felt, not in the midst of all that piss-colored sand.

They were all different, those new Italians, and they loved being themselves. They loved their accents, their elongated vowels, their tousled locks of brown hair.

There were no mirrors they could look at themselves in, down there in Sahati. But many of them knew in their hearts that they weren't so different from the *abissini*, those Ethiopians they were supposed to do battle with and conquer. Same amber skin, same big eyes, same long limbs, same unruly curls.

But the pay was good, and back home there were bawling infants and waiting women. Back home, they were hungry. A soldier's pay could plug up all the holes.

It was the prospect of money, more than patriotic sentiment, that had brought them to East Africa. And then there was a beguiling thought, one each of them harbored deep down inside: that a beautiful Ethiopian girl with large, opulent breasts would soon be pressing herself against his pallid chest.

But there was no beautiful Ethiopian girl inside that redoubt of theirs. Only a bunch of starving

grunts, ready to stage a rebellion and surrender to the enemy.

The officers were overwrought. Who was it they were supposed to fight? The Ethiopians outside the little fort or the rebels inside?

"When will the reinforcements from Massawa arrive?"

Rome knew nothing of the dilemmas her soldiers were facing in East Africa. She knew nothing of the siege, nothing of the urgent request for help telegraphed to Massawa, nothing of the relief column that was about to be massacred at Dogali. Rome was too wrapped up in herself to care about a handful of ragtag soldiers catapulted into the sun of darkest Africa.

The city was all wrapped up, as usual, in her own trivial little affairs: the premieres at the Teatro Argentina; the juicy gossip about the commendatore's daughter, who had run off with that French lady-killer; and then there was politics, omnipresent politics, always center stage.

In the drawing rooms of Rome, nobody was talking about the African enterprise. Only in socialist and anarchist circles were there people who condemned that waste of public funds, that governmental rhetoric about colonies, that aggression against free nations.

But apart from a few rare exceptions, as far as Rome was concerned, Dogali didn't yet exist.

Rome didn't know that in a few days' time, *Italians*, troops in that African wasteland, would be slaughtered, between a brook and a hill. She didn't know that an Ethiopian commander named Ras Alula Engida, a native of Mennewe in the district of Tembien, the son of a modest farmer, had prepared a plan to teach the invaders a lesson.

After an unsuccessful attack on the fort at Sahati, the Ethiopian *ras* had decided to abandon his position. He'd feigned a total withdrawal but instead had remained, along with his troops, in nearby Dogali, where they waited in a hollow and readied themselves for a surprise attack on the reinforcements the Italian officers in Sahati had requested from Massawa. Sooner or later, the Italians would pass through that hollow, and Ras Alula would give them a sound thrashing. The Abyssinians' blades were sharpened and ready. Ras Alula's plan was predictable, but none of the Italian officers could be bothered to predict it. Lieutenant Colonel Tommaso De Cristoforis, a native of Casale Monferrato in Piedmont, had been charged with leading the relief battalion to the redoubt in Sahati, and he felt rather too sure of himself.

"Those niggers are our inferiors," he said to all who could hear. "I don't care if there's a billion of them, they don't stand a chance against us. We're better tacticians and better fighters. We are Europeans, we are the supreme race."

It was obvious to whoever took a look around that the situation was getting dangerous. And that hostility toward the occupying forces was mounting day by day. In Massawa, the workers had disappeared from the factories and workshops. Many of the Eritrean askari serving with the Italians had deserted. It wasn't hard to imagine that those men had run away in order to swell the ranks of the Ethiopian patriots.

But De Cristoforis paid no attention to any of this. He felt big, strong, puissant. An Achilles, invincible and supreme. "They're niggers, there's nothing to worry about."

And that was how he marched straight into Ras Alula's trap.

IT WAS a little past eight o'clock in the morning. The relief column was about an hour's march from the fort in Sahati.

When the reinforcements began to pass through the hollow, the first to understand were the Eritrean askari. They saw the concentration of native troops; among them, some of the askari even recognized their own relatives.

I don't want to shoot my brother, many of them thought. And, taking care not to be spotted by their Italian officers, they abandoned their mercenaries'

uniforms and the invading army on whose behalf they killed in exchange for money. They deserted silently, in small groups.

Then it was the scouts' turn to discover that something wasn't right. The word *massacre* was not uttered. It was too terrifying.

At that moment—it wasn't eight thirty yet—the officers could have ordered a retreat. There was still time for them to save their troops' skins. The day was already very hot. The sun, alternating with the frequent cold of the high plateau, had exhausted the few trees in the hollow. It was a climate that crushed your soul, infernal heat and then freezing cold. Rectangular wounds covered sun-roasted skin.

The relief column was in bad shape, an inadequately trained battalion with only a few experts in guerrilla warfare. Continuing to advance was risky. A gamble.

The officers could have ordered a retreat, but they didn't. De Cristoforis had no desire to be marked out as a coward by the senior military leadership. As someone who was afraid of niggers.

Niggers aren't anything, they can't do anything, he said to himself, and then, to the troops: "We are superior in race and in intellect. Even if they're fifty thousand strong, we'll beat them all the same. We're white, aren't we, soldiers? Well, then, forward!" he yelled. *"Viva l'Italia!"*

Thousands of Africans appeared as though from out of the bare earth and fell upon the relief column like a sudden storm.

Rifle shots echoed through the hollow in Dogali. The Italians were encircled, completely surrounded. Some officers even heard their names called and were dismayed to find themselves face-to-face with askari deserters they had whipped only a week earlier, accompanying the lashes from the kurbash with insults. Here was the revenge of those who had been humiliated, raped, and outraged by the Italian invaders.

And in an instant, the earth of the hollow was drenched in blood. It was a slaughter.

AFTER THE BATTLE, shouts of jubilation resounded over those African lands. Ras Alula had won a great victory.

"We are a free people," he said, or someone said for him. "This is our land, and we will fight to the last man to save it from the enemy invader. The Italians are hereby warned. We will never stop defending ourselves."

IT TOOK six days for news of the massacre to reach Rome.

The task of announcing the sad news in the parliament fell to Prime Minister Agostino Depretis. His voice shook under the strain of suppressed sobs and fear of the consequences to come from the bloodshed. He stared straight ahead; he had no wish to look either his majority or the opposition in the eye. In great distress, unable to hide from his infuriated audience, he concluded by muttering something incomprehensible to the assembled parliament.

WHILE THE PRIME MINISTER was speaking to the Chamber of Deputies, a man named Franco Mussi was walking naked through the desert around Massawa, nearly dead from hunger and thirst. He was short, with muscular shoulders and a member that dangled between his legs. Many of the corpses in the hollow at Dogali had been emasculated, a practice the Italians also applied to deserters and terrorists, as they called the Africans who resisted them. Mussi touched his penis countless times in his desperate trek, making sure he was still alive and had really survived the slaughter in Dogali. The rest of his body, however, no longer responded to stimuli. And behind him were his comrades in misfortune, all in the same condition. Feet covered with cuts and sores, nails black with dried blood, legs gashed by enemy bayonets.

In the battle, Mussi—from Zollino, a small town in Grecìa Salentina in southern Italy—had been wounded in the head by a blade and in one arm by a bullet. The man, who was a goatherd back home, had pressed grass into his wounds to stanch the bleeding.

He and his comrades, one from Calabria and the other from Lombardy, walked on during the day and at night slept in the branches of acacia trees. How frightening, the night sounds in East Africa! Some were like a witch's laughter. And then there were the owls, the wild dogs, the sleepless lions. The night was dark and hostile.

They walked for days and were on the verge of succumbing when they reached the encampment.

Franco Mussi, his comrades, and the other soldiers were full of rage. They were furious at the officers who had sent them to confront the Ethiopian blades on the battlefield while those same officers, smart and elegant in their starched uniforms, stayed in the rear to watch. The officers hadn't dirtied their hands with the soft soil of the hollow or with the enemy's blood, so like their own. They had limited themselves to mouthing their stale, repetitive buzzwords, to saying *Long live our homeland, long live Italy*. But their Italy wasn't the Italy of the battered and wounded Franco Mussi. Franco Mussi had enlisted out of need, because a cruel and treacherous disease had killed all his goats. Franco Mussi had nothing to call his own,

not even his breath. *Viva l'Italia* was for well-to-do
officers, possessed of money and protections—for the
officers who limited themselves to issuing orders far
from the battlefield.

"I'll tell the whole truth once I get home. I'll spill
my guts about Dogali, about how those pomaded
pretty boys of the Royal Army treated us. I'll tell
about our cowardly officers and our raggedy clothes.
I'll describe the officers' arrogance and unbridled
luxury. I'll spill my guts."

Franco wasn't the only one who wanted to do that.
But the army took the preventive measure of singling
out potential troublemakers among the survivors
and simply not releasing them from the hospital. The
order to detain them was given by Prime Minister
Agostino Depretis in person.

"How can they do this?" Franco Mussi protested.
"How? I have to go home. I've got a wife waiting for
me and a son I've never seen. They need me, I'm the
head of their household."

But Franco and others like him were considered
hotheads and compelled to remain in the hospital
for just as long as it took the government back home
to prepare its propaganda; the nation didn't want
to hear cacophony and cockeyed words. Politics re-
quired silence about the failings of De Cristoforis
and the other officers. "We must turn this defeat into
a victory," the politicians said.

And the director of this pathetic farce was Agostino Depretis. In his youth, the prime minister had been a brimming vessel of ideals, like everyone else. A devoted disciple of Giuseppe Mazzini, affiliated with his Giovine Italia (Young Italy) movement, appointed dictator pro tempore of Sicily by Garibaldi. A revolutionary career, but now old age was upon him and the taste for power still lingered in his mouth. And like so many before him, he bowed completely to what is called "reason of state."

"I want some martyrs," he said. And the propaganda machine was started up right away.

Four hundred and twenty dead soldiers became five hundred because the number sounded better in newspaper headlines. And all the fallen were promoted to the ranks of national heroes who had bravely fought to the death against the savage Ethiopian foe.

"Italy cannot abandon Africa," the politicians said. "Italy must avenge its heroes, Italy must return to Dogali, because the fatherland always finishes what it starts."

"Viva l'Italia!"

Franco Mussi, lying in his hospital bed, didn't know what was happening. He couldn't have imagined the flood tide of rhetoric that was diluting all thought. By the time he found out, a good while later, it was in his best interest to keep quiet, because

nobody would have believed him. Army life had been nothing but a con from start to finish.

Once he got back to Zollino, however, he found that a bit of glory had attached itself to him too. His fellow *zollinesi* gave him a hero's welcome, and there was a celebration in his honor.

At a certain point in the proceedings, Franco Mussi drank a glass of grappa; then he climbed up on a table, and with all the breath in his body, he too cried out, *Long live our homeland, long live Italy!* His truth, his rage, his feeling of helplessness—he'd swallowed all that with the grappa. In the end, he too came to terms with the devil of propaganda. And in the end, even he came to enjoy being a false hero of a false nation.

On February 1, 1887, when Rome learned from Depretis's stammering mouth what had happened in the hollow at Dogali, an American named Lafanu Brown had just turned into Via del Corso.

Every morning, Lafanu Brown went to the Protestant Cemetery, the one next to the Pyramid of Cestius, to pay homage to the Poet. It was her habit to bring him roses and violets. She was glad that the Poet wasn't surrounded by gloomy cypresses or hedges, glad that, even dead, he could still enjoy the sunlight of Rome, so warm, so penetrating. She would

stand there at his grave for fifteen or twenty minutes, in silence, gazing at the epitaph that the Poet had composed for himself, and every time she'd be seized by a sense of wonder, as though she were standing before a kindred spirit. This was the Poet's epitaph:

Here lies One
Whose Name was writ in Water

Lafanu's name too, years earlier, had been written in water. But her waters were murky and impetuous. The Poet had also been a rebel, in his fashion, a man misunderstood. Maybe that was why Lafanu liked him, why every morning she'd bend down and remove the weeds and worms from his grave, which she cherished like her own soul. And Lafanu would dream there; she'd dream she was a butterfly, hovering in the air, free, even if only for a fleeting moment.

She'd buy the flowers from a man named Lucio at a little kiosk near the Spanish Steps. Some flowers came to him from the Castelli Romani, the Roman Castles, a group of municipalities located near the city, and when things were going particularly well, he would even manage to acquire some bulbs from Holland. "Rome's climate is suitable for tulips," he'd always say, giving her a conspiratorial look. But those tulips, so desired by Lucio's customers, including Lafanu, were never displayed on the counter of

his kiosk, because a certain cardinal—whose name everyone knew—wanted them for his secret chambers. And so she had to be contented with what was left: austere chrysanthemums, capricious gardenias, sprightly roses. But the flowers Lafanu was fondest of were violets. Their intense fragrance was like a whiff of Paradise. Violets, sweet violets, like a starry mantle spangled with promises that Lafanu placed on the Poet's grave. She was intoxicated by that place, so filled with peace and flowers, lining her way with hope. A YOUNG ENGLISH POET—that's what was written on the tombstone. No name, no crest to identify him, only that vague hint about poetry. His true homeland, in a world of exiles and losers. Now under the naked earth, there the Poet lay, at once Lafanu's imaginary friend and something much more concrete. He was her best friend in that city of cupolas and gardens. The only one who'd been listening to her troubles and regrets all these years.

On that first day of February 1887, Lafanu was wearing her hair gathered into two sponge-cake-like clouds. Her supple body was cinched into a severe dark-brown dress so close-fitting it almost blocked her breathing. The possessive garment mounted to her throat, giving the woman the shape of an imperial lantern. In the course of the past year, Lafanu had put on a few pounds, especially in the buttocks area, and the fact embarrassed her a little. But age

pardons no one, and even she, who only a short time ago had been a reed, was acquiring the roundness typical of mature ladies. Yet her face had remained the face of a rambunctious young girl. A countenance without wrinkles, marked only on the sides by nostalgia. "Those colors do you the opposite of justice," Hillary, Bathsheba McKenzie's daughter, would always say to her. "If Mama were still alive, she wouldn't let you dress in mourning every single day, my dear." But those somber colors calmed the heavy weather inside her and stopped her from thinking too much about the carefree girl she had been before fate broke her heart. As the only concession, almost a tribute, to her happy past, she would add a bit of color to her hair: There was always some flower lodged in her geometrical coiffures. Indeed, that flower was often a violet, whose purple hues lit up the whole face of the future. Lafanu was already forty-five years old, and she recognized the bitter taste in her mouth as the sensation of never having truly lived.

ALL AT ONCE, she leaped to her feet, abandoning the violets to their fate.

"*Arrivederci, Poeta,*" she said to him in Italian. She never addressed him in English, the language they had in common. Besides, for nearly twenty years now,

she'd been a permanent resident of Rome, the Caput Mundi where she'd come to study the classics.

That day, Lafanu was without her carriage. Hillary was using it. "I have to go and see the Widow Heathcliff, they say she's very ill," she'd said, adding, almost in a sigh, "Ever since Mama died, Rome seems like just one big, long funeral. A generation's disappearing, a world, our world."

Lafanu's knee hurt a little; she'd fallen off a ladder exactly a week ago. Her tumble had alarmed Concetta, her Sicilian servant. Lafanu's feet had got tangled up in her own skirts, and she and her clothes were spattered with paint. She'd been preparing the canvas for a portrait that little Barney Towalds—who these days was no longer little—had commissioned from her. "I'd like something classy, something I can hang over the chimney in my country house."

Lafanu Brown was a portrait artist, much appreciated in the small world of the expatriate American bourgeoisie. And although the styles of former days had changed, her acquaintances or their children— for example, Barney Towalds—would commission small paintings from her, or sketches to be kept close to their hearts. It was nostalgia operating in all these friends, the images of a past, of an Italy more benevolent and less frenetic than its current version, a flower-filled garden where resident foreigners could

pursue their trivial occupations. Lafanu herself, even in the frenzy of her professional commitments, from time to time yielded to the nostalgia game and managed to revive with her brushstrokes the rituals of that lost world.

She showed no pity in her portraits, however: She remorselessly depicted a society in decay, a society that had not yet resigned itself to the new wind of the nineteenth century, which in a short time would sweep away an entire, flabby universe. But many people liked Lafanu's contribution to the Decadent movement, and the success of her canvases was almost embarrassing. In fact, it often happened that American tourists who had heard about her in some club or at some masked ball would crowd around her doorstep on Via della Frezza just to meet the strange negress who drew faces.

It was so bizarre for a woman with black skin to be a painter that people wanted to touch such an oddity with their own hands. It wasn't rare for Concetta the maid to shoo off the hordes of "bothersome tourists who want to see where my signora works." Lafanu had told Concetta a thousand times not to call her that. "I'm not your signora, I'm not your mistress, you belong only to yourself, Concetta." Lafanu spoke in Italian, pronouncing the words clearly, making sure that Concetta understood them. The servant, like many in her class, had received no education. "They

keep them in their natural state so they can exploit them better," Bathsheba McKenzie would explain to Lafanu, upset and shaking from head to foot. "And then," she added with a sigh, "the Italian newspapers go on about the 'southern problem.' But that's just another way of swindling them, the poor wretches."

But Concetta—and this was what Lafanu appreciated about her—never buckled under the adverse fate that had been strapped to her back. She accepted it, but she didn't submit to it. The sun, which gleamed in her eyes, was what gave her courage, and besides, as Lafanu had noted from the start, Concetta had an instinctive color sense. She often helped Lafanu mix her paints and treat her canvases. And conversations with Concetta were also a source of great delight for Lafanu, especially when the servant clicked her tongue to indicate her disapproval, with a sucking noise that sounded obscene to Lafanu's ears. Ah, how that sudden click would remind her of her childhood! Her childhood near the great waterfall, over there in that great American land where she was born and where she had vowed never to return.

Concetta particularly reminded her of her sister, Timma. Lafanu hadn't seen her for many, many years, not since the day when Bathsheba had taken Lafanu under her wing. Timma was slender and beautiful, not like her sister, who'd always considered herself an ugly duckling. Timma had inherited her physique

from her Chippewa side. She was a girl of the tribe, with almond-shaped eyes, long silky hair, and imposing arms that gave her almost bronze skin the consistency of oak wood. Timma was strong, and she was beautiful. And now, who knew where she was? She and Lafanu had the same mother but not the same father. Lafanu was the daughter of the Haitian, the man with the open smile and the coffee-colored skin who had appeared on the promontory from who knew where and preached rebellion to the Chippewa, urging them not to stand by and watch the slow, inexorable decline to which the whites had condemned them. Her father had stayed with the Chippewa for only two seasons, not long, but long enough to make the women of the village fall at his feet. Lafanu's mother wasn't the only woman the Haitian lay with in those two incredible seasons, but she was the only one whose womb produced a marvel. One day when it was already clear to both what would happen between them, the Haitian said to the woman, "The revolution will come soon."

And then, without any preliminaries, he stroked one of her breasts.

But the woman wasn't ready, not yet.

"All right with you if we talk at least a little while longer, stranger? Just so I can get used to you."

And they talked. He told her that rebellion ran in his blood. He was the grandson of a brave man who had fought alongside Toussaint Louverture to

liberate the island, their beautiful island of Haiti, from French rule. And like General Louverture, his grandfather had died a bad death, a very bad death, in exile in a fortress in France, where not even sighs could hope to outlive themselves.

"And where's France? What's France?" the woman asked, confused by all the geography that she failed to grasp.

"France is the chains we wear, my dear," he said simply, and then he stopped talking. He pressed his mouth passionately against her bosom, and the woman too abandoned herself to the magic of one body sinking into another. When they resurfaced after that great turbulence, he looked her in the eyes and then touched her belly, saying, "This is where the future, our future, will come from."

BELLS WERE RINGING in the distance. Lafanu had lingered too long with the Poet. She had to be on her way. Via della Frezza, where she and Hillary Hastings lived, was far from the cemetery. Hillary had been a widow for two years. She'd decided to move with her twelve-year-old daughter into what had been her mother's spacious apartment, and she had asked Lafanu to join them there, "for old times' sake." Before that, Hillary had lived with her husband in Amsterdam, "but that city was bad for my migraines, too

damp, too drafty," and once poor Matthew had gone on to a better place, she had hurried to Rome, looking for the sun and the bohemian life she'd enjoyed with her mother and Lafanu so many years ago.

But Rome had changed. Lafanu noticed the differences with every step she took. There was a time when the city used to hang her flowered bloomers out the window to dry, but now they embarrassed her. The word *decorum* had become the order of the day, a word that urban planners and architects wrathfully imposed on the citizenry. The Romans' city had to be worthy of her new role as capital of the Kingdom of Italy. And in an instant, in the name of a still-invisible future, Rome lost herself. *L'Italia unita*, United Italy, wanted an efficient, contemporary, fast-moving city for its white-collar workers, and it wanted that whole transformation to take place at once. And so ritualized life under the Papal States—a slow-paced existence, full of climbing plants, that Lafanu had adored—had given way to trolley tracks and a sparkling train station that reminded visitors of the Gare du Nord in Paris.

Lafanu had arrived when the city was not yet the capital of Italy, and what she missed most of all was the solitude she'd known in the Roman countryside at the time of her first wanderings. Cud-chewing Italian buffalos, ruins, cowherds in traditional outfits, unrestrained weeds, shoes sinking into mud. Walking

through the fields and vineyards that filled the space between Santa Maria Maggiore and Saint John Lateran was a great delight to her. Lafanu recorded with her watchful eyes the bright colors the city offered her as a gift. And then there were the magnificent grounds of the noble villas. She'd often accompanied Bathsheba McKenzie on visits to counts and grand duchesses, who would appear opulently attired in gorgeous clothing torn in several places. The Roman nobility was severely debt-ridden, but they would not renounce their kowtowing ceremonies or their appalling conversations about nothing. Bathsheba brought Lafanu to see those lordlings and their consorts so that she could further her research into faces. "They're a strange breed of humanity," she'd tell Lafanu complicitly. "They have museum faces. You'll find many opportunities to exercise your skills by painting portraits of the specimens in that circle." And so for months, which then became years, Lafanu had been summoned to those colossal palaces, which had been sold at the first opportunity to the new masters of Rome, the Piedmontese. The northerners used the palazzi as places to stay for more or less extended periods of time, or when only passing through the capital city. But if the nobility left a lot to be desired—they reeked of closed doors and ancestral fears—their villas, by contrast, were authentic splendors.

When Hillary Hastings returned to the city, it was Lafanu who had to deal with her friend's disappointment. Rome was a field of the fallen. What they had once loved had been razed to the ground as though by a war. In the heart of the capital, from the former site of the Cenci Tower to the Palazzo Piombino in Piazza Colonna, nothing was left of that Rome where the two women had taken the first steps of their exuberant youth. Moreover, the city had become suddenly serious—or maybe it was only that they had grown old. The salons were languishing, and the people were dying. Not exotically from malaria anymore but ordinarily, from common, banal diseases, inoffensive in their placid normalcy.

"But what's become of the spirit of the city?" Hillary would ask forlornly, and Lafanu could only shake her head. "Did everything really die when they put up all those gas lamps around Bernini's Triton Fountain?" Hillary was searching for her youth, but nobody could give it back to her. Nevertheless, *Rome always remains Rome*, Lafanu thought. After all, it was there that she had felt free for the first and only time in her life. Her body wasn't crushed by a boss's stare, by some random white man's stare, by the stare of those who considered her a mere object to be exhibited or someone to have pity on or to be repelled by, depending on their state of mind. Not the inhabitants but the city, its ruins, its multifarious history,

its limpid sky, and that stark light had allowed her to be herself, a free black person in a free world. The year, barely begun, was 1887, and Lafanu was discovering some of the Spanish writers of the seventeenth century. Among them was the poet Francisco de Quevedo, who wrote (with his usual sarcasm) in one of his sonnets, "You look for Rome in Rome, oh pilgrim, / but Rome's a place in which Rome can't be found." Nevertheless, it was in her search for Rome, in the very fruitlessness of that search, that she, the pilgrim Lafanu Brown, had finally, unexpectedly, come upon herself. That was something Hillary couldn't understand; she was white, everything was her due, honors, beauty, even eccentricities. She was Hillary in America and Hillary in Rome. But Lafanu could be Lafanu only in Rome, and not always there. In America she was just a negress, a bastard cross between a Chippewa Indian woman and a Haitian man with strange and subversive ideas. In the authorities' view, hers was a race of slaves, people to keep an eye on, people who weren't allowed to grow within normal limits. Only in Rome, only in that quadrilateral space filled with fountains and Corinthian capitals, was Lafanu Brown Lafanu Brown.

THE WOMAN was gasping for breath—she'd been walking too fast. She was already in Piazza Colonna;

the smell of fried fish from the streets adjacent to the Pyramid had faded from her nostrils. She'd passed the Campidoglio with its twin angels and the majestic statue of Marcus Aurelius, which could be glimpsed from the street. Lafanu loved the Campidoglio. "It's as though Michelangelo made it on purpose for your meditations," Bathsheba McKenzie often told her. She was teasing her, but it was true: In a certain sense, that space contained Lafanu, especially the *cordonata*, the ramped staircase that was like the veils worn by Arab women in French paintings.

There was electricity in the air in Piazza Colonna that day. Carriages were inexplicably lined up along almost the whole length of the street in front of the square. In the distance, shouts and the blare of a brass band. Inside one of the carriages, Lafanu recognized the Italian writer whom Bathsheba, when she was still alive, often invited to dinner. Gabriele— yes, that was his name—had on a beige suit, and a luxuriant gardenia blossom was surging out of his jacket pocket. A pince-nez set askew on his nose and a certain restlessness completed the picture.

What Lafanu remembered most about this writer was his fondness for theatrical gestures. His way of moving in slow motion, his habit of checking his reflection on various surfaces, like a little girl. He was a popinjay, vain and peevish, disinclined to any sort of tranquillity. He wished always to astonish, to be

the center of attention because of a scandal or some madcap antics. Women adored his excesses, which were basically quite juvenile. They all dreamed of redeeming him, of leading him back to the straight path, of making him a man who could be counted on. But although women flocked around him, he'd never really bonded with any of them in his turbulent life.

It was strange to see him in that carriage at that hour. His furrowed brow showed his annoyance at the surrounding chaos, which had stopped his forward progress and played havoc with his schedule. "Hurry up, hurry up!" Lafanu heard him shout furiously. He probably had a romantic assignation with a lady. Rumor had it that D'Annunzio had been enjoying the favors of a certain matron, a Roman noblewoman, for several years. And the matron—at least according to hints dropped by the writer himself, with an eye to enhancing his reputation—was particularly satisfied with his services.

Elbowing her way through the tumultuous crowd, Lafanu quickly drew even with the writer's carriage. As she passed it, she clearly distinguished his irate voice: "For four hundred dead brutes! Brutes who died brutally!"

Lafanu turned around, hoping to meet the writer's eyes, but he'd already closed the window and settled back inside the carriage.

But who had died? And why?

Lafanu would have liked to ask him, but she didn't have the nerve.

The crowd seemed to have gone mad. And she couldn't do anything but let herself be carried along by that carnivorous fury. She felt isolated and scared.

"For four hundred dead brutes! Brutes who died brutally!" But who had died?

Lafanu tried pricking up her ears. She wanted to hear more. Was it possible that death had really struck down so many people at once? *And where, pray tell?* she thought. *And how?*

Nevertheless, trying to listen closely was pointless. It was as if all those people were speaking a foreign language or using a secret code she was excluded from knowing. The city was drooling rage. Just at that moment, she saw some women approaching her. They were scruffy and poorly dressed. Then several men joined them; their husbands, maybe, even though they looked better-off to Lafanu than the poor, unkempt women. In an instant, she was surrounded by those people. She could feel their breath, strangers' breath, on her burning cheeks, the shadows of their furious fingers on her pinned-up hair. With a swift, cruel movement, a young boy pulled out her hairpins, and Lafanu's hair, which she'd patiently done up that morning into two matching buns, tumbled down in a sea of frothy curls she had

never displayed to a living soul, except to Frederick, who had wanted to touch it and begged her to let him. Lafanu had exploded on Piazza Colonna, her curly African hair had exploded. Now she was at their mercy, all of them, and she felt naked.

"Our soldiers were just youngsters!" a female voice shouted. "They were Italians. And your people, your nigger people, killed them! Why did you kill us, nigger? Why hurt our boys? And us girls, who are we going to marry now? Their bones are rotting in East Africa, they're rotting in Dogali!"

Suddenly other voices, other laments, joined in. Tears ran down the rosy cheeks and the swarthy cheeks of that diversified people. Rich and poor were united for the first time in the genuine fury of the street demonstration.

"Why did you kill us, nigger?" Lafanu didn't know what or how to respond. What had happened in Africa? And what did she have to do with that distant tragedy, whatever it was?

"Leave me alone," she managed to murmur, striving to break free. She felt faint, staggered, and fell to her knees. A blue shiver went through her limbs as she felt the cold breath of noon. "Leave me alone," she begged.

All she wanted was to get away from there. This Rome wasn't her Rome. She didn't recognize the city

anymore. She knew she must get up, at once. But her knees, already hurting from the fall she'd taken the week before, refused to obey her orders.

She was alone in a vast, hostile darkness. Alone like a dead leaf on that gray piazza in the heart of the city. And at that moment, Lafanu Brown's body yielded to the weight of events.

She was trembling all over. Her full cheeks were trembling, and so were her chapped lips, her loosened hair, her soft arms, her long legs, her large breasts, her sweet eyes, her pointy ears.

The last thing she remembered from that strange afternoon was the face of a man about thirty years old, with a blond mustache and blond hair. He bent over her and pulled her tongue out of her mouth, where it had curled itself up against her palate like a tarantula.

"Stand aside," the worried man cried. "Can't you see this woman is ill? Give her some room, she has to breathe!" Then, looking at the crowd with displeasure, he added, "You pack of imbeciles, don't you realize that the real patriots are the Ethiopians?"

L AFANU DOESN'T KNOW if she was raped.
She knows only that they found her at
dawn one Friday in front of a stable. In Co-
berlin. A few steps from the college she attended. She
was nearly frozen to death. Her clothes tattered, torn
in several places. Her exposed breasts covered with
filth as with a veil. She was befouled. Beaten.

Lafanu doesn't know if she was raped on an un-
usually bright night in 1859.

But she knows how old she was that night. She
was seventeen.

An uneasy number, seventeen. Uneasy like her.

Now Lafanu is writing her story. Trying to. She
writes on sheets of paper that are like parchment.

The nib of her pen is dipped directly into her menstrual blood, in the very center of her pain.

She stumbles on the words. Trembles. The words seem false to her. Inadequate.

I must write. I have no choice. Because he's already gotten under my skin, and this is the only way he'll know how to love me.

So there she is, Lafanu Brown, gripping her pen like a dagger.

Minerva on the battlefield, obliged to subdue the words that are still crushing, still rending her.

She's glued to the desk. Trapped in a palazzo not far from the house where Goethe, the German bard, once lived.

Lafanu's in the center of Rome, which is the center of the world, in a room overloaded with memories, sitting with her elbows pressed against her sides and concentration in her eyes. She's completely focused on her search for words. She'd like to have them all to herself, even if only for an instant. If she could, she'd swallow the entire alphabet. Just like that, so she could hurry up and be done with the torment of writing.

Writing's so tiring. It drains me.

If it were a drawing, she would have an easy time with it. A few lines would suffice, and maybe he'd understand, or at least he'd put his arms around her. A drawing would have exempted her from the

embarrassment of explaining too much, of explaining badly. Lafanu's a painter. Drawing is her world. She knows every trick of the trade, every shortcut. She can identify the different colors by their smell. She can combine them in concentric swirls. And then, with a pink or black brushstroke, create a world. Oh yes, it would have been much easier for her to explain in a drawing!

But this time, Lafanu has decided to write, not draw. To write her story, or at least what she thinks is her story. She's decided to make room for grief, to place the letters one after the other. To create a meaning. She wants to try to let it all out.

And then she'll tell him, he who already loves her, *Know me. Here I am. Here among these letters, these words. For you.*

MAYBE SHE'S WRITING him a love letter and doesn't know it. Or maybe she just wants to thank him.

His name is Ulisse Barbieri. He's an anarchist. And he's the man who saved her from the frenzied crowd in Piazza Colonna.

He dragged her away by force from that tumultuous piazza, preventing the Romans from trampling on her with their pointy little shoes.

Lafanu could have died there, and she knows it. *Died!* But he swooped down on her like the Angel

Gabriel on the Virgin Mary, and Lafanu turned into a feather in his arms.

He's a beautiful man, Ulisse. His beauty is quiet and gentle. Grizzled beard, eyes green like oak leaves, French-looking pointed nose. And then those teeth, so straight, so white. Except for one canine that's gray, like solidified pitch. As a good southerner, he's got enormous hands, with huge fingernails.

Lafanu still knows very little about him; after all, they've been acquainted for only a short time.

His parents are southern Italians: his mother Sicilian, his father from Apulia. His father's rich, a big landowner whom Ulisse hates, and whom he disowned while still in early youth. Like a proper rebellious son, he chose a life among common laborers; later came the journey to Rome, the writing, the newspapers, the mission of giving voice to the marginalized. His curly hair falls over his face like a wave and gives him a boyish look. He's also got a slight tendency to corpulence, which he conceals with the help of his wayfarer's frame. Ulisse laughs often but never unbecomingly. His smile is quiet as well, even though Lafanu has caught a glimpse, under his fair eyelids, of a perpetually burning fire.

Ulisse loves to read.

And on his afternoon visits to Lafanu, he never fails to bring her some little book, or occasionally poems of his own composition.

It's he who talks to her about what Italy is up to in Africa. He says, "We're treating those people as though they were our slaves."

Lafanu listens to him, mouth open with astonishment. She didn't know that Italy too had become an arrogant actor on the world stage. That when all was said and done, even Italy, the country she loved so much, was no better than the country of her birth, the United States of America.

And the thought that Italy has turned nasty saddens her.

But how can a country that has suffered as Italy has, that's been unified for such a brief time, impose suffering on others?

Ulisse keeps on talking. And soon their conversation is filled with strikes, exploited workers, and the country's sun-drenched south, "which Italy has colonized the way it's trying to do now to Africa."

Then, however, Ulisse forgets all his struggles and lightly touches her hands. Physical contact with her always makes him shiver, almost throws him into confusion. *How small and smooth her hands are, her woman's hands,* he thinks. He's known the coarseness of a solitary life, enlivened from time to time by some prostitute or other; he can't get over the marvel before him. And now he feels a little ashamed, because he doesn't know how to court, really court, a lady. He's afraid of being brusque, of touching her wrong.

He was always careful and cautious with his prostitutes too, and they would laugh at him, the handsome youngster who treated them like porcelain. And so they'd make good-natured fun of him every time, and only then would he feel authorized to penetrate them.

Lafanu looks at him with curiosity. Ever since he gathered her up, half dead, from Piazza Colonna, she's thought that she loves him. Ulisse is a great talker. He monopolizes every conversation. Then, when he realizes he's gone too far and ought to let her have her say too, he apologizes awkwardly. He takes a breather. And he ends up losing himself in her eyes, in that look she has of a woman from another world.

ULISSE COMES TO VISIT her every afternoon in the apartment above her studio on Via della Frezza. He always brings her lilies or gardenias. And then he sits next to her. They brush against each other with their eyes. Sometimes she reads poems to him: by her beloved Keats, and sometimes Shelley too. More rarely, Wordsworth. Then she translates them for him.

"They're more beautiful in English, even if I don't understand them," he says.

The two of them are lulled together by the rhythms of the lines. They'd like to kiss. But they don't dare.

He has asked her to marry him.

She said, "Give me a month. Or rather, give me six months. At the beginning of the seventh, I'll give you my answer."

"Can I hope?" Ulisse asked her, his eyes imploring. And she replied, "Of course you can."

She shares his wish, she'd like to marry him, but he doesn't know a thing, not a thing, about Lafanu Brown. About her life, her sorrows, her choices, her follies. He knows nothing about Frederick. The Frederick whom she still occasionally misses, occasionally still regrets. And Ulisse knows nothing about Mulland, Lizzie, Marilay, Lucy, Bathsheba, Hillary, Henrietta...

She must tell him everything. Even if everything sometimes seems too little. However that may be, she must tell her story to this man who's so devoted to her.

That's the only way Lafanu Brown and Ulisse Barbieri will be able to be together, each of them happy to know that the other is there.

This is the reason why she's writing. So that she can give herself to him without skeletons grabbing her by the throat anymore. Without any more shadows.

She's writing so that she can feel free to love him. Free to love herself, too.

But where to start? Her head is always occupied by that one accursed night.

The night between February 5 and 6, 1859. She was seventeen years old. She had fainted. And a dairy farmer had gathered her up, half dead, from the snow where she lay. Back then, she hadn't had any Ulisse Barbieri to protect her.

ACTUALLY, sorrow had swooped down on her the previous evening.

On that evening in 1859, the day before what came to be called "the incident" at Coberlin, Lafanu had gone to the opera with several other girls, classmates of hers at the college.

Coberlin was well-known for philosophy and the arts. And also because it inculcated its female students with the good manners and the measure of cunning necessary for securing a good match. Many wives of important politicians had been educated at Coberlin, an unequivocally liberal college. Born in the glorious state of Massachusetts thanks to the decision made by a minister and a businessman, who had taken it into their heads to give women as well as men the benefits of higher education, Coberlin had also been among the first colleges to accept black women as students. Not many took advantage of the opportunity, because blacks were in fact barely tolerated and, for the most part, marginalized. But this state of affairs was kept from becoming too well-known in

the abolitionist circles that envisioned Coberlin as a paradise of civil rights.

And besides, Coberlin cost a lot of money. And no young black woman had much of that.

But Lafanu had a white lady, Bathsheba Mc-Kenzie, subsidizing her. And every time she thought about that, she felt deep humiliation. When would she be free from need, free from the charity of white people?

On that accursed evening, Lafanu had put on her most elegant dress to attend the opera, and her class-mate Marta Lee Jones had sprinkled her with eau de cologne "because tonight it's our duty to go all out."

"But this is too much," Lafanu had protested, un-accustomed to that sensuous fragrance.

"Nothing's too much for us," her friend explained.

"FRIEND"—too strong a word. Lafanu stops writ-ing and holds the pen suspended over the white page. She's written "friend," but neither Marta Lee Jones nor anyone else at Coberlin was her friend. She must make that clear to Ulisse. She didn't have any girlfriends, much less there, much less white girls. Of course, they didn't show their animosity openly, but they barely tolerated her. They had grown used to her curls and her black skin, but they con-sidered her merely an eccentricity of the college.

A misinterpretation of the rules. Had there been a crocodile in her place, perhaps they would have considered it less strange.

To share classrooms, lessons, even the dining hall with a negress . . .

Lafanu slept near the bathrooms, far from all the other girls. She attended solitary classes, in which some good-hearted teachers tossed her a few scattered, basic concepts in their spare time. She didn't see many people. It wasn't even possible to brush against them, those classmates of hers. And when it happened, the girls of Coberlin were careful to reestablish the distance between her and them.

My God, how disgusting! the students would think, refusing to tolerate the presence of their negro classmate. And they'd complain about her at home.

They were all girls from good families, and for them it was unthinkable to have Lafanu at their college. It was something obscene.

Parents had protested vehemently. Some of them had even taken their daughters out of Coberlin; others had limited themselves to blaming "modern times" and left their daughters at the school, because after all it was an institution with an excellent reputation and the tuition fees weren't so very high. Not all families could afford the luxury of a college in Boston. Coberlin represented a middle way, an acceptable compromise.

"If we have to put up with a negress, well then, that's what we'll do," those parents said resignedly. "But take care not to talk to her, my girl. And if she touches you, wash your hands seven or eight times. Negroes, even free ones, carry diseases. And pay close attention to what they say. All negroes are liars, it's their nature."

Friend. No, that's not a term Lafanu can use to describe any of the girls who were her fellow students in the college. She crosses out the word with a single long, tremulous line.

Then she starts writing again, inscribing the parchment in her minuscule hand, the marks as deep as a bas-relief.

LAFANU WAS VERY BEAUTIFUL on that evening in 1859. And boldly colorful, with stylish yellow stripes brightening her bodice.

That dress, a used dress, had been given to her—like everything she was wearing—by Bathsheba Mc-Kenzie, who had passed it on to her the previous year, when she was still living with the Trevors. Before the chaos and confusion with Lucy. Before abruptly getting sent off to college. Removed from Salenius.

And she'd altered her secondhand dress a little, thanks to Miss Mallony's wise suggestions. Miss M. had helped her enliven the dress with an array of

colored fabrics obtained from discarded material, which could be found in abundance in the sewing labs of the college.

That yellow was the sun, it was gold, it was nectar. What a contrast between her stylish dress and the cold gray outfits worn by the three tutors who had escorted the festive crowd of college girls to their first opera.

Besides, since she was really in the company of her fellow students for once, Lafanu didn't want to make a bad impression. She was determined to show those simpering little snobs that she, a black girl, knew what she was doing.

MISS MALLONY had insisted that the teaching staff should allow Lafanu to go to the opera with the other girls. "If she goes, everyone will see how modern we are, how liberal-minded and compassionate," Miss M. had said, with rather excessive enthusiasm. Her suggestion, however, found no favor and was instead greeted with grumbling, shrugs, and a few sardonic words. Everyone preferred Lafanu tucked away in some dark library or stretched out like a corpse on her cot near the bathrooms. To reveal her—or, worse yet, to flaunt her—seemed risky at best.

But the word *modern* had persuaded the dean. "Trotting her out could be a boon to our enrollment

efforts. Nowadays a great many families cherish radical ideas, especially those families that might consider sending us their daughters. A respectable negress would send them into raptures." And so, thanks to the dean, Miss Mallony got her way. Lafanu too could enjoy the performance of Mozart's *Don Giovanni* announced in the playbill.

The main attraction on that evening of Mozartian music was a soprano from a distant country whom everyone, including Lafanu, was awaiting with some trepidation. Her name was Fabiana Zollo, and she'd been born near the tumultuous waters of the Mediterranean Sea. It was said that her voice could wake the dead from their eternal sleep and revive in disenchanted hearts the love they'd thought was lost. It was a lovely thing for the townspeople, who would finally be able to admire the celebrated singer in person. She'd been the subject of their conversation for months, and now that she was about to perform for them at last, the air was electric with anticipation. The evening was sure to be a happy one for all. And Lafanu too hoped that fate would let her bite off a little morsel of happiness. After all, it would be the first opera she'd ever seen, the first Mozart she could reach out and touch. From her first theater box, she imagined she would hear and see the slightly excessive joviality of a Don Giovanni, a seducer, a gay deceiver. And then the red velvet curtain would come

down, there would be clamorous applause, there would be ladies' fans, opera glasses slyly peeking about, laughter...

And instead there was only darkness.

IT HAPPENED in a square right outside the theater and close to the college. Lafanu had found herself alone there, because a theater attendant had made her leave the opera.

"This is not a place for people like you," he'd scolded her. None of the three tutors accompanying the group of students intervened in the discussion. None of them told the attendant, "Leave her alone. The girl's with us." Imitating the adults, the girls too averted their eyes in cowardly fashion. But one of them giggled and whispered, "I told you they'd kick her out."

The attendant loomed like a vulture over Lafanu and her stylish dress. "Stand up," he told her harshly. But instead of getting scared, Lafanu started to resist. She made herself a dead weight. She didn't want to get out of that theater seat. It was hers. She'd earned it. She looked so beautiful that evening. She'd used the array of colors to make her yellow dress so resplendent that even Miss Mallony had praised the results. *I won't give in*, Lafanu thought, *not for anything in the world.* She wouldn't run away with her tail between her legs, she'd fight, she'd put out her

claws, she'd wriggle like a snake. "Well, are you going to get up the easy way or the hard way?" the attendant asked in his squawking voice. Lafanu didn't get up. Her body made itself heavier and heavier, she sank into her red seat like the sun at sunset. So then the attendant called in reinforcements, which came in the form of two more big bullies. The audience couldn't understand the reason for the hubbub, which was an insult to Mozart's opera. Whispers of disapproval circulated among the red velvet theater boxes. "Throw her out and get it over with!" someone shouted from the orchestra seats. Lafanu was lifted up bodily, carried outside, and unceremoniously flung down the front steps of the theater. Like waste into a cesspool. Flung down at the exact moment when Fabiana Zollo, the Italian soprano, made her triumphant entrance onto the stage.

I DON'T REMEMBER how I ended up in that square. I'd walked a long way. I was very angry . . . at Coberlin, at the theater attendants, at life. I was also angry because I had no money and I was at the mercy of a capricious white lady. My anger distracted me, and I didn't notice that they *were following me.*

Lafanu underlines *they* five times.

She doesn't know, has never known, who *they* were. If they were only men, or if there were a couple of

women in the mix—she doesn't know that either. She doesn't even have any idea how many of them there were. Much less where they'd come from. Did she know them? Were they strangers? The only perception she'd had of them was their smell. It was, at one and the same time, acrid and carefree. A potpourri of hormones, desire, delirium, and lilac. The very same lilac fragrance that more than one Coberlin student used to daub herself with on special occasions. Lafanu would like to tell Ulisse Barbieri something more about *them*, about what *they* were like—their enormous shoulders, for example, whose weight on her she still can feel— but all is dark, too dark, inside her head. She lacks any information about that evening. She doesn't remember much, only shadows. There is, however, one thing she hasn't forgotten, despite the passage of time, and she writes it down for Ulisse, pressing the nib of her pen forcefully against the parchment paper. *I only know that they tore off almost all the colors I was wearing that evening. Yes, almost all of them.*

The first color to fly away from her was the yellow from the dress with the yellow stripes that she'd tailored for herself with such great care, using the array of colors and Miss Mallony's wise suggestions. The dress was quickly reduced to shreds. Of the bright yellow, of the yellow that had made her feel the sun was inside her chest, there remained barely a glimmer. Then the green of hope went away. All her cherished

little dreams for her future evaporated in a frenzy of pain and oblivion, not what she'd expected to be overwhelmed by on the happy evening she'd anticipated. The other colors likewise fled from her, one by one. The orchid blue, the eggplant purple, and the frosted rose petals she'd strewn on her hair so she'd look like a nymph. The amaranth left her too, and the fuchsia, and the cyclamen pink. The orange looked at her for a moment before it vanished, gazing on her with pity. Lafanu was lying on the ground and groaning. Through its tears, the orange couldn't withstand the girl's blank stare, when a minute before she had been so alive. Even the mandarin, the hollyhock crimson, and the cornflower blue turned their backs on her.

Not to mention the cowardly ultramarine, which departed in a shower of lapis lazuli, searching for some other girl to please. Every color Lafanu had on was canceled. There remained to her a vague trace of mother-of-pearl in her terrified eyes and the black hue of her ebony skin. The black didn't want to abandon her. "I'll never leave you," it promised, resisting the blows ferociously raining down on her. And Lafanu held on with all her might to her half-African, half-Indian skin, as if it were the only available lifeboat in sight.

LAFANU DIDN'T REMEMBER anything of what was subsequently known at Coberlin as "the Incident,"

but her skin felt the entire weight of that outrage. She felt every kick to her ribs, every gob spat into her half-open mouth, every slap on those soft cheeks that she wore like a trophy. But Lafanu didn't hear the voices. She didn't hear the shadows guffawing and having a grand old time. And she didn't discern the extent of the outrage her body was subjected to. They took turns, one after another, while someone held her arms tight. Throughout her epidermis, the color black, faithful to its mistress, suffered each of her pains. She could hear the shadows threatening to turn her white by kicking and punching her. *White*, they kept repeating obsessively. *We'll turn you white.*

There was also another color that stayed with her that evening: the color red. And to think, it had been the first that wanted to break away and flee far from that nightmare. It had no wish to be the sign, the very emblem, of the outrage done to Lafanu. But life doesn't always let you run away from yourself and from the thankless tasks that destiny randomly assigns. However reluctantly, the red abided with the violated girl. And then it started to run down her thighs like a river in spate.

AS WAS TO BE EXPECTED, news about the assault on the student Lafanu Brown, Bathsheba McKenzie's

protégée, spread through the Coberlin community in a few hours. The first to rush to her side was none other than Miss Mallony. Somewhat cautiously, she entered the house, a construction of imitation marble and flagstones that Dr. Jones had had built in the center of town. The man had regularly treated black women as part of certain experiments he was conducting on ovarian cysts. "Negroes don't feel pain. Moreover, negresses are bitches, which makes them perfect for my experiments." Dr. Jones was from the South, and for years he had performed studies on slaves, naturally without anesthetics: "Why waste precious morphine if they are quite capable of enduring suffering?" Miss Mallony knew that Dr. Jones had not stopped his experiments after moving to the North. But instead of negresses he used immigrant women, mostly Scottish and Irish. He'd give them some small change as payment, and if they died on his operating table, he'd hand out some more small change to their families, who were happy enough to have one less mouth to feed and a bit of money in their purse.

And so Miss Mallony, who like everyone else was acquainted with the doctor and his sinister reputation, had grown worried and hurried to his house. She didn't want him to get strange ideas about Lafanu too and test who knew what infernal contraption on her.

As soon as the maid let her into the house, Miss Mallony headed straight for the doctor's office. She knew the place well, having so often accompanied her sister Ruth there.

The sight of her student lying on a cot made Miss Mallony feel almost faint. She hadn't expected to see all that dried blood on the corners of her mouth and her face so swollen from the punches and slaps she'd received. Lafanu's whole body was covered with bruises and scratches. There was no longer any trace of the smiling, lively girl with whom she liked to discuss painting. Even Lafanu's eyes, usually so curious, looked lifeless. They'd torn out clumps of her hair; Miss Mallony could glimpse the girl's scalp, and she noticed with horror that some surviving strands were quivering alone, like the shreds of a tattered sail on a defeated ship. The woman began to tremble, whether in indignation or dismay she couldn't tell. However, her trembling didn't prevent her from asking the doctor, in a low, pained voice, "Has the girl been . . . dishonored?" And then, in an even lower tone: "Doctor, you must tell me, was she . . ."

"Louder, Miss Mallony! Speak louder!"

The doctor's hands were encased in gloves, and a grimace of disgust contorted his mouth.

All of a sudden, they heard Lafanu's voice—still strong, in spite of everything. "Is that you, teacher? Miss Mallony? Please come closer."

Teacher...

Hearing herself addressed in that way, Miss Mallony moved closer to her student's bedside. She stroked the girl's forehead like a mother, but Lafanu was already elsewhere again. Exhausted by the effort it had cost her to call out, she'd plunged back into the state between sleeping and waking typical of people who are suffering.

Miss Mallony really was Lafanu's teacher. She was the one who had taught the girl to see. She was the first to introduce Lafanu to Michelangelo's dazzling luster, to Raphael's austere swirl. She'd spoken to the girl about Caravaggio and his dark abyss and showed her Artemisia's smothered rage. And now Lafanu herself was Artemisia. Like the seventeenth-century painter, she, Lafanu, was a rape victim.

Miss Mallony moved away from her student's bedside and once again approached Dr. Jones. "Now, Doctor," she said. "Tell me."

"Please go away," he replied, visibly peeved. "I have to examine her."

"You won't hurt her, will you?"

"Go away, I said."

"Leave me alone with her for a moment," the woman implored him. "Please."

Dr. Jones gave her ten minutes and "not a second more." Miss Mallony began to stroke Lafanu's forehead again. It was scalding hot, like a coffeepot on an open flame. Miss M. didn't speak, she only caressed the girl's forehead. And Lafanu was ashamed of what she didn't remember and closed her eyes to avoid looking at her teacher. Ashamed of the outrage she'd forgotten. She wanted to thank Miss M., but instead she lay there and kept her eyes closed. She felt like a coward.

How many hours had the two of them spent together that year, closed up in the workshop and chatting as they leafed through books that contained prints of old paintings? In fact, Miss Mallony was the only teacher who taught Lafanu anything with any regularity. And even before discussing Michelangelo with her black student, Miss Mallony had told her about a Dutch painter named Judith Leyster. Miss M. spoke of this woman as though she were a friend and showed Lafanu her self-portrait. "She wanted to be what she was, so she invented a place where she could exist," Miss Mallony had said. "A place where she could resist."

"And where was that place?" Lafanu had asked in her hoarse voice.

"You know very well where it is," the teacher had answered pertly.

And she'd touched the girl's hands. Then she took the palette and pointed out the white canvas to her

black student. She dipped her brush in the green, in the blue, in the purple, in the red.

And she drew a line: the color line.

A line that was green, blue, purple, and red. A line that was nothing and everything. A black line that could divide or unite. As black as Lafanu Brown's skin.

"Here's the place. Where the colors meet the surface. This is where Judith existed. Where Judith created. And you'll exist here too."

BUT ON THAT FEBRUARY NIGHT in 1859, Lafanu Brown had ceased to exist for a few hours.

Only pain existed. Only cold existed.

Only Miss Mallony's hand existed, compassionately stroking her forehead.

But it was in that very room, in Dr. Jones's home clinic, all imitation marble and frosted glass, that Lafanu decided on her future.

And it was then that she grasped with all the strength in her body the color line Miss Mallony talked about. She decided she wouldn't give up. She'd regather her colors. She'd become an artist.

Crossings

I

When I was attending the university, I had a friend from the Castles named Lorella. We both took courses in classical Arabic at the Università La Sapienza in Rome, but the truth is, I never really learned Arabic.

Nevertheless, studying that language at least allowed me to understand the meaning of my name, Leila: night.

Lorella, on the other hand, was good at Arabic. She was always raising her hand in class, and the professor praised her for her excellent Egyptian accent.

Lorella . . . Everything began with her.

Lafanu Brown had yet to appear in my life, but the destiny that would lead me to her had already put

itself into motion. And the first piece of the puzzle was none other than Lorella.

I have no idea what became of my old university friend. I should seek her out on Facebook or Instagram, but I don't dare. I don't want to look at her wrinkles, the wrinkles of a woman in her forties, and see my own. And besides, it would be humiliating to discover that she actually learned Arabic, whereas I didn't.

I don't remember much about her appearance. The only feature that has remained in my brain is her large mouth, an African-looking mouth, bigger than mine, and I really am an African. Or rather, my parents really are Africans; I'm just an offshoot. A peculiar blend of Rome and Mogadishu, the issue of a scruffy couple who fled dictatorship in Somalia and instead of taking refuge in Paris or London headed for Rome because the year before, while there on their honeymoon, they'd watched the Ethiopian distance runner Abebe Bikila win the marathon barefoot in the legendary 1960 Summer Olympics, held in Rome. So my parents told each other that they too could win the marathon of life, or at least return to some form of the normalcy that the dictatorship of Big Mouth—which was what everyone called the Somali dictator—had taken from them. And I was their new beginning. A chubby baby with big, astonished eyes who nevertheless was unable completely to erase the melancholy from their faces. Maybe that's

why, from time to time, I'm melancholy too. In exile from a country that has basically never been mine.

But as I was saying, Lorella's lips were decidedly more African than mine. Not that she used them very much—she talked so little! But I remember finding her silence very good company.

One day in class, out of the blue, she asked me if I'd ever been to Marino, a hill town near the city, one of the Roman Castles.

I said I hadn't.

And she said, "Too bad for you. Next weekend's the grape festival, why don't you come? My mother will be happy to put you up."

"It's a deal," I said.

We shook hands, and so the following weekend I went to Marino.

For dinner, we had pasta with tomato and basil, prepared by Lorella's mother. Very simple, very tasty, served with lots of Parmesan.

At one point in the meal, Lorella's mother poked me with her elbow and said, as though letting me in on a secret, "We eat a lot during the festival, so it's best to keep things light this evening. Otherwise you won't have room tomorrow for all the good things the festival puts out every year. We'll eat *porchetta* and drink plenty of wine. A real treat!"

I smiled out of politeness. But my smile was forced. A bit worried, even.

I'm a Muslim. *Porchetta*—pork roast—and wine are haram. They surely weren't right for me.

But I didn't have the nerve to tell Lorella's mother I didn't eat or drink any of that *gaal* stuff.

Gaal, what an ugly word. It means "infidel," someone who's not in our club, not from our "tribe." It's a Somali word I used a lot when I was twenty, but which now, well into my forties, I find horrifying because it separates me from other people. But at the time, I felt so different, so "other." And I remember my shame at always being the person who gets noticed because she doesn't eat this or drink that. I was always the odd one, the one who obeyed incomprehensible rules. I was, in short, ashamed to be myself. And so I didn't have the nerve to blurt out to Lorella's extremely blond mother that I was an Italian girl but different from her. And that I would prefer a cheese sandwich.

If that were to happen today, maybe I'd speak. But it was 1992. My cultural difference weighed on me. I didn't know how to make sense of it.

It was so hard to have to explain myself all the time. Explain the skin, the kinky hair, the big butt. My melanin was always getting in the way. And I always had to respond to stupid remarks such as, "Ah, but you speak good Italian."

Well, maybe that's because it's my native language, damn it! I certainly did speak good Italian. Often better than some who considered themselves

more Italian than me. But people couldn't compre-
hend the fact that we—other Black Italians and I—
were there among them. In 1992, we were invisible.
We were specters.

We were there in the society, we immigrants and
children of immigrants, and it wasn't as though we
had just arrived, but the majority of the population
knew little or nothing about us. They didn't know
how to place us. They got us mixed up and called us
foreigners. As far as Italians were concerned, we—
whether Muslims or Sikhs or Hindus or Orthodox
Christians—were simply outsiders, aliens, certainly
none of theirs!

Italy hadn't noticed that we were farther along
and already mingling worlds, ours and theirs. That
Italy, a nation born only in the previous century, was
already pulsing with our migrated blood. Italy, run-
ning naked and mad between the Mediterranean Sea
and the Indian Ocean.

But I didn't have the nerve to say all that to Lorella
and her mother. To say that I would never eat pork or
drink wine because I wanted to stay connected to my
ancestors somehow. They had taken their first steps
in the fabulous Land of Punt—in Somalia, famed for
frankincense, where sometime before Christ a fe-
male pharaoh, an Egyptian ruler named Hatshepsut,
would go to drench herself in our heavenly perfumes.
I dreamed about my ancestors every night, but they

received no mention in any school I ever went to. There was so much I wanted to learn about them. What sorts of faces did they have? Did they look like me? And how did they show love? Did they kiss each other? On the mouth, on the nose? What did they dream about? How I would have liked to meet them, to read about them. And so food—that is, following our dietary laws to the letter—was the easiest way to make contact with their history, which I felt was mine as well.

Without saying anything, therefore, I went to my room and the bed that had been prepared for me.

It was a large house. And only two people lived there.

I didn't ask Lorella about her father. Maybe he was dead, or maybe he'd run off with a lover. In any case, the two women, mother and daughter, didn't seem to have any financial problems.

I envied them a little. And I thought about our immigrants' apartment in the Prenestina district, where we were packed tightly together, practically on top of one another, and where I was never able to study.

Low-income housing. My mother always used to assure me, "We weren't poor in Somalia. We had a nice house in the Skuraran quarter. I had a vegetable garden, some chickens, a mango tree, and a lemon tree. The curtains came from Zanzibar, the furniture

from Milan. We could afford lots of things." My mother clung to her opulent past. She would tell me about her family, who were dealers in fine fabrics, and especially about Daddy's pharmacy. "All Mogadishu came to seek his advice for upset stomachs, for pounding headaches, for broken bones. Daddy knew the right advice to give to everyone. He was good at his job." And I wanted to believe her. But then my reality had collided with another Daddy, a man whose degree the Italian government wouldn't recognize, and who had grown severely depressed, cut off from his chosen profession. But my parents did what they could, they did their best. They sacrificed themselves for us and for the relatives they'd left behind in Somalia, to whom they regularly sent money. Mama scrubbed the floors in white people's houses, and Daddy eventually found a job doing the cleaning at a pharmacy near our place. He'd accepted the work because going back to a pharmacy, even if only to clean it, had seemed to him like catching a momentary whiff of the paradise he'd lost. We certainly couldn't afford any luxuries. The little money my parents earned—and this made me furious—was used to take in other "refugees" from Somalia, whom they lavished with food and attention. So if I needed a new pencil case, or if I longed for a certain blouse because all my classmates had one, my parents would say, "Don't be selfish, we have to help others." And at the time, since like all teenagers

I was too selfish, I hated those homeless people who came in and occupied my home. They were invaders. I detested them. And even by the time I was twenty, my feelings about immigrant solidarity hadn't changed all that much. I knew I was a bitch, and deep down inside I felt kind of proud of myself. Fortunately, as more time passed, I changed. But that night in Lorella's house, all I could think about was how many things life had taken away from me.

I switched off the light. A bed I didn't have to share. Finally. For two nights, I'd be able to stretch out my legs.

I often think about that night, and about how selfish I was when I was twenty years old!

But the following day, everything changed. Even though I didn't know it yet, I was retracing the footsteps of Lafanu Brown.

Days of silence at Coberlin. A grim silence that filled the college with foreboding. The administration had not yet made a pronouncement regarding Lafanu Brown's fate.

A nuisance, the president of the college had called her. A big black nuisance. And he gave orders to the entire faculty to keep the assault on Lafanu quiet. "There must be no leaks," he said. "Be careful around the servants. We can't ruin our image because of an insignificant negress. Therefore mum's the word, keep your mouths shut, and if any one of you dares to talk about this, know that the guilty party will end his or her days in penury. I will personally oversee your ruin, and you know I say nothing in jest."

Threatened and frightened, the teachers held their tongues. It seemed to all of them that taking a risk for a negress was at best inadvisable.

Even Miss Mallony kept quiet. The president's eye was particularly alert and fierce when it fell on her.

"How is your sister, Miss Mallony?"

And Miss Mallony bowed and said only, "Poor Ruth is in stable condition."

Poor Ruth. Miss Mallony's sister was immobile, a prisoner of her bed for many years now. She needed continuous care. Everyone at Coberlin was aware of "poor Ruth's" situation. Everybody knew that Miss M. and Ruth were alone, without men, without any independent income, and that having the college provide them with their board, their lodging, various attentions, and "that Dr. Jones whom you always send to me, sir," and who was "dedicated to my sister's health," was a privilege Miss Mallony could not afford to lose. The doctor was a contemptible man, but her sister needed his care.

The president declared himself happy to learn that Ruth's health hadn't declined. He smiled, and from the hair covering his face there emerged two pointy teeth, like those of hyenas. Then he uttered some ironic words that sounded to Miss Mallony like a threat: "You will always have our loyalty, Miss Mallony, if . . ."

This was a way, one of many, of putting the old spinster on notice that she must be a good girl and

forget about the negress. Were she to disobey, the consequences for her and her sister would be catastrophic.

The president smiled again, his yellowish eyes fixed on Miss Mallony's elongated, weary countenance. And once again, the woman saw the sharp canines protruding through the clotted beard that covered the president's face. "Lafanu, forgive me," Miss Mallony whispered, a plea audible to her ears only. Her sister, poor Ruth, had no one but her . . . Miss Mallony couldn't put her sister's medical care at risk. She bit her lip, hard, and wrung her hands.

Then, in her consternation, tremulous words issued from her mouth: "Thank you for your generosity, sir." It sounded like a capitulation.

At that moment, though with a heavy heart, Miss Mallony was abandoning Lafanu Brown to her fate. She couldn't do otherwise; her back was against the wall.

And the others did likewise.

AFTER THE ATTACK, Lafanu Brown was forbidden to talk to the other female students.

She couldn't let herself be seen in the halls during class hours. She wasn't allowed to visit the library. Borrowing books was prohibited. No professor was authorized to address her.

And while she waited for someone to come and pick her up, Lafanu Brown was segregated in a sort of large closet on the top floor of the college.

A young kitchen maid named Daisy would carry up Lafanu's meals.

Lafanu requested notebooks, books, pens. None of that was given to her.

Late at night, when everyone else was already asleep, Daisy would accompany Lafanu to the public bathroom on the fourth floor so that the girl could wash. She had to do so without making any noise. She had to pour water over herself and then silence it with a muted slap.

Daisy would help her. Lafanu was still having trouble bending because of the beating she'd received. The violence inflicted on her was continuing to cause her immense pain.

To quiet Lafanu's cries, the president of the college had authorized Daisy to stuff cotton into her sore, battered mouth. And thus, thanks to that cotton, Lafanu cried out without making a sound.

Sometimes she felt as though she were suffocating, and at such times, Daisy would remove the cotton. "Learn to scream in silence," she'd tell the girl in her thick Irish accent.

But Lafanu didn't know how to scream in silence.

"You have to block your breath," Daisy told her.

"Block?"

"Yes, block."

"And how do you do that?" Lafanu asked.

"You clamp your guts like you have to go to the toilet. And then you puff out your cheeks and cry. Breathe through your mouth. Swallow your moans. Swallow your tears too. It's child's play."

And so Daisy taught Lafanu Brown the trick of dying in silence.

"How many times can you die in one life, Daisy?" Lafanu asked on one of those interminable nights.

"Innumerable times," Daisy replied, eliding the vowels. She was an Irish scullery maid who had never read a book in her life and conducted a running battle with words. But sometimes, unexpectedly, poetry came out of her mouth.

"How many more times will I die, Daisy?" the black girl asked.

"Every time you remember. Every time you fall in love. And you'll be afraid you can't love anyone anymore."

DAISY WAS Lafanu's only companion during her days of convalescence. Without books, without paintbrushes, without her beloved notebooks, she felt lost.

It was as if she had become mute. Without language. Almost without blood in her veins.

And in the beginning, she didn't know what to say to Daisy. She was so coarse, so primitive. The very opposite of Bathsheba McKenzie, the woman who was paying for Lafanu's tuition in that college of great expectations.

Lafanu had never seen a poor white woman. She hadn't thought that white people could be poor too. Her discovery amazed her.

She'd seen destitute people, of course. But she'd never met anyone as dramatically poor as Daisy.

"I'm an immigrant," Daisy told her. "I left my country and followed a man. Charles O'Rooney. A handsome red-haired lad. He would take me from behind, just the way he'd do his only cow from time to time."

Daisy told Lafanu that as far as Charles was concerned, she and the cow were just two holes he used when he liked. Two deep, dark holes.

"He never once kissed me. Nobody has ever kissed me. They say it's very nice. Have you ever been kissed, Lafanu Brown?"

The girl shook her head violently. She still had a bitter taste in her mouth, left over from that terrible night. A kiss, perhaps? A tongue forcefully thrust between her lips? She couldn't remember.

Daisy gently stroked her, like an otter with her whelps. "Maybe someday it will happen, maybe someday we'll be kissed too," she said. Then she burst into

tears, stifling her sobs with her hands and blocking her breath.

How lovely it would be, Lafanu was surprised to think, *if I could catch Daisy on a canvas, Daisy crying over a kiss she never got. She'd make a fine subject, with her pink cheeks and soft body, like a loaf of bread fresh out of the oven.* Lafanu imagined painting her in a sitting position, her chin thrust forward, her eyes fixed on the eyes of whoever was looking at the picture. Indeed, Daisy's eyes were big, oval, perfect. And her long, coppery lashes provided a unique frame for playing with the red-and-green tonalities that Lafanu's palette would include. Daring though the combination might be, the girl was nevertheless unafraid of tackling it. Miss Mallony would remonstrate with her. Maybe she'd shake her head and tell Lafanu that the colors would end up devouring one another. But Lafanu, though bearing in mind her teacher's advice, would do things her own way. And she'd play with Daisy's eyelashes. But it was only a dream. The closet she was living in contained no canvas, no easel, no paint, no colors. And her colors...how she would have liked to get them back! She didn't want to leave them in the hands of her attackers, but they hadn't come back to her yet. And her life was still enveloped in a gray cloud that seemed to her worse than a prison. All the same, looking at Daisy's ruddy face

gave her a little hope. How she longed to paint that face! But her experience with handling brushes was still pretty minimal. She'd never painted a human face on a canvas. She had no idea how to draw on such a large surface.

A month before the assault, Miss Mallony had escorted Lafanu to a big room on one of the lower floors and placed her in front of an easel holding a blank canvas. Then she ordered her, "Paint."

And Lafanu, stammering, "But miss, I don't know how to."

Miss Mallony had burst into loud laughter. Then she put some brushes in the girl's hand and in a breathy voice whispered to her, "You sketch in your notebook all day long. And I've seen you in the gardens after a rain, picking up a stick and drawing birds in the muddy soil."

"But that's different, miss."

"No, it's not." Then, vigorously gripping the girl's arm, she started making her trembling hand move over the white surface.

"What are we doing, miss?"

"We're spreading the color."

They didn't draw anything that first day but spent the time spreading colors on the canvas: all the colors of the palette, including their shades. At the end of their session, Lafanu's dress was stained with rainbows, but that didn't matter, she was so happy.

"I'll teach you the techniques," Miss Mallony had promised her the next day.

But they had time to paint only a single flower on the canvas. The flower was red, and thus full of the future.

Then, on a starry night in February 1859, those who would steal everything from Lafanu made their appearance in her life. They stole everything from her, starting with her colors.

"YOU'RE HURTING ME," Lafanu wailed. They were in the bathroom, and Daisy was washing her, as usual, with great energy. And at every stroke, the Chippewa felt her ribs splintering under those big Irish hands. Lafanu was on the verge of crying, but instead she unexpectedly asked Daisy for a favor: "Would you steal a book for me this evening?"

"I don't know how to read," said Daisy.

"No matter. Go into Miss Mallony's room and steal me one. Miss M. always has good books lying around. If I don't do something, I'll go crazy."

Daisy stole two books.

"So you don't ask me to do it again. I don't like stealing. It's a mortal sin. I don't want to go to hell for two books I can't even read."

"But this isn't really stealing," Lafanu tried to explain to her. "When I'm finished reading them, you'll

put them back where you found them." Then, with a sigh, she added, "Relax! Miss Mallony won't notice."

"But what if she does? I need this job, I can't lose it! I don't want to go back to the port. I had to clean the sailors' toilets there. And they put their hands all over me."

"Don't worry, Daisy. Nothing's going to happen to you."

The Irish scullery maid had managed to pinch a two-volume set of Keats's poetry. Lafanu read her a couple of the poems, and Daisy said, "I didn't understand nothing."

"The poems talk about life."

"And what do they say, then?"

"They say life is hard."

"Well, your Mr. Keats was right about that."

Crossings

II

I ate a big breakfast on the day of the festival, so big that Lorella's mother murmured to her daughter, "What an appetite your friend Leila has!"

I'd heard everything she said, but I played deaf.

My plan was to stuff as much food as possible into my stomach at the start, because there wouldn't be anything for me to eat from then on. The festival offered nothing but haram food, which was forbidden fare for a second-generation Muslim like me.

I didn't know what to expect from the festival. Lorella hadn't briefed me on anything. I knew only that at some point, wine would flow from the fountains, as it does in the well-known Roman song.

Wine from the fountains. A miracle.

"All these people drinking wine, they won't bother you, will they, Leila? I'd feel bad if I thought . . ."

As my friend, she recognized the problem; however, I reassured her: "Everything's all right, I'm not so orthodox as all that. I don't drink wine, but if you all do it really won't bother me." And I played the modern, easygoing girl, even though my reaction to wine was exactly like my mother's—that pungent smell disgusted me. But I wanted to avoid being the different one for once, the strange girl who was having trouble assimilating. I wanted to be part of an anonymous crowd, I wanted to be anonymous too. And the festival, with all those people, seemed to me like the ideal occasion for that.

I remember that we got caught on the main street of the town, teetering on a sidewalk packed with sweaty bodies.

When the trumpeters arrived, the crowd shouted for joy.

I joined in with the festive crowd but limited myself to applauding.

We seemed to have been plunged into the midst of a medieval tournament. Flags were flung about. Pirouettes were performed. When the ladies and their cavaliers, all in period costumes, appeared on the scene, I really started to enjoy myself. Lorella and I cast votes for the best couple. And in the meantime, we examined the boys. Of course, when you saw them

in tights and ostrich feathers, it was hard to tell if they were cute or not, but we ventured to speculate anyway. Undeterred by the sixteenth-century outfits, we already knew who we'd focus on afterward, when the procession was over.

The girls had grapes in their hair, and I too stuck a little cluster in my braids, almost as if I were Caravaggio's Bacchus.

Naturally, I was the only Black person in all that multitude. It often happened that I was the only Black person in a room, in a class, taking an exam, attending a concert, or—worse—in a discotheque. I'd long since grown used to it.

Lorella, her mother, and I followed the historical parade for a while, and eventually we wound up in a large square.

There we saw a distinctly odd trio standing on a balcony: a woman sheathed in an embroidered dress, a sort of grand chamberlain all in red, and a boy wearing a pure white costume, including a Renaissance-style jerkin with gilt buttons. The man in red—Lorella told me he was the town butcher—began to declaim in a solemn tone: "On the seventh day of the tenth month of this current year of grace 1571, in the waters at the mouth of the Gulf of Lepanto, a mighty victory was won against the Turkish enemy, and it is for that victory, and in the name of all *marinesi*, that I have the honor to present to you,

most illustrious commander, the keys to our city of Marino . . . And here are the keys, illustrious prince."

It was in that moment, when the chamberlain handed the prince the keys to the city, that a mindless fear struck me in the pit of my stomach. I started trembling and almost fell to my knees.

I'd caught a glimpse of the fountain, the famous fountain from which wine miraculously flowed.

It was a fountain of grayish tuff stone, and it was filled with an improbable abundance of grapes. Grapes also decorated the faces of the four statues chained to the fountain; their arms were tied behind their backs. They were prisoners. Maybe they were part of the war booty, the victor's spoils, that the boy in the bright white costume, or rather the historical personage he represented, had brought back from the battle. I looked more closely at the statues' faces. They were filled with suffering. And then I started trembling harder. The four prisoners, two men and two women with naked breasts, looked like me. They had black skin like mine, curly hair like mine. In fact, the two women's hair was braided in exactly the way I happened to be wearing my own at that time. We shared a code that was hidden among our plaits. The four prisoners were gazing at some indefinite point on the horizon. They had the same nostalgic look my mother had when she thought about her life in

Somalia. But there was something besides nostalgia in their eyes. I saw fear there too.

I felt as though those prisoners, especially the two women, were calling out to me for help. But I didn't know how to set them free. Poor nameless women. And poor me, who had no way to give them names. We were three Black sisters, foreign to one another, separated by centuries, but companions in suffering. Because being Black meant having to deal once again with the chains that cut into our flesh. It meant, as Ta-Nehisi Coates declares in *Between the World and Me*, living in constant fear of losing your body. And those two women had lost their bodies forever.

Coates wouldn't write his book until many years after my excursion to Marino, but the fear of losing our body has been present for centuries in every Black person's life. I'd known that fear a thousand times myself, when I'd be on a bus as a teenager and someone would say, "These niggers are all thieves," and people would give me hateful looks, or when—it happened on certain rainy afternoons—I'd find myself alone at a bus stop and men in big cars would pull up and flash banknotes and proposition me: "How about a nice blow job? I'll give you a hundred thousand liras." The big cars terrified me. There was never anyone else at the stop on those occasions, and if the drivers had only wanted to, they could have

forced me inside their vehicles and made me do horrible things. Luckily, that never happened. I just had to avoid looking at them and move away. And they'd drive off fast.

I looked around. The people who had flocked to the festival were happy. They were all singing, drinking wine, eating sandwiches crammed with *porchetta*. Joyous laughter rang out. How I would have liked to feel some joy myself! But I couldn't, I couldn't anymore. Not now, not after my eyes had met the Black prisoners' eyes. And I realized that what my mother always told me—*There comes a moment in life when everything changes*—was true. There in Marino, in Piazza Matteotti, everything was changing for me, really changing. I suddenly understood that my mission was to save those four suffering people, and that they had asked for my help with their stricken look. It didn't matter that they were stone statues, I wanted to save them all the same. I groped for Lorella's arm. She gazed at me with wine-blank eyes. I pointed in dismay to the fountain. She laughed and said, "Can you believe it? The fountains of Rome have nothing on this one. Don't you think it's just beautiful?"

That adjective, spoken so nonchalantly, struck me like a projectile. Lorella was an intelligent girl, a student of Arabic, open to the world. But even she, in spite of all the knowledge she carried around, was blind to the pain of those four prisoners—at that

moment, I refused to call them slaves—with black skin. Maybe she hadn't even noticed that they were Black.

It was then that the future appeared clear to me. It was then that I decided (though I would become conscious of my decision only in the following days) that I would help people to see better. To probe beneath the surface, to decode the paintings, the bas-reliefs, and the statues that were all around them.

Like my parents, I'd help people too.

My parents offered a handful of displaced Somalis food, smiles, and a temporary roof over their heads.

I would give others new eyes for seeing the world they made their way through every day. Lenses for understanding the past and laying hold of the future.

Ultimately, I chose to become an art curator thanks to that outing in Marino with Lorella and her mother.

But back then, in 1992, I didn't yet imagine that a Black woman, an artist named Lafanu Brown, had stood before that very same fountain in the middle of the nineteenth century and had an epiphany similar to mine. Twenty years were to pass before I would make that discovery.

D_{AISY PLACIDLY STRETCHED} herself in one corner of the storage room that by this time had become Lafanu Brown's accommodations at Coberlin. The Irish girl was talking a lot about her homeland. About how arid it could be, about how fickle the sky was, its blue hidden by unstable, gray, imperious clouds.

Home was a word Daisy didn't like.

Home meant a roof and a hot meal, and those were two things Daisy had never had in Ireland.

"If it hadn't been for that bastard Charles O'Rooney, who tore me away from my country—which gave me nothing—I'd surely have starved to death like a rat by now."

Ireland, hunger, potatoes, steamship, flight. Those were the words that came flooding out of Daisy's mouth.

Green Ireland, the Emerald Isle ...

"Not everyone sees the same colors. If Ireland had been green for me too, I'm certain I never would have gone away. I was forced to leave. Because even potatoes were getting scarce. I can't call a place 'home' if it doesn't have potatoes. A place where I suffer from hunger all the time isn't home."

Lafanu looked at Daisy attentively, furrowing her brow. And then, unexpectedly, she who almost never asked questions asked one.

"And Charles O'Rooney? What became of him?"

"He died like a dog on the steamship, thank God," said Daisy, laughing coarsely. She couldn't hide her joy at being free of that man, who had been nothing but a burden to her. "He never managed to reach the promised land like I did. *I* became an immigrant. Not him."

Immigrant.

Lafanu thought about that word. It had a full sound that filled the mouth all the way to the molars. She pronounced it softly and noted how her lips spread in a smile. How her tongue took on the colors of the future. Immigrant ...

That word had power. And Lafanu knew she had it as well. After all, she too was an immigrant. She too,

like Daisy, had left behind a home that she loathed and loved with all her heart.

AND LAFANU BEGINS to write about that home, once so hated and so immensely beloved, on one of those sun-filled afternoons that Rome has been bestowing on its residents for centuries and centuries. It's right that Ulisse should know where she escaped from.

THE VILLAGE where Lafanu was born didn't have a name. It was just a conglomeration of tents and a few scattered brick houses built in the vicinity of a rushing river that the natives called simply "Buffalo Drool."

And that vigorous river enthusiastically flung itself into an even bigger river, and together they formed the waterfalls for which the area was well-known to all the nations. Everything about those cascades (also named after the buffalo) was grand: the uneven drops, the three stages—which gave the waters a certain childish playfulness—and the sediments, which thanks to the reflections of the light resembled crystals of white marble as they plunged down. Those waterfalls had attracted the attention of travelers, who now made the area a regular stopping place. But for the Chippewa, the cascades had

become a prison. They had been exiled there; there they had to be born, there they had to live out their lives, like it or not. And to think that Lafanu's people, not so long ago, had dominated the lands that were later to become Michigan and Wisconsin and Minnesota and North Dakota, even reaching into Montana. Now almost nothing remained of that glorious past. The Chippewa, also sometimes called the Ojibwa, had been—and in part still were—hunters and tuber-gatherers. They were also still very brave. The stories they passed down from generation to generation told of decent folk who nevertheless, in the heat of battle, never left so much as a tuft of hair on an enemy's head. They knew how to fight, and they didn't retreat from danger. But the stories told of their magnanimity as well. Unlike other tribes, they didn't torture their enemies. Violence was an inevitable consequence but not the purpose of their actions. They loved animals and respected the gods. Who could do nothing when the fury of the whites came crashing down on them. They opposed them with whatever they had, they put up resistance. And then came the surrender. After which the white fury began to divide them. Lafanu didn't want to believe that those weary shadows that wandered around the village were the descendants of the glorious Chippewa. The men were staggering drunk, and by noon the women were already specters. And besides, could you call that accumulation

of tumbledown hovels a village? From time to time, news of other members of the tribe would arrive. And Lafanu, entranced, would listen to those messengers with the silver feathers as they related that the resistance in the West was fierce, and that the Chippewa were holding their own. She was proud of those men, who still believed in the struggle. And she often dreamed that she was at their side, all dressed up, holding an ax, a sword, or even just a little knife like the one her aunt and Timma used for carving wood. Lafanu felt ready to strike, to deal out blows with her weapon, to die for freedom. She would have done anything to escape the inertia she was stuck in.

The village was condemned to have no future. The little girl who was becoming a big girl looked around her and saw only desolation. Nothing but desolation. Some missionaries had given the village a gift of brandy, and it was brandy that had extinguished all energy. Instead of thinking about protecting themselves, about living, the grown-ups were occupied with guzzling brandy and acquiring more and more substantial supplies of it.

Lafanu hated the grown-ups. But she couldn't manage to hate her aunt.

Her aunt was adorable, especially when she looked at her affectionately and warned her, "Don't expect too much of yourself, little one." Lafanu's

aunt knew she was a perfectionist. And she knew how much the child, so different from the rest of the tribe, needed a shoulder to lean on. The aunt often felt unequal to the task. But like many Chippewa women, she had the gift of gab, and whenever the opportunity arose, she'd dispense little pearls of wisdom for the girl's benefit, gems gathered from the ancient knowledge of their ancestors. Only after having completed this duty would the woman go back to placidly weaving the rugs, carving the little figurines, and sewing the moccasins that the sight-seeing white people who came to visit the waterfalls liked so much.

Like everyone in the village, the aunt was a slave to brandy.

But when she was sober, she tried to talk to the rebellious niece who had fallen to her lot. "A Haitian heart beats inside her," she'd tell the other women. "She's a horse that won't be tamed."

She was so different from Timma. Lafanu was taller, her hair curlier, her eyes bigger, her forehead broader, her feet larger. Nobody in the village had such big feet. When it came to those, even though she was still a child, Lafanu could compete with some adult men. And how she could ask questions! Her aunt was, so to speak, deafened by them. Lafanu asked about everything—why green was green, why goats ate seeds—and above all, she asked about her

past, or rather, about her parents, whom she'd never known.

Of her deceased mother, there had remained to her the long neck and the full lips. There also remained a drawing in which the woman appeared in profile—a drawing made, according to her aunt, by her father.

Her father, the Haitian, was adept at depicting faces.

And Lafanu, over the course of her childhood, had tried to imitate him as best she could. To feel him a little closer to her heart, among other reasons.

She could often be seen squatting in front of her aunt's tent, tracing lines and ovals in the dirt with a stick. She wanted to produce something like the perfection her father had been able to create with a few strokes.

But drawing was so hard. Especially drawing faces. You had to look at them closely, to understand them, to take them in, and only after all that to try to compete with God in re-creating them.

Lafanu was always muddy. And always absorbed in the dreams she dreamed with wide-open eyes.

In her aunt's telling, her father had seen the world. "He's seen the strangest places on earth. The ones where men speak through their navels, the ones where birds are dressed in light, the ones where women turn into dewdrops."

And Lafanu, when the talk was of traveling, would shiver.

She dreamed, as her father might have dreamed, of stamping around the globe on her big feet.

TIMMA WAS VERY DIFFERENT from Lafanu. Timma loved her village.

Of course, the general desolation smothered her, as it did everyone. But she knew how to avoid the trap of despair.

Timma ran. And sometimes she'd drag the reluctant Lafanu with her on her runs. She'd take her by the hand, and together the two sisters would dash up and down Buffalo's Hump, their sacred mountain; its name came from the legend of a buffalo that sought refuge in the heart of the mountain from a hunter, a white man who had no respect for the natural world around him. The mountain covered the great animal with a shadow of snow and flowers.

In reality, nobody knew how long ago people had started calling the mountain by that name. And the buffalo were only in the valley. But it was a lovely story, and everyone accepted it.

Timma ran fast. Lafanu trudged along behind her, barely able to keep up.

They wore badly sewn moccasins as they ran, and they often hurt themselves on the mountain's

troublesome protuberances. Lafanu in particular was always covered with scratches. And every scratch made her regret being there instead of in front of the tent, drawing ladybugs and flowers in the dirt. Only playing with her drawing sticks and giving form to the world soothed her nostalgia for the parents she'd never known.

Once they reached the summit, Lafanu would sit cross-legged and contemplate the spectacle of those ancient rock formations. It was Timma who had told her that the goddess in charge of all the souls of the village gave each one the chance to make a wish. And one day, to reinforce her words, Timma gave her sister a rough little statue of maple wood that she had made herself. Timma was good at carving statues but terrible at sewing moccasins. And so, by common accord, the sisters had divided up the chores. The moccasins fell to Lafanu, and Timma got the figurines. Lafanu had watched her sister work. Her hands were knowing and fast. Using a sturdy little knife, she needed only a few movements to produce wonders: lynxes, owls, storks, prairie dogs, buffalo. But as for goddesses, the one she carved as a present for Lafanu was the first she'd ever made.

The goddess who had taken shape in her hands was a tall, slender woman with a pensive expression. Adding a personal touch to her gift to her sister,

Timma had given the figurine a thick, curly hairdo in the shape of a half-moon.

"Our goddesses look like us," she told Lafanu. "Maybe they even *are* us." Lafanu shivered as she touched the figurine. "And now, sister," Timma said, "make a wish."

Lafanu closed her eyes, pressed her lips together, and thought about that wish as intensely as she breathed when she ran on the trails of her mountain.

And a few days later, the wish was made flesh and bone and crinoline.

A few days later, Bathsheba McKenzie descended on the region, renowned for its waterfalls and breathtaking panoramas.

BATHSHEBA WAS A RICH WOMAN. She had made a good marriage at an appropriate age, and at an appropriate age, she had been happily widowed. She had a daughter. And a brother who managed her fortune (but less and less conscientiously) to make sure she didn't dissipate the rich patrimony she'd inherited. Her daughter—not much older than Lafanu, all blond, all ringlets—was already giving Bathsheba a great deal of trouble. Hillary had been spoiled by her father, and she had a penchant for mischief that didn't give her mother great hope for her future.

"Just like her father, the snotty brat!" That is, like the late Andrew, vain and deceitful. For the entire brief duration of her marriage, Bathsheba, along with her brother, who had been a real help to her in this regard, had traveled the country, hushing up the scandals that her husband constantly and shamelessly left in his wake. His premature death was her salvation. And in her widowhood, she found her mission. As a wife, she had embraced the movements for the rights of women and black people, but her little girl and her nannies gave her more than enough to do. After she was relieved of the burden of her husband, there was nothing to stop her from becoming one of the most active volunteers in the city of Salenius. She was always busy. Together with a core group of battle-hardened women from various parts of the county, she raised funds, distributed propaganda, prepared petitions for signing, and pressured legislators so that the poor negroes whom the South was devouring in its rotten jaws might receive fairer treatment.

Ultimately, those women were fighting for themselves above all. A white woman certainly wasn't in a much better situation than a black one; she too was property, only better dressed. Maybe that perception was what moved Bathsheba to join the struggle. In reality, she loved her little hats more than the propaganda materials she gave out, but she found, in

throwing herself into a fight for rights she didn't even know she could claim, new lifeblood, new reason to go on living. Her brother didn't look on her involvement in these matters with an approving eye, but now that she was a widow, she could no longer be bossed around as she could when she was unmarried and looking for accommodation. He couldn't bear seeing her attached day and night to that worthless book by Harriet Beecher Stowe, *Uncle Tom's Cabin*, which was said to have sold three hundred thousand copies in the United States alone. But the good old days were gone, and the brother had to resign himself. Women were changing; his sister had completely emancipated herself from his supervision. Besides, Bathsheba's ambition was now unrestrained. The whole city knew that she wanted to be the most benevolent, most charitable lady in all Salenius. But in order to achieve that, she must somehow dent the solid primacy of Emma Stancey, who wiped the butts of the Irish and Scottish immigrants.

What a colossal waste of time, Bathsheba sighed to herself, thinking about Emma Stancey. *With all the negroes we have right now, must we really deal with those reeking immigrants too?*

"Negroes," she often said, "are my only reason for living." She would affectionately refer to them as "my negroes," as though they were trained monkeys in her possession.

Bathsheba found herself in the valley of the Chippewa almost by chance. Her cousin Clo, who lived in the West, was the one who had insisted on visiting the savages. Clo was Bathsheba's enthusiastic admirer, given to repeating incessantly, like a crazed parrot, the declaration that her cousin was "the most adorable creature on earth." And Bathsheba put up with this clingy relative only because of the very fine compliments she was wont to pay her. Therefore, when Clo proposed to go to the "Sleeping Buffalo" waterfall, Bathsheba couldn't get out of accompanying her. "It won't be very exciting for you, I know," Clo said. "But for me it will be an adventure. I've never seen a cannibal in my life." The "cannibals," naturally, weren't cannibals at all, but poor native women who sold their pathetic merchandise near the waterfall.

Clo wanted a pair of moccasins to display in her Victorian parlor. "Such a colonial touch," she sighed nostalgically. And then, tirelessly, she assaulted her cousin with a cartload of useless questions. Bathsheba replied with some inarticulate mumbling. Her cousin was being so annoying, she never stopped asking her about Queen Victoria. Yes, true, Bathsheba had been received by the queen . . . and so? The sad truth, however, was that she no longer remembered anything that had happened during the years of her marriage. Of course, she had traveled with Andrew. She'd seen the cities of Europe, sojourned in London,

given birth to Hillary in Paris—maybe that was why the girl was so cheeky—but of all those places, and of all the people Clo asked about, she couldn't remember anything anymore. The things she'd done with Andrew had slid away from her as if she'd never experienced them. Everything that happened after she was widowed, by contrast, was bright and shining. She felt like a young girl ready to take flight. She was ready for anything.

She didn't yet know that she would go back to Salenius with another girl child to raise, a child she would make the star of her own personal firmament.

TIMMA WAS THERE, her nearly blond hair in braids, keeping an eye on the merchandise. The aunt had stepped away for a moment to speak with some other women of the tribe, while Lafanu, as usual, was making drawings in the dirt with a little stick.

Timma was concentrating so hard that she didn't notice the rustling of skirts beside her. Bathsheba found the girl's Caravaggesque beauty striking. What a contrast of coloring and silky hair, and then, what refined manners! The older woman looked at Timma's hands. They were white, almost snow-white, so fair that had it not been for the exotic and intoxicating aura that certain hints of racial mixture lent Timma's skin, Bathsheba would have taken her for a

pure-blooded American girl. And when she inquired about the price of the figurines, she was impressed by the young savage's impeccable diction. Bathsheba didn't know that Timma's aunt, whom the Haitian had taught to read and write, had passed on her knowledge to her two nieces. She didn't know that in the evenings, if the aunt wasn't too drunk, the three of them would read the Bible together. The same Bible that the Haitian used to carry around with him, not for God's sake but because it contained "some of the most exciting stories" he knew. The Haitian didn't believe in God or gods, but he believed in the power of stories. Bathsheba knew nothing of all this. She noted only that the girl with the coppery braids was a splendid creature. And then a thought flashed through her head: *Suppose I take her back to Salenius with me?* She surely could afford to satisfy that sudden whim of hers. *I'll turn her into a great woman, the greatest of her race. How beautiful she would be in a pleated evening gown.* Bathsheba was already cherishing the thought, and she blinked her eyes in contentment.

The only one who understood what was happening was Lafanu Brown. After all, she'd heard her aunt tell similar stories a thousand times. One or more ladies arrive in the area and carry off one or more young people, those with the lightest skin and the fairest hair. They're children of a rape, or of some arrangement made in exchange for a little food, or a

little brandy, or just for some hope to hold on to. The ladies shower the tribe with money, and the children travel far away to lands no one in the tribe knows anything about, not even their names. Such stories were told in the village as useful for scaring children, warning them that a pale lady might carry them away with her if they weren't good. But the pale lady was precisely what Lafanu dreamed of for herself. She was tired of that foul-smelling village where nobody dreamed anymore. They were isolated by the mountain and slaves to brandy. No possibility of making a better life there. Lafanu wanted to traverse the world on foot, like the Haitian. To see her feet grow more and more calloused from traveling the globe, one side to another. She had no idea what world she'd find beyond the mountains. But she knew it would be a thousand times better than the one she was living in now. She couldn't tolerate the air anymore, the smell of fir trees, the noisome scent of moss. During the warm, sunny season—granted, it didn't last very long in these parts—Lafanu couldn't stop sneezing. Blood veined her eyes, and a sensation both icy and burning dried her mouth.

She had to find a way out of there. Before she got too old. She had to escape now.

But the woman heaven had sent to take her away was talking amiably to her sister, Timma, and patting her cheek.

Lafanu loved Timma. She was the only person in the village for whom she felt real affection. The only one who listened to her torments. And Timma knew better than anyone how their village confined and stifled Lafanu, how different she was from the Chippewa they'd grown up with. Timma knew her sister wanted to travel the big world on her big feet, to gather up scents and colors and sensations and store them inside. And then she'd put everything in a picture colored like a rainbow. Lafanu had felt that fate would soon present her with a good opportunity.

And now the opportunity had come, but for Timma, not for her. *It's not fair*, Lafanu thought. And suddenly she felt very selfish.

Nevertheless, she couldn't suppress the turmoil in her heart.

I'm the traveler, not her. I have my father's big feet, not her. Lafanu was furious at fate, and also, for the first time, at her unwitting sister.

Then she bit her tongue. She looked at Timma. She was so beautiful. Of course people preferred Timma to her and her black skin. Lafanu's kinky, frizzy hair lost from the outset to Timma's luxurious mane, so soft and silky to the touch.

Tears as big as wheat sheaves formed on Lafanu's smooth skin, which she wore almost by chance.

Timma noticed the tears on Lafanu's face but didn't immediately understand what was troubling

her sister. It was a normal day at the waterfalls, under a clear sky. The aunt had gone off, and Timma was showing the merchandise to this clingy, chatty white lady. Then she suddenly felt the lady's hand on her hair.

"Not even my daughter's hair is as soft as yours," the woman said.

And all at once, everything was clear to her. Timma saw that the woman was appraising her, like a commodity she was thinking of buying. Something she'd shortly be haggling over with her aunt.

And the aunt would let her go. Some small change would do the trick. There was so much hunger, and the white merchants charged a lot for brandy.

I can't live without the mountains.

That was the first thought that came to Timma. At bottom, she was selfish too.

Without the mountains, I'll die.

Timma was inches away from Lafanu. She gave her a dumbfounded look, like someone who doesn't know what to do or where to go. It was as though she were paralyzed. How she would have liked to say to her sister, *You can have my place.* How she would have liked to put Lafanu's hand in the white lady's hand. *I don't want to leave, but she does. Turn around, stupid white woman. Look at my sister. For God's sake, look at her.*

But the white woman didn't turn to look at the black girl.

Then, seized by rage and by the fear of losing her mountain, Timma bit the lady's arm, which was covered with frills from wrist to shoulder. She bit it hard, as hard as she could.

Bathsheba cried out. But Timma didn't relax her jaws and kept growling like a rabid dog.

It was Lafanu who sprang at her sister and detached her from the white lady's arm. Then she hastened to bring the woman a wet cloth, which she angrily snatched. Lafanu didn't want to give any weight to that rancor. She looked at the white woman, and then, as she'd seen missionaries do when they occasionally showed up in the valley, she bowed obsequiously to her. It was then that Bathsheba asked her, "And who might you be?"

"I'm Lafanu Brown. My father was a Haitian man, and the girl who bit you is my sister, Timma. I apologize for what happened. My sister never behaves like that."

And it was true: Timma never behaved like that. But she'd done it for Lafanu.

Bathsheba dabbed at her arm with the wet rag and then, quite by chance, she noticed the drawing that the black girl had made in the dirt with a twig.

What she saw astounded her. The girl had drawn a woman's face, adorned by her hair, which cascaded down to her shoulders like shooting stars.

"Who is it?" Bathsheba asked.

"It's you, miss. Don't you recognize yourself?"

Bathsheba, taken by surprise, replied, "Well, now that I look at what you've done, there certainly is quite a resemblance."

And at that point, her attitude changed. This black Indian girl's manners seemed exquisite. Admittedly, her hair was coarse, her skin could use more sheen, her roughnesses required smoothing. She'd need a long bath to wash off the dirt and get rid of the lice that these people surely carried around. *But this girl has something inside her,* she thought. *I can't let her get away. I'll turn her into the finest member of her race. It will be child's play to make her become what I want her to be.*

As soon as she returned to Salenius, the woman decided, she'd give the order, she'd have someone come here and pick up Lafanu. She surely couldn't travel with her now, just the two of them; first the girl had to be made presentable. And Bathsheba already knew to whom she'd entrust the young girl: Mulland Trevor.

He and that dried-up wife of his will have the where-withal to transform this raw material into the most coveted diamond, she thought.

"Girl, run and fetch one of your grown-up relatives. I have a business proposal to make!"

Lafanu ran off like a shot. She knew that proposal concerned her—her and her freedom.

Crossings

III

Years later, I went back to Marino for a wedding. A friend, Stefania, was getting married. We'd met in a belly-dancing class four years earlier and had been close ever since. We weren't great dancers—no one in the class was. Our teacher, Tiziana, didn't want perfection of steps so much as perfection of joy. "The first thing you must learn to do is to feel the rhythm of your breathing," she'd say. And then she'd add, "As you perform the movements, never stop seeking your joy in them." And that was how the miracle happened. Every time. I was ecstatic. In every class, our rigid bodies (mine was a block of marble) softened and melted like candle wax. Our steps were liquid, vaporous, airy. And that dancing and that joyousness united us. While we danced, we talked about the men

who were doing us wrong, about the cellulite that gave us no respite, about our increasingly painful periods, about the menopause that had already carried off our dreams, about the child that was so late in coming, and about the delicious *supplì*, fried rice cakes, that we would have eaten a thousand more of apiece had it not been for fear of belly rolls. I even talked about my cancer with those girlfriends. One day it had appeared unexpectedly, inside a nostril, like a flower. Afterward it spread until it reached my ears, so that one day, just like that, I suddenly had a hearing problem. Next came a whirlwind of visits to the otorhinolaryngologist, of CAT scans and MRIs, plus the boyfriend who leaves you because "I can't stay with a sick person," followed by the surgery, the operation to excise the tumorous mass, the chemotherapy, the radiotherapy. And then there was the clutching, the clinging with all my might to doctors, to life, the taking stock, the making of a will, the regret at not having seen Mogadishu again, the putting up with the consequences of the therapy, the scaly tongue, the baby-food diet, because by that point my mouth was a crater and eating solid food was totally out of the question. Through the whole infernal time, dancing was my only salvation. I didn't have much strength, but being with my friends gave me courage. They would hug me and refrain from pitying me and then, just as usual, fire off a barrage of gossip and

news. "You're going to get well, you'll see," they'd tell me, cheerful as could be, and then I really did get well. It happens; sometimes you get well. "But you'll have to have a checkup every three months for five years, because with diseases of this kind you never can tell," the doctor said. Right, of course, you never can tell, but I immediately went out for a delicious pizza with my girlfriends. I'd been living on smoothies and baby food for too many months. My mouth was still a crater, but I sure enjoyed that pizza Margherita! And my friends were there, applauding me.

So that was what being part of Tiziana's dance class meant to me. We were women of all ages, and we were all friends. And on that wedding day in Marino, all of us were there to share our Stefania's great joy.

The ceremony touched our hearts, and when it ended, we left the church and proceeded on foot, walking unhurriedly to a trattoria in a narrow little street behind Piazza Matteotti. As we were approaching the piazza, I suddenly began to tremble.

My head didn't remember anything yet, but my body had retained, in every square centimeter of its epidermis, the images of what I'd seen twenty years earlier, when I went to the grape festival with Lorella, my old friend from the university, and her mother.

Face-to-face with the fountain, I felt, once again, that sensation of unbearable discomfort.

The two stone women were still in place, looking desperate as ever. Still chained to the base of the column in the center of the fountain, bare-breasted, with the eyes of those who know that rape is all their future holds.

That vision had terrified me the first time too. As Lorella and her mother were lurching toward the fountain, mother yelled at daughter, "Fill my glass!" Then she gave me a guilty look and tried to justify herself, stammering, "It's Castelli Romani wine, the festival, tradition, you understand?" I nodded without taking my astonished eyes off the crowd surging around the two statues, around the poor tuff-stone girls, girls who were chained to the column and whom nobody—except me—saw.

Only later did I discover that the fountain was originally built in the seventeenth century and subsequently rebuilt after the bombings of World War II, which had partially destroyed it. It was the first fountain in Marino to flow with wine.

This wonder took place in the year of grace 1925, the year the festival was born, three years after Mussolini's March on Rome in October 1922. The grape festival tradition began that year, totally supplanting the preceding festival, which had been dedicated to the Madonna. The fountain was called the Fontana dei Quattro Mori, Four Moors Fountain; according to the encyclopedias I consulted back when there

was no Internet and nothing was available at a click, the "Moors" were Turkish pirates. But those weren't statues of pirates, they were just slaves. People in chains, desperate, alone, bent into inhuman poses. The women's breasts shook with terror.

I discovered (by simply going to a library) other things about that fountain: the name of the man who conceived it—Sergio Venturi—and the reason why it was built. The citizens of Marino wished to commemorate the Battle of Lepanto and Marcantonio Colonna, one of the commanders in the fight. This was the great battle that pitted the allied forces of Christianity against those of the Ottoman Empire. I thought the parade I'd seen was a commemoration of Marcantonio Colonna's triumphal procession, a procession in which captured persons formed part of the spoils of war, slaves whom the powers that be would divide among themselves. For a while, I was obsessed with that fountain. In fact, it was the reason why I chose to enter the world of art. But like every obsession, that one too faded away, squeezed out by my crowded schedule in those days, made up of exams and boyfriends and planning for the future and various uncertainties that seized me by the throat and wouldn't let me breathe. Or maybe I was just doing my best to forget what I'd seen, because it's easier to remove a source of suffering that way.

But that day, Stefania's wedding day, I once again felt those afflicted eyes on me.

I was standing before the fountain as Lafanu Brown had stood before it the first time she saw it, an occasion she described in one of her letters to Lizzie Manson, her first tutor and friend.

> *Those women, those ancestresses of mine—*
> *because we're descended from the sufferings of*
> *slaves—want someone to give them a voice. Oh,*
> *dear Lizzie, I see how hard they're trying to lean*
> *out toward us. How they're thrusting their torsos*
> *forward, almost as if they wanted to plunge into*
> *the void. Baby Sue told me countless times that*
> *when they pulled her out of the hold of the slave*
> *ship and held her fast, making her wait her turn*
> *to be violated, she strove to break free and throw*
> *herself in the ocean to escape that nightmare,*
> *which she'd never known back home in Africa.*
> *Baby's a proud Fula from the hinterland, she*
> *never imagined there could be anything more*
> *ferocious than a famished hyena. But then she saw*
> *the white man, and she realized that cruelty has*
> *no limits. My Baby Sue, who found peace in her*
> *pies, which she sweetened with incredible amounts*
> *of sugar, because only that sugar could take the*
> *bitter taste from her mouth. The same bitterness I*
> *can yet sense on my own tongue.*

I still knew nothing about Lafanu Brown. I'd read those words months before, thanks to Alexandria Mendoza Gil, one of Stefania's colleagues, who was also one of the wedding guests. Stefania was a researcher, and after the wedding she and her husband were going to leave for the United States, for Salenius, where Alexandria lived too. She taught in the art history department, and she was doing research on Black artists of the nineteenth century.

It was she who put a hand on my shoulder when she saw me standing there in front of the two chained women, on the verge of tears.

"I cried the first time too," she said, in an English that smelled of cassava root. "My grandmother's from Santo Domingo, in the Dominican Republic. Like you, I have African blood in my veins. We can't be indifferent to this fountain. Lafanu Brown wasn't indifferent to it either."

I remember looking at her. I felt the welcome in the words she'd spoken. Yet there was something else, something I wasn't getting. "Who's Lafanu Brown?" I asked her. Even before introducing ourselves to each other, we both pronounced that name. And in the name of Lafanu, we became friends. Throughout the wedding banquet, we talked of nothing other than that woman painter, who had marked Alexandria's life and was about to mark mine as well.

Nobody was there waiting for her. The walkway in front of the general store was deserted. No human presence. No friendly sound. Except maybe, in the distance, the feeble braying of the little donkey that had brought her from Coberlin to Salenius.

The driver of the cart, a taciturn, sparsely bearded fellow named Rufus, was the handyman at the store. And he too, like everything in the landscape, was enveloped in a gloomy, tense, fraught silence.

Lafanu looked about her. She heard nothing at all. The very flies had stopped buzzing. Not even they wanted to know that she'd been expelled from Coberlin. Not even they wanted to get mixed up in that sad business.

The letter received by Mulland and Marilay Trevor, the free couple of color whom Bathsheba McKenzie had delegated to see to the girl's education, was unequivocal.

The word *expelled* was inscribed on the paper in bright red ink. Red, the color of infamy. The reasons for the expulsion remained vague. The teaching staff presented the whole matter to the Trevors as stemming from problems with the girl's character.

"She disturbs the academic peace," the letter said. And then came a sentence that someone on the faculty had underlined violently: "Miss Brown is liable to do harm to our students' well-being and to our institution's good name."

The contents of that letter and of another one featuring even more details and sent directly to Lafanu's mentor, Bathsheba McKenzie, were known by only a few people. But the news of Lafanu's expulsion soon made the rounds of the city.

The free people of color in Salenius—there were about two hundred and thirty-five of them—were the citizens who most deplored what had happened. And many of them started to sow doubts about the girl's behavior.

"She asked for it, the little fool."

"It had to be her fault."

"I'm sure she deluded herself into thinking a black girl could live like a white girl."

"Women, especially ours, should always stay in their place."

"Stupid girl, nobody taught you that we live in a jungle? The North isn't Paradise. Sure, we're not slaves like we were in the South. The clothes we wear here are civilized. Clean. Starched. Embroidered. We've forgotten that we're Igbo, Yoruba, Fula, Sa'ad, and Murusade. We've forgotten that our mothers were taken by white men on slave ships in the middle of the Atlantic Ocean. And that until not so long ago, many of us also scratched at the damp soil with our fingernails to gather sugarcane and filthy cotton. They made us believe in the equality we never actually saw. And women like you, Lafanu Brown, you took that big lie about the North and swallowed it whole. The lie that tells us we're equal to the whites. That we even have the same privileges they do!"

"You got your hopes up, and now sorrow and shame weighing you down, ain't they?"

"Serves you right!"

"So have the decency to keep your mouth shut. Not a word! Head bowed. And woe is you if you raise your eyes, girl. If you dare to challenge the whites."

"What you think you doing with all those notebooks you always carrying around? You playing artist? Chase that unhealthy idea right out of your head, honey. A nigger girl's a nigger girl, you won't ever be an artist."

"Bowed head and tight pussy, little girl, don't forget. And hide it good under rolls of fat."

"Girls like you, even if they're free, even if they were born in the North, they get screwed in the end, screwed real bad, by one of these stinking white men."

"You'll wind up fucked, some white man will fuck you . . . that's the way these things go. And now you know it. It's happened to you."

So nobody greeted her when she descended from the cart, and it wasn't long before Rufus was a good distance away. Lafanu was alone, her wretched bag on her shoulders and a tear splitting her face. She stood up straight, waiting for someone to say, "Welcome home." But no one had come to welcome her.

Not even the first time, at the end of her first journey after leaving the Chippewa, had the people in the house bidden her welcome.

That day, now a distant memory in the back of her mind, she'd carried a bag and worn the beige dress that Bathsheba had had delivered to her. And she had stood erect, like a cow, in front of the closed door.

The dress was Bathsheba's gift to her, "for your trip," the older woman had written. And when Lafanu had put on the dress before leaving the tent she shared with her aunt and sister, she'd felt like a new person. As if, all of a sudden, she'd become someone else. Timma had touched the bows on the dress with

her fingers and said, "You look gorgeous." Her dewy voice still resounded in Lafanu's heart. Their aunt, on the other hand, had been too drunk to acknowledge Lafanu's departure. Overcome as she was by brandy and her inner torments, the poor woman was unable to tell her niece goodbye. So with a delicate gesture, Lafanu had stroked her aunt's hair and kissed her on the forehead. The older woman had practically pushed her away.

Lafanu had spent the entire journey weeping, and when she arrived at the Trevors' house, the house she was supposed to live in, everything seemed like a mistake. *Maybe I shouldn't have left my people*, she said to herself. Already, just from the outside, the Trevors' house looked inhospitable, as if inhabited by ghosts. She stood unmoving at the door, alone, while nobody came to open it and she felt lost. But hadn't it been her dream to leave the mountains, her tribe, and a future made up exclusively of brandy? Hadn't she done all she could to get Bathsheba to notice her and take her away with her? Then what was this wavering? What was she so afraid of? She looked down at her feet and saw that they were even bigger than she remembered. Her feet! Oh, her beloved feet! Gazing at them, she took heart again for a moment, and she realized that she was where she wanted to be. She loved the Chippewa, she was a Chippewa herself, but at the same time, she was so different from them.

The Haitian's blood had made her restless, and ultimately, as she stood before that closed door, Lafanu saw an opportunity.

In the end, somebody came and opened the door. A boy whose hair was a thick mass of tangled curls appeared. One of his eyes seemed smaller than the other, but the apparition was too brief for Lafanu to take in any other details.

The girl took one step forward. But then a powerful voice—belonging, she would learn, to Mulland Trevor, the head of the household—invited her inside. "Come on, come on in, we're not going to eat you."

They were all lined up, waiting for her. There was Tommy, the boy who had opened the door; he was giggling, maybe because he'd seen her first and had won some kind of bet. Next to him, and taller, were his two older brothers, William and Geoffrey, the latter endowed with a prominent jaw that gave him a certain air of seriousness and scared Lafanu. And last was a girl, Lucy, with an arrogant smile and silky hair gathered at the back into a cheeky, insolent tail. She seemed to be a couple of years older than Lafanu, or maybe that was just because she was taller. She had kind eyes and a much lighter complexion than her brothers. Lafanu couldn't imagine the infernal trials the couple had been put through because of that girl. In the free black community, it was said that Marilay had conceived her with a white man so that

her daughter could have the light skin she'd always dreamed of for herself. But her husband shrugged off such gossip. He believed in his Marilay. *She dotes on me*, he'd think with pride, still finding it hard to believe that this magnificent creature had chosen him—*him*—instead of one of the many free men of color with more resources.

When her eyes settled on Mulland's full face, which was framed by a handlebar mustache, Lafanu finally felt happy to be there. The man inspired trust. Maybe he could be a father to her; of course, he wouldn't be able to compete with the big-footed Haitian, who had a special place in her heart, but he might provide a shoulder for her to cry on or perhaps even become someone to whom she could confide her dreams, as she'd seen some Chippewa girls do, ones who had fathers not yet destroyed by brandy. But she had no idea how free people of color talked among themselves. The Trevor family was the first family of free blacks she'd seen in her life. She didn't know any, not even one. They didn't seem bad, she thought, all things considered. But that thought was proved wrong as soon as Marilay Trevor made her entrance into the drawing room, where the family was assessing the new arrival.

"You're short," she said without preliminaries. It already sounded like a death sentence. "And you have a wild, disheveled appearance."

"But . . ." Mulland tried to say before a hard glance from his wife silenced him. And then he retreated, his tail between his legs.

"Bathsheba McKenzie thinks we're her servants. And maybe we do owe her something, but put this in your head, girl: We don't owe *you* anything. You'll obey our rules. And you'll do whatever I say. Now they'll wash you, they'll show you how to wash yourself, and they'll take the lice off of you."

"I don't have lice, and I know perfectly well how to wash myself," Lafanu protested. "We're clean people, we Chippewa!"

"Clean? You're a pack of savages. And I see I'll have to put a clamp on that sassy mouth of yours, little girl."

Lafanu tottered a bit, partly because of the violence of those words and partly because of hunger. Except for a tuber Timma had given her for the journey, she hadn't eaten anything in the past two days.

"She must be starving," Mulland intervened.

"She can wait. Now I want her washed." She called the tallest of the boys and said, "Bring her to Baby Sue and see that she's washed from head to foot."

The glassy voice that issued from the woman's mouth turned Lafanu's stomach. What had she come to? This wasn't her idea of freedom. And it wasn't what she wanted. She wanted books, dreams, she wanted her big feet to roam the world, as her father's

had surely done. She dreamed vivid dreams of him wandering through white-hot countries where sea monsters and dragons made war on one another. She saw him drawing portraits of the inhabitants of those countries, each stranger than the next, which he traveled through with his Haitian curiosity.

She wanted to draw too. As soon as she was free to do so, she would look for a sturdy twig and some fresh dirt. And she'd draw the crooked mouth of that light-skinned black woman whom she already found so disagreeable.

Before being brought to Baby Sue, Lafanu noticed that Lucy was winking at her. That made her feel less alone. After all, she'd just arrived, and already she'd found another Timma. She liked this Lucy, even though they hadn't yet exchanged a word.

QUITE SOME TIME had passed since that first afternoon, and now Lafanu found herself standing in front of that big door again. She'd been expelled from Coberlin. She'd been... my God, she didn't even know what the devil had happened to her, she didn't remember it. She couldn't make up her mind to enter the house. Would she find them as she'd found them the first time, all gathered in the drawing room? Ready to judge her, or—worse—to try her? She fantasized a convenient invisibility. Lafanu didn't want

to show herself with the infamy of her expulsion on her face, especially not to Marilay. No, she didn't have the nerve. And so she stood there in front of the door, shaking all over, her hair disheveled, her back and the palms of her hands covered with sweat. The name of the Trevor family, swaying on the bellpull, made her feel queasy. To put an end to that, she decided in spite of herself to enter that free black household.

She pushed the handle down; the door opened. The house was exactly as she had left it.

YEARS BEFORE, right after he and Marilay got married, Mulland had remodeled the house with his own large, expert hands and turned it into a residence with all the trimmings. There was a big kitchen, a drawing room crammed with books and scattered piles of antislavery pamphlets (Lafanu had had enough time with the Trevors to ransack this room for reading material), bedrooms, a large stable, and an outbuilding, a shed Mulland had built to accommodate two cows and, for a few days or even an entire season, fugitive slaves escaped from plantations in the South. Out of gratitude, the latter guests helped in the kitchen, in deliveries, or even in the vegetable garden.

The Trevors were well-known in the city for their culinary productions, and business had been growing,

thanks also to Mulland Trevor's amiable ways and the investment that Bathsheba McKenzie had made in him. It was typical of many free blacks to go into business for themselves. They might do very well, but only up to a certain point. And Mulland didn't violate the rules. He was an excellent businessman, but he never went beyond the limits preestablished for those like him. Furthermore, he had Bathsheba backing him; without that widow, who believed in the cause of the negro, he would never have made it. They had a mutual interest: He needed money, while she wished to be recognized in her city as a great benefactress, greater in her generosity than all the other ladies. And so, at the abolitionist meeting when she first met Mulland, she'd had no doubt, and she'd said to her associates, "This man inspires trust in me. I shall help him."

Thus it was that when, at the start of his entrepreneurial activities, Mulland Trevor achieved a certain fame with his oyster business, everyone understood that his enviable success was due to Bathsheba's money. The oyster trade did not count among the surest of enterprises; uncertain were the fortunes of a man who trafficked in shellfish. And in order not to deplete Bathsheba's investment, Mulland decided to widen his sphere of activity by opening a small general store, which he managed thanks to two white figureheads procured for the purpose by

none other than Bathsheba McKenzie, who continued to assist him financially in periods of crisis. As a result, along with fine oysters and lobsters, good Scottish brandy—much appreciated by almost all of the city's well-to-do businessmen—became available in Salenius. Mulland then branched out into wines and started organizing and catering to banquets. Few of his competitors in the market could beat his prices, and the service he provided was impeccable.

It was because of Bathsheba's money that Marilay hadn't left him for a more handsome man. Their benefactress had saved them from bankruptcy more than once. It hadn't been easy to convince the whites in the county that a negro knew more about oysters than anyone in Massachusetts. But even though everyone now recognized his abilities, Mulland never forgot that Bathsheba had never left him on his own. The only favor she'd ever asked in return was that he and his wife take care of Lafanu Brown. So when he saw the girl standing alone, as straight as a cane stalk, in the hallway of his house, Mulland felt a tightening around his heart. He knew he ought to go up to her, welcome her with kind words, maybe even embrace her. She'd suffered so much, poor girl. But Mulland didn't dare take a step toward her. He had an uneasy feeling.

Bathsheba asked me to do just one thing, and I've failed at it, he said to himself. He felt a hot flush in

his cheeks, and even the hairs of his mustache were standing up like porcupine quills. *I should go to her*, he thought, *and make her feel at home*. But he was afraid of his wife. Ah, Marilay! His sweet torment! The woman had thrown a fit when he'd told her of Lafanu's expulsion from Coberlin. "What did she do to deserve it? Were men involved, by any chance? She's a lascivious bastard. I knew it," she said with a sneer, and then, the expression on her face a mix of triumph and disgust, she added, "You don't intend to receive her into our home again, do you, Mulland? I won't allow it." Whereupon Mulland left the room, feeling he was caught in a cross fire. If he didn't let the girl come back, Bathsheba would withdraw all of her investments, and he'd be ruined, completely ruined; but if he took Lafanu in again, his wife would exile him from her bed. And he couldn't live without losing himself every night in that woman's charms, which it was his great good fortune to have all to himself.

LAFANU ENTERED the house. Silence reigned. Her light footsteps caressed the shiny floor. Her head was elsewhere. She should go to the kitchen, she thought. There she'd find Baby Sue, and there, if her luck still held, she'd find the little room, the storage closet that had become her lair. Marilay hadn't wanted Lafanu to share her Lucy's room. "She'd ruin her," Marilay

had said, persuading her husband. "She's probably
got some strange Chippewa notions in her head."

Lucy, however, had been the only person in the
family Lafanu had made friends with.

The days after she first arrived in that house had
passed monotonously. Lafanu stayed in the kitchen,
peeling potatoes, cutting carrots into rounds, filling
puff pastries as soft as angels' wings with strange,
sticky mixtures. Her hands, so skilled at sewing moc-
casins, became more and more expert in creating
dreams out of spun sugar and pastry cream. Every
day, her fingertips produced wonders. Her first year
with the Trevors had been spent almost exclusively in
the kitchen, listening to Baby Sue's stories about far-
off Africa, about how men from a neighboring tribe
had snatched her and sold her to the whites, "who
then brought me here."

Every night, Lafanu dreamed about that slave
ship, the thought of which filled her with indignation.

She would tremble all over. Because even though
it hadn't happened to her personally, her ancestors
also had been brought to the Americas in shackles.
Baby Sue's stories concerned Lafanu too.

Nevertheless, during that first year, except for
chats with the cook, Lafanu was very much alone.

The Trevors' male children avoided her. When
Marilay met her in the hall, she practically growled
at her. Mulland would smile at her warily, almost as

though he feared doing so might appear too friendly. And as for the white lady who had lodged her here, Lafanu hadn't seen her since. Didn't she have big plans for her? Could she have deceived her?

Lafanu couldn't know that Bathsheba was in Europe, staying with a friend in London.

And it was when Bathsheba returned that Lafanu's life finally changed.

MULLAND COULD STILL REMEMBER how angry at him Bathsheba McKenzie had been when she got back from Europe. "I had faith in you, Mulland. Was that faith misplaced, perhaps?"

Mulland was perspiring. Quaking. "No" was the only word he managed to say.

"Then explain to me why the devil you put my ward in the kitchen! I said you were to give her a room and provide her with clothes and let her study. I surely wasn't asking very much of you. And as for money, if you need more, you know all you have to do is ask."

After that little discussion, Lafanu was taken out of the kitchen and given a bed in Lucy's room.

Marilay had opposed this move. But Mulland, apprehensive at the danger of losing everything, had for once imposed his will on his capricious wife.

From that moment, a new world opened before Lafanu. She joined the Trevor children in classes

taught by Mr. Harry, a free black man with a long white beard. This "preceptor," as Mulland pompously referred to him, would come to the house every morning, and the children would pile into the drawing room, the only really large room in the house, to listen to him. Tom, William, and Geoffrey would yawn; Lucy would get distracted; Lafanu alone would hang on Mr. Harry's words. After a year of classes, Lafanu screwed up her courage, went to Mulland, and said, "Mr. Mulland, Teacher Harry is very nice and patient with us, but in my case, there's nothing more I can learn from him. He's already taught me everything he knows. May I be excused from classes? I prefer reading the books in your library."

Alarmed, Mulland rushed out to see Mr. Harry, who told him, "That girl's a genius. I can't keep up with her. She's not like your children, she's got a perpetual fire burning inside her, a rage for knowledge. I don't want to hurt your feelings, but none of your children has that rage."

Mulland was the only person in the house who knew that his family was harboring a sort of genius. And besides, he'd begun to appreciate Lafanu's elegant, spontaneous ways. If only Marilay could have seen her for the charming creature she was. But that was beyond the realm of possibility. Marilay detested her, maybe because she too had noticed that the Chippewa girl was polite and kind, a composed,

courteous young lady such as her own Lucy, so un-ruly and unkempt, would never be. Envy played a role in the senseless hatred the woman felt for the girl who had been entrusted to her. Often, during the meals the family consumed together, Marilay didn't spare vulgarities and pointed words that wounded Lafanu's skin like blades. But the girl stood her ground. After all, not being loved by Marilay mat-tered little to her. She didn't get along very well with the male Trevor children either. Every now and then she'd converse a bit with Geoffrey, but what they ex-changed were civilities, empty, useless words. Lucy, on the other hand, was different. She laughed. She had dreams. And every night, she planned her es-cape. "One of these days, I'll get out of here, Lafanu. I know my mother wants to make me marry some-body from Salenius, someone like David Field, who has helped Daddy a lot in the store. He comes from one of the first free black families. But I couldn't care less about David Field. I'm going to pass for white." Whenever she said something like that, she'd explain to Lafanu how she intended to carry out her plan. "Whites aren't nearly as white as they think they are. The sun cooks them, and if they themselves didn't tell us they were white, nobody would really know it. You'll see, all I'll have to do is say 'I'm white' and they'll believe me. My skin's light. There was a white man at some point in Mama's family history.

Female slaves were raped, you know—Baby Sue told me about that—and mulattoes were worth their weight in gold. I carry around the white skin of the man who violated my ancestress, and now that white skin is going to save me. I'll leave Salenius. I'll have nice clothes. I'll do what I want. And I won't marry no David Field."

Lafanu liked to listen to Lucy talk. She was older, and she said a number of things Lafanu didn't yet understand. And then Lucy would stop, she'd revert to being a young girl again, or maybe she was putting on an act to please Lafanu. They'd chase each other inside and outside the Trevor home, passing through some neighboring houses, inhaling other smells. Then they'd always end up rolling around on the ground somewhere. And every time, Lucy would tickle Lafanu, who didn't like that very much. One day, Lafanu asked her, "Why do you always touch my breasts, Lucy?" The girl jumped as if bitten by a tarantula. And for a little while, she stopped running around the premises with Lafanu.

NOW LAFANU was in the drawing room. Mulland Trevor, sunk in his armchair, was staring at her. The girl was afraid of whatever questions he might have. She was particularly afraid that he would ask her about that night in Coberlin. But she quickly

recognized the benevolent expression in Mulland's watery eyes.

In reality—but Lafanu couldn't know this—the man was terrified of her.

He didn't know what to say. Every word that came to him seemed wrong. Even a simple "How are you doing?" struck him as absolutely incongruous. How could she be doing? She'd been attacked, she'd been humiliated. Mulland could discern the pain on the girl's face, which was still partly swollen, and he felt sorry for her. *We free blacks must stay shut up inside the secure perimeters of our little lives* was the first thought that crossed his mind. And then: *I've heard about free black folks who had the bad luck to run into unscrupulous bounty hunters. Free black folks sold to Southern landowners to work on their plantations. Free black folks turned into slaves. No, black people like us, we can't afford to get ahead of ourselves. We must be very careful. All you have to do is look at this poor girl to understand how cautious we must be. They've destroyed her, the bastards.* He wanted to put his arms around her, but he didn't dare. Suppose Marilay should come through that door?

There was a rustling sound. Mulland flinched. He caught a glimpse of a sky-blue skirt through the door, and then Lucy appeared, come to greet her dear friend. *All right, Lucy, good girl*, Mulland said inaudibly. However, he failed to notice that Lafanu's face

had hardened. Her stony look hadn't escaped Lucy, however. All the same, she crossed the room to Lafanu and, despite the girl's obvious reluctance, embraced her. A shock went through Lafanu's body, and she abruptly withdrew from that embrace. She didn't want Lucy to touch her. She mustn't ever touch her again.

It was Lucy's fault that Lafanu had been sent to Coberlin a year ago. Yes, all her fault.

A YEAR AGO, Lafanu had discovered drawing on paper. Mulland had noticed that the girl spent hours and hours drawing doodles on damp soil with a twig. He talked about it with his children, who confirmed that Lafanu did some strange things: "You know, Pa, she's kind of a savage." Like their mother, the Trevor children didn't think very highly of that young girl, who had come to them from her mountain home. And besides, ever since the preceptor had praised her in class, they'd looked upon her love of books with suspicion. "Nobody will ever marry her, she's too strange. Mrs. McKenzie sure did us a bad turn!" The Trevor offspring who took against Lafanu most violently was Tommy. He still resented her because Mr. Harry, their teacher, had made such a fuss over her, while he, Tommy, got treated like a donkey. That was why he went to his father and said, "She's a witch.

It isn't normal to draw symbols in dirt—maybe that's her way of talking with the devil. She gives me the creeps."

But then Lucy intervened to clarify the situation. "Lafanu just needs some sheets of paper, Daddy. All she wants to do is draw." And it was thanks to Lucy that Lafanu received some drawing paper and paints in colors that inspired dreams. Later, Mulland also supplied her with notebooks, in which Lafanu began to catalog her world. Lucy often made a request: "Make me beautiful, Lafanu. Make me a beautiful portrait," and Lafanu would set to work. Lucy took excessive delight in being observed so intensely by Lafanu. When the Chippewa girl's eyes settled on her, they made her feel alive. And every time Lafanu passed close to her, the girl felt something like a dizzy spell. To her, Lafanu was fragrant with goodness, she carried the aroma of the mountains. Lucy struggled with longing to fall asleep on Lafanu's stomach. Those were unconfessable thoughts, but with the passage of time they had only grown more frequent. And Lafanu wasn't their sole object. Lucy had realized that men didn't interest her; she found their bodies inharmonious and themselves boring. Women's curves, on the other hand, their dewy smiles, and those strong-willed mouths attracted her as nectar draws bees. And besides, women knew how to open up worlds. They spoke about so many things, and if

she could have, she would have spent ecstatic hours listening to them. When abolitionist meetings were held in the Trevor home, or when they'd join the white women selling knickknacks at the local street markets to finance the antislavery cause, Lucy would lose herself in the sounds of swishing crinoline and gentle laughter. But she had never yet dared to make advances to anyone, even though she'd noticed more than one free black girl of her age gazing hard at her fair figure. Gazes that were sometimes like fiery darts and made her feel liquid between her legs. And then there were the fugitive slaves who occasionally showed up at the Trevor home and were lodged in the cowshed for a few days, or sometimes months. The shed could accommodate a maximum of two people; it wasn't the most comfortable situation, but for those who had known the sorrows of the plantation, even such a place as that could seem like Paradise. It would have been so easy to go to them and ask to be loved, if only for a few minutes. Lucy wanted to be caressed the way she sometimes caressed herself. And she dreamed of those women's kisses, hot, wet, yearning kisses. But then again, she didn't have the nerve. Marilay would kick her out of the house, and Mulland would disown her.

She had learned to conceal her feelings.

At least until that afternoon a year ago, when she'd found Lafanu alone in the drawing room, sitting

on the sofa, concentrating on the poem she was reading. She was so engrossed, so beautiful! Lucy moved closer to her from behind, and Lafanu, hearing the rustling of her skirt, turned around and smiled at her. Lafanu had a lovely smile, open to the world. Her dark mouth and fleshy lips had become, for Lucy, a genuine obsession. Unable to hesitate a moment longer, the girl flung herself on Lafanu and crushed her own lips against that mouth. Lafanu was so flabbergasted that she couldn't move a muscle. Only after several seconds, when she grasped the situation, did she try to wriggle free. They both fell off the sofa, Lafanu underneath, Lucy on top. "Get off of me!" Lafanu shouted, but Lucy seemed lost inside a frenzy of lust. "Get off of me, please," Lafanu begged, and then Lucy released her. But it was too late. Marilay Trevor had seen everything.

By the time Lafanu got up off the floor, Marilay had already pronounced her sentence: "You wretched little tribade, you will leave this house at once."

Marilay couldn't lay the blame on her daughter. That would have been too painful. She had plans for the girl, who she knew could pass for white. She intended to marry her well, for example, and she couldn't let a Chippewa savage ruin everything. That very evening, she threatened her husband: "It's her or me, Mulland. That girl has to go." Lafanu was sent to Coberlin in great haste.

When Mulland informed Bathsheba McKenzie of his decision, he told her only, "The tuition fees aren't high, and it's for her own good. She's too intelligent—our preceptor has already taught her what he knows." Bathsheba accepted with good grace. "They'll turn her into a refined young lady. Afterward, it will be a pleasure to introduce her to the Salenius Abolitionist Society. They'll see how good I am to you negroes." The prospect of those future successes excited Bathsheba. And Mulland was happy to have extricated himself from a bad predicament.

Now, however, everything had to be done all over again. Lafanu had come back from Coberlin and was standing stricken in front of him. His daughter, Lucy, wasn't looking so good either. Besides, he had a feeling that, at any moment, Marilay would come into the room and broadcast her displeasure. She surely wouldn't tolerate having the Chippewa on her hands again. The situation was one big muddle. Moreover, there was Bathsheba, who would need soothing. She wouldn't stand for letting her investment—because that's what Lafanu was—be subjected yet again to unfavorable treatment. Mulland would have to work up his courage. He got to his feet, and at that moment, Marilay entered the drawing room. Mulland's watery eyes trembled, but after only an instant of wavering,

he opened his mouth to deliver the little speech he'd been preparing all morning. Lafanu Brown would be sent to a white private tutor—a woman teacher in disgrace, but extremely competent, according to what he'd heard—who would be willing, for a good price, to instruct even a black girl like Lafanu. *She'll be out of the house as much as possible. And I'll have her take her meals in the kitchen with Baby Sue. She'll have little or no contact with Marilay. And Bathsheba won't be able to say that I'm not treating her Chippewa girl with kid gloves. That way, I'll be able to salvage everything. Including, and especially, my own skin. Those two women are not going to drive me crazy. I won't allow it,* he thought.

Mulland filled his lungs with air. And in a self-satisfied tone, he began to speak.

Crossings

IV

There are only seven extant photographs of Lafanu Brown. In one of her three diaries, presently in the collection of the public library in Salenius, Massachusetts, she herself explains how the idea of those photos came to her. The diaries cover the years 1885, 1886, and 1887. We won't find great stories recounted there; they seem more like collections of memoranda, notes jotted down to keep from forgetting.

"Brought the Poet some flowers, bought tulips for Hillary, went to see that Tosi woman, that harpy from Verona who never pays anybody, and told her I wasn't going to work on her portrait anymore. She starves her servants, I won't let her starve me too ... Got a commission from Lord Hamilton Barrey, he pays well, acts like a fine gentleman, wants a portrait in

the old style...The cardinal canceled our appointment, he has influenza...Must visit the Caravaggios again, it's been at least seven months since I last went to San Luigi dei Francesi and saw *The Calling of Saint Matthew*...Must watch sky at sunset, the light in Rome is perfect this time of year...It's persimmon season, must tell Concetta to buy me some, I like them too much, they give me energy...I'm bleeding less, drying up, the thought scares me."

In the midst of those sentences, Lafanu also wrote, "Today, appointment with photographer for pictures, what shall I wear?" And several lines later: "They delivered the photographs. I look like a little girl, I can't figure out why. Have I shrunk, by any chance?"

The images are impeccable. Lafanu Brown wears a shawl that almost entirely covers her flowered dress, which is barely visible through the fringes. She's got a hat, a kind of fez, pulled down low on her head, she's not looking at the camera, her gaze is fixed elsewhere. And this gives her whole figure a dreamy aspect. She hadn't wanted to be portrayed as a grande dame. She's not posing on command in any of the photographs; on the contrary, her whole body exhibits a sweet bashfulness, the shyness of one who chose never to do a self-portrait. She explained this more than once in the letters she wrote from Italy to her tutor, friend, and accomplice Lizzie Manson: "I'm in everything I paint, I'm the gerbera in bloom, the

chipped vase, the dying snake, the frightened cat, the books the grand gentlemen hold in their hands. I'm the rushing, storm-tossed waters, I'm the crooked ray that escapes the rainbow, I'm the dew and the unseasonable snow. I don't need to put my face on any canvas. It's already there, dear Lizzie."

But then she let that face be captured—to our good fortune, says Alexandria—by that recently invented contraption, the photographic camera. Lafanu didn't go to just any studio but to the best, Fratelli Alinari, the Alinari brothers of Florence, the oldest photographic and communications company in the world. Their online catalog even includes a photograph of Lafanu. It's one of those images that pierces the screen. In the midst of Florentine vistas and some ladies leading camels on leashes, there she is, in all her regal simplicity. A goddess.

Maybe it was those black-and-white images, old but so modern in their subject's pose and smile, which barely flickers across her almost childlike face, that persuaded me to act, or maybe it was my constant chatting with Alexandria. It was good to find a new friend to be reflected in. And Alexandria and I had lived through very similar, fucked-up childhoods, with excessively altruistic parents who filled our houses with strangers. And then there were the daily apocalypses we needed to confront, major disasters that our white schoolmates saw as part of their daily routine.

The more I got to know her, the more I came to realize that being of Somali origin in Italy was basically not all that different from being of Dominican origin in the United States. I was lost in those thoughts when I decided to send her a message in the middle of the night: "We have to introduce Lafanu to the general public." I knew that Alexandria's book *A Free Woman Abroad* had created a certain amount of curiosity about Lafanu in the academic world, and that her name circulated through almost every humanities department in the English-speaking world. Readers were absorbed by Alexandria's account of a free, open-minded woman living in times in which women still struggled to loosen the tight grip of a cruel patriarchy. Furthermore, the book reflects a period when the stories of nineteenth-century African Americans were being rediscovered. Articles about the pioneering men and women who had been the first to break through the glass ceiling constructed by a white-supremacist, capitalistic society were appearing in increasing numbers. But Lafanu, in spite of Alexandria's efforts, had not yet emerged in all her splendor.

"We have to make her *pop*," I said to my friend the next day. She'd called me as soon as she woke up and read my message.

Pop was a word I used a lot; for me, it wasn't just an abbreviation of "popular," it also connoted "glamorous," "fascinating," "successful."

"Lafanu ought to become a model for girls, for anyone who wants to escape society's traps and follow their own dreams."

Alexandria laughed heartily. Her Latina spirit let her see how comical my words were—they sounded like copy for a commercial. "You're describing her as if she were Lady Gaga," my friend said with a smile in her voice.

And I responded in kind, smiling too, but speaking frankly: "I'm an art curator. I have to think in those terms."

Then we both got serious again. When we said our goodbyes, they were dense with thoughts.

I had barely put down my cell phone when an idea began to dawn on me. As a little girl, I'd been crazy about the Disney character Gyro Gearloose. He looked a bit like me—even Daddy said so. Gyro was tall, lanky, and slightly clumsy, and he was always coming up with fresh ideas. In my profession, I was paid to generate ideas, and so I did, one after another, not always on subjects I found interesting. But now there was Lafanu, with her intense eyes, her flowered dress, her portraits, her landscapes, her flowering gerberas. A Black woman who had chosen, through the sheer force of her will, to be not just free but a free artist in a time when women in general weren't free at all. Nevertheless, the nineteenth century was the very period in which women had started to

agitate, some in the name of their entire sex. Many had made monuments of their lives. They had paved the way, had lived through experiences that could be useful to other women.

It's such a shame that no one knows about Lafanu, I thought. Then my phone began to ring.

"Is that you, Alexandria?" I asked in one breath, without taking the time to check the name on my cracked display screen.

"Yes, Leila, and I wanted to tell you that we have to make Lafanu—"

"Pop," I said, finishing the sentence I was hoping to hear.

"We could get her into the Venice Biennale in two years. If we start working right now, it's doable. In the meantime, if you're up for it, I could arrange a visiting professorship for you, which means you would spend a couple of months here in Salenius. It would be wonderful to show you her paintings."

"Wonderful!" I said, echoing her.

It was early morning. The sky threatened rain. And Lafanu Brown and Marilay Trevor had arrived at a decidedly shabby house. No trace of a servant, except for a slovenly-looking scullery maid posted at the door and more or less standing watch.

"We're expected," Marilay said in that hoarse, almost masculine voice of hers. An authoritative voice that made Lafanu's insides tremble.

The scullery maid trembled too. And jabbered an incomprehensible reply. In this house, where there was no housekeeper and no proper servants, she was used to performing tasks that no one had assigned to her.

Opening the door. Closing the door.

Playing hostess.

Performing the requisite curtseys.

She was simultaneously butler, chambermaid, and sometimes even cook, and as far as her employer was concerned, this lowly person was surely a presence that made her self-imposed solitude less bitter.

Lizzie Manson, the lady who owned the house, was a widow. Her situation was a common one, but only about her did people say, "She had a jewel of a husband, and she drove him to an early grave with her scolding and her demands for 'freedom.'"

A crumpled flower. That's how she was categorized by polite society in Salenius. "She could have had so much, and she squandered everything," they murmured. "And all to follow false illusions. What a wretched old age lies in store for her."

People were mean to Lizzie Manson. Because people are always mean to those they consider eccentric.

But Lizzie paid no attention. She had a mission. *I'll give the girls who pass through my hands shoulders sturdier than mine. I'll be their best teacher.*

Not all families, however, sent their daughters to her. "She'll turn them into rebels," they said in consternation. "The scandals will be outrageous."

But some considered scandalousness a virtue. Among the city's abolitionists—there were more than a few in Salenius—the rumor spread that Lizzie was a nonconformist, and for the abolitionists of those

days, especially in that county, nonconformism was everything. As long as it wasn't overdone, of course.

From that day, the day when she met Lizzie Manson, Lafanu had a clear memory of the large chest. It was made of shoddy mahogany and occupied almost the entire hallway of the little house. Lafanu observed that termites had been eating the chest and saw that the scullery maid had tried to cover up the damage as best she could with a piece of fiery-colored fabric.

Lizzie Manson's residence, despite some good furnishings, was very modest. It had been slipped in among little houses of polished brick where artists lived and the new Victorian constructions that the city's emerging financial bourgeoisie was starting to build and occupy. The facade was painted a dazzling yellow, the color of early-morning sunlight. But the yellow was interrupted, judiciously, by hints of pink, which provided a certain counterbalance to the fanciful spirit of the structure. The garden was tiny and well maintained. The coral red of the gerbera, which sprouted from every corner, dominated the whole.

As soon as she saw the gerbera flowers, Lafanu thought the house marvelous.

THE SCULLERY MAID, whose accent sounded Scottish, showed them into the small sitting room and said, in an English heavy with consonants, "Mrs.

Manson wasn't expecting you so early. If you don't mind waiting, she should be back from her errand at any moment." Not content with those excuses, the poor scullion couldn't help adding others, piling them all up as though in a warehouse of circumspection. And so it was that Marilay and Lafanu took their seats in that sitting room, which looked like the basement of a junk shop.

One piece of furniture made a big impression on both of them, a Louis Philippe settee carved in walnut. Its iridescent white covering hurt the eyes, feigning an opulence that the house didn't possess.

Marilay sat down practically on the edge of the settee, concerned about soiling that white expanse with her person. And Lafanu imitated her. What an effort it was to hold your belly in, fold your hands, and lean your body slightly forward the way Marilay Trevor did. The girl sought in herself the fluidity of movement that she saw in the grown-up woman beside her. Her pronounced awkwardness angered her, for in her dreams, she was a butterfly. Mrs. Trevor looked almost like a queen seated on a crystal throne, while she, Lafanu, resembled nothing so much as an ugly duckling.

"Keep still, Lafanu," Marilay scolded her as they waited. "Don't you have any pity for my poor nerves?"

"Yes, Mrs. Trevor," Lafanu replied obediently.

And then there was a sound, a pattering, like a ballerina's footsteps. It was Lizzie Manson, slowly turning onto the walkway that led to her house.

Marilay and Lafanu pricked up their ears at once, suddenly anxious.

"They must be satin shoes," Marilay Trevor said knowledgeably.

They must be so beautiful, Lafanu Brown thought.

They were beautiful, but implacably mud-stained.

BEFORE DAWN that morning, Lizzie had gone to the cemetery. She went there the first Wednesday of every month to visit her husband, Charles. On every such occasion, the woman, who at this point carried the weight of several decades on her shoulders, wore the girlish dress she'd had on when she first met her husband. A ruffled dress with plenty of ribbons and bows that enveloped her completely in a dazzle of white muslin.

At that moment, however, Lizzie was no longer at the cemetery, no longer with Charles, but on her feet, strolling straight into the sun, on the walkway to her house. She was there, wearing shoes that were caked with mud. Through the half-open window of the sitting room, she heard the scullery maid speaking with someone and realized that her guests had already arrived.

I can't let those people see me like this. They're here to engage me to give lessons. I could certainly use the money another pupil would bring in . . .

She needed to change her dress. Without making a sound, she entered the house and flew to her room.

Her expression vacant, as usual, the maid gaped at Lizzie, who'd had to call aloud for her to come and help her dress. "Have you offered our guests downstairs some tea and cakes?" Lizzie asked. She chose to interpret the reply—unintelligible mumbling—as a yes. "Button me up in back. And be quick."

She liked that dress.

Not long before, Lizzie had at last put aside the deep mourning she'd worn since Charles's death. She'd followed her friend Harriet's counsel as though it had come from an oracle. Harriet, who lived in Italy, had said, "You have to dress, as I did in my time, in strict mourning. Etiquette requires it."

On this subject, the fashionable magazines, such as the English periodical *The Queen*—and Harriet in her letters was always assuring Lizzie that *The Queen* was like the Bible—had been clear in their prescriptions for the duration of mourning, and Lizzie insisted on following the dictates of etiquette. If the widow was a lady in high society who possessed a modicum of self-respect, her mourning was supposed to last at least two and a half years. During and after the funeral,

the appropriate dress could exhibit no embroidery, no bows, no whimsy. The black had to be matte and not shiny. The widow was to wear no jewelry, and each time she left the house, she was obliged to cover her face with a black veil. Her mourning costume, at least during the first, most difficult year, hardly allowed her to do anything at all. Fortunately, however, the period of half mourning began with the arrival of the second year, in which—within reasonable limits—colors returned to enliven the widow's outfits. So women in Lizzie Manson's position were allowed to adorn themselves with such shades as lavender and Parma violet. Lizzie discovered that dark purple suited her; it was austere without being gloomy. Then too, she liked to remain a little in the background, far from the men's viscous looks, which she'd found difficult to bear even as a young girl. When there wasn't too much jewelry shining a light on her face, she felt freer.

"My dear Harriet," she wrote, "I'm so unburdened without all those feminine encumbrances." And then she added, "Besides, one can wear a mourning dress a thousand times. That's a fortunate state of affairs for a woman as nearly destitute as I am."

Her husband had bequeathed her only debts. After the first year, Lizzie Manson had little money left, just enough to rent the house on Thirty-Ninth Street, to hire an unskilled domestic worker with

sciatica, and to get by. She'd had to go to work, like an ordinary woman of the people.

The debts had changed her life. They were the reason why, on the first Wednesday of every month, she would visit the grave where Charles lay, the husband barely tolerated in life and even more odious in death, and spit on it.

"Now I'm ready," she said, addressing the scullery maid. "Announce me to my guests."

Lizzie and the maid slowly descended the stairs.

"My apologies for being late," Lizzie said. As she entered the drawing room, where Marilay Trevor and Lafanu Brown were still balancing on the edge of the settee, a rainbow-colored beam of light came in through the window.

Lizzie Manson went up to Lafanu and said, "Welcome to Italy, my dear."

It was only then that Lafanu, who had kept her eyes cast down the whole time, looked around her. And she was glad to see that her future tutor wasn't making some kind of joke at her expense.

They really were inside an Italian landscape. A landscape of ochre walls and green leaves. Of bright marble and gray tuff stone. Every surface was filled with it. "Italy . . ." Lafanu Brown murmured.

And in that moment she understood that if this was to be her life, she could still save herself.

Crossings

V

Salenius is about an hour from Boston. Alexandria had given me thorough instructions: "You must take the train from the station and get off at the end of the line. The bus station's right there. The buses are comfortable. They have Wi-Fi. It's a pleasant trip. If you have too many bags, take a taxi. But settle on a price first. They're prone to ripping you off."

I laughed. "I'm from Rome," I reminded her. "Our taxi drivers are worse." I set out for the bus station. The air was cold, but fortunately, I had on a wool cap and a down jacket that was impervious to drafts. I climbed into the bus and put on my earphones. I was listening to an old album by Elza Soares. I was fond of Brazilian music, and I especially liked the old-ies by Chico, Caetano, Gal Costa, the divine Maria

Bethânia. I, an Italian woman of Somali descent, loved faraway Brazil, about which I'd read and heard so much. Besides, I never could read on buses. I'd be overcome by nausea right away. I had to look straight ahead and not think about anything. And the music helped me to dream, to escape, to leave my weary body. It was a panacea.

So I was deep in the Amazon rain forest when I received a message. It was from Binti, my twenty-year-old cousin, writing me from Somalia. We had quite a loving relationship, even though we'd never laid eyes on each other. This often happens among Somalis. Some stay in Somalia, some emigrate here and there . . . and that's how, in the twinkling of an eye, we lose sight of one another. But not completely; with modern technology—Facebook, Instagram, Snapchat, Twitter, WhatsApp—it's impossible to disappear. People don't ever just vanish anymore, unless they're really strangers. Physical acquaintance may be lacking, but on the other hand, you know those unseen others' hobbies, their obsessions, you know how they express sadness, you know their expressions of joy. Things are no longer the way they were in Lafanu Brown's time, when separations were clear and definitive. After Lafanu left her mountains, her sister, Timma, became a ghost to her, alive but a ghost. In her letters, Lafanu often mentions Timma, but her chances of seeing her again were, as she well knew, nonexistent.

Binti and I had started writing to each other after her thirteenth birthday. She was the one who did the reaching out. We wrote in English. "I'm studying it," she said. "And I like it. One day, when I'm far from here, it will come in handy. Everybody speaks English." In the beginning, she wasn't all that good, but then, in addition to her studies, she and her sister got cleaning jobs in an international "compound," and after that her English improved. "We have a library here in the neighborhood that nobody goes to because they're afraid the terrorists will blow it up. The beards don't like places of culture," she told me. "The library is empty. I get my courage up and go there, as do a few other people, very few. I usually have the books all to myself. There aren't many, but the librarian says they're going to get a shipment soon."

We called each other *cuginona* and *cuginetta*, "big cousin" and "little cousin." And we reciprocally explained to each other the worlds we lived in. Binti was champing at the bit to get away, but I told her it was dangerous and she had to be patient. "The world will change," I wrote to her, but it never did. And she champed all the harder.

Sooner or later she'll cross the border. And I won't sleep at night, I thought. The moment came just when I was traveling from Boston to Salenius.

"I'm out of the country," she wrote to me on WhatsApp.

My blood froze. "Where?" I asked immediately.

"Across several borders . . . Sudan." Another message followed: "Please send me 500 dollars. I'll use the money to cross the desert in a truck. The trip takes five days, the smuggler told me. If you help me, I'll be in Tripoli soon. Spread the word to the rest of the family. I don't need much. And once I'm in Libya, I'll get a job and make enough to take a boat to Italy. But for now, I need that money. I won't go anywhere on my own."

I was shaking. I wanted to tell her, *Please, please, go back*. But then she started talking about her mother. "I'm sorry to cause Mama so much pain. But you know how it would have ended. They would have made me marry an old man, one of those who go back home from the diaspora to take girls away and chain us to their old age. And they don't even live with us. I have friends who are in despair, married to some of those old guys. They screw us, they knock us up, and then they go away, back to their first wives, who stay pampered and happy in one northern country or another. They're the women the men buy perfume for, and elegant *diracs*, and high-heeled shoes. The old men go back to their new countries—Sweden, Norway, Finland, Britain—with their comforts and their strong passports. And we stay here with some snot-nosed brats and a passport that's no good for anything because it's toilet paper. I didn't want that life.

So now I'm over the border, out of the country. There will be no more shooting for me, no more terrorist attacks, no more fear of being owned by a dirty old man. I'm at the beginning of my journey."

I think she sent me forty messages.

"I need to leave. This is the only place I've found with Wi-Fi. Tell me something nice before they cut me off. I won't have any cell reception in the desert. Please tell me something nice, big cousin."

I understood her. Somalia had turned into an obscene country very hard to live in. But I still remembered the beautiful Mogadishu of the 1980s: the Arba'a Rukun Mosque; the Southern Cross hotel; the cathedral; Hotel Shabelle; the clean streets; the yellow taxis; the ruminating camels; the wild goats; the girls draped in the *guntino*, which left one shoulder bare; the women's sheer veils and their painted lips; the area known as Number Afar; the "Arch of Triumph," built by Italian fascists and inscribed *A Umberto di Savoia, romanamente* ("To Prince Umberto di Savoia, Romanly"); Jumbo Gelato in Via Roma; the Fiat billboard; Siad Barre's big face peering out everywhere; Italian tourists on holiday; the National Theatre, which Mao Zedong had given as a present to Somalia; the Chinese dragons; the happy children; the Bollywood movies; the tailors who made for you, on the fly, clothes you'd seen in Postalmarket; the shops that sold VHS and Betamax videocassettes;

the stars, which looked so enormous and almost tickled your nose; the airplanes that flew so low they practically grazed our roofs; the fragrance of cardamom . . . Somalia. Somalia, the white star of its flag, centered on a light blue field. I had seen that Somalia. Binti hadn't. Her mother and father kept her closed up in her house with the other females. And when all the big buildings in Mogadishu collapsed, Binti wasn't aware of the extent of the tragedy. She'd never seen those buildings, and what she saw afterward was only their ruins. So for a long time, she believed Somalia had always been like that. And even though some people, including me, told her the opposite was true, she didn't believe us. "No way," she'd say. "You're lying." And then she'd get snippy. "Somalia has always sucked. You're Italian, what can you know about it?" I'd swear that my family went back there every summer when I was a little girl, but she wasn't convinced. She didn't want to believe me.

And now this message from her, with the request to tell her "something nice." All I wanted to tell her was, *Turn back, you little idiot! They'll tear you to pieces!* I watched the TV news. I knew what happened to girls in that desert. I didn't want it to happen to Binti too, but I didn't know how to stop it.

"Tell me something nice."

And then I remembered Lafanu Brown. Among the documents Alexandria had sent me was a letter

from Lafanu to her tutor Lizzie Manson. I'd been
struck by a passage in the letter:

> *Nothing has set me as free as traveling. I was*
> *born on the ship that took me to Liverpool and*
> *Europe. Born at eighteen years of age. Sailing the*
> *ocean where my people, black people, had endured*
> *hell. And after I'd gone through hell, I was reborn.*
> *Now I'm off on another journey, I'm leaving this*
> *gray England for Italy, which I so long to see.*
>
> > *Wish me safe travels, dear Lizzie. And may*
> *your kind words be so many good omens. I'm*
> *going to make my acquaintance with the land*
> *where I'll finally be able to be myself.*

I thought about that letter and wished my little
cousin Binti safe travels. The only admonition I gave
her was, "Please be careful." I knew that sentence
was useless when I wrote it.

Then I threw my cell phone into my bag and burst
into tears, hiding my face in my scarf.

OLD. Wet leaves, melted wax, desolation.
It was always cold in Lizzie Manson's sitting room. Not to mention damp! The maid was growing more and more listless, and her cleaning left a great deal to be desired. She should dismiss that girl—Molly was her name—on the spot, as Lizzie knew all too well. She should do it right away, send her back to Glasgow, her filthy birthplace, but Lizzie didn't have the nerve. She didn't like the idea of kicking the girl out onto the street. And then there was another reason, as she often wrote to her friend Harriet: "If I sack her, I won't find anyone better anyway."

Harriet, for her part, had renewed her invitation to Lizzie to come to her in Italy. "You won't ever have

money problems here, my dear friend. You would be able to take up painting again, you know. American artists have found their Paradise in Italy."

Lizzie never responded to those kind invitations. She let the matter drop, but charmingly, like certain embroidered gloves in the course of a fraught courtship. And she gave Harriet to understand that she couldn't leave her pupils in the lurch. "I'm all they've got."

Writing a letter to Harriet would occupy the time between her frugal midday meal and the arrival of her last pupil of the day. And in that half hour, she'd recount to her friend the assorted miseries of her daily life.

Dorothy and Laurie came at ten. We translated some passages of Suetonius. The girls do so poorly in Latin, but I insist—not that they ever give me, not even once, the satisfaction of translating a complete sentence. Then, right afterward, that adorable creature Margareth Pricher arrived. She talked to me about her progress on the piano and described how she has been practicing and re-practicing a transcription of Beethoven's Eroica symphony. With her, I limited myself to reading aloud some of Charlotte Brontë's mawkish prose. Her protagonist Jane Eyre is a nitwit, a woman who still believes in love. Harriet, I

know you won't agree with me, you like Jane Eyre,
you've always been a romantic, but to my mind
she remains just a pitiful nitwit who lets herself be
bamboozled by that piece of human salvage Mr.
Rochester. How can she fall in love with such a
useless fellow? My God, what bad taste in men!

After Margareth, Ann Sheldon came in, as
always, and we had a philosophy class. Descartes.
But the girl is quite distracted these days, she's
getting married in three months and can think
of nothing but her Robert—the Harrisons' son,
the one with the limp—don't you know him? She's
going to marry that wreck. Once the honeymoon's
over, she'll realize the terrible predicament she's
put herself in—I almost feel sorry for her.

Then came Lafanu Brown's turn, and Lizzie's
tone changed.

That girl is a constant source of surprise,
Harriet. She looks so far away when you talk to
her, as if she had a veil over her eyes—she seems to
be staring at someone only she can see. I observe
her as she watches shadows on the walls, follow-
ing them all over the room, and at such moments
it doesn't matter what I'm talking to her about,
whether Suetonius, Descartes, Jesus Christ, or Jane
Austen, she never takes her eyes off those shadows.

*She gives the impression of someone who's fighting,
absorbing slaps and punches. Every now and then,
I see her shut her eyes tight, I don't know whether
from fear or pain . . . At first I believed her mad.
After all, she was a negress, I thought, and maybe
negroes just can't manage to keep up with us.
We've always been taught that they are our infe-
riors. And so I thought that maybe this girl was
inferior too. But I was grossly mistaken. During
the first month, I was tempted to abandon that
particular employment, I was ready to tell Bath-
sheba and the Trevors that nothing could be made
of the girl, that she was as coarse and rough as a
calcareous stone. That spending money to educate
her was pointless. But then I realized that none
of the lessons I'd tried to impart to her had been
wasted. A few days ago, Lafanu Brown spouted
back at me all the Descartes, Machiavelli, Chau-
cer, and Virgil which I had diligently expounded
to her. After two months with me, her French is
melodious, she is making fine progress in Italian,
and she has already learned the small amount of
Latin we have construed together. She would like
to learn more, but as you know, there are certain
limits to my ability to teach the classics. And I
told her so, I said, "What I know I can teach you,
but what I don't know I can't." Whereupon the girl
made an altogether unexpected request. She put*

on her most serious face—all of Lafanu's faces
are serious—and said, "Mrs. Manson, I know you
used to paint in the past. Would you please teach
me the techniques of painting? I want to become
good." "Good at what?" I asked her. And without
batting an eye, she replied, "At painting." Then she
added, "I'm not just a dabbler," and she showed
me her sketchbooks. Her father used to draw, she
told me.

Her drawings are surprising, Harriet. Still very
crude, but genuinely surprising. You should see how
precisely she renders birds and their plumage, with
a line that looks, I swear, like a bas-relief. The girl
insisted on making me understand that she is se-
rious about a career as an artist. I saw the light of
ambition in her eyes. An artist. She pled her cause
so convincingly that she persuaded me to help
her. I shall open a workshop like Verrocchio, and
who knows, maybe she will be my Leonardo. The
talent and the determination to succeed are there.
Of course, she's a negress. That's a great obstacle.
But a woman so ambitious will surely be able to
overcome that great obstacle, don't you think? I will
teach her the techniques. And she shall do the rest
herself. She already knows that she must stand on
her own two feet. It will be fun, Harriet. If you think
about it, a black female artist would be a revolu-
tion. And you know I do like revolutions.

———

LAFANU BROWN had actually done it. She'd said to her teacher, "I want to be an artist."

That idea had been born out of rage. It all began with her restless nights. Shadows around her cot, unknown monstrous hands around her throat. They weren't phantoms from another world but the tangible shadows of her reality. And every time, she could feel the weight of a thousand bodies piled on her own. Smothering her. Every night on her cot, she struggled to shake off the opaque presences that were crushing her chest. From second to second, the presences became more and more aggressive. She couldn't free herself from them. She hacked at them, kicked at them, railed at them, sometimes even cursed at them, so harshly that her own words made her blush. But the infernal shadows remained, there they were, with their hands around her throat or worse, ready to smash her face against the floor. Most nights, she fell off her cot with a sharp thump, got up from the floor, and lay down on the thin mattress again, sore and achy, her eyes wide open in the dark. Only when daybreak was near did she manage to sleep a little, but the Trevors' morning sounds and busy footsteps put a quick end to that ephemeral repose. In the kitchen, Baby Sue would hand her a piece of bread

slathered with honey and a cup of hot tea. Lafanu voraciously gobbled up everything she was served. By this time, she'd given up the hope of tasting her food. After Coberlin, her mouth had lost all ability to taste. "It happens to every woman who . . ." Baby Sue told her, stroking her haggard cheeks. "This will all pass, you'll see." But the shadows continued to hound Lafanu Brown, mocking her, even in broad daylight.

She would cry out, "Who the devil are you? What do you want from me?" But there would be no reply, only scornful laughter.

And in the distance, the echo of a threat: *You're a failure, Lafanu Brown. You'll never accomplish anything in your life.*

Then the girl would clench her fists and slash at the air. She'd kick and spit. She wanted to avenge herself. But who can avenge herself on people unknown to her? The shadows came from the past, from Coberlin, from that hideous night in 1859.

Infernal shadows! They never left her in peace.

Lafanu thrust her hands into her pinned-up hair and wept. Tears of salt, tears of vengeance, big as a sheepdog's back.

And Baby Sue would find her like that, every time.

The older woman, who had known the sorrow of slavery, would gently caress Lafanu's head. "Bear up," she'd urge the girl. "Turn your sorrow into love for yourself."

———

AND LAFANU had indeed turned her sorrow into something else. By sketching it.

She drew it in its entirety, including those terrible shadows, in the sketchbooks that Mulland never failed to provide for her, and then, with cupped hands, she made it fly far away, a thousand miles from the bundle of nerves that constituted her body.

But her sketching couldn't subdue all of the shadows. Some were fiercer than others and would not let themselves be captured. And they had no wish to let her go. They held her close and nailed her to a cross without the prospect of a resurrection. They continued to mock her: *You're a failure, Lafanu Brown. You will never accomplish anything in your life.*

The desire to prove the shadows wrong, to refute their words, had now become a priority for her. She wished to excel, to reach heights others hadn't reached. Her dreams were quite rational: Given that a normal life had been denied her, she thought she must at least have an exceptional one.

When Lizzie Manson agreed to teach her the technical skills she longed to acquire, a new life began for Lafanu. Painting was a language; Lafanu, so unsure when she used words, was better able to express herself when she used pencils or brushes. But now that language, which had always been a part of her, would

become the key to her getting ahead in life. A key that would open doors, would allow her to exist. Did she have sufficient talent? How many sacrifices would she have to make to become an artist? As for money to pay for her studies, she didn't have any; she lived off Bathsheba McKenzie's charity. And should her patroness change her mind about her, Lafanu would be finished. But her ambition was stronger than her fears, and it pushed her forward, as the east wind drives the clouds.

To BECOME a real artist, the first things Lafanu needed were the tools of the trade. Therefore, Lizzie went to talk to Bathsheba McKenzie. "I need some money for your negress," Lizzie said. She used an imperious tone that brooked no objection. Bathsheba was tempted to ask why Lizzie wanted more money, seeing that she was already paying her a generous fee for Lafanu's education, but she didn't want to appear stingy, and she was confident that Lizzie knew her business. Therefore, she opened her purse and said only, "Make good use of it."

So Lizzie was able to fill the house with brushes: flat brushes, round brushes, curved brushes, fan brushes. Each of them had a function. One was right for painting backgrounds, another came in handy for shading, yet another was useful for corrections

or ideal for long, swift strokes on flat surfaces. High-quality brushes, with pig or goat bristles, the proper tools for achieving on canvas the precision that Lizzie wanted to impart to Lafanu. In addition, Bathsheba's money enabled the purchase of a palette, which was indispensable for mixing colors; an easel for when the girl would be ready to handle upright canvases; and finally a capacious bag she could stash her materials in.

Before essaying oil paint, as thick and greasy as the residue in a roasting pan, Lizzie decided to teach the girl water-coloring technique. At first, Lafanu was unsure about how to dilute the colors. But then, thanks to Lizzie Manson's attentive eye, Lafanu succeeded in obtaining a denser line. Together, the two women experimented with new colors, mixing blackberries and ashes, coffee grounds and green leaves. Lizzie let her pupil try whatever she wanted, but with a single piece of advice: "Leave room for disorder. That's the only way you'll learn how to find yourself in the order you've chosen."

Weeks passed, weeks filled with grueling exercises. With observations. With pictorial techniques, at first roughly applied and then learned.

Scottish Molly, with her haggard face and hollow eyes, became Lafanu Brown's guinea pig. The girl followed the maid into every room. She gave her no rest. And when she grew tired of Molly, it wasn't unusual

to find Lafanu in the house's little yard, observing birds in flight or immortalizing on her white pages the grimaces of the passersby.

Then, one day, Lizzie Manson proposed an excursion. "Have you ever seen the sea, Lafanu?"

"No, Mrs. Manson. Is Salenius near the sea?"

"Yes, it is."

"But the city doesn't have an ocean smell."

"The city hides the sea."

"Why?" asked Lafanu, puzzled.

"Because it's ashamed of it. The ocean is where the rottenness comes from. Once upon a time, slaves used to be brought ashore on the beach there."

"I've never seen the sea."

"It's a sort of light blue, you'll like its color. But sometimes it's also green, or dark blue."

"I'd go with you . . . I would like that. But Mulland says we shouldn't step outside the perimeter."

"What perimeter?" It was Lizzie's turn to be puzzled.

"Mulland says that we black folks are protected only if we don't go beyond our boundaries. The ones established for free people of color. So we're safe in the church, we're safe in our own house, and even going to the abolitionists' houses is safe, it doesn't expose us to any harm. But Mulland always warns me not to venture beyond the big oak tree."

"And why do you have to stop there?"

"Because we free blacks don't know where there may be slave catchers. Bounty hunters. They don't care a thing about our freedom. For them, there's no difference between a free black person and a black slave. A black's a black, and they all belong in shackles. To be sold for a good price. And once they get sold, they're supposed to be forgotten. And the hunters go back to hunting, looking for other black folks. Other profitable goods. That's life, at least for us."

"And you're afraid to go beyond the big oak?"

Lafanu had inherited her father's feet. Her whole body trembled. With eagerness for movement, eagerness for life. With the urge to travel.

"I...I'm curious, Mrs. Manson...yes, I'm definitely curious to see the ocean."

"And you'll come with me?"

"I've already gone beyond the big oak, all the way to Coberlin, but they brought me back."

"But the sea isn't Coberlin. Nor will it ever be."

"You're right. I'll go with you." And Lafanu's feet started to fidget, the way her father's had done.

"You'll wear a veil. And you'll be with me, so if anyone gives us trouble, I shall say that you're my servant. You mustn't worry, Lafanu. Go put on your overcoat. We have to be back before it gets dark."

"Yes, ma'am, before it gets dark. I don't like the dark."

Crossings

VI

Besides her paintings and diaries, Lafanu also left numerous sketchbooks and notebooks. Around sixty of these are kept in the main library of Salenius University, others are scattered in private collections, and three have remained in Italy, deposited with the Jesuits in Rome. There were probably many others, but they were evidently lost, or pulped by the artist herself, or misplaced in the confusion that followed her death, as it does most others. Luckily, Silvia Peruzzi arrived and put an end to the chaos. It was she who told everyone, "We can't leave Lafanu alone, now more than ever. She worked all her life; we must honor her talent and preserve it for posterity."

Over the years, Silvia Peruzzi had become a pragmatic woman. And Lafanu had recognized that

potential at first sight, when she painted a portrait of Silvia as a little girl against the background of the Campagna, the Roman countryside. They had met, the artist and the young girl, in the golden years of the American circles in Rome, at the time of Bathsheba McKenzie's great success in the city. In those days of yore, Silvia's parents, the Peruzzis, refined art connoisseurs, could always be found in Bathsheba's salon, and their meeting Lafanu was the result of a fortunate intrusion. When Lafanu fell seriously ill, Silvia, now a mature woman, was among the first to hasten to the artist's bedside. They hadn't seen each other for many years, but they had maintained a long, steady correspondence. Lafanu Brown's letters to Silvia Peruzzi are veritable treatises on art. The subjects the two women discussed included color sense, surfaces, and the mysteries of the human face.

"I seek in beauty," Lafanu wrote to Silvia, "the restlessness of movement, the journey our feet undertake so as not to die crushed by boredom."

Mostly, in those letters, they talked about women painters: Artemisia Gentileschi, Sofonisba Anguissola, Angelica Kauffman (that "adorable madwoman," as Lafanu referred to her), Élisabeth Vigée Le Brun, and others, minor artists destined to leave no trace in the history of art. But without a doubt, the female painter they talked about the most was Rosalba Carriera, the melancholy, taciturn Venetian

for whom half the nobility of Europe almost literally went crazy. Lafanu wrote to Silvia, "I feel that Rosalba is in tune with my heart. I've learned from her what light really is." Like Rosalba Carriera, Lafanu was exercised, even tormented, by the mystery hidden in the human countenance. In her sketchbooks, more than in her portraits themselves, she carried on the investigation of faces that absorbed her all her life. The pages are covered with eyes, noses, mouths. Thanks to Silvia Peruzzi, the notebooks and sketchbooks have been organized by subject and date; this task of cataloging took her three years. Silvia didn't want her beloved friend Lafanu Brown's work to be lost after her own death, so she spoke of her concern to a cardinal and ultimately left the books and letters to a Jesuit confraternity, with an agreement that they would be donated at some future date to an institution supportive of Black people. "When the time is ripe, this material may be precious," Silvia maintained.

The material lay for a great many years in the subterranean rooms of a library in Rome until a young librarian, Father Costantino Guidi, decided to fulfill the promise made to Silvia Peruzzi so long ago. And with the blessing of his superiors, he contacted the university library in Salenius. He wrote only, "We have some material, left by one of your fellow townspeople, that should be in your keeping."

"Since then—it was only fifteen years ago—we have the Lafanu Brown Collection in Salenius," Alexandria had told me. "And for the past six years, I've been studying the collection on behalf of my tutor Anne Baker Smith, who was for a long time the custodian of the collection and its only scholar. Father Costantino is happy with my research, but now he'll be even happier to have you on the team."

I started to immerse myself in those documents.

My attention was quickly drawn to the ten sketchbooks that Silvia Peruzzi had cataloged under the rubric "The Slave Route." They cover the years from 1869 to 1889, a period when Lafanu Brown was making meticulous notes on the traces of slavery she found in Italy. One of the first images was none other than "the Twins," as she called them, chained to the fountain in Marino. Lafanu didn't always comment on her sketches, sometimes accompanying them with only a single word or sentence fragment. But under the sketches of those two women, I read this: "Have they been raped?" and this: "They're humiliated goddesses."

In the enclosed space of the silent library, the word *raped* struck me like a whiplash. During those days of research and discoveries, I was absolutely unwilling to think about my cousin Binti's fate. I'd heard nothing from her since I sent her the five hundred euros she'd asked me for. When I did think about her—which happened when I was in bed,

alone, and worn out to the point of exhaustion—my thoughts wandered to her, and horrible images pursued one another in my head. Vultures feeding on her corpse, her death in the desert from privations and hardships or caused by a random bullet fired from a guard's Kalashnikov. And then there were the images of rape that never departed from my mind. Shadows that followed me, even in my dreams.

I<small>T WAS WHEN</small> she was seventeen and eighteen, in 1859 and 1860, during the magical year that she spent as Lizzie Manson's pupil, that Lafanu Brown discovered Italy.

Italy was something that Lafanu, apprehensive about the future, grasped tightly in her small but growing hands. Lizzie, of course, recommended books for her to read, and the girl quickly fell in love with them. They were substantial, persuasive books, thickly and sometimes morbidly written. Italy was a castle in flames, a dark lake, a band of libidinous monks. Italy was a tangled mystery made of hidden rooms and traps scattered along its pathways to fool young knights, whose only weapon was a fearless heart. Italy was a tempestuous sea. A sea of demons

with comely faces, monsters that duped their fellow humans with a smile before devouring them in broad daylight. It was a sea with islands where there were witches who could turn men into swine. It was a sea of fear. But it was also a mountain too high to climb. It was the shallows where ships ran aground. It was the jaws of a famished wolf. It was Circe. It was Scylla. It was Charybdis. The gentle Sibyl. The outraged Sabines. It was Beatrice the disdainful. Catherine the saint. The brave Artemisia. The gifted Sofonisba. Italy was a chilled bare foot, a pound of consumed flesh. Italy was pasta, sauce, puff pastry with filling, entrails seasoned with onions. Italy was Nature gaining the upper hand over Man, Nature making sky and earth tremble, Nature covering the heroes' high road with asps. But Italy was also its people's love for one another. It was made of passionate kisses exchanged in dirty under-stairs closets. It was shaped to fit adulterous loves lost in a chaos of lies.

Ah, Italy, land of thwarted love and corrupt sovereigns. Land of adultery and betrayal. Of Paolo's trembling kiss on Francesca's mouth.

And thus it was that loving couples born under a bad star traveled the peninsula in search of a place to lie down or a way to forget. In search of a kiss or a grave. But in Lafanu's reading during that magical year when she was Lizzie Manson's pupil, Italy was also the land of shepherds who used every possible

occasion to offer thanks to the moon with melodious singing and dancing. Music-making shepherds, and shepherdesses in youthful bloom. It was Italy that made Lafanu become a woman, and Italy that taught her guile. And Lafanu was aware that the closer she felt to Italy, the more the little girl she'd been in the Chippewa village disappeared into the body of the adult she was becoming.

And then the struggle of that country as yet unborn, with its martyrs, its bayonets brandished against the Austrians, thoroughly fascinated her. On stormy nights, Lafanu would envision herself with an Amazon's elongated face, ready to unsheathe her sword like the young Italian men who yearned to reclaim their homeland. She was anxious about a people she didn't even know. And every day, her eyes—thanks to her reading—were filled with far-off Italy, "where I swear I'll go someday."

The big feet she'd inherited from her Haitian father were what stirred up in her the desire for new travels, new smells. The woman she was becoming eagerly desired to tread the paths of the future. And by traveling on them to leave behind, once and for all, the opaque shadows, the shadows of Coberlin, which perturbed her sleep every night.

Lafanu wasn't the only person in the house who thrilled at the thought of "that fair land where *'si'* is heard." Mulland was reading with growing

enthusiasm the writings of Giuseppe Mazzini. And Bathsheba, for her part, found in the Italian cause— or, as they called it in Salenius, the Sicilian cause— yet another way to demonstrate her charitable bona fides and to get the better of that fanatic Emma Stancey. This was the reason why she made such a dedicated effort—money was certainly no object—to ensure that some Italian patriots, persecuted in their own country, were welcomed in Salenius with all appropriate honors. "We must show great generosity toward those poor people," she declared. And, draining a bottle of brandy, she decided to organize an evening so memorable the city would not easily forget it.

MULLAND WORKED BRISKLY for days to make the proposed evening a genuine event. Bathsheba McKenzie had given him an order, and as a good vassal, he didn't want to make a bad impression on his patroness. Everything must be perfect. The pheasants, the salmon, the cheeses, the caviar. The wine had to be exclusively French. And brandy for the men could not be lacking, not for any reason in the world. Mulland had asked Baby Sue to outdo herself, and she had shut herself up in her kitchen to prepare puff pastries and custards. Lafanu paid her a couple of visits in the kitchen, which was her favorite place in the Trevor house. It had been a long while since she'd been able

to taste food, not since that hellish night in Coberlin, and only in Baby Sue's kitchen could she perceive the enveloping aromas. That made her almost as happy as reading books about her beloved Italy.

Lucy joined her in the kitchen. The two girls didn't meet each other's eyes. Lucy's eyes held a supplication, a desperate request for forgiveness that Lafanu had no desire to grant.

Had it not been for the treacherous kiss Lucy had given her, no one would have dreamed of sending her to Coberlin. And no shadows would pursue her, as they did every night.

Lucy had a dress for her. "My mother told me to give it to you. It's for this evening." And handing over the dress, Lucy hurried away, fighting back tears. She couldn't bear Lafanu's eyes, which no longer looked at her.

For a little while, Lafanu stood gawking, holding the bundle as if it were a stillborn infant.

"Go try it on," Baby Sue said gently.

Lafanu mumbled some incomprehensible words. Then she said to herself, *I'll have to tolerate her sweat,* and the thought of Lucy's perspiration mingling with her own made her uneasy. Just as living on constant charity made her uneasy. She had nothing of her own, and the fact humiliated her.

But she also had no choice: She was obliged to put on that dress, mostly because she had no other dress

suitable for such an important evening. And seeing those Italian victims of oppression, who had brought a bit of Italy all the way to Salenius, was the only thing that really mattered.

The dress was a little too tight across her shoulders, which were broader and stronger than Lucy's, but Lafanu managed to get herself into the garment all the same. It was a taffeta dress, ivory in color, covered by a virginal silk veil and embroidered almost entirely with tiny blue flowers. The bodice was closed in back by a series of hooks and gave Lafanu's body a slight roundness that made her resemble a cloud. It was a very beautiful dress. Lafanu had never worn anything more beautiful. But that sweat, Lucy's sweat, penetrated her nostrils. And it spoiled her illusion of being a princess.

It was just a borrowed dress, after all. A dress that Marilay, who as a rule wasn't exactly tender with her, had ordered her to wear. For a moment, a worrisome thought had furrowed Lafanu's brow. But then her forehead had grown smooth when her eyes fell on those little blue flowers, as delicate as flowers in a dream.

The evening of the reception arrived in a flash. And Lafanu put on the dress, the stuff of dreams.

Outside, a frigid wind was blowing; it gave faces an anomalous, deathlike pallor, which nevertheless completely disappeared when the guests, who

came in droves, were introduced into Bathsheba McKenzie's mansion, agleam with white marble and polished mahogany. The expatriate Italians stood open-mouthed, marveling at the opulence that surrounded them and giving one another little pats on the back in mutual surprise while remaining careful not to appear uncivil to their hosts, the right-thinking progeny of the New World. The Italians—there were four of them, three men and a woman who was wearing several violet petticoats—stood at bay in a corner, a little frightened by all the interest swirling around them.

"These people are our allies?" the woman asked in amazement. "Really, they've all come here for us? For Italy? Tell us something, please . . ."

The request was addressed to the interpreter, a man around thirty years of age, with a bald head and a large mole at the base of his right nostril. He looked bored and seemed more interested in contemplating the lady guests' necklines than in translating the Italian patriots' words.

"Well?" the woman continued. "What are these Americans saying? Will they give us money? That's why we're here, isn't it? For money? But wait, don't translate that. We want to be diplomatic and do things right."

The youngest of the Italians, a man with blond hair, said, "We shouldn't talk about money, Marianna, not

in front of the interpreter." And then, in an instant, the four began to smile at the interpreter—whom they loathed—because their whole mission depended on him.

The man knew he had the upper hand. He could even have extorted these Italians for a percentage of whatever funds they received and put it in his own pockets, but he was lazy. And besides, he was interested only in the women. Women unapproachable by the likes of him, ladies with leading roles in the Salenius Abolitionist Society who not only were wealthy and therefore out of his class but who also would never tolerate his scanty appreciation of those whom they considered the heroes of the evening. The name of Italy had great force in Salenius. Many of its citizens, including those outside of abolitionist circles, loved that country across the ocean: its beautiful landscapes, its Michelangelo, the soft cheeks of Raphael's Madonnas. But in those days, few of them had actually traveled in Italy; the Salenius beau monde remained provincial, and its preferred travel destination was New York City with its Opera House. It wasn't a question of money—some families in Salenius simply didn't feel ready yet, even though there were a few pioneers, among them Lizzie Manson. But precisely because they were pioneers, those first female travelers were frowned upon. In Salenius, people in high society expressed some unsurprising

views. "Those reckless girls have lost all their good American spirit," people said. Others declared, "Italy overheats the blood, it's a land of unrestrained lust." "Only a lady with some experience of the world can cope with that ardent land of beauty and wonder, whereas a young girl . . . a young girl could get scorched, or burned, or ruined." "We have to protect our girls' futures. They need a good marriage and a husband with a good income and few relatives, that's what they need. And they certainly don't need Italy, which would just disconcert them."

But Italy's reputation for being both beautiful and damned was the very reason why many citizens of Salenius were so curious about it. And they had heretofore seen very few Italians in the flesh. They had only read about them in books, of course, like all educated Americans, and among the most popular of such books was Madame de Staël's *Corinne, or Italy*, which had already been issued in more than fifty-seven editions in France alone. The story of a love affair between the half-caste Corinne and the handsome Scots nobleman Oswald Nelvil had driven Salenius wild. Every society woman passed the book on to her daughters with a wink, reminding their romantically inclined girls that "everything good for art is bad for real life." Before getting married, those mothers had loved Corinne so much they wanted to be her. They dreamed of being liberated, bohemian,

with hearts full of passion. They dreamed of the breathtaking natural landscapes depicted in the novel, the setting in which the heroine, too Italian to be English, enacted the drama of her life. But then they had grown up, they had married, they had been obliged to submit to their tedious husbands and had disfigured their bodies. And the taste of that book, once so beloved, had turned bitter in their mouths. Now that they were matrons, they had gone over to the side of Oswald Nelvil, the handsome Scots nobleman, and they told their daughters, "The Scotsman was right not to trust that shameless half-caste with the black curls and the intense doe eyes." They lectured their sons too: "Corinne's Italian blood is a contamination. The nobleman can't marry her, you understand? Corinne is inferior to him. She does well by dying and getting out of his way." That book, more than anything else, was what had convinced members of polite society in Salenius that Italy could be harmful to noble spirits, especially to those delicate girls of theirs. But when they learned that living Italians, genuine Italians, had come to America to visit them, the matrons, the patriarchs, and their progeny couldn't wait to devour the visitors with their eyes. Accordingly, they all hastened like an army of ants to the fundraiser organized by Bathsheba McKenzie. They all wanted to see those victims of persecution. And perhaps even to touch them.

Lafanu was excited by the idea of seeing some Italians—like everyone else, she had loved *Corinne*—but the girl could never have imagined that she too would be one of the evening's featured attractions.

She realized it only when some of the staff sat her down like a maharaja on a carpet littered with pillows. There was no chair of any sort, nowhere else to sit more comfortably. Her excitement soon gave way to discomfort. It was so embarrassing to sit there and pretend nothing was amiss. Also embarrassing was any attempt to bend her legs elegantly as she sought a way to cross them without wrinkling her dress. Furthermore, she couldn't see the Italian patriots from that position. She could barely manage to glimpse the backs of their heads.

Eventually, her dress began to torture her shoulders and skin. Lafanu felt as though she were in prison, with a thousand eyes aimed at her like beacons. And she heard Marilay Trevor say quite distinctly to someone, "The savage is wearing my daughter's dress. I hope she doesn't tear it, clumsy thing that she is!"

THE ITALIANS WERE SUPPOSED TO give a talk at the gathering, but it was canceled. Using the interpreter was too much trouble—or at least, so it had been decreed by the mistress of the house. "I think it's

sufficient to let people eat and get a good look at our Italian guests. It's sufficient to let people get a good look at Lafanu, to let them observe her. Let them see how I've transformed a little slip of a girl who lived among savages into an elegant, civilized rose." Then, in her head, she added triumphantly, *This evening they'll all see how good I am.*

Twisting and craning her neck, Lafanu finally managed to get a decent look at the Italians, who were drinking and smiling big smiles at the guests. Lafanu envied the foreigners. She was sitting uncomfortably, trapped between her crinoline petticoats and the floor. Her legs were starting to go to sleep, and she could already feel a suspicious tingling in her toes.

But it was only when she heard someone say "Poor thing" that she finally grasped her situation, which was worse than what she had imagined.

She could see Bathsheba some distance away, waving her beringed hands and shaking her head pitifully in Lafanu's direction. Then she clearly heard the words "Coberlin," "violence," and "disaster."

Lafanu was confused. Also angry and disgusted at her transformation into any sort of *poor thing*. And it was only because this Bathsheba woman paid her bills.

Was it possible, were they really doing this to her? Publicizing her shame?

She wanted to get to her feet. And scream. And slap her tormentor and benefactress, the rich white woman who treated her like a puppet.

But instead, out of a sense of duty, which the Trevor household had instilled directly into her veins, she remained seated, forcing herself to keep calm.

Then she heard a lady murmur, "That poor negress is ruined."

And another one replied, "But it's different with darkies. They're not like us. They're predisposed to sin from birth."

Those words wounded Lafanu like a hatchet stroke to the jugular.

She felt the retching begin, the vomit on its way up her throat.

"Nigger women are worse than Italian women ... and *they* certainly aren't paragons of virtue," someone added.

Did I commit a sin, Lord? Lafanu Brown wondered to herself. *I don't remember anything. I don't know if I sinned. I just remember the kicks, the hitting ... I remember the pain ...*

A tear she couldn't hold back slid down her cheek. She didn't have the strength to wipe it away.

Not even the idea of being just a few feet away from the Italians could bring her any consolation.

Bathsheba, far removed though she was, spotted the girl's tears and thought her protégée was weeping

out of compassion for the sufferings of the Italian pa-
triots. *Good*, the hostess said to herself. *Maybe that
will move these burghers to hand over some money for
the cause.*

While Lafanu Brown was lost in her gloomy
thoughts, someone stood gazing at her with lively
interest.

It was a man. Tall, burly, with a resolute chin.

As if feeling those eyes on her, Lafanu turned
around to look, and that was the moment when the
back of her dress tore open in a quick sequence of long
rips, right alongside the hooks. She felt so humiliated.

The man smiled at her. But she wanted to die.
Like that dress, her heart had been ripped open in
several places.

"HE WAS TALL. And he was very handsome," La-
fanu wrote to Ulisse Barbieri. "I noticed that at once,
when our eyes met. I don't want to lie to you, Ulisse,
or cause you any pain either. But he was so beautiful
it took your breath away. And even today, when I hap-
pen to see his picture in the newspapers, I still find
him fascinating. With his aquiline nose and his leo-
nine mane. All that frizzy hair he carried around so
proudly filled my soul with a happiness I don't know
how to explain, in that moment of maximum unhap-
piness. In my own case, I fought nature with lotions

and hairpins, and I found it a liberation to see our blackness so openly displayed. He knew he was special. And he was so elegant, so sublime. Now you'll get angry. And you won't want to marry me anymore. You'll tell me things like, if you like him so much, then marry *him*. Will you say such a thing? Or will you try to understand what that man meant to me? Certainly that evening, he was a ray of sunlight. He shone. And I found myself reflected in his splendor. I'd become a thing of light because he saw me as light. He was capable of enhancing your worth. And he did it with everybody. With simple farmers, with escaped slaves, with all those who fought injustice. He knew how to cope with the hypocrites who sympathized with our suffering out of self-interest or boredom. When he saw my tears flowing, he handed me a handkerchief and said, in a voice full of concern, 'It will be over soon.'

"And that's how I met Frederick Bailey. The man of my shattered destiny."

Crossings

VII

The phone call came in the middle of the night. And the very ringtone already sounded like disaster. I'd fallen asleep on the bed with my computer. I'd been watching a TV series about ghosts, boring enough to lull me into slumber. It was very late, and that phone call exploded in my head like a bomb. "Someone needs to figure out time zones," I stammered, fairly miffed. I grabbed my cell phone and mumbled a weary "Hello."

"Cousin" was the first word I heard. It was Binti. *"As-salamu alaykum*, cousin Leila."

I whispered an *Alhamdulillah*.

"Are you okay?" I asked. No reply. "Binti, are you okay?" I repeated, practically yelling.

A few more seconds of hesitation from her. I could hear her rapid breathing and sense her fear. And then she said "I'm alive, cousin," which sounded like a lie.

I knew my Binti. She had never used that tone of voice. She seemed like someone else. And then I thought, *You bastards, what have you done to her?*

"Tell me what's going on, Binti, please," I begged her.

Intuition told me she was in the hands of traffickers, smugglers of some kind. "Where are you?" I launched that question straight at her, but unfortunately, it fell into the void. She said, "I need money, Leila. I'm a prisoner. I'll let you talk to the person who's holding me prisoner."

Then I heard a man's voice. The English he spoke was both swift and halting. He kept saying, over and over, *"Fluss, fluss,* now. Money, money, now. If not give me *fluss* your sister die. *Mūt, fahimti*?"

It was a horror film. Deep down inside, I thought, *Little cousin, what have they done to you?*

I whispered her name one more time: "Binti..." And for response, I could hear the sound of the desert sand swirling around behind her. Then she said curtly, "I'm alive," and the call suddenly ended.

Right after that, I received a message on WhatsApp. It was Binti again, or maybe the group that was holding Binti prisoner. A large sum of money, in dollars, which I naturally didn't have, flashed on

the screen briefly, followed by the number of a bank account. *What should I do?*

I spent the next few days contacting our relatives. From Minneapolis to Stockholm, from Oslo to Berlin, from Manchester to Milan. Money, I asked them for money, all of them, men and women alike: money for Binti. A collection. An extra effort from the diaspora.

"Please, she's being held by gangsters! Smugglers!"

Some relatives I called would grumble: "What did she think she was going off to do, the little ninny? And now she'll return home ruined on top of everything else."

That "ruined" buzzed around in my head for days.

Luckily, there were also relatives who felt pity for Binti and her plight, especially the women of the family, who trembled at the thought of what the traffickers might do to her. But I noticed a touch of displeasure even in those who were worried. "These young people dream about the West too much. We have to find a way to get the dream of Europe out of their heads." Such recriminations usually came from a member of the family who lived in, of all places, Europe, who had arrived there as an immigrant, and who now had forgotten what it felt like to be squeezed into uncomfortable clothes. And when I pointed this out to them, they'd tell me, "But we were better immigrants. We didn't ask for much. The immigrants of today want everything handed to them, they don't

want to perspire." They didn't get my point, and sometimes I even thought they might be the worst racists of all. It wasn't a question of Europe, damn it, it was a question of the body's natural right to movement. Nevertheless, I preferred to let the subject drop. I just needed them to cough up some cash for my Binti. That was all I really wanted.

Days passed. I accumulated the required sum and sent it to the account the traffickers had given me.

But I heard nothing further. Had they received the money? Had they let her go?

They didn't call me. They didn't ask me for more money. And she didn't call either.

I lived in desperation. And in order to keep from going crazy, I immersed myself more than ever in the life of Lafanu Brown, in her paintings, in those sketchbooks. Again and again, I leafed through the ten sketchbooks that Silvia Peruzzi had classified under "The Slave Route." I recognized some paintings and their African figures, which she'd copied in detail. I spotted Annibale Carracci's Black servant, Vittore Carpaccio's elegant gondolier, Veronese's surprised Black girl, the misshapen slaves from Doge Pesaro's tomb in the Basilica dei Frari in Venice.

Lafanu would study the details of those proud, tried Black faces. She'd bend closer to look at the wrinkles, graze the full lips with her dry brush, dive into the mystery of the rigid masks those sixteenth-

and seventeenth-century Blacks put in place between themselves and the world.

Details upon details. Fingernails, finger joints, eyelashes, smirks.

And in the end, that accumulation of details fueled her imagination and the visual vocabulary of her final works, particularly *Woman in Chains*. The shackled woman Lafanu depicts, both in her preparatory studies and in the finished painting, also has that hard look, established like a border between herself and the world. An opaque veil. The shackled woman strives to respond to the violence she's subjected to with the pride of her flesh. At least, apparently, she wishes to defy the sneering fate that has made her become an object. But that look, as well as the attitude of her entire figure, is a filigree mask that lets her fright show through. Everything in her is fear. All I had to do was to look her in the eyes and I could glimpse the flash of confusion so typical of one who anticipates physical punishment. It was as if those perpetually challenging eyes were saying, *What else will you do to me?*

"For her *Woman in Chains*, Lafanu combined several female slaves," Alexandria explained. "The two women on the fountain in Marino and the Black servant in Lorenzo Lotto's *St. Lucy before the Judge*, which is now in the Municipal Art Gallery in Jesi."

Alexandria showed me a reproduction of the Renaissance painting, in which the young Black maid

Lotto portrays is quite busy, her scarf slipping off her head as she tries to restrain a particularly mischievous child. The little boy's mind is made up, he wants to enter the main narrative at any cost. The servant's holding him back with great difficulty, and thus she remains in the place she thinks is the only one due her: the margin. In the center of the picture, Saint Lucy appears in all her Junoesque majesty, her right index finger raised, her person radiating the wisdom of one who knows she's already part of the Kingdom of Heaven. Behind and in front of her are pagans, like a diabolical tangle of bodies, but they cannot so much as scratch her. The story is well-known: The pagans want to make the saint abjure her religion, but she doesn't yield and chooses martyrdom.

"In her studies, Lafanu makes sketch after sketch of Lotto's Black servant," Alexandria patiently explained. "She eliminates everything she considers superfluous. It all disappears, even the little boy disappears, and all that's left is the Black girl and her anxiety. Lafanu transforms the scene into her obsession. Into an investigation of terror."

I too looked at Lafanu Brown's drawings, and I saw that Alexandria was right. The girl Lotto painted is afraid of making a mistake. Afraid of getting a beating. Afraid of being punished if the little boy gets away from her. She's terrorized. And she sees the child as an enemy, as someone who has the power

to do her great harm. She tries to hold him back by force. She can't allow herself to make a mistake. And that fear of punishment is captured in its entirety in Lafanu's sketches for *Woman in Chains*. The artist seems very well acquainted with the dread of some unjustified, unexpected punishment suddenly coming down from out of nowhere.

While I was paging through that sketchbook, I suddenly remembered the awful phone call with my cousin, a prisoner somewhere between Libya and Niger.

Like Lotto's servant girl, Binti was frightened too. On that count, her voice hadn't lied. Something had happened to her, and she didn't want it to happen to her again. She was gauging every word in that agitated call, determined to avoid the smallest mistake.

And so it was that from Jesi to Tripoli, terror was a daily experience.

MY DEAR ULISSE, it's best that you know a few things about Frederick ..."

Lafanu Brown leans low over the mahogany writing desk, bent under the weight of her memories. As she sometimes does, Concetta looks into the room to ask when she wants dinner to be served.

"You're alone this evening too?"

"Yes, I'm alone."

The servant finds her employer's solitude vexing. "Miss Hillary's not coming for dinner?"

"No, she's busy with some old friends. It's just me and the cat." The cat is a new tenant, and Lafanu hasn't yet decided to give it a name. "Suppose we just call it 'Cat'?" she adds.

"But all Christian creatures have a name," Concetta replies.

"What makes you think this cat is a Christian? Do cats practice a religion?"

The thought of living without a religion seems diabolical to Concetta, and she starts crossing herself obsessively. "In the name of the Father, and of the Son, and of the Holy Ghost . . ."

This is followed by evocations of Saint Cyril, Saint James, Saint Anthony, Saint Stephen, Saint Agatha (the patron saint of Catania), and two Palermitan saints, Rosalia and Benedetto.

Lafanu laughs at these popular devotions and feels superior to that sort of thing.

She and Bathsheba, a convert to Catholicism "because that way you have more protection—in Rome, it's a good thing to know cardinals," often used to talk about God. Sitting in front of the fireplace in the damp house on Via della Frezza, the two women would toy with the idea of atheism.

"But a world without God," Lafanu would say in closing, "is a world without art. We painters need the beyond, the other side. Think of Giorgione. He's talking to someone beyond the painting—maybe it's God. There's something guiding his painting *The Tempest*, which he presents to us suspended in an apparent calm that opens abysses. We artists work

with the divine. To deny it would be to deny ourselves and our essence."

And it was to the divine that she committed her fears.

CONCETTA'S VOICE breaks the spell of those thoughts: "This evening, mistress—"

"I'm not your mistress, Concetta. You're a woman. I'm a woman. I pay you for your work. You work for me. It's only work. You don't belong to me. You're free."

"Yes, Miss Brown..." Concetta says, slowly nodding. She's not thoroughly persuaded by Lafanu's words. She knows the world. It's a jungle. A world of masters and servants. Of those on top and those down below, the trampled-on. She would dearly like to explain this to Lafanu Brown, to tell her, "There are still masters." *She's a good person*, Concetta thinks. *She treats me well. But if she should go away, I'd have to find another job. And she will go away. Already five times this week, I've seen the gentleman with the beard standing outside in the street. Early in the morning, he looks up at her windows. Eyes full of feeling. The bearded Apulian's in love with her. And he's going to carry her off. He's determined. He knows how to wait. He knows he must wait. And so he'll wait. Now she's bent over her writing desk. Surrounded by her ghosts. But once she frees herself from them, she'll go away with him. And I'll have to start*

searching for a future again, any future will do. If I'm lucky, I'll find someone like her, or like the late, lamented Bathsheba McKenzie. I have little ones back in my village. My children's children. I send them money. I have to work hard for their sake. And if I happen to find a mistress, I'll bow my head and say, Yes, mistress. Yes, mistress. Yes, mistress. Everything you command me to do will be done, mistress. It will be done immediately.

That evening, Lafanu starts to write more extensively to Ulisse about Frederick, but her thoughts keep returning to their first meeting, when that most beautiful man kindly offered her his handkerchief. It was white, with a lace border, and even as she barely touched it, she already knew who he was; she had recognized him at once, especially because of his legendary head of hair. Like everyone in the room, she'd already seen Frederick Bailey in some photographs taken when he was younger, and on the back cover of his book *The Life of a Fugitive Slave*, there was a sketch of his proud face. By the time his book appeared, many such autobiographies had been published in the United States of America, the land of freedom and slavery. The autobiographies recounted their authors' lives in bondage and escapes from it. But Bailey had a prose style that captivated readers like an adventure novel, so much so that when the volume was published, nobody believed that the author was really a black man.

"Come on, out with it, admit the author's white," everyone said. "Clearly, a white man wrote this. Out with his name and get it over with."

The author, however, insisted on his authorship. "Written by myself," he proudly declared in every place where he was invited to present his book. Lafanu had read the preface by Ronald Perkins, the publisher of the famous abolitionist magazine *Freedom*. In his vigorous introduction, Perkins describes his first meeting with a black man who would make history. His first meeting with Frederick Bailey.

Lafanu knew passages of that preface by heart. Like everyone in Salenius, like all those engaged in the struggle for the abolitionist cause, she admired Ronald Perkins. Bathsheba McKenzie had invited him to visit the city, but his work and the cause had always prevented him from coming. For years, both Bathsheba and Mulland Trevor had carried on an extensive correspondence with him. Mulland had enjoyed the good fortune of encountering him at one of the few dinners Mulland had been hired to cater outside the county.

"He's a man of absolute integrity," Mulland had said. He'd used that set phrase because a more fitting one hadn't occurred to him. Because Perkins was, in fact, just such a man. The mere sight of him had made such a favorable impression on Mulland that he could think of no words adequate to describe him.

Lafanu would devour *Freedom*, her favorite monthly reading. It was those pages that had introduced her to Frederick Bailey and made her familiar with his life and work. She knew all about his failed attempts to escape from the plantation where he was a slave, a condition he'd been in practically since birth. He was the son of the most beautiful slave and the most brutal master. Frederick was the offspring of a rape, a fact that he didn't conceal from his readers.

"I was the parasite who lived in his mother's womb and destroyed it. I was born a murderer. I killed the woman who brought me into the world. My head was too big, my body excessive. And my mother's womb—she was only a child herself—couldn't withstand the challenge of the growing creature nesting inside her, nearly as big as she, slip of a girl that she was, with legs so spindly as to give the illusion that she was capable of flying away. I say what I was told, for I have no memory of my mother. I know that for five years I remained on the rapist's plantation. Then he sold me to Gustavson, who sold me to Palmer, who sold me to Karandine, who sold me to Salinger, who sold me to Ford, who sold me to Frost. Then nobody sold me to anyone at all, because I ran away."

He was caught and brought back four times.

Caught, whipped, tortured, humiliated.

"But the fifth time, I jumped onto a wagon that would take me far from Maryland, dressed in a sailor's

uniform and carrying in my heart the hope that had never wavered." He'd chosen to pose as a free man of color rather than take a chance, as he had the other times, on a flight through the woods. "They'll catch you there unless you're fleet of foot. And I am very large, I run pretty slowly. I cannot bound like a gazelle. I am no deer. Nor have I ever been one, not even as a boy."

And every time Lafanu read those modest, heroic words, she wished she could give herself wings, wished she could transform herself into feathers for so courageous a man.

"Baby Sue, did you escape like that too? Where were you a slave, Baby Sue?"

But Baby Sue would never talk about her origins.

By way of coaxing her to open up, Lafanu was reading Bailey's autobiography to her. And now this perfectly heroic man had stepped out of the pages of one of Lafanu's favorite books and was offering her his handkerchief. Lafanu was ashamed of having cried like a little girl in front of him. She was dying of shame at being so far beneath him, for he, during his entire captivity, had not shed so much as a single tear.

"I cannot weep," he'd written. "I must not weep. We have to demonstrate that we are ready to face up to the white man, whose will it is to shackle our dreams. For this reason, instead of wearing the

slave's shirt of tow cloth, I put on the clothes of a
sailor who granted me the favor and said, 'You can
travel with my papers, along with a legal document
that will assure their return to me.' He too had been
a slave. And he liked me. I almost wept for gratitude,
but I suppressed my tears. When you think every way
is blocked, you can find a friend with a set of keys that
will open for you the great door of hope."

In her notebook, Lafanu had outlined the stages
of Frederick Bailey's escape, the crazy twenty-four
hours he'd lived through and the places he'd passed.
Starting in Maryland, then by boat across Chesa-
peake Bay and up the Susquehanna River, with a de-
tour on foot to Delaware, eventually to Philadelphia,
with its gleam of freedom, and finally to New York,
where he went directly to Ronald Perkins's house and
knocked on the door.

Perkins writes in his preface, "Frederick was per-
vaded by fear and pervaded by hope. I said to him
only, 'Come in and welcome, brother. You are now a
free man.'"

Even though he really wasn't one legally, he was
well away from the plantation. And in the following
years, he'd made a name for himself among abolition-
ists and those sympathetic to their cause—a large
audience—with his columns in the pages of *Freedom*.
He had won mass approval easily, naturally.

And the ladies found him very handsome.

It had surprised him to discover that he could sleep with white women too. He took advantage of this discovery.

"Pretty effective, isn't he?"

The voice came from behind Lafanu. It was husky, warm, an odd voice that got under your skin. The voice of a woman of the world.

However, Lafanu couldn't bring herself to turn around to see the voice's owner. At that moment, the girl was too absorbed in what was taking place before her eyes. Bailey, Frederick Bailey, had already vanished. And Lafanu had his handkerchief in her hand. An embroidered handkerchief, with his initials entwined in shiny gold thread.

Lafanu's hand was trembling. Now she saw Bailey again, in conversation with two elderly gentlemen. He laughed, and his irregular teeth brightened every corner of the large room.

Lafanu couldn't take her eyes off him. Especially his buttocks, which gave his body an upward impetus. The thought embarrassed her, made her feel lewd. And her cheeks grew very hot.

"He has a certain effect on you too, I see." It was the same husky voice behind her.

This time, Lafanu turned around. And she saw a woman in a strange gown like a peacock's tail.

"Do you like my dress? I see you staring at it, my dear. So is everyone else, it seems. When it comes to

clothes, you people in Salenius are ten years behind Europe. I bought this dress in Paris last season. Now it's already out of style in Europe. But here, it's absolutely new. Ah, what an easy thing it is to astound the poor bumpkins of Salenius. But it's such an endearing little city. It has a port, but it doesn't want to know about it. It keeps its defenses up. Because modernity is frightening. But not facing it would be stupid."

The unknown woman had filled Lafanu Brown's auricles with words. The girl stared at her with poorly concealed puzzlement.

"Ah, but how rude of me," the woman said, holding out her hand. "I'm Henrietta Callam, a friend of your tutor Lizzie Manson. We went to Europe together. Except that she went on to Italy, and I didn't. I stayed in the first country we visited: Great Britain. That was where I stopped. London is so vibrant that leaving it seemed intolerable to me. And you're like me, my dear girl! A person of your kind is thrown away in these rural wastelands, in this provincial place that doesn't want to know anything about its seaport. You ought to come to London with me, and why not, Italy too. Yes, that's it, I really should take you to Italy. I haven't been there myself yet, but that's the only place to go if you want to become a great artist. And from what I've seen—Lizzie has shown me your sketchbooks—yes, from what I see, my dear, your work is not in any way inferior to what is produced by

academy students. You have the fire. And if one has the fire, one has everything."

Lafanu could do nothing to stem this verbal tide. She didn't even try to interrupt the woman's monologue, which came to an end with, "Now, my girl, arise from that Persian rug. You have already provided the circus audience with sufficient entertainment. I shall try to teach you how to protect yourself from these unpleasant situations."

She gave Lafanu her hand and helped her get to her feet.

"Let's go and have a glass of the delicious punch. I'd been told that the receptions organized by Mulland Trevor were exceptional. And I can say that this Mulland is, by our American standards, really a marvel. Even in London, he would be much sought-after."

CLATTERING HOOVES. Streets, groves, public squares, art galleries, cafés. Henrietta Callam's days in Salenius were hectic. However, she regularly found time in her mad bustle to visit her friend Lizzie Manson and Lizzie's promising protégée Lafanu Brown. When Henrietta arrived, the two would usually be discussing Roman classics or daubing colors onto a canvas. On one particular day, they were both attired in afternoon dresses of a cold brown color and resembled

linden trees after the flowers are gone. Rather shabby dresses, which did, after all, reflect the dreary mood of that fall day in Salenius. A hard winter was preparing its invasion, and nobody felt like putting on a rainbow of colors and celebrating. Lafanu was especially peeved, because it would no longer be possible for her to go out with her palette and try to capture the perfection of ladybugs.

"The cold will wipe them all out and I'll be left alone," she complained.

Molly the maid went to the door of Lizzie's little house and let in Henrietta. "Miss Callam and a gentleman friend are here," Molly announced. The impish maid came down hard on the word *friend*.

That word alarmed both Lizzie and Lafanu. Lizzie, because she feared the disorder in the house was too great; Lafanu, because she already knew who the friend was. When she saw Mr. Bailey's aquiline nose, her face showed none of her surprise, but her heart seemed ready to explode. Lafanu had never felt her heart beat like that. It was a new experience. Strange even just to describe.

"I THOUGHT I was going to die," she writes to Ulisse. But he's a man who might see a threat in that past of hers. She strikes her last sentence.

And she marvels at herself, and at all her solicitude in regard to Ulisse Barbieri. So maybe she loves him too? The discovery makes her smile.

FREDERICK HAD COME to commission a portrait of himself. "So far, I'm not satisfied with the ones I've sat for. They're so . . . impersonal. I don't know if I'm making myself clear."

Lafanu didn't say a word. Henrietta advised Lizzie to move with her to another room and leave the two younger people to themselves.

And when they were alone, tête-à-tête, Lafanu staved off her emotions by concentrating on her work and quickly produced a sketch. Then, dissatisfied, she made another one. It was his chin that confounded her. It evaded every rule. And Frederick's eyes were so hard that they would have torn any sort of canvas. He was a puzzle, that man. But Lafanu didn't want to give up. "We'll need several sittings," she said. "Do you have the time?"

"All the time you need, Miss Brown."

And then he moved close to Lafanu's stiffened body and tenderly kissed her hand.

Crossings

VIII

Then Binti returned. Went back home, to Mogadishu. Finally. Alive. I was notified in a simple text message.

There had been no phone call. That silence made me suspicious.

I called immediately. "Put her on," I said.

"She doesn't want to talk to anyone," the irritated relatives said. They added, "She's tired."

"Tomorrow?" I insisted, not letting go.

"Better wait a while. A good while."

Those words, spoken by a chorus of women—most of them distant relatives—sounded ambiguous to me. I insisted on speaking to Binti.

So then they put a male cousin on the line. And in no time at all, the chorus of women abandoned me. Maybe they were having trouble doing justice to the

phony roles that had been assigned to them strictly for the benefit of their Italian relative.

Anxiously, I asked the cousin, "How does she seem to you? Has she told you what . . . ?"

"Binti's doing fine. You ask too many questions, Leila, you're like the *gaal*. Isn't it enough for you to know she's all right?"

There was a lot of hostility in his voice.

I said only, "Okay."

That "like the *gaal*"—"like the infidels"—suddenly struck me as a defensive fortress built in desperate haste by persons who didn't have any good ideas for what to do about the calamity that had come crashing down on them.

But there was one thing I didn't understand: Why was she barricading herself against me? If I hadn't helped her, Binti would still be in the traffickers' hands, or worse, she'd be dead.

I'd found the money and sent it to her. And now I was being treated like this. I didn't understand.

I promised myself not to let the matter drop but to postpone the final reckoning. *The important thing*, I said to myself, *is that Binti's back home and okay. Those creeps aren't holding her anymore.*

"Oh God," I said, and sighed aloud. "Who knows what they did to her."

The disjointed words that smuggler had said to me on the phone stuck inside my head. They made me

shiver all over again—that way he had of pronouncing *fluss*, money, with a long hiss. Absurdly enough, I remembered the character of Gollum, the hobbit driven mad by excessive greed in *The Lord of the Rings*. A creature whom avarice has rendered cruel.

When I told her Binti's story, Alexandria shook her head and put her hand on my shoulder. And she uttered a series of set expressions, hackneyed words that nevertheless sounded comforting to my heart. Ah, how I hung on them! Those words were a lifeboat I leaped into without hesitation. I'd been like a shipwreck victim, barely afloat in a sea of uncertainty and unable to swim.

My other lifeboat was, of course, Lafanu Brown.

In two weeks, my visiting appointment at Salenius University would come to an end, and I'd have to go back to Italy. My short stay had been a highly important parenthesis, a delightful opportunity to study the life and works of Lafanu Brown! And a privilege to enter into her thoughts.

"Well? How will we introduce our Lafanu to the public at the Venice Biennale?" Alexandria asked me that question one evening when we'd gone out for sushi with her new boyfriend, a fascinating artist whose cause I championed at first sight. He was the spitting image—except for his nose—of Ryan Gosling.

"Not bad, your young stud," I said, after he'd gone to the men's room to wash his hands.

She laughed. "Brazen hussy," she said. And then, insisting on her question: "So what are we going to do about her?"

When her guy returned to the table, I told him the subject of our conversation. "Lafanu Brown. What do you think about her?" I asked, looking him in the eyes.

He smiled. Alexandria had already pulled him into our vortex. "Powerful stuff," he said. "The old girl was ahead of her time." Then he added, "You should set up a dialogue between some living artists and her work. Find the right artists and then see what comes out. Several of us—painters, illustrators, cartoonists—dialoguing across a century and a half or so with Lafanu. If you want, I'll help you." And he smiled again.

It was a good idea, I liked it, and I said, "Maybe some African American artists."

"Why limit ourselves?" Alexandria said, almost echoing me. "Why not artists from the whole southern hemisphere?"

"We'll put out a call!" I said, overcome with enthusiasm.

"And if the Venice Biennale doesn't take us and offer proper funding, I know who to ask for the money," Alexandria said, with great assurance.

"George Soros?" I joked.

"You know, Open Society has financed some pretty good projects for us."

I turned serious. "We'll start working on this tomorrow. Am I or am I not the best available curator?"

The lovebirds ordered another round of sake, I stuck with my usual green tea, and together we toasted Lafanu Brown.

I went to bed happy, but in the morning I woke up with the thought of my cousin in my head. The dinner had been a parenthesis, now closed, in the anxiety that was plaguing me.

I picked up my phone. In Somalia, it must have been around three o'clock in the afternoon. I wanted to try out another strategy. I called another cousin, Shukri. She was a big gossip. *I'll get her to talk*, I figured. I had to know, that's all there was to it.

Shukri answered after a few seconds. Her voice was shrill, like a telemarketer's.

We spent two entire minutes on salaams and ritualized small talk, how are you singular, how are you plural, how are they now, how will you be, do you have any news of this one or that one or the other one, the one whose name I don't remember . . . After a while I got tired of that, and like a female leopard, I went for my cousin's jugular.

"How's Binti? What did they do to her? Why am I not allowed to talk to her?"

"But . . ." she began to stammer.

"No buts, I want the truth. I'm worn out. You know how much I care about her."

She started sobbing. "They broke her into little pieces."

I felt my heart come to a stop. This was what I'd feared. "And . . . ?" I knew there was more.

"Cousin Omar Geele shut her up in a room, in the dark. And you know, she's not right in the head anymore. It's like she's gone crazy. She tears off her clothes. Screams obscenities. She's said some things against God—I can't repeat them. They gave us back a madwoman, those damned smugglers. We're afraid to find out exactly what happened to her, but we think we know. And Cousin Omar, rightfully, doesn't want our shame to become common knowledge."

The word *shame* made me angry.

But by this point, cousin Shukri was off and running. And she kept repeating, "Shame, shame, shame," as if it were an exorcism.

Finally she used a Somali expression, *"Wa la kuf-sade meskinta,"* that conveyed all the brutality of the rape.

I seemed to see my Binti lying on the ground, covered in her blood, covered in her fear.

"But did you ask her any questions? Have you spoken to her?"

"She doesn't remember anything. But the same thing happens to all the women and girls who cross the desert. None of us has any doubt about that.

Those monsters took her, used her—if you saw her face, you'd understand, cousin."

I felt nauseous. Cold sweat ran down my back.

I just said, "I'll talk to Omar tomorrow," and then I added, "You can't keep her shut up in a room. It's inhuman. Please, let her out, let her be in the sun, not in some dark, damp room."

I ended the call. My voice was breaking apart.

I didn't cry, but I vomited on the rug.

On my knees on the floor, I murmured, "Lafanu, help me, please help me!" I prayed to her as to a goddess.

NUMEROUS OBLIGATIONS kept Frederick Bailey from finding the time to pose for the portrait he'd expressly requested Miss Brown to paint.

Meetings, gatherings, documents to be submitted to public opinion, articles, editorials.

All things worked to thwart the desire that beat so strongly in his breast.

In those recent months, no one, not even Ronald Perkins, had received any news of him. Only brief letters and articles to be printed and published posthaste in *Freedom*.

In those letters, Frederick apologized to his mentor: "I'm closely following the extraordinary events

that will soon lead to open war with the secessionist states."

Everyone knew that South Carolina was champing at the bit. That the whole South was about to erupt. And that the coming of the new president might precipitate events.

November 6, 1860, wasn't so far off. And the victory of Abraham Lincoln and Hannibal Hamlin no longer seemed like a pipe dream. These facts were widely discussed in abolitionist societies, including the one in Salenius. There was a certain excitement in the air.

"War will bring us closer to our ideals," the men said. Whereas the women took a longer view, because the smell of their loved ones' dead flesh was already in their nostrils, and it frightened them.

Those were serious, sober months, and a bleak atmosphere quickly settled over Salenius too. There was less banqueting, less ostentation, more pragmatism and rigor.

Even Mulland Trevor's general store and catering business, which in previous years had delighted the city with practically Parisian luxury, was offering austere dishes in the Puritan tradition. Almost tasteless dishes, which the abolitionist haute bourgeoisie accepted with reluctance. No more cognac, no more oysters, and—to Bathsheba McKenzie's great disappointment—no more Scottish brandy.

The hard times to come were appearing on the horizon.

"But they're times that will lead to our victory," someone murmured. And Frederick Bailey stood astride those very times. He was virtually everywhere. He rode stagecoaches all over the fearful North, declaring in one place after another that the negro question was an American question. And it was in those months of nomadic delirium that Bailey started to distance himself quite markedly from certain extremist positions, positions that Ronald Perkins openly supported, such as, for example, the view that a complete rewriting of the United States Constitution was the only solution to the country's problems. Because of such disagreements, the correspondence between Frederick and his mentor had slackened dramatically.

"Dear Ronald, it's not necessary to change the whole thing, I think it's fine just as it is."

Perkins, on the other hand, felt implacable hostility toward the Constitution, which as he saw it had sprung from the carcasses of slaves. "It's tainted by a technical defect," he would say. And he'd add, "And by a substantive defect too. The Constitution approves everything we despise, in the first place, the slave-based structure of our society, where one group enjoys everything and another group suffers everything. You cannot, Frederick, you of all people, you

who have paid the price of that system with your very flesh—you cannot adhere to this fraud."

Perkins was wounded by his favorite's transformation. "I no longer recognize you, my friend," he wrote.

There were many people who, like him, no longer recognized Frederick Bailey.

But there were also others who saw that Frederick was taking his time, trying laboriously to cement alliances for the future. "Rome wasn't built in a day," he maintained. And it mattered little to him if someone called him irresponsible or, worse, accused him of being a traitor. He paid no attention to what people said, and he wasn't interested in the gossip about himself. It was whispered that a blond lady from Philadelphia, a certain Susan Flint, had pretty much manipulated him, but he didn't get manipulated by anyone. He had his own ideas, his own methods, and he disseminated them to the four winds. And above all, he had a goal. Where he wanted to go was quite clear to him.

"The Constitution," he would say, "is not against negroes, it's never been that. These sorry years we're living through are the result only of faulty interpretations. It's up to us, us blacks, us whites, us Americans" (he pronounced that word *us* with something like messianic emphasis) "to transform it into a constitution for all. That's our mission, the only one that's

genuinely worthy. But let's be very clear: We must not distort or overturn anything. We're good patriots, good Americans. May God bless our sacred land."

And so, in those early months of 1860, the good Frederick Bailey was in the eye of the hurricane. Like everyone else, Lafanu Brown would read his editorials in *Freedom*, pages thick with suffering and political insights; the girl savored every word of that radical journal, especially his. But at a certain point, Bailey grew tired of writing for *Freedom* and along with a white friend named Thomas Lyndon founded the *Bailey Quarterly Review*, a periodical resolutely moderate in nature but at the same time decidedly antislavery. Many of his devoted readers (such as Lafanu) followed Bailey in his new adventure. The first issue of the *Bailey Quarterly Review* appeared in February 1860 and provided definitive proof that the two old friends, Bailey and Perkins, would from now on man opposing barricades.

February was an important month in Bailey's life for another reason: He became legally free. Now he was a man again, in every respect. During that time, however, he was also a man who was very much alone.

That solitude of his was one of the subjects Frederick wrote about to Lafanu Brown. His first letter came around the end of that same month, February.

I'm alone. Alone in my room, and I'm thinking about how brief our meetings have been, the first at the reception in Mrs. McKenzie's house, and the second, a fleeting moment at Mrs. Manson's. I'm writing to you because of the great regret I feel at having exchanged with you nothing but a few phrases of polite—that is, cold and austere—conversation. But my spirit, and this is the beauty of life, my spirit felt, from the very first moment, a certain affinity with your combative heart. I recognize a warrior when I see one, and you, Miss Brown, are a warrior. In the few instants when my eyes were resting on you, I was able to appreciate your courage and your patience in the face of those oafs who wanted only to mock you with their oafish laughter. Soon I shall return to Salenius, and I would like to see you again. And perhaps, if it's convenient for you, I can pose for that portrait we talked about. I've seen your portrait of our great supporter and my most esteemed friend Margareth Miller. You have captured her essence, her mixture of force and fragility. Force combined with the obstacles fate puts in our path. Her backlit veins, her sunken gaze, her skin tone, which you're rendered perfectly. Sublimely. A sublime painting, sublime like its creator. You, Miss Brown.

———

FROM FEBRUARY TO APRIL, Lafanu received numerous missives. Missives that arrived at Bathsheba McKenzie's house, because Frederick didn't know any other way to reach Miss Brown.

Bathsheba, who was as curious as a cat, melted the wax seals and avidly read the contents of those private letters. Then—employing skills she'd perfected in her years of marriage to that reprobate Andrew—she restored everything to its former state.

This could be the birth of a beautiful union. I'll do everything I can to encourage it. I want my little pickaninny to be settled in a good situation.

And then Bathsheba daydreamed about the compliments she'd receive from the other abolitionists for having facilitated that romance.

Yes, it was a brilliant plan to have those two fall in love. The activist and the little Chippewa. A perfect union. Two model negroes. The plan was already sending her into raptures, almost as much as her brandy.

In reality, Lafanu was already in love.

She kept those letters under her bed. Although one, the first, she would slip under her tulle dress, close to her breast, close to her heart.

And every night, she'd dream of her Frederick, she'd see his forehead, drenched with the future.

They had barely spoken, but she already considered him *her* Frederick. She liked his scent. He smelled of moss and salt. Of forest and red flowers.

In her sketchbooks, she often drew him surrounded by a riot of begonias, primroses, and bottlebrushes. He was always in a three-quarter pose, with his eyes, like a sailor's, turned toward his distant island.

She didn't dwell on his political contradictions. "It's the times" was the way she justified him. And while some of the most inveterate abolitionists called him a traitor for the way he'd treated poor Perkins, others praised him as the consistent and moderate black voice that had been missing in American political discourse.

"He's not like the others, he's not trying to incite a dark revolt, he's looking for a compromise, often enough in times of mutual suspicion." In March, someone said, Bailey had secretly met with Lincoln. Others referred to a dinner at Perkins's house a little later. Reconciliation or definitive rupture? Nothing transpired.

In April, Frederick was caught up in a riot in North Carolina but escaped uninjured. The news scared Lafanu to death. She devoured newspapers and eagerly listened to rumors, hoping for more information about him.

It was during those turbulent months, in which young Lafanu was totally preoccupied by Frederick

Bailey's almost superhuman exploits, that the disaster involving Lucy and her mother had occurred.

In her long letter to Ulisse, whom she already considers her lover, Lafanu describes that debacle too. "I'm telling you all this because the squabble between Lucy and her mother drove a wedge between me and Frederick."

Then she crossed out the word *squabble*.

It wasn't a squabble, it was a full-fledged family drama.

It was known to the free black community in Salenius, and to Lafanu more than anyone, that girls who had escaped from the Southern plantations could find a place to stay, free of charge and with no work obligations, for one or two weeks in the Trevors' cowshed. It was there that they recovered the strength to resume the journey that usually ended in Canada, where many of them had already found freedom.

On the other hand, those who didn't want to continue on the journey north would lend a hand in the business or quickly find work in the home of some upper-middle-class white abolitionists, who paid the girls for their work—a ridiculous sum, but it came with many of the rights of the white domestics. This was a situation of absolute privilege in comparison with that of certain immigrant women.

The girls often changed.

And it was known that sometimes, in a group of fleeing women, there was one willing to be embraced by any other human being who showed kindness and affection toward that body of hers, so tortured, so wounded. Those girls wanted only caresses, only friendship. And so when Lucy appeared, with her bright mouth, her silken hair, her frank smile, they saw in her the sister they had lost when someone dragged them away from Africa. And Lucy would sit cross-legged on the floor of that shed, which stank of cow, and listen to their tales of woe. She knew how to make them laugh, as she had made Lafanu laugh in days gone by. And sometimes those girls, enthralled by the softness of Lucy's hair, would shyly ask her if they could touch it, and then she'd stretch out her neck and let them touch her hair. Her heart would beat so hard she'd almost lose control. She'd start to perspire, and every time, she'd jump to her feet and justify her sudden departure by saying, "My mother must be looking for me, there's so much work to do in the house." At night, she would dream of those girls. She'd dream of the scratches on their faces, of their shapely muscular legs, of the kinky hair that covered their heads like halos. And then, if she closed her eyes a little harder, she could hear their slow breathing in the peaceful sleep that finally, after years, they were able to allow themselves. Lucy would feel a mighty

urge to go and visit them. To go to them and caress them in those hidden, prohibited places. But then, every time she encountered them—and it was never by chance, for she made sure to wander over to the cowshed at almost any hour of the day—she felt ashamed to recall her filthy thoughts of the previous night. Ashamed of the wetness between her legs. The girls, however, would smile at her.

Since Lafanu's return from Coberlin, Lucy had tried more than once to have a quiet talk with her former friend. She wanted to apologize for her self-indulgent behavior, but she would also have liked to confess to Lafanu that her body continued to betray her.

Lucy was afraid of the future, because Marilay had decided that her daughter would soon wed David Field.

David was a bulky young man with horse teeth and an elongated forehead. But he was rich, and he had the flair of a self-made man. "He has the right character to break a stubborn filly like my Lucy. She seems easygoing, but she needs a man to keep an eye on her." Unable to bear the obscene cruelty with which Marilay spoke those words, Lucy ran outside into the garden, crouched under the big oak tree, and wept.

The scene was often repeated. Lucy would take refuge under that oak, which served as her mother,

and she imagined that its leaves were hands caressing her head.

Then, one day, someone really caressed her.

The person was a tall, extremely black teenager with a furrowed brow and big eyes.

"Markissa," she said. "My name is Markissa. What's yours, sad girl?"

And that was the way their friendship began.

Markissa caressed her, and Lucy let herself be caressed. They talked. Not much, to tell the truth. They sniffed each other, they grazed each other. And so as not to attract attention, Lucy would visit her in the cowshed at night.

They would lie down and clasp hands and wait until love gave them the nerve to begin. Markissa never talked about her experiences in slavery. She didn't talk about the master who raped her or about how he smelled like a privy. She didn't talk about the sufferings of her sisters, whom she had watched die of exhaustion.

She only wanted to see Lucy smile.

And it was through the laughter that the kisses came, and the increasingly intimate caresses that they'd waited too long to give each other.

Lucy was ravenous for Markissa, who allowed herself to be explored like an unknown land in a far corner of the globe. It almost seemed as though the

two girls' bodies had been purposely constructed to fit together.

Nights of happiness passed, weeks of nights.

As everyone could tell at first glance, Lucy had blossomed. Her face was more radiant, her breasts were growing fuller, her back was straighter, her clothes more colorful. And her eyes were as brilliant as emeralds.

Those eyes quickly attracted the attention of David Field, Marilay's preferred choice as Lucy's suitor. Captivated by all the light that Lucy was emanating, he hastened to ask for the girl's hand. Marilay was in seventh heaven, and Mulland, offering him a pinch of the tobacco he kept hidden in his vest, merrily replied, "Well, what are you waiting for? Run and tell your girl." But Lucy wasn't in the house. They looked for her in her room, in the kitchen, in the dusty, book-lined corners, until Mulland thought about the cowshed. "Oh, that stupid girl, she'll be all dirty and ruin everything as usual."

Lucy, of course, was in the shed with Markissa.

The nights were no longer enough for those two lovers, who had taken to seeing each other whenever they could, and that included foggy afternoons. And that day, like every day, they were lying naked on the straw, holding each other.

They were making escape plans. Lucy was trying to persuade Markissa. "I can easily pass for white.

Nobody will think I'm not." She laughed before going on: "You'll be my personal maid. Everyone will believe us."

Markissa, a more practical girl, replied, "And what will we do for money?"

Lucy put her hand over her lover's mouth and whispered in her ear, "I'll take what I'm entitled to, my love."

The plan was to take part of the proceeds from the general store. Lucy knew exactly where Mulland hid what she ironically called "the loot." She wasn't greedy, she'd take only enough money to get them to Canada.

"Once we're there, we won't have to hide. We'll have a room all our own. A real bed, no more straw! And just think, Markissa...we'll really be free...there'll be no one to spy on us, not even these two busybody cows."

Love makes you careless. And on that afternoon, while the two girls were exchanging loving effusions, a trio composed of David Field and Marilay and Mulland Trevor were striding purposefully toward the cowshed, bringing the happy news.

David was the first to enter the shed. He was the first to see.

And at the sight of those two nude girls, he got an erection that he had a hard time concealing. To dissimulate his embarrassment (and, above all, his

arousal), he started shouting at the Trevors, "You want to make me marry a devil?" and then quickly left the scene. Mulland, his face burning with shame, followed him, desperate to change his mind.

Marilay stayed behind, frozen by the spectacle. "I have given birth to a monster," she whispered. It was only afterward that the howling began.

LAFANU WAS IN ECSTASY that afternoon. The previous day, she'd received another letter from Frederick, and she'd been reading those dear, sweet words ever since. The letter spoke of Italy, a country that Lafanu had by now come to think of as an ideal home. The letter began, "Garibaldi has crossed the Strait of Messina." And Lafanu was excited to know that she and her Frederick had a shared interest in Italian political events. At that time, she would react to anything related to Italy, *her* Italy, with an almost feverish intensity. She and Lizzie were closely following this Giuseppe Garibaldi and his fortunes. And Henrietta Callam was stoking their interest with whatever fresh news she'd heard firsthand from some particularly trustworthy friends.

"But don't ask me who they are, I don't want to betray their secrets," she'd say.

Lizzie would shake her head vigorously. "No, no, my dear, we won't say a thing, I swear. Our lips are

sealed. We know how costly it can be for secrets to leak out just when victory is nigh."

The three women often met in Lizzie Manson's little sitting room. They'd sit there in that house on Thirty-Ninth Street in Salenius and calculate how long it might be before any of them would see their beautiful Italy, their favorite country, now united at last.

"It would be grand to take our Lafanu there," Henrietta repeated cyclically to Lizzie Manson. "Besides, I've never been there myself, so it would be doubly grand to travel to Italy with her."

Lizzie would nod with great solicitude and say, "And I would be enchanted to know that the two of you were in Italy together." Lizzie could already see Lafanu roaming the austere corridors of the Palazzo Pitti in Florence, sketchbook in hand, unendingly curious, and surrounded by masterworks of Van Dyck, Rubens, Guido Reni, Giambologna. Roaming the same corridors where she, Lizzie, had been perfectly happy years ago. She imagined Lafanu copying the intense stare of the peasant girl from Velletri whom Raffaello Sanzio had transformed in his masterpiece *Madonna della seggiola* (*Madonna of the Chair*). Lizzie could see her already, her favorite pupil, who astonished her every day with inventive techniques and innovative touches of color. How meticulous and alert that girl was, and how much passion showed in her hands, which never stopped moving.

Meanwhile, over at the Trevor house, all hell had broken loose, so much so that Lafanu heard the shouting, abandoned the letter on the writing desk, and rushed outside. What she saw was so harrowing that it seemed unreal. The pantomime of a cow in the slaughterhouse.

Commotion. Screams. Weeping.

"No, Mother, don't touch her, she didn't do anything, leave her alone! For the love of God, let her go, please let her go!"

The response to those words was scornful laughter, followed by callous words. Marilay threw all her sacrifices in her daughter's face.

"And you can leave God out of this, Lucy Trevor, because you don't know a thing about him. You're a sinner, that's what I've brought into the world, a sinner. Damn you, girl! My daughter! When I think of the hopes I had for you!"

Instinctively, Lafanu moved closer to the shouting, which seemed to be coming from the cowshed. Many people in the neighborhood were doing the same thing. Mulland Trevor wasn't among them, as he'd shut himself up in the house. He didn't want to attend that ignominious spectacle, whose final act he could already foresee.

While still some distance away, Lafanu could see a girl, as black as the blackest pitch, on her knees, her back bare. Marilay was whipping her pitilessly.

The neighbors were terrified, particularly the former slaves among them who had recently become Northerners. The poor things hadn't seen a whip since they escaped from the plantations and traveled north on the Underground Railroad.

Lafanu quickened her pace and was soon close enough to see that Marilay's dress, a daytime dress in striped taffeta, was getting spattered with blood.

It was the black girl's blood, Markissa's blood.

Every blow slashed open raw strips in the coal-black flesh, and every strip spurted like a fountain.

The poor girl was just one big wound, a surging river of blood. Marilay didn't stop hitting her, all the while insulting her with the most abominable epithets, incongruous though they were in the mouth of one of the city's most prominent free women of color. Lucy was clinging to her mother's skirts, arms tight around her knees, impeding her movement.

"Please, please, leave her alone! I'll do whatever you want. Anything you want. Just let my Markissa go."

"*Yours*?" Marilay thundered. "How dare you say this worthless nigger girl is yours, Lucy. Haven't I taught you anything in all these years? And look at me when I talk to you!"

Lucy obeyed. How alike their eyes were, hers and her mother's. How alike their long faces, too. Only their hair was different. Marilay gathered hers on top of her head and kept it in place with pins. Her hair

was too kinky to wear without using some tricks, she always said. "It looks too barbaric," she'd add, identifying it as a fault. Her appearance saddened her. Her black skin, her kinky hair, her excessively thick lips. Lucy, by contrast, was a siren. Besides her bright skin, which Marilay defined as "pure light," she also had hair as soft as swan's down, which her lover had stroked with infinite tenderness.

"I'll let this darky go, and I won't touch her again. But do you promise to submit to my will? You've driven David Field away. You could have had a brilliant future with him. And now you've lost everything, you little fool! But I'll find you another husband, and soon. At this point, just about anyone will do, including some know-nothing bumpkin. And you'll marry him fast, early next month, if I can manage to make the necessary arrangements."

Lucy trembled. She felt an urge to run far away from there. Far away from a man she didn't want to go to bed with.

Disappear, that was what she wanted to do. Disappear into the woods that bounded the city on the north. Become a ghost. Become nothing.

But Markissa was there, injured, humiliated.

Lucy had to save her.

"Get up, nigger gal," Marilay said to Markissa. "You're leaving tomorrow. Now go to the kitchen and ask Baby Sue to put some ointment on your back."

Then, turning to Lucy, Marilay went on, "And now for you, my depraved daughter. Are you stupid enough to think you're going to escape punishment? I want this to be a day you'll never forget."

Lafanu was a bundle of nerves. Could it be that all these people were just looking on? Why didn't anyone intervene? Why was she herself standing still?

But when the first lash landed on Lucy's back, Lafanu's stomach turned.

She took a step, two steps, three steps toward the spectacle of torture that so much resembled some of the Renaissance paintings Lizzie Manson used to discuss with her. She wished to intercede on behalf of the victim, her scapegrace sister, who on a day not so long ago had gotten her in trouble too. But just as she started to open her mouth, she felt a powerful hand restraining her.

"Don't get involved in this. It's not worth it." The speaker was Frederick Bailey, in the flesh. A Frederick with weary eyes. A Frederick who'd sprung up out of who knew where.

"The girl's lost, Lafanu," he said. "Don't let her contaminate you."

Then Frederick dragged Lafanu far away from that violence.

And forever afterward, she was, deep down inside, unable to forgive him.

Crossings

IX

"Daktaradda dadka Waalan," literally "the lady doctor who treats crazy people," was what the residents of east Mogadishu called Dr. Lul Ahmed Hagi. One day, she went to that godforsaken district, part of a city that had been at war for what seemed like a lifetime, and for the first time entered Forlanini Hospital, which had been named after a hospital in Rome and was currently under military occupation. Around the hospital, the spectacle that presented itself to Dr. Lul Ahmed Hagi had offered nothing but sand, worms, *barambaro* (cockroaches), and a few scavenging rats. "But right away, I felt at home," she said, and as she spoke, she looked directly at the camera, smiling, steady, unhesitating. She was a somewhat

plump woman of around fifty. Chubby cheeks, thick eyebrows, oddly slender hands.

The first time I saw her was in a documentary on YouTube. I'd found the link on the Facebook group called Sei di Mogadiscio se ... (You're from Mogadishu if...). It was a nostalgic, melancholy page, written in Italian, because all Somalis have a weakness for that colonial language, which—in the chaos of a diaspora that reached from Finland to the United States, from the United Kingdom to Kenya—functioned as a lingua franca for a generation of forty- and fifty-year-olds.

I liked the doctor at once; I recognized in her the best of the Somali spirit, the spirit of a country bent double by the blows of fate.

I stared at the pixels that constituted her face on the screen, and from there my head transported me to Mogadishu, to that gleaming white city where I'd been as a child and which now lived in me only through old photographs in family albums.

The doctor told the interviewer, "I walked into that hospital, where I was born and where my mother was born. I had with me my medical kit, my stethoscope, and a great desire to turn the world upside down." She found filth, little children reeking of piss, rachitic cats, patients' rooms occupied by desperate families, and operating rooms filled with cobwebs; she found tears and trampled hopes. And that was

when she rolled up her sleeves. She occupied a half-empty wing of the establishment. She cleaned up the whole thing and began to create her center, which she called Welwel.

At first, no one trusted her. People said, "We need a doctor who slits open bellies and sews up wounds. If you don't know how to remove a bullet from a shoulder blade, you're not worth anything to us. And if you can't even deal with glass shards or the nails the terrorists fill their bombs with, you're useless! Go back to Italy, get another degree, a useful one, and don't come back to us until you've learned how to do something practical. What did you expect to accomplish here, anyway? A doctor who treats crazy people might be able to help some pampered Westerner, but we need a sawbones, someone up to handling emergencies. Look, a male nurse would probably do more for us than a useless woman like you."

She liked to repeat the things they told her in the beginning. "They wanted to make me move somewhere else, because my wing of the hospital was all cleaned up now and many doctors coveted it." The office she'd chosen for herself overlooked the garden, and the garden too, after a few weeks and with the help of three volunteers, was cleaned up, the weeds and dead leaves and animal excrement cleared away. Three months after her arrival, Lul was ready to begin.

"And by the end of the fourth month," she says with a smile in the documentary, "the first patients arrived. Many were schizophrenics. A few were suffering from depression. After a year of treating such cases, word had spread, and the castaways started to arrive. 'Castaways' is what I call people who have tried to get to Europe but couldn't get through the desert or across the sea. Those individuals, their brains were fried by the sun or curdled by the sea, they were fragile and extremely violent, and I had to find a new method of treating their multiple traumas."

I'd never forgotten that documentary. The doctor's merry, round face had stayed with me for years, tattooed on some hidden part of me. Hidden, but visible to the heart.

And it took about a second for me to remember her when my cousin Binti's brain broke.

I looked for Dr. Hagi's telephone number on the hospital's website, found it easily, and called her.

Lul answered the phone herself. She had a thin voice, something like short pastry. A voice that made you feel at home right away, and welcomed.

I told her everything—that is, everything I knew.

After I hung up, I made another call, this one to Shukri. By this point, I'd practically entrusted my little cousin to her. "Take Binti to Skuraran, to the old Forlanini Hospital, and see Dr. Lul Ahmed Haji. She knows what's up, I've told her about Binti. Don't

worry about money, I'll take care of all that. The doctor and I have an agreement. Just pack a suitcase for Binti, and put her only book in it, the one with the green cover. She reads it obsessively, or at least she used to before . . . before . . ."

I couldn't put into words the nightmare that had ravaged my cousin's body. I didn't finish my sentence, I merely hung up. And in the course of the following days, I thought of nothing else.

Shukri was keeping me updated on the situation. And I'd reply anxiously, compulsively, firing off one text message after another, not all of which the poor thing understood.

When I was away from my phone, however, all that existed for me was Lafanu.

As always, I plunged into her to distract myself. I'd found financing for our show. A foundation was interested in putting up most of the money, and several universities wanted to participate: Princeton, New York University, the Ca' Foscari University of Venice, the Sorbonne in Paris. I'd also received support for my proposal from various museums in the United States as well as the Louvre, whose storerooms contained some of the Roman portraits painted by Lafanu Brown between 1865 and 1886.

The work distracted me and gave me a respite from the pain of thinking about my little cousin, whose life had been so maliciously shattered.

But then I still had to face that pain.

One night I was alone, going through various papers and replying to work-related e-mails, when my cell phone rang. My heart started beating hard, and I seemed to intuit that the phone call wouldn't be bringing me any good news.

It was Dr. Lul Ahmed Hagi. She quickly got to the point: "The girl has lost her sense of taste."

"She can't taste?"

"Only *bis-bas*, hot sauce, and that's because it burns her tongue."

"Nothing else?"

"No."

"And . . ." I didn't know what else to ask.

"Binti doesn't talk much. Sometimes she says things that make no sense. But that's just where I'm following her most closely, tracking the elaborate ways the mind takes to distance itself from horror."

I was all the more alarmed. The doctor went on, "She's told me what happened, in her fashion. Using strange words, some of them incomprehensible. But now I'm sure. They forced her to perform oral sex on them. She feels sand in her mouth, and a sensation of bitterness. She brushes her teeth often and spits a lot. She can't stand food, she avoids it, as if she doesn't want to put anything in her mouth. I gave her an IV, and I'll give her another one in three days. But

right now, we really need her to eat something. Then we'll see what to do."

I was shaking in silence. Cold to the bone. The doctor kept talking: "I studied in Europe. And I got there on an airplane. When we—I mean Somali women—planned to travel by air, we'd dress up as if we were going to some gala event. And now our girls are being reduced to rags, made to cross the desert—oh, damn Europe! That's the reason I left and came back here. People over there live shut up in a fortress and think they're saving themselves from who knows what. My profession is to study what's inside people's heads. And Europe's head is all rotten inside, like a worm-eaten apple." This outburst was followed by an angry silence, at the end of which the doctor said, "I'll get your cousin back on her feet. It'll take time, but we'll do it."

After I hung up the phone, I wanted to cry. I tried to cry, but no tear fell. My cheeks were dry, my pupils clear.

Your cousin has lost her sense of taste . . .

Your cousin was forced to perform oral sex . . .

Your cousin won't eat . . .

And I thought about Lafanu. After that dreadful night, she couldn't taste anything either. She'd probably suffered the same agony as Binti.

I crumpled to the floor within reach of my phone. My strength was gone. I was lost in my fear of the world.

THEN AUTUMN CAME.

And in Salenius, Frederick Bailey was the missing jewel, the ornament that lit up the gray city.

Frederick was the intellect, the struggle, the desire for redemption, the elegance, the obstinacy that Salenius craved. He was the civilized negro who must be displayed in every drawing room. The negro everyone must coddle in order to feel that they were better people than was actually the case.

And he played right along, allowing himself to be looked at and admired by the slobbering white folks at his feet. By white folks who weren't particularly good, but who adored pretending to be.

In the course of those long weeks, Salenius was delighted to have among its citizenry a person as intelligent and combative as Frederick Bailey. And he reciprocated the delight. "This is the ideal place for me to write my second book," he said from drawing room to drawing room. "Here is the genuine peace I've sought all my life."

Lafanu too was delighted that Mr. Bailey was a resident of the city she lived in. In her view, Frederick's eyes were stars that shone for her alone. And so it was that Salenius became for those two young people the privileged location of their little love rituals.

A complicit wink. His finger brushing her gloved hands. The awkward salutations, when he would have loved to kneel and touch the hem of the Chippewa's skirt. She was nineteen now, and she wore it like a trophy.

His loins caught fire when Lafanu passed near him. And an unexpected joy surged up from deep inside her every time he grazed her, if only with a look. Their excuse for seeing each other was always the portrait the famous man was supposed to sit for and Lafanu to paint. But then they were too absorbed in mutual gazing to start working in earnest. On a couple of occasions, Lafanu had called Frederick to order, but he'd distracted her with his turns of phrase, and she, captivated by his charm, had suspended her project.

And besides, why break the beautiful spell they were both falling under?

Those were strange months for Lafanu. Her daily suffering, the pain she'd been dragging around since Coberlin, suddenly stopped lacerating her soul and cracking her head in two. In its place, a diffuse heat covered her shame like a thick blanket of soft ivy. And in that exuberance, her battered body found, for an instant, a bit of peace.

She inquired about his life. "Are you making good progress on your new book, Mr. Bailey?"

And he, not to be outdone, would reply, "Have you found any interesting subjects for a new painting, Miss Brown?"

Their replies were lost in the void, but those questions contained all the intensity of a sentiment neither of the two expected to feel.

They often talked about politics.

Or rather, he talked to her about politics; she was embarrassed to express her confused thoughts about the United States, which had treated her people with nothing but wickedness.

Lafanu Brown didn't have a high opinion of the USA. She didn't believe, as he did, in the country's ability to redeem itself. *This slavery business won't be going away anytime soon*, Lafanu always thought. *They'll hold that knife to our throats as long as they can.*

Those were ideas she preferred to keep to herself, ideas some people might even have defined as subversive.

He was talking, as he often did, about the war that was on the point of breaking out. And suddenly she feared for his physical safety. She threw an arm around his shoulders and squeezed him tight, briefly digging her fingernails into the delicate epidermis that covered the man's powerful shoulder blades.

Frederick Bailey found this gesture sweetly audacious. But he took no advantage. Ever since he became a free man, he'd had a great many women. Including white women. He knew how starved for passion a woman could be. He had let himself be devoured, thousands of times, so as not to yield to the desire he didn't thoroughly understand.

It wasn't unusual for him, in the secret intimacy of those forbidden alcoves, to adopt a swaggering attitude. He wished to be seen as strong, even though in his heart he was trembling like a young girl in love for the first time. At such times, he'd grit his teeth, put on a mask, and act the part of the untamed lion.

But with Lafanu he wanted to be different, he wanted to be a man. The man he knew he was, or perhaps only hoped to be.

He wanted to put her on a pedestal, his young beauty. And he wanted to court her, to talk to her, to

fill the air around her with sense. And to cover her completely with the virginal satin of modesty.

Lafanu, for her part, wanted to be kissed. Only a kiss could take away her fear of being possessed. Therefore, she often moved her face perilously close to his.

She wanted to banish the shadows that ever since Coberlin had never stopped pursuing her. But Frederick gently shifted her aside, not without some effort.

He wanted to do things properly. To do the right thing. As well-brought-up people do. Civilized people.

But can one be civilized in love? Lafanu often wondered about that.

Meanwhile, there were many women in the city who wanted to marry Frederick Bailey.

In Salenius, he was the guest of a white, middle-class abolitionist couple, Mr. and Mrs. Blicher. The rumor that Bailey was looking for a wife had spread through the free black community, and from morning until evening, swarms of black and mulatto girls would buzz around the Blichers' front door. They were honored that their most esteemed friend had chosen no other place but Salenius and no other lodging than their very own home for the composition of his new book. "We'll be part of history," Tom Blicher said to his smiling wife, Eleonor.

The Salenius Abolitionist Society saw in those months a plain sign that Bailey was searching the

area for a good deal more than inspiration for a novel; he obviously wanted to settle down there.

"He's looking for a wife. We must give him a helping hand," the activists murmured.

Only a few knew of his feelings for Lafanu Brown, and those few encouraged him to take a decisive step toward that young woman, who everyone said was extraordinarily charming.

"Girls are capricious."

"You must act quickly, Frederick."

"Propose to her at once. Before it's too late."

ONE DAY, Frederick Bailey found the girl he so desired in Lizzie Manson's little garden, concentrating on drawing a sunflower.

Lafanu was very glad to see him.

"No, don't go away, Mr. Bailey. Now that I have you all to myself, you can't get out of posing for me. You're caught. Like a mouse in a trap," she concluded, laughing.

The man smiled and assumed a pose.

"I'll just make a pencil sketch and memorize your colors for later," Lafanu said. But she had barely begun to outline the lineaments of that face she liked so much when she noticed that something was slipping through her fingers. She looked hard at Frederick's eyes. And for the first time, she saw that they were shifty. Distant. Lost in some unknown world.

She didn't have him pose long. She found that vacant look of his intolerable. Under those conditions, she knew, she wouldn't be able to make a portrait of him worthy of the name. What she saw concerned her, but not so much that she would deny him a cup of tea.

They entered the house and were soon joined by Lizzie Manson, who had just returned from an errand.

"How lovely to have such a profitable pastime, Miss Brown," said Bailey, speaking of Lafanu's painting.

And then, without noticing the frown on Lizzie Manson's face, he sipped his tea and added, "Every so often, we men could use some form of pleasant distraction such as you have with your sunflowers, Miss Brown. It would certainly help to clear my mind. I'm so taken up with commitments that I fear I'll go through life without ever really being able to rest."

That word *pastime* remained suspended in the air even after he went away.

"You should have corrected him, Lafanu," Lizzie said. "You should have told him that painting isn't a pastime or a distraction. If you don't set him straight now and don't tell him that your 'pastime' is your work, your life...that you're a painter...Well, it will just be more difficult for you in the future, after you're mar—"

Lizzie Manson bit her lip. She couldn't bear to say the word. She'd been married, she'd done that, and

she had suffered a great deal during the years after she'd been obliged to trade happiness for the first man her family imposed on her.

Lafanu, however, had guessed what her tutor almost said. "So everyone thinks Frederick and I are going to get married?"

Until that moment, she hadn't understood to what extent she and Mr. Bailey had become a closely watched couple, a pair gossiped about and analyzed. She didn't know that frustrated mothers cursed her every night, calling her "the Chippewa trollop." Other people disseminated a handful of well-aimed calumnies against her, the negro artist, "the black girl who thinks she can be like the whites, poor deluded soul." Lafanu Brown did indeed become one thing in that fall of the year 1860: a most envied woman.

The increasingly tipsy Bathsheba McKenzie also had her say on the matter. She went from one abolitionist circle to another, both in the county and elsewhere, declaring that soon Salenius would celebrate a historic wedding, the union of Frederick Bailey and Lafanu Brown, "two of the finest exemplars of the negro race." And then, not yet content, she would add, "Besides, I've always spent my money to assure that my protégée would be well settled. And with this Mr. Bailey, she will achieve the hoped-for result."

Her condition became more and more worrisome. Her daughter, Hillary, indifferent to her mother's

nerves, bounded from scandal to scandal. Yet by some miracle and in spite of everything, clan Mc-Kenzie's reputation remained intact. It was Bathsheba who chased down her daughter and brought her back to the fold. It was Bathsheba who spent large sums of money, repeatedly, to shut the mouths of the parasites Hillary ran around with, and who then drowned all that unpleasantness in brandy. In that slow, steady decline, day after day, she could feel all her strength slipping away.

One day she'd confessed to Lizzie Manson, "I can't go on like this for very much longer. Oh, how I wish Hillary had Lafanu's good judgment. That girl will get herself settled, she couldn't find a better partner of her race. And she'll lay down those paintbrushes and finally become a woman, with a woman's responsibilities."

Lafanu, who normally didn't listen in on other people's conversations, couldn't tear herself away from this one. Bathsheba was talking about her and Frederick Bailey, about their future together. But then that reference to her brushes frightened her to death.

Lay down her paintbrushes? She got goose bumps. It so happened that this was a period when her brushes were always in contact with a canvas. She was working on a painting with a mythological subject: Diana and her faithful nymphs.

"I MUST TELL YOU, dear Ulisse, that I had thus far produced very few works of any importance," Lafanu writes. "A few portraits of lady friends of Bathsheba or the Trevors, a sprinkling of sunflowers, some little birds. In short, a batch of imperfect, insignificant paintings. I wasn't an artist yet, but I wanted to become one, whatever it might take. And it was during those very days that I was taking the path which would lead me to my goal. I spent most of the time, at least, the part I didn't spend with Frederick Bailey, studying the human body, female and male, the latter sometimes harder for me to take in. I covered the white surface of the canvas with shapely arms, long necks, tapered fingers, narrow foreheads, swollen eyelids. I studied the details of those bodies, I counted their hairs, one by one, and sometimes I inhaled their anxiety. I wanted no detail of their appearance to escape me, I wanted no aspect to escape me of their troubled heart."

THEN FREDERICK LEFT on a speaking tour, a round of lectures to be given at different venues along the northeast coast. There would also be a stop in New York, and in that city, perhaps, or so it was murmured by the usual well-informed sources, he would

meet someone important. In Salenius, numerous bets were laid on who this personage would turn out to be. Many maintained that Frederick's trip was a journey of reconciliation, and that Ronald Perkins would be awaiting him in New York. They could already see the two of them in an embrace, ready to confront together the storms that were on the verge of sweeping across the nation. Perkins hadn't been well—the news had transpired thanks to a talkative cousin—he'd had a bad bout with pneumonia and come close to dying. But then, thanks to ointments and hot broth, he'd recovered. He was made of hard fiber, and he had an even harder head. The cousin had reported that one of the first things Perkins said, after emerging from the delirium that had made those with him fear the worst, concerned none other than Frederick and how Perkins wanted to see him again and chat as they had done in the good old days.

Maybe Frederick, moved to pity when he learned of Perkins's illness, had decided to see his former friend again?

Some in Salenius would not accept this explanation. With some confidence, they declared that the person Bailey intended to meet in New York was Abraham Lincoln. It was known that the two men thought highly of each other. And that they corresponded as frequently as a pair of lovers.

Frederick, naturally, maintained the utmost discretion on the subject of his movements. Not even Lafanu knew the purpose of his trip; as far as she was concerned, the explanation "lectures" more than sufficed. When he came to say his goodbyes, it was with a smile, and Lafanu lovingly gave him her hand. He kissed it elegantly, as if following stage directions. Not so much as a mischievous wink passed between the two, even though Lafanu, in her heart of hearts, dreamed of receiving a passionate kiss on the mouth. Every night, she dreamed about that forbidden kiss.

TO DISTRACT HERSELF from the misery of his absence, Lafanu set herself to working with increased alacrity on her first mythological painting. She wanted to surpass herself. To be done with the cute little portraits of repellent women, to be done with the enervating exercises she performed by way of finding her own style. She wanted to be done with acting the dilettante. She wanted to be an artist.

She worked tirelessly for days. And the days became weeks, and then an entire month. Frederick was still away. He sent a few terse letters. He was always in a hurry. He didn't have time to write. But he never forgot to send her, between the lines, signs of his deep and lasting affection. There was an

intimacy in those missives that made Lafanu jump as a tarantula might. Her picture was proceeding. Layer after layer. Across rivers of second thoughts. Never satisfied with what she'd done, Lafanu made many corrections. But then, in spite of her fears, the nymphs and their goddess Diana, fleshy like one of Rembrandt's women, emerged from the waters of the artist's discontent.

Lizzie was satisfied. Her pupil was making great progress. Of course, she was far from perfect. But her teacher could detect in those nymphs and in that Diana the light of what Lafanu could become. And every time she did so, she remembered that Frederick Bailey was lying in wait to deliver Lafanu from her talent. Lizzie would bite her lips until she couldn't take it anymore. She didn't understand why members of their sex had to sacrifice their talents to men.

HENRIETTA CALLAM liked the painting too, even though she didn't have her friend Lizzie's erudition. One of the figures in the painting immediately excited her curiosity. She pointed a finger at it: a nymph standing at the extreme right of the picture.

"Who is she?" Henrietta asked Lafanu.

"Callisto, one of Diana's nymphs."

"Why is she so sad?"

"She's hiding a secret."

"A secret?"

"Jupiter has seduced her and left her with a baby in her womb. She can't undress in front of the goddess, she'd be put to death, she can't allow that to happen."

"And who's the man turning his back on the whole scene?"

"A man who's waiting for Callisto, despite everything."

"Waiting for her or going away? He seems to me to be leaving . . ."

"No, he's waiting for her. She's the one who's leaving. She's looking westward."

"It's a complicated painting," Henrietta said, grumbling a little.

"You don't like it?"

"Yes, I like it."

"Really?"

"It makes me feel a burning desire to see Rome, Lafanu . . . don't you feel it too?"

"Rome?"

"Yes, of course, Rome. The setting of your scene is Rome, isn't it? This certainly looks like the Roman Campagna to me. It reminds me of the paintings I saw in the National Gallery in London. Look, you've put some ruins here, and over here a column broken into three pieces, and there on the side is an arm from an

imperial statue. This city is Rome, my girl. Could that be a cupola peeking out in the background?"

Puzzled, Lafanu looked at her painting. She looked at it as though she were a viewer, a stranger, and not the person who'd painted the picture.

She shivered. Henrietta was right. The landscape she'd immersed her nymphs in was Rome. Or, at least, the Campagna she'd read about dozens of times in Madame de Staël's *Corinne, or Italy*. Maybe one of the nymphs was Callisto herself.

Her shivering didn't stop. Her hands seemed to be made of mud. She eyed them, hoping to squelch their distress with a stern look.

Henrietta, fortunately, noticed nothing. She kept gazing at the painting, admiring the girl's talent. She limited herself to saying, "Only in Rome can one become a great artist. Did you know that, Lafanu Brown? Only in Rome."

Then she turned and fixed her light eyes on Lafanu's black irises.

The girl was still shivering.

TWO WEEKS LATER, Frederick returned to Salenius. The painting was almost finished.

"I showed him into the sitting room," said Molly the maid. Lizzie was also in the house, but she was indisposed. Lizzie lay in bed on the upper floor, curled

up among the pillows. She had no trace of fever, but a powerful headache required her to remain in a dark room and as quiet as possible.

Her heart galloping like a wild horse inside her chest, Lafanu apprised Frederick of her tutor's indisposition. "But I'm here in her house anyway, because I'm finishing a painting."

Frederick didn't ask to see it. And although she didn't show it to him, Lafanu was hurt by his lack of interest. But Bailey quickly started talking about his speaking tour.

He's even handsomer than when we first met, Lafanu thought. His hair was longer, and it hovered over the nape of his neck like a cloud full of rain. His eyes, though tired, were burning. And it was as though he had, in a fit of rage, opened his shoulders to the world. Only his big hands had remained the same. And now those hands were clasping hers.

Bailey kept on talking. He was telling her about his meeting with his old friend Ronald Perkins. He gazed at her intensely, never looking away. Then he squeezed her hands with some force. The girl's palms got quite hot, intermittently, but she didn't move. She just tried to pay attention to the words of this man, whom she loved more than her own breath. But Frederick's words slid off and didn't manage to take hold of her.

Then he dropped to his knees before her. His leonine mane brushed against her flowered dress. Lafanu

saw Frederick's tears running down her skirt like little brooks. She couldn't follow what he was saying, she didn't understand the words. She tried to listen to them, but they kept sliding away, inexorably.

Thoughts were spinning around in Lafanu's head as though in a vortex: *Why hasn't he asked to see the painting? Why does he ignore the most precious part of me?*

Frederick was producing a great flow of words and perspiration.

And he was still on his knees. Like a penitent on Golgotha, before the cross of Jesus Christ.

The words continued to stream out in a torrent.

Which wet Lafanu Brown's face.

But the girl's ears wouldn't cooperate. Or maybe it was her head. She didn't understand the man's words, even though she surmised that they were words of love.

However, it was only when silence fell, when she saw his imploring eyes staring at her mouth, that the words he'd just said penetrated her understanding, all at once. Only then did she realize what was happening. He had made her the proposal of marriage that everyone in Salenius, including her, had been expecting him to make. But instead of responding to his proposal, Lafanu disrespectfully burst out laughing.

Her laughter thoroughly displeased Frederick. His face stiffened into a grimace. He asked, "So this is your response, Miss Brown?"

She wanted to tell him that it was just her nerves. That she hadn't thought black folks treated these matters with such solemnity. That the mask of a well-mannered white person didn't fit her right. And that all she wanted from him was a kiss. On her mouth, with lots of tongue, a deep kiss that would eliminate the taste of Coberlin, which had canceled all other tastes. She wanted a kiss. *That's all I need, and I'll be yours.* But Lafanu couldn't make up her mind to speak to him from the heart; it was as if something were blocking her respiration.

"So this is really your response, Miss Brown?"

Lafanu had stopped laughing. The air around them became disastrously thick. "Please," he said. "Show some respect for my proposal . . . and give me a reply, Miss Brown."

Then Lafanu moved closer to him. To his scent of moss and nervousness. She moved her full lips closer to his. She nibbled his lip, and Frederick followed her in what seemed a dance of lips and tongues. Then he put his hands on her hips and pulled her to him as hard as he could. He was tempted to undress her, to make her his in that bourgeois sitting room, a decent room for decent people. Frederick was hungry for her,

but he restrained himself. Lafanu was hungry for him too, but she composed herself. And waited for him to speak again.

"I insist on an answer, Miss Brown," he said in a sepulchral voice.

"Mr. Bailey . . ." Lafanu swallowed saliva. "I must go to Rome. I love you, Mr. Bailey, I mean, I love you, Frederick. But I must go to Rome. Do you understand? Only there, in contact with the classics, can an artist become really good. And I want to become really good. The best woman painter of all. Do you understand what I'm saying, Frederick?"

Silence.

Then the man turned his back. And without so much as a sigh, he left that house forever.

Crossings

X

Alexandria sent me a WhatsApp message to announce that although they hadn't been together for very long, her Ryan Gosling had proposed to her.

At the end of her text, she asked me, jokingly, "And when are you going to get married, girlfriend?"

"When I find my Idris Elba, but I wouldn't mind a Jude Law either!" I replied. Then I added, "Enjoy this moment," a message that elicited a flood of little hearts.

Not even this distraction, however, could make her forget to be a dedicated professional. She wrote, "This won't delay our plans at all. I've already told my betrothed that we're going to have a lovely honeymoon in Venice for the Biennale . . . we won't take a

chance on ending up in some depressing place, we'll go to Venice, city of lovers!"

"And of mass tourism," I answered sourly.

I'd been in the Floating City for two days, testing the terrain for our project. And my heart was troubled.

The city was immersed in its usual splendor. Lying like a feather on a bed of water. But there were many people around, and they seemed to have gone mad. They were walking fast, following a guide without looking at anything, until they massed in front of some display windows where rivers of melted chocolate were flowing.

My friend Riccardo, whose family has been Venetian for generations, sipped his spritz and reassured me. "Venice is us, we're the ones who give it a soul. As long as some of us hold out, Venice will hold out."

Riccardo and I had met at a Biennale some time ago. A small spark had gone off between us, but so faint that it had never led to anything. I had a boyfriend, he was single. By mutual agreement, but without exchanging a single word about it, we'd decided a solid friendship would be better than an unsatisfactory clandestine affair. And so year after year had passed, we'd become friends, and when that tumor appeared in my nose, he was especially supportive. And now we were glad to see each other again.

I sipped my nonalcoholic Cedrata and looked at him with admiration while he spoke in ardent tones about his beloved Venice. Riccardo was an optimist, whereas I saw around me—and I hated to admit it— nothing but rubble. "We're not finished yet," he said, "and you and many like you come here and bring us culture. As long as that happens, Venice has nothing to fear. We're stronger than melted chocolate, pigeons, and uncivil tourists who destroy our fragile balance."

After the drinks, he took me to a small, colorful bookstore in Campo Santa Margherita, located in the university area, a center of Venetian nightlife. In the shop, a girl with round, thick-framed eyeglasses was smiling at the world. She looked like a sprite—big eyes, heart-shaped mouth—in a turtleneck sweater. She greeted my friend warmly, and then, to my surprise, she addressed me. "I was hoping you would come by," she said. "Riccardo has told me about your project, and I've taken the liberty of preparing a gift for you. I hope you like it." And she handed me a package. I practically ripped the paper open, and inside I found a small, rather old book. It had well-worn, greenish pages and faded print.

The bookseller, whose name was Sabrina, said, "These are memoirs of Italy by the late Victorian author Henry Skeffelton. He mentions your Lafanu

Brown more than once. I think you may find this little volume very useful."

I hugged her so hard I almost broke her.

"How can I thank you?" I stammered, using the formal pronoun *lei*.

"Well, you might start by using *tu*, for example."

I left the bookstore, eager to browse those precious pages. I quickly headed back to the room I'd rented near Campo San Tomà. A small but comfortable room. On sunny mornings, I'd step out onto the balcony and gaze at the majestic Basilica dei Frari.

Seven floors, no elevator. I arrived out of breath.

Then pajamas, herbal tea, knee socks, couch. Book on lap.

My cell phone vibrated. Shukri had sent me some text messages and a photo of Binti in which my broken little cousin was faintly smiling. However, her eyes were still swollen, perturbed, and her nose was wrinkled in a look that was either a grimace of pain or a smirk of joy, I couldn't tell.

Shukri wrote in Somali, naturally—her Somali always sounded archaic to my ears—and her message read, "Dr. Lul is wonderful, *Aad ee u ficantai*, Binti's beginning to trust her." And then she went on, catching me off guard: "The world is so unjust. You in the diaspora and all the *gaal* have strong passports, passports of steel, almost, and you can go wherever

you like. Our passport is worth less than toilet paper. And it keeps us stuck here, like rocks, forever."

I put down my phone with a guilty feeling that gave me no rest.

It was true. Only people with a strong passport, people who could cross borders, enjoyed the right to travel. For the others, travel meant only death, disaster, borders that grew into walls.

We live under apartheid; this is apartheid.

Impulsively, I turned off my phone. I wanted to spend that evening thinking of something else. The thought of Binti, of the journey that had been denied her and had broken her, was killing me. I suppressed my tears so as not to remember the violence she'd suffered, and I started leafing through the book the bookseller had given me. At first, I was just looking for a distraction, but, as I hoped, the book soon captured me, and I opted for full immersion.

The pages were so fragile they seemed transparent. The print was intermittently faded. But I quickly took the plunge into that vintage era.

I had studied Henry Skeffelton's work in school and come across him a few times in my university years as well. I'd read a few of his books: *The Glass Matron*, *Babette of the Woods*, and his best-known volume, *The Lady's Journey*. He was a cold, austere author, excessively judgmental of his female characters,

sometimes downright misogynistic. Although he was a writer who traveled the world, he remained attached to the Puritanical values of the United States, his native country. His style winks at the Victorian writers of the preceding era, but by and large, his prose carries the scent of the nineteenth century hurtling toward the follies of the twentieth, which he didn't live long enough to see. Tormented characters, struggling with definitive life-or-death choices, stand out in his literary production. But his plots, with their late-Romantic flavor, always come down to some moralizing finale that stops the momentum of the dreamy females, wounded by life's slings and arrows, who are his protagonists. It was as if Skeffelton wanted to depict chaos before reestablishing order. The rules had to be followed, no exceptions, no happy endings. His novels leave a sour taste in the reader's mouth.

In his little book of memoirs, Skeffelton writes of his travels in Italy. The author observes the natural world, the monuments, the people, but always remains uninvolved. He considers Italians indecent and the natural world in Italy wicked; only the monuments, which demonstrate the Ancients' genius as well as their good sense, give him a thrill of pleasure.

And between an Ionic capital and a Gothic facade, Mr. Skeffelton also finds time to describe the American characters—a bizarre lot, in his view—whom he met in Italy.

I found Lafanu about halfway through the book. Skeffelton sees her at the home of a sculptress named Mildred Hopkins. The room is crowded with women, and conspicuous among all those hairdos are the gray-blond locks of a strangely silent Bathsheba McKenzie.

I read:

Mildred was a talented little fool, a budding sculptress who loved to amaze and scandalize. And so she led us to her sculpture studio, which we reached by passing through a narrow corridor that ran alongside the kitchens. We followed her feather-light steps in single file, like conscientious students. She dawdled along the way to create expectations and delay the vision. She didn't talk, she sighed inaudibly. As did we, all nine of us, strung out silently behind her. The diminutive studio we arrived in was so dazzling white it hurt our eyes. Had it not been for the little point of blackness we had in our midst, the young negress who is the eccentric Bathsheba McKenzie's protégée, our retinas would have been scorched by the glare of all the white marble that Mildred had accumulated in there. In the center stood the Goddess of Love, lascivious and very beautiful. And even though Mildred had not been scrupulous in her execution of this Callipygian Venus, the deity's

scandalous, frank gesture survived intact. It was pure blessedness to stand a few meters from the goddess as she so sweetly revealed her buttocks to our concupiscent eyes. Someone explained to me—or maybe Mildred herself said this to all of us—that there was more scorn than seduction in Venus's gesture. Perhaps, but in any case in was impossible to avoid falling under the spell of so much beauty. Especially if compared with the monkey-like creature we had with us, Bathsheba McKenzie's protégée. According to murmurs that had reached my ears, she was considered to represent the best of her race. To me she just seemed infernally ugly. And what a contrast with the purity of the white marble, so perfect to touch and look at. Ah, our American women abroad, how eccentric they are! Taking a negress for a protégée. Paying her bills. And bringing her among us, among decent people, here in Italy. This is eccentricity bordering on insult. Not long after that visit, when Mildred invited me to dinner, I asked her whether that young negress would be at table with us. She replied in the affirmative. She added what struck me as a provocation: "Our Lafanu is a delight, you'll see." Her words irritated me, and I declined the invitation. I did not wish to sit at the same table with a negress. I was still capable of feeling some compassion for myself.

I closed the book. I didn't much like what that Henry Skeffelton had to say. "Racist," I muttered in annoyance.

I felt deeply offended.

But reading that passage had been useful. Now I knew how I would make the figure of Lafanu Brown emerge. I knew how I would design the show dedicated to her. And I knew what I'd have to battle against: the same malice that had violated Lafanu's body more than a century and a half ago and Binti's body in our dystopian present.

THE TIME FOR PARTING came.

Hugs, kisses, farewells, a sprinkle of tears.

Henrietta Callam had procured a ticket for Lafanu Brown on the steamship *Arabia*. "It's very fast," Henrietta wrote to Lizzie Manson from London, to which she'd returned some months previously. "And so our Chippewa won't have to bear the torments of a transoceanic voyage a minute longer than necessary."

The ocean steamer was to set sail on December 28, 1860, and to reach Liverpool barely fifteen days later, in the year of grace 1861.

Lafanu Brown was traveling light. There wasn't much in the small trunk Mulland Trevor had picked

up for her in a secondhand shop—a few dresses, some books, comfortable shoes, and her indispensable sketchbooks.

EVERYONE TOLD HER GOODBYE in his or her own way during those final days, when the very air was redolent of departure. Baby Sue sewed a pink blanket for her; Lizzie Manson stroked her face; Mulland Trevor handed her some money; Hillary McKenzie, unbeknownst to her mother, whispered in Lafanu's ear, "We'll meet again someday, we'll meet in Italy, and we'll both be happy."

Only Bathsheba McKenzie and Marilay Trevor failed to make themselves available for those farewells.

Marilay had forced Lucy to get married and thereafter taken to her bed, which she hardly ever left. She groaned like one of the damned. And she rejected all the food that Baby Sue carefully prepared for her. The physicians who rushed to her bedside—the desperate Mulland called more than one—said, "The lady is perfectly healthy, but if she doesn't eat, she'll die soon." And the general store was pervaded by a tomblike atmosphere that wouldn't allow even the most timid of sunbeams to shine through. Everything was gray, extinguished. It was murmured that the wretched

Marilay would never recover without Lucy's forgiveness. "She's dying of remorse, the witch," Lafanu Brown heard someone say in the city. "Who knows who it was she made her poor daughter marry. Who knows who she sold her to." The other person who refused to tell Lafanu goodbye was, of course, Bathsheba. She called her "the ingrate" in every abolitionist circle in the county. "After all I've done for her. After all the bills I paid. An ingrate . . . she could have been the best of her race. She could have got herself settled. But instead, how stupid she turns out to be! How much money I wasted on her. I should have left her rotting in her valley."

THE NEWS that Lafanu Brown, Bathsheba McKenzie's protégée, had dared to refuse Frederick Bailey's hand had quickly entered the public domain.

"I didn't want anyone to know . . ." Lafanu confessed to Lizzie in desperation a few days before her departure. "I didn't want to cause poor Frederick any pain, Mrs. Manson. But you see, don't you, I just couldn't . . ."

"You don't have to justify yourself to me, my dear," Lizzie said. "You've made a decision for yourself. That should be enough for you."

"But I—"

"Dearest, we know why you turned him down."

Lafanu looked at the woman incredulously. "But Mrs. Manson, *I* don't know why I said no to Frederick. I don't know why I didn't become his wife."

"You don't know? How can that be?" asked Molly the maid, who had suddenly appeared behind Lafanu's back. "Even I know!" She snatched Madame de Staël's book—stiff covers, orange, bulky—from the table and shook the big volume forcefully. Lafanu and that book were never far apart.

"It's all written in here, miss. I can't read it, but you always say it's got everything you need."

And after a pause, Molly added, in her multicolored, poppy-scented voice, "Take it from me—I was married to a scoundrel. Have no regrets. And enjoy your journey."

"THAT BOOK, the one Molly was shaking at me, do you know I've still got it, dear Ulisse? That same copy of *Corinne, or Italy*, now yellow with age, is here in my house. It crossed the ocean with me. Soon we'll read it together . . . you and I."

And as she writes those last words, Lafanu gets scared.

She springs to her feet. Her impulse is to give up and throw everything away. Pages, time, thoughts. The man who loves her and is waiting for her. Her own desire to be normal at last.

Everything, all of it, to the rubbish heap.

But then her love of discipline prevails and makes her sit at her mahogany writing desk once more. She assumes the unnatural position, folded over upon herself like a clam, bending to the page. She's in Rome, on Via della Frezza; she's forty-five years old. And it costs her a great effort to return to her eighteenth year, when, once again, everything was changing for her.

"I MUST TELL YOU about the voyage on that steamship, the one that brought me to Europe. As I've already said, she was called the *Arabia*. But I haven't mentioned that she smelled of candied fruit and death, have I? Well, now I'm telling you: The *Arabia* smelled like candied fruit and death.

"For my people, the Atlantic Ocean was a mass grave. And that ship was carrying, melded with the bulkheads, all the suffering of those centuries. Making that crossing was nothing short of torture for me. I don't know how I survived it."

THE SHIP HAD CAST OFF her moorings, and Lafanu Brown was finally alone. Tricked out in heavy garments and wearing a hat that covered three-quarters of her face. Nobody on the steamship had noticed

her black skin yet. All the passengers had their eyes fixed on the dock, searching for their loved ones before the ocean separated them from everything. She didn't have anyone to wave goodbye to. She'd been accompanied by Rufus, Mulland Trevor's attendant, who was practically a stranger to her. And good old Rufus, once he was certain that the girl had boarded the ship, had turned away without a sign of farewell.

It was a cold day, and a solitary draft of air began to buzz incautiously around her slightly exposed ears. She coughed, and that didn't seem to her like an augury of good things to come. She coughed again. This time a man looked at her, but without paying her much attention. "Miss," he said, "the ocean is freezing cold in winter. If you go out on deck during the crossing, you must be sure to dress warm."

She didn't even look at him. She kept her eyes fixed on the dock, which was slowly but inexorably receding from the ship and her great load of passengers.

Water all around. The same water her shackled ancestors had seen. And now she was traveling in the opposite direction from the one taken by the slaves. She was going in search of a kind of freedom.

Lafanu found it quite strange to be surrounded by all those white people. Their skin gave off an odor of spices and tobacco that stunned her in the first moments of navigation. She felt almost faint and grasped a rail to keep from falling and making a spectacle of

herself. She'd never been on a ship, and certainly never on a steamer like the *Arabia*. However, Mulland had offered her some advance encouragement: "Ever since the voyage of the SS *Savannah*, which took place even before I was born, sea travel has become child's play. You'll be in Europe in fifteen days."

The dock had disappeared. Boston was only a tiny point in the remote distance. The passengers started to disperse, heading for spaces that provided more cover. That gentleman had been right: Out on the ocean, it was freezing cold. And so Lafanu too left her station. On her way somewhere, to do something. To find her room, to get under some covers, to read. To try not to throw up. To hide her black skin. But a man stopped her. White beard, white hat, blue jacket, green eyes, papaya breath.

"I was advised that I was going to have a black female on board, but no one told me that she would be so elegant a lady as yourself."

He was the captain, and he had called her a lady.

"I'm on your side," he said to her in a whisper. "I support your people." Then he added, "A war is coming soon. And after it's over, you and yours will be respected, partly thanks to us."

"And to whom do I owe the honor . . . ?" Lafanu asked, extending her right hand to be kissed even though she wasn't sure whether the captain would take it.

But he was a gallant gentleman, and he placed his lips on her waiting hand, just freed of its glove.

The captain's gesture was a bit too hard and went on a bit too long for the girl's taste. For an instant, it seemed to Lafanu that the man's tongue had licked her knuckles. That the captain hadn't limited himself merely to putting his lips on her skin, he'd gone further. She looked at him in amazement. Unsure of what had happened, unsure of how to behave.

Had this man offended her or honored her?

Had he decorously kissed her ungloved hand, or had he licked it the way men did with whores in a brothel?

Despite her doubts, Lafanu smiled.

"My dear friend Bathsheba McKenzie notified me that you would be one of our passengers. She and I are old, old friends. Her late brother Robert and I were cadets together. Oh, how we loved him, both of us. But then there was that stupid hunting accident . . . And now dear Robert is in Heaven, as is only proper and just."

Lafanu nodded, even though she hadn't the faintest notion of who this Robert was. After all, she knew so little about Bathsheba. But she was content; maybe this was Bathsheba's way of bidding her farewell. When all was said and done, Lafanu couldn't deny that she was greatly in the older woman's debt.

"I can see you're a well-mannered girl. Bathsheba told me in a letter that you represent the best of your

race. And I'll do everything in my power to keep from disappointing her. You should know that on this ship you have not only a captain but also an ally, perhaps the most dedicated ally on this voyage. Should you have any problem, no matter how trivial you may think it, do not hesitate to come to me."

Lafanu nodded again, embarrassed, and mumbled a shy "Thank you." And then, quickly, she hastened away from that captain, still unable to tell whether he had offended or honored her.

She ran away to confront the Atlantic Ocean, which had watched her people suffer.

Crossings

XI

Dafne Balduzzi, in art LEA, was there with her blue harlequin Great Dane. She smiled at me. Healthy teeth. Injected lips.

I hadn't seen her for three years, although like everyone else in the art world, I followed her quirky exploits. She still had her sullen giraffe face, even though she'd had her cheekbones touched up and her lips were now fuller. She was wearing her hair in a 1950s-style chignon that looked great on her. Her clothes, not so much. I thought at first that she'd chosen them at random, but then a second glance persuaded me that every single item she had on cost more than the entire contents of my closet.

She greeted me, I responded listlessly.

"I just wrote to you yesterday, Leila. Did you get my e-mail?"

I gave an unenthusiastic nod.

"And don't you find it extraordinary that I sent you a message yesterday and today I run into you by chance like this, in the middle of Rome?"

"Extraordinary," I said, my voice neutral.

Dafne had no particular accent. She liked not letting on where she was from. Whenever anyone asked, she'd reply mysteriously, "Somewhere in the mountains, near a beach," as if ashamed of her origins. I knew her because she frequented art openings. At the Venice Biennale, she could be found in some corner getting drunk with improbable Uzbeks or defenseless Cambodians, always accompanied by her exceedingly rich lover, who saw to it that she sold all her work. Vernissages were for her an excuse to drink and "do me some of those hot boys." When she said that, she'd always add, "Fabio doesn't care if I screw other guys. He's my Maecenas, my patron. He approves of everything I do and pays the bills besides."

Her work was mediocre, but her boyfriend was all too powerful in the art world and wouldn't take no for an answer.

Dafne was the nightmare of every art curator; nobody wanted to team up with an artist whose work was so lamentable and who was arrogant to boot.

But at the same time, nobody had the nerve to go against her protector. And so someone always got blackmailed into giving her an exhibit or finding her prestigious spaces for her forgettable performances.

Of course, I too—in this case, I was no exception—had started avoiding her.

But now there I was, trapped. It was raining, and I was supposed to dash home and Skype with Alexandria.

Dafne wouldn't let me go. She had evidently found out that I had a new project in the making. In artistic circles, unfortunately, news moves at the speed of light.

Fortunately, on the other hand, she didn't know I was working on Lafanu Brown. Alexandria and I had maintained almost total silence on that subject.

"People tell me you have a new project ... about immigrants, they say." She spoke in the most enthusiastic tone she could find in her vast repertoire of make-believe.

"It's not exactly a work about immigration," I stipulated.

"I want to be a part of it. I'm working hard for migrants. There's a photo of me ... I don't know if you've seen it."

Everybody had seen the photograph of her lying naked on a stack of the isothermic blankets used to wrap up aspiring immigrants rescued from the sea.

The photo was impossible to avoid and had even been published in a national newspaper.

"I've seen it," I finally replied, filled with a mad desire to run away.

"I still have the body of a twenty-year-old. I received all sorts of compliments at the shoot," she said, and then she burst into coarse laughter.

I stiffened suddenly. I envisioned the photograph— her tanned, soft body, lounging there as though on a tropical beach, her heavy makeup, and the thermal blankets, crumpled like sheets clutched during an orgasm—and recoiled. A disgusting spectacle, which had nothing at all to do with the tragedies that were turning the Mediterranean into a grave.

"I want to take part in your project. Migrants mean the world to me."

Since when? I wondered. I couldn't forget the time she'd sicced her blue Dane on some poor Bangladeshi street vendors. That was during the period when she'd tell the whole world, "I'm going to rip the veils off those Muslim sluts," or "These Arab terrorists, I'll snip off their testicles." Still not content, she often added, "You know, their sacred book says that dogs should be hated and mistreated. Look, as far as I'm concerned, a religion that makes mistreating dogs an article of faith should just disappear."

She knew I was a Muslim, and she'd spit her hatred in my face. Another reason why I avoided her.

But now, something completely different was emerging from her words.

The rain came down harder and harder, it was terribly cold, and she wouldn't let me go.

"Migrants are so fashionable in our circles. If you do a painting of them or take a photograph with your smartphone, you have a good chance of selling it for lots of money. Not to mention the possible prizes. You know I'm always in the middle of the things that count. These days, I'm so concentrated on what's happening to those poor buggers I don't have time for anything else. I've signed petitions, I've participated in demonstrations, and soon I'll write a book on my Mediterranean experience . . . I just love doing good. I wish I'd known sooner how gratifying, how electrifying it is!"

I was aghast. I had to leave before all her bullshit made my head explode.

"Will you call me? I'll expect to hear from you, okay?"

I said goodbye and hurried off. And my thoughts quickly turned to Lafanu Brown. Her letters often include complaints about abolitionist societies, about the ladies who "pretend to be benevolent to us because it's a way of increasing their prestige. I hate it when they call us 'poor little darkies' or 'our little negroes.' They treat us as though we're infantile. To them, we're always stupid children. I hate it when

they pet our heads like little monkeys, tamed and taught to smile and bow. They're so complacent with us, these sham 'good people.' And they take what's ours. Our skin, our talent, our dreams, our struggles. They speak in our place and take away our right to speak for ourselves, our right to exist. They don't really know us, and they don't really want to know us. We're just bodies to them. Oh, how I hate being dependent on this lady and on this sick society. If only I had money, money that was mine! I would have more freedom to flout all the rules and make some of my own. But I have no choice. I must bow my head. This is the fate of someone who gets to the brink of revolution before others do. I'm breaking through the barriers all by myself. I have to be proud of myself in spite of everything, in spite of my mistakes."

Those words appeared to me like a vision.

I won't disappoint you, Lafanu, I mentally assured her. *Nobody's going to use your ebony skin to make themselves look good, my darling, I swear to you: nobody.* Then I added, *I promise it will be a beautiful show, with people you would love . . . or rather, people you will love.*

HENRIETTA CALLAM, suffering from one of her usual migraines, was in a bleak mood.

"What claptrap they write in these Murray guides," she said sorrowfully. "They're completely unreliable, and they have no consideration for us women."

Then, casting a mournful look at Lafanu, the look of one on the verge of agony, she added, "According to *Murray's Handbook*, this road we're on is comfortable and verdant. Can you imagine such a swindle? Hack writers, that's what they are! And you, you believe every word, my dear young friend. Sometimes you're really naive."

Having thus vented her displeasure, the woman fell back into a silence, which soon became a deep sleep.

Lafanu, on the other hand, was completely absorbed in gazing through the carriage window at the landscape. Henrietta's words had no effect on her. She was in another dimension, where the tedious and difficult route was made bearable by all the novelty that was nourishing her soul. Since their landing in France, Lafanu had done nothing but gaze at the landscape. Nose against the glass, eyes wide open, and a great desire to embrace creation.

An odd shiver ran down her spine, and her chest was full of anxiety about this journey, which she had anticipated for so long. A journey that would take her to the heart of color, to the city of Rome, where, so everyone said, one could become a great artist.

The carriage was zigzagging along, the driver doing his best to avoid the road's steep, muddy shoulders and deep holes. It had rained for days, and the way was littered with animal carcasses and dead branches, each an obstacle to be swerved around. But Lafanu didn't see the bodies of those poor beasts, didn't notice the obstructions. Her eyes were fixed on the poplars and the vineyards. Even the scrawny willows, leafless and lifeless, caused her to feel an inexplicable tenderness.

The carriage traveled through poor villages, and Lafanu, practically in ecstasy, observed women in shabby clothes sweeping streets or, like their husbands, breaking their backs in the fields. Then the

carriage left the plain and began climbing into the mountains, along paths that the Murray guide, with its habitual optimism, described as positively marvelous. In reality, very little was marvelous: the trees became more and more spindly, and rock replaced vegetation. But at those higher altitudes, the travelers saw gamboling fawns and big ibexes attentively examining them from atop boulders.

During their stops, Henrietta, who prided herself on being an amateur alchemist, went off in search of minerals. When they passed through villages, she bought bluestone crystals that she later abandoned at her first opportunity. And every time she did so, she reproached herself for her frivolous spirit.

"Lafanu, I authorize you to scold me. We're not in Italy yet, and here I am, squandering my humble savings on useless rocks. You've got good judgment, so save me from myself."

Naturally, Lafanu didn't dare do that. She was in debt to this woman, and she didn't feel that the subject of Henrietta's finances was one that she, Lafanu, should pronounce upon.

Money—more than art, more than their political cause, more than their dreams—was what bound the two women together. It was money that had created their bizarre association.

Even though the terms of the transaction were different from those which, years earlier, had bound

her to Bathsheba McKenzie, Lafanu Brown was for Henrietta too nothing more than the talented darky she could exhibit on social occasions. She was just a little black servant, but elegantly attired, her hands inside a handsome pair of chenille gloves. Her status as a completely dependent person was unchanged. She was constrained by a system that would not allow her to earn enough to support herself, and so, in order to live, she had to accept charity from those more fortunate ladies.

In the years she and Lafanu had spent in England before that journey to Italy, Henrietta Callam had paid the girl's tuition at Bedford College without a hint of complaint. But in return, she had wanted Lafanu to acknowledge her devotion whenever she could. Henrietta had never made that an explicit requirement, but they both considered it an unwritten rule. And so Lafanu, on every public occasion, repeated to all and sundry, "Without Mrs. Callam's generosity, I would be nobody."

This genuflecting weighed on her, this confessing to the world that without her patroness she was done for. It wounded her pride to know that her art wasn't sufficient unto itself. In her years in England, starting when the SS *Arabia* landed in Liverpool, Lafanu had tried to escape Henrietta's charity. She'd done hundreds of portraits. She'd worked hard, running around like a crazy person from noble palazzi to the

houses of rich merchants from the East. But despite her labors, despite her busy brushes, one of which was always in contact with a canvas, she didn't earn enough money to live independently. Therefore, she bowed her head, and also because Henrietta Callam was her only bridge to Italy. She alone could take La-fanu to the country she'd been dreaming of for years.

And besides, apart from a modicum of adoration, Henrietta Callam didn't ask much of Lafanu.

Their living together had been perfect. In the mansion on St. James's Street where Henrietta had lived for years and where she ruled over one of the liveliest and most frequented salons in London, they almost never encountered each other. Henrietta had so much to do. She was always busy with her political work, her efforts in support of women's suffrage, and for the past few years she'd been even more intensely involved in the cause of Italian unification, which had recently been achieved and was in the process of being cemented. There were rumors that the lady even had a lover, a certain Rodolfo, but Lafanu, who lived shoulder to shoulder with Henrietta, had noticed no lover, no man, and it occurred to her to wonder whether her protectress was spreading those rumors herself in order to appear more interesting in the eyes of the people who came to her salon evenings. Henrietta liked to be on everyone's lips. And as time passed, she'd developed—by way of

amusing herself—a taste for scandalizing friends and acquaintances. In reality, she spent very little time in the company of Italians. There was that Mazzini, for whom she often collected money, and whose portrait Lafanu had painted: the great man, looking pensive, glued to his desk. And then there was Tiberio Baldazzi, "the most impossible and adorable man on earth," as Henrietta defined him. What she loved about him was his eloquence—she'd say, "That fellow, he's got the fire inside"—and she was also fascinated by his extreme rage against everybody and everything. He'd lost a foot doing battle for the short-lived Roman Republic. And during sumptuous evenings at Henrietta's house, he could often be found in some remote corner, feeling heartily sorry for himself.

"I'm a poor cripple without a country. And now that the new country has been born, we who gave our blood to create it have been expelled from it. Look at what those scoundrels are doing to our great leader Mazzini. But they'll pay for that one day, one day they'll pay dearly."

Lafanu didn't do his portrait and practically never exchanged a word with him.

But less than a week before the longed-for trip to Italy, and right in the middle of one of Henrietta's animated literary salons, the Italian came up to Lafanu and gave her some sheets of paper. "Here," he said, "is everything you should know about my Italy, my

disgusting homeland. You will find useful addresses, contacts, directions for good taverns. I hope that all the spirits of the Ancients may accompany you in your journey. It is what you deserve. You have suffered like me, my girl. I have followed your story in the newspapers . . . the years you lost waiting for that document they did not want to give you . . . Ah, how sorry I felt for you! They wished to rob you of all your youth."

Embarrassed, Lafanu softly murmured, "Thank you."

"Write to me," he said. "Don't forget." And, kissing her hand, he left her with all those words, which he'd written down for her over the course of several nights.

There weren't many pages, but the writing on them was dense and the lists they contained nearly illegible. Lafanu gave the notes a quick perusal that evening, promising herself to go over them more closely and calmly in Italy. And now she was in the carriage, a thin barrier of mountains all that separated her from the *bel paese*, and those words were bouncing along in a light traveling bag that she kept always at her side.

PLAINS, HEATHLANDS, and then a series of hairpin curves, wriggling like malicious snakes as they slipped into the belly of the mountain. The carriage was rolling at a smart pace. Lafanu, impatient and

excited, couldn't wait to reach Lanslebourg-Mont-Cenis. In a few minutes, not many, they would arrive at the inn where they were to spend the night. From there their plan called for them to begin the ascent to Moncenisio, the last obstacle to clear before they could at last embrace what they so yearned for: Italy.

Lafanu hadn't seen a mountain in years, not since the days when she used to chase after her sister, Timma, up and down the Buffalo's Hump.

And now, a new mountain. A new challenge. No more buffalo; this mass rather reminded her of an elephant. It was so stately.

The ascent started at ten o'clock in the morning. The conditions were none of the best. Thick fog made any sort of viewing difficult.

"Won't this be dangerous?" Henrietta asked in alarm.

No one answered her. The coachmen didn't speak English.

And Lafanu, who had good Italian, was too embarrassed to translate her companion's fear. Instead, she chose silence.

The carriage was partly dismantled and the passengers, ladies included, were asked to proceed on foot. Twenty minutes of difficult walking, during which Henrietta and some women who were traveling in another carriage did little but complain about their

sore feet. But Lafanu inhaled the mountain's scent and restrained herself from contaminating what she saw with her words. Every step seemed lighter than the previous one. And more than once, she had the sensation that she could hover in the air like a butterfly. From time to time, the young woman—she was twenty-four now—reached out her hands to embrace the air and take hold of the white mist swimming around her. And tears like dew ran down her smooth cheeks. Tears of joy for Italy, which was on the other side of that mountain.

When the party reached the crest, the travelers were invited to sit on light wicker chairs, mounted on poles to form a kind of sled, to be transported by their guides.

Lafanu would have liked to keep walking, but she wasn't wearing suitable shoes, and she was no longer a little girl, recklessly scrambling over big rocks with battered moccasins on her feet. And so, even though the idea of letting herself be carried embarrassed her, she too sat down on a chair.

Henrietta came close to fainting. The altitude gave her vertigo, and she couldn't look down without flinching.

"Buck up, Mrs. Callam," Lafanu said, almost brusquely. But then she spoke in a gentler voice and said that once they were on the other side of that

wall of rock, they would finally be in Italy. "Isn't that wonderful?"

"Wonderful," muttered Harriet, not entirely convinced, and then she closed her eyes.

Lafanu closed hers too. But not in fear. In ecstasy.

Crossings

XII

I found it hard to look at the person talking to me when the Grand Canal was glittering behind her. My eyes were captivated by the lagoon, and I was making a titanic effort to tune in to the woman's words as she kindly introduced me to some of the many wonders of Ca' Foscari. She worked at the museum center, and in those first attempts to identify an appropriate space for exhibiting Lafanu Brown's work, she had been my guide, my compass in the tentacular mazes of the city of Venice, which I didn't yet know very well. I was looking for a place to host the show as well as a venue where Lafanu Brown scholars could hold a conference; Alexandria and I had decided that schools and universities must become privileged partners in our undertaking. We wanted Lafanu to

reach young people. She offers an example not only of struggle but also of artistic excellence. Besides—we were convinced of this—Lafanu was *pop*, she would have great appeal for the rising generations. She was in no way inferior to a Marvel superheroine. She had superpowers, namely her artistic work, and she never surrendered. She was, in short, perfect.

"The chancellor will see us soon," the soft-voiced woman said. "I see you're captivated by the view," she went on with a smile. "It happens to everyone."

"It's astonishing," I said tritely.

I leaned out over the balcony. It was one of the first really warm days of the year. And there was a great coming and going of vaporetti, gondolas, and motorboats. Seagulls dominated the sky, their eyes alert for food scraps or possible prey, such as a sparrow roaming heedlessly nearby. My shoulder blades froze at the sight of the gulls, they scared me, but then I relaxed and cried out like a child: "Oh my God, you can see the Rialto bridge from here!"

In Lafanu's letters to Lizzie Manson, she often writes of Venice, and the lagoon city also comes up in her correspondence with an acquaintance named Rita Marlowe, a sculptress she met in Florence. Those letters show Lafanu enthralled by the city's beauty but angered by the way the jewel was falling into decay. For her, Venice was still the "ghost upon the sands of the sea" that Ruskin had spoken of. A ghost

that needed to be saved from itself. In those missives, Lafanu often complains about the dampness attacking her bones. The waters of the lagoon both tormented and delighted her. And every visit provided her with different perspectives on that delight. Lafanu made three trips to Venice. The first was the most amazing. It took place in 1868 or perhaps early in 1869, and it was during that trip that the American painter absorbed the art of Paolo Veronese. In the church of San Sebastiano, a gem well off the beaten tourist track, Lafanu had a personal moment of ecstatic delight. The church, almost entirely decorated by Paolo Caliari—Veronese's real name—was an exultant triumph of colors, forms, and classical settings. The frescoes, an awesome display of virtuosity and skill, show Veronese at his most quintessentially theatrical and mythological. But in the center of one vast scene, amid a swirl of horses and archers and drapery and movement, Lafanu saw a Black child. She wrote to Lizzie Manson about the fresco:

> *Saint Sebastian is about to be tortured to death. He's lying on a wooden table, his face full of distress. He is going to be scourged, my dear Lizzie. This is his second ordeal. The first—when they shot him full of arrows—failed to kill him. But this time, as his face proves, the young saint knows he will not survive. A tumult of emotions surrounds*

his condemned body. Some people are watching the scene curiously, while others are acting. In the middle, and this is what moved me to tears, dear Lizzie, there's a black child, a boy of nine or ten at the most. He's holding the whips that will be used on the saint. His eyes are sad. His immobility, surrounded by motion, is striking. He's so solemn in his mute sorrow. The child knows that he and the saint will die together. He knows that the guilt, all the guilt for that martyrdom, will fall on his shoulders. And that someone will make him pay. He's the scapegoat. It's no use his casting his eyes down or trying to hide. He is visible to all. The real murderers are invisible. The boy's sadness springs from his knowledge that the saint's torture will be his own someday, as it will be mine and our people's. The child will pay for everyone. He will pay for the executioners. We cannot see their eyes. One of them is partly concealed by his cap and has his back to us, while the other, a monk, is wearing a pearl gray habit with a hood that covers his face. The person we can see most clearly is the child. He has the same fuzzy hair I had when I was a little girl. My sister, Timma, really liked my hair and was always touching it. And it's been touched by others since. Timma's touch was light, a loving touch; others touch my hair out of curiosity, which I have never liked. I look at the boy in the fresco,

I cannot stop looking at him. At bottom, that sad child painted by Veronese is me. So are we all, all of us who have Africa in our blood.

I make the sign of the cross as the Catholics do, but I make it as a gesture to ward off bad luck. I want to rid myself of the fear that child aroused in me. In the name of the child, and of the Holy Ghost, amen.

I remembered those words. And spontaneously told the woman from the Venetian museum center that the lecture hall we were in would be perfect for our conference of Lafanu Brown scholars. Then I smiled at her and said, "So now let's go and meet this distinguished chancellor."

THE MOUNTAINS, Italy, ecstasy, the clouds in the heavens, the sun with its burning eye. Sleet. Chills. Then a sighting—the inn, their refuge—one step toward it, another step—the thought of getting warm, of taking some refreshment . . .

But in spite of the hunger that was splitting her stomach in two, Lafanu couldn't manage to break her concentration on the landscape. On those violent reds, which flickered all around her and reminded her of J. M. W. Turner's restless paintings, though she couldn't recall where she'd seen them; maybe in a private collection or maybe only in a dream. The paintings had left a trace of anxiety inside her, and she seemed to see that mark again in the landscape she was just starting to know. Everything looked like

a fire to her, Italy was in flames, and Lafanu, spell-
bound, began to wonder whether she would be able to
do justice to such beautiful colors.

"O God, help me to put them on canvas," she mur-
mured under her breath. Unexpectedly, she remem-
bered when she was in England, dreaming of being in
Italy, of being inside that fire.

The memory of London could still upset her.

The memory of when she was stuck there against
her will, throwing back her head to contemplate the
gray sky, could still bring tears to her eyes. She hated
that sky and those people, who swarmed around her
so assiduously. She detested the efficiency of London.
And she was saddened by the lackluster moon, which
dominated the city and turned its desires into shad-
ows. Every day, the girl would sigh sadly and think
how different, how beautiful the weather in Italy
would be. During her time in London, Italy had be-
come an obsession for Lafanu Brown. She couldn't
think about anything else.

But for six long years, an official of the United
States government had forced her to remain in Lon-
don: She, who was wild to embrace the country of her
dreams, saw those dreams taken away from her. And
sometimes she thought, *What if I don't make it? What
if Italy slips through my hands?*

For six long years, that thought had poisoned her
existence. A long, long time it was, and in later years

Lafanu would call it—as she does in a letter to her dear Ulisse Barbieri—"my English prison."

AMONG ALL THE IMAGES of the English prison, the one that still gave her the cold sweats was the vision of Mr. Harwell and his sparse mustache.

It was he, George W. Harwell, who was the major impediment to her Italian journey.

The program that Henrietta had written out for Lafanu in Salenius, a program that Lizzie Manson had also helped to devise, was clear. The girl was expected to spend a year or, at the most, eighteen months in London.

"We can't send Lafanu on to Italy without at least a smattering of classical languages and culture," Henrietta would insist.

And Lizzie, somewhat miffed, would remind her friend, "Lafanu knows Latin, I taught her myself."

"What about Greek?"

"We didn't have enough time for Greek."

"You see? She can't be lacking in Greek. And her Latin as well—with all due respect for your methods, dear friend, the classical tongues must be taught by someone who's a genuine expert in them. And you'll agree with me that although you have a thousand talents, dear Lizzie, you are not an expert in classical languages."

Lizzie reluctantly admitted the truth of this assessment.

Chatting at the walnut table in Lizzie's sitting room, they decided that Lafanu would attend the classes given by Mr. Oswald Perry, one of the most notable Latinists in the British Empire.

"He also teaches members of the royal family."

"And he'll accept a negress like Lafanu as a student?" the girl's teacher asked in a worried voice.

"Of course, he's one of us, he's in frequent correspondence with Ronald Perkins."

"A radical, then?"

"A radical perforce, Lizzie dear. Besides, how can anyone who loves Socrates not be a radical?"

A year and a half, no more. This was the duration that the planners of Lafanu's London sojourn agreed it should have. At some point during that sojourn, Lizzie and Henrietta thought, the girl could also go on a tour of British political societies to talk about one of the most pressing issues of the day, namely the situation of black people in the United States.

Liverpool, Birmingham, Bristol, Manchester, and a quick trip to Edinburgh in Scotland. Then, at last, Lafanu would go to Italy.

"A speaking tour will advance the negro cause and bestow prestige on me," Henrietta murmured, satisfied.

An unobjectionable plan. Unfortunately, however, they hadn't reckoned on George W. Harwell, the assistant secretary of the legation of the United States of America to Her Majesty's court.

HARWELL'S LETTER came to Henrietta's house on St. James's Street on a cold day in March. The missive was addressed to Lafanu Brown.

"Who could be writing to you?" Henrietta asked, puzzled.

Lafanu turned the envelope over, held it up, and read the return address. The letter came from the American legation.

She immediately felt that something was amiss but made an effort to retain her composure and repressed the urge to panic. She started to read and continued until her knees gave way and she was obliged to sit down.

> *Age, around twenty. Height, five and a half feet. High forehead, black eyes, flat nose, prominent lips, kinky hair, color of hair: pitch-black, bony face, negroid complexion. Does the foregoing, or does it not, correspond to your description, Miss Brown? This is, naturally, a rhetorical question; I need no reply to it from you.*

You are a member of the negroid race. And no negro can be a citizen of the United States.

According to the information I have before me, after a voyage of fifteen days from the port of Boston, you arrived in the port of Liverport in mid-January of this year, aboard the ocean steamer known as the SS Arabia. *My informants report that you traveled by carriage from Liverpool to St. James's Street in London, where you currently reside in the home of the eminent Henrietta Callam, an Anglo-American woman who has attracted notice for her progressive ideas as well as for her involvement in certain minor scandals of a vulgar nature.*

I am not here to judge your protectress's way of living or dubious conduct, but I am here in my function as a public servant of the country. And as such, I enforce the country's laws.

The laws speak clearly. No negro can be an American citizen. There is no such thing as a negro American. You and yours contribute nothing to the nation's advancement. You are the dregs of society.

I have been informed that you sailed to Liverpool with a travel document issued by our agency in Boston and signed by its secretary, Trevor Smith. This document authorized you to travel on the steamship Arabia.

But I contest the validity of the said document. My colleague Smith has never seen you in person. According to his statement, a lady, one Lizzie Manson, came to collect the document in your stead. Secretary Smith thought that Mrs. Manson was you, Miss Brown, and he turned the document, which serves as a passport, over to her. But here is the deception. You and Mrs. Manson took advantage of my young and inexperienced colleague. Had he seen you in person, he would certainly have refused to provide you with a document to which only Americans are entitled.

You, Miss Brown, are not a citizen of our country. You have no right either to the protection or to the tutelage that the American legation is obligated to grant to American citizens. You have deceived us. You have made illegal use of a document that does not belong to you. This letter is only a warning. Do not ever attempt to deceive us again. And do not again dare, as you have already dared, to request an exit visa from Great Britain. Not only will your request go unheeded but no visa of any kind can be provided to you, as you are not an American citizen. You have already taken ample advantage of a system that does not adequately punish illegal aliens such as yourself, and so I suggest that you enjoy England and Scotland.

Go as far as you can, visit the Hebrides, enjoy the sight of the most ancient rocks to be found on the island of Great Britain. Enjoy the stormy weather and the turbulent landscape, the dolmens and the bagpipes. Travel the length and breadth of this island. Because in future, that is all that you will be able to do. You shall remain here for life. And with this I bid you farewell, Miss Brown, in the hope that I will never again hear your name.

 Respectfully,

 George W. Harwell

THE FOLLOWING DAY, Lafanu, accompanied by Henrietta, went to the American legation, which was located in the city center.

They knocked on the door. Once, twice, three times. At the fourth, a butler opened the door and asked for their personal details. "Please wait here a moment, *ladies*," he said, stressing the word and hissing its final syllable.

It was cold that morning. Fog covered every nook and cranny. The door opened again and a man appeared; he was wearing a tweed suit and carrying a pipe.

"Good morning," he said. "Obviously, you must be Lafanu Brown. And I take it that you," he went on, turning to Henrietta, "are her foolhardy protectress."

He cleared his throat and added, "You are taking up a government official's precious time, are you aware of that? Do you know that we're working here? We're not sitting around scratching ourselves the way you niggers like to do! You're a race of idlers, that's what you are. I know you." He snapped his fingers. "Life lasts for a moment. And I certainly don't want to waste my moment on a nigger wench." Then, crossing his arms, he spat out, "What I had to say to you, Miss Brown, I said in my letter."

"That letter"—it was Henrietta, intervening at last—"is illegal."

"How dare you call a document issued by the American legation illegal!"

"Because that's what it is. It denies my protégée her identity."

"What identity? A half negro, half Indian doesn't have an identity, or a country for that matter."

A deep shiver ran down Lafanu's back and expanded her ribs. She felt she was on the point of exploding. And she was furious. She cried out, "It was you! You stole the Chippewa's land, our land! You!"

"Do you hear your protégée, Mrs. Callam? She's accusing the United States of theft. Have you ever heard a more pernicious lie? Your protégée disrespects the nation and all those who have contributed to building the real utopia it represents. And do you now think that I, George W. Harwell, am going

to issue a citizen's visa to this vile, ungrateful nigger tart? You can forget it."

And he moved to close the door.

"Wait!" Henrietta Callam shouted.

"I've already given you too much of my time. Good-bye, and don't ever even think about showing your faces around here again. If you do, I shall be forced to call the guards. Do I make myself clear?"

The last image that Lafanu retained of George W. Harwell on that day, right before the door snapped shut, happened to be his mustaches. They quivered every time the secretary raised his voice. They looked, those mustaches, like two knife blades.

BUT SHE'D HAD ENOUGH of thinking about that odious little man and about all the bitterness of the past several years.

Now there was Italy.

It took them a little more than three hours to descend to the valley, where they were, definitively and finally, on the Italian side of the border. Henrietta Callam shouted for joy, and the other ladies imitated her. Only Lafanu remained silent as she looked around. The Susa Valley at once struck her as gorgeous. The perfection of that uncontaminated landscape made her heart beat faster. She felt a need to pray, she who never prayed.

O almighty and merciful Lord, I offer my thanks to you for having given us this valley. Preserve it from the hatred of men and from the madness that accompanies their nefarious undertakings.

Dinner at the inn where they stayed was a sober affair: bean soup. They all ate enthusiastically. Except for Lafanu Brown, who took a few small spoonfuls. Her tongue had turned into fire. On the tip, she could sense the tingle of salt. She looked at the beans. They were floating in a hot sea among tubers and celery. The fiery red of the beans nearly blinded her. When her bowl was almost empty, the flavors of the countryside suddenly filled her mouth. And for the first time since Coberlin, she perceived a familiar taste.

"Are there onions in this soup?" she asked in Italian.

"Of course, that's how we make soup around here," a woman replied from the kitchen.

Lafanu started to shake. Onion. And she could taste it. How was that possible? She'd lost her sense of taste, she hadn't been able to taste anything since that night in 1859. She looked in the direction the voice had come from. She was puzzled. "Did you make it?" she called out. Now she was suspicious, as if she were speaking with a kind of witch.

"You like it, don't you?" The woman, all disheveled, was approaching the newcomers' table. "Onion,

dear girl, is good for the heart! And I put enough on-ions in this soup to raise the dead," she said, winking at Lafanu.

"I'm mad for it! Would you give me another bowlful?"

At last, Lafanu felt that her body had escaped from the snares of the past. She distinguished all the tastes in her mouth: bay leaf, lentils, fava beans, red beans ... and above all, the onion that had reawak-ened her taste buds.

When the second bowl came, she devoured it. Italy was getting under her skin. And she was already immensely grateful.

Only later, as Lafanu lay on her bed at the inn with the sleeping Henrietta snoring and muttering beside her, did the memory of George W. Harwell's countenance cross her mind. She imagined his face going livid at the thought of her, happy in Italy. *By now, he must know I'm gone.*

And while sleep took its time in coming, her thoughts turned to her English prison.

AFTER THAT DISTRESSING DAY at the American legation, Henrietta Callam shifted to a war footing.

"No one can treat a girl under my protection that way," she proclaimed. She spent an entire week writ-ing letters to her journalist friends. "They owe me

more than one favor," she told Lafanu. "You'll see, sweetheart. Tomorrow your name will be on the lips of everyone in this city. Even Buckingham Palace will know about you."

And so it was.

The first newspaper to report the injustice done to Lafanu Brown was the *London Inquirer*. Then the *Edinburgh Scottish Press*, the *London Morning Star*, the *Lancaster Gazette*, the *Leeds Intelligencer*, and the radical *New Star* came in like an avalanche. But it was the *Western Daily* and its correspondent Morgan Lee that provided the most complete account of the affair and concluded that Miss Lafanu Brown's own country had deprived her of her right of citizenship: "Can a talented young woman such as Miss Brown be a foreigner in her own nation? A young woman whose forebears were brought into that glorious land in chains? Can such a woman as Miss Brown be defined not only as a foreigner but as an illegal alien?"

The newspapers' words calmed Lafanu's fury, but for only a short time. Because the torrent of mostly positive comments that rained down on her also included a heavy load of insulting rubbish, from various sources.

Some newspapers defended Harwell and the American legation; some aristocrats who owned property on Antigua or elsewhere demanded that the young negress in question be silenced immediately,

by the Crown, no less; other citizens, who called themselves "friends of the United States," suggested a possible remedy: "If Miss Brown is so eager to travel, let her be put in shackles and brought back to the ape-land where she was conceived."

Henrietta responded point by point to these outrages, stressing that her protégée was born in the United States and was indeed a United States citizen. "No other place is her home. And she has a right to that confounded document!"

The polemic went on for days, furiously, as if it were the disastrous prelude to a war that was on the verge of breaking out. On the battlefield, across the sea in America, the atmosphere was charged; every piece of news that came from the United States was blood-drenched and loud with cannon fire. Lafanu had no more illusions. The war was coming for her too. And when she was alone in her room, she would clutch her legs to her chest and try to imagine the fate of the people she loved. *May God not let anything happen to Mulland or my darling Baby Sue.*

Amid that great clamor of pitiless attacks and stout defenses, an unexpected article appeared.

It was published in the *New Statesman Review*, a progressive weekly with Republican sympathies that often printed pieces by American abolitionists, including Ronald Perkins and others whom Lafanu had met at Bathsheba McKenzie's fundraising soirees in

Salenius. This morning, however, the lead article was signed by Frederick Bailey. As soon as Lafanu, returning to the house from her Latin lesson, stepped over the threshold, Henrietta handed her the review and said, "Your Frederick still thinks about you."

An unprecedented dismay seized Lafanu. Neither she nor Henrietta had spoken of Frederick since before their voyage to England. She hadn't thought of him during the entire crossing, and now that she was attending Bedford College, he never crossed her mind. She had erased him because the thought of him had become too intolerable. Lizzie Manson had written about him in a letter to her: "He has found consolation with remarkable alacrity. He's married a former slave named Menilla Jones, a simple woman, perhaps a little too simple for a man of the world like himself, but she offers him a degree of loyalty few women could match."

Menilla Jones and Frederick Bailey had tormented her many a night. To know they were together, the two of them lying beside each other in a bed, made her feel bad.

But then, after her initial sensation of loss, Lafanu had decided to leave that couple out of her happiness. She didn't want to know about them.

And now this article . . . she stooped like a falcon over the review in Henrietta's hand and started reading the article without even taking off her coat.

When she finished, tears as big as pearls were running down her cheeks.

The article was perfect. A perfect defense of Lafanu Brown, American citizen.

That was just what he'd called her: *citizen.*

"You should thank him," Henrietta said. "He's your most effective defender. It takes him just a few lines to put that nasty little functionary Harwell in his place. Maybe you made a mistake when you refused to marry him."

Then Henrietta realized how out of place the words she'd just uttered were and bit her tongue. Practically leaping to her feet, she retreated in haste to her rooms.

BUT AT THIS POINT, London was a yellowing page in her biography. And, sooner or later, Frederick Bailey must become one too.

Lafanu was in Susa now. They had to leave rather early the following morning for Turin, where there would be a two-hour stop at the Sant'Agostino, the Church of Saint Augustine. According to their schedule, they would reach the Savoyard city around four in the afternoon. Lafanu couldn't wait to have some of the hot chocolate for which Turin was known all over the world.

In his thickly written pages, which Lafanu found more reliable than the Murray guide, Tiberio Baldazzi had warned her: "You cannot leave Torino without tasting a bit of her nectar." Lafanu closed her eyes. Would she be able to taste chocolate too?

Crossings

XIII

After I left the main office of Ca' Foscari, I stopped in the university bar. It wasn't yet rush hour, but the place was already quite full. I ordered a salad and received an enormous plate with lots of tuna. As I was very hungry, I appreciated the giant helping. I followed it with a delicious cream of zucchini soup. While I ate, I fiddled with my cell phone and distractedly read the news. The usual Italian political controversies. And then an item that made me laugh: In Germany, an obese rat had gotten stuck in a drain. Too fat. Guiltily, I looked at my dishes, now perfectly clean. Then I clicked over to the social networks to see what was trending. The rat was the topic of the day. Not only had it been photographed in that ridiculous pose, it had also been rescued by firemen. The people

online extolled the magnanimous gesture: "Hurray for German civilization!" "May all who hold animals in their hearts live long and prosper." "A small victory in the fight against barbarity." And if they didn't commend the German firemen, they focused their remarks on the rodent, which was called "very sweet," "a darling," "a love rat." The more I kept reading, the more anger rose up in my chest and made it hard for me to breathe. How was this possible? Europe built concentration camps, and these folks were talking about European civilization? People like my cousin Binti were risking their lives, and what was Europe, this great civilization, doing? Putting up walls, walls, nothing but walls and barbed wire. Maybe the same people who praised the firemen for having saved the rat disparaged nongovernmental organizations and whoever ventured to save human lives. Yes to the rat but no to the migrants, they must be turned back. I started feeling nauseated. I paid and left the bar, where professors and students were chatting and laughing. I wanted so much to share their joy. But knowing that the life of that rat counted for more than my cousin's life made me ill. Not that I was angry at the rat. It had simply been born in the lucky part of the world. Basically, it had a strong passport too.

THEIR ROUTE was marked out: Turin, Genoa, Livorno, Lucca, Pisa, Florence.

And then there would be a choice to make: Which road should they take? Did they want to reach Rome via Arezzo or via Siena?

The ferment of Turin, then posthouses, brigands, hot soups, chatty innkeepers, ill-tempered English travelers, cold, dampness, hot chocolate, Renaissance colors, and then the schedule, as crowded as a field of grain before the harvest, rise early, retire very early, sturdy shoes, airy clothes, heavy capes, and then capitals, pillars, paintings, paving stones, flags, palaces, boats, castles, cloisters, churches, libraries, manuscripts, frescoes, mosaics, museums. Nothing was to remain outside the scope of those visits.

———

BUT THEIR ITALIAN JOURNEY had barely begun. And now they were leaving austere Turin, all yellow and ochre, and heading for Genoa, to look at the sea, to eat fish, to lose themselves in streets teeming with rats and enlivened by blue doors. Lafanu and Henrietta didn't like Genoa, and not only because of the rats; they didn't understand the city, parts of which seemed to be dying. It was mazy, and the streets were dark. Then, unexpectedly, the two travelers changed their minds. After all, as their courier said, "Genoa knows how to make you love her, eventually—you need patience with Genoa."

The bread in Genoa was good, and they found a type made with olives so delicious the two of them nearly swooned. The loaves, each as tall as a cassapanca, brought tears to Lafanu's eyes. Her arrival in Italy had marked the return of her sense of taste; she couldn't taste everything just yet, only the things with the sharpest or saltiest flavors. Sweet tastes were still beyond her perception. But even detecting just the sharpest tastes was already wonderful. That bread, for example—she could taste it all, it melted in her mouth, the way Baby Sue's pies would do, long ago, before Coberlin. "Baby Sue doesn't know I have my taste back." Lafanu Brown sighed. She'd had no

news of Salenius since they crossed over into Italy at Moncenisio.

The two women (Henrietta also wanted to write home) searched for a post office in the chaotic maze of Genoa. They found what they were looking for at the top of a hill, and it was from there that their letters departed for England and America, letters in which they implored their correspondents to send them some news, to Livorno if they could, or to Florence if more convenient, because that was where they were headed, and then they enclosed kisses and hugs and lots of love always.

The journey had already begun to make Henrietta tired. She missed her London salon evenings terribly, the beautiful clothes, the friends, the idle chatter, the scandals, the gossip; she missed waking up and feeling lazy, stretching in her bed, eating bacon and eggs, reading *The Times*, and writing letters to her lady friends; she missed London itself and its chaos and its impeccable people, including the gentlemen who would whisper to her at sunset, "You look lovely this evening, my darling."

Lafanu, on the other hand, didn't miss London at all. She was anxiously waiting for Rome. Besides, in those days she had other things to think about. Her body had begun to change; she'd grown taller lately, or at least, so it seemed to her. Now her forehead

nearly struck the lintels of the doors she passed through, her neck was longer, her back straighter, her head more solid on her shoulders. She hadn't imagined that a person could keep growing after the age of twenty.

And then, the evening before they left Genoa, she had touched herself.

She'd never done that in her life. She hadn't even known it could be done. But she'd heard two Genoese girls talking, half in Italian and half in dialect, right under her window, and one of them said, "I stuck my finger in my privates and danced around like a magpie on water."

The wound that women have down there—could you really put your finger into it?

She never touched herself there.

Baby Sue had counseled her to wash those parts, but Lafanu didn't pay much attention to her.

"Don't do like white women, they never touch themselves there. You got to keep your intimate places clean and fresh, you got to get rid of any trace of a smell and any nastiness that been done to you." Lafanu washed herself every day. And every day she felt ashamed.

But as for touching herself, my God! She couldn't imagine it. And now those Genoese girls—vulgar girls with loud, shrill laughs—were saying to each other, right under her window, "I put my finger in mine, did

you?" She felt anger, inexplicable anger, at those ill-bred little tramps. Or maybe only admiration. The question they asked seemed to be directed right at her, at Lafanu Brown.

She had a room of her own that evening, and after she went to bed, she began to touch herself. First she pressed her palm against her mons, and then she ran her finger along the wound.

Her finger slipped in deeper and deeper, while outside the silence and the crickets of Genoa were howling. The finger entered her, Lafanu trembled. The finger moved gently, Lafanu trembled. Her finger was cold, the wound was hot, and so the finger, eager to warm itself, started moving faster and faster, and Lafanu started to dance, slowly and sweetly at first and then more and more frenetically. She didn't know if what she was doing was a mortal sin, if she would be condemned or found out. She knew only that it felt thrilling. One moan. Two moans. At the third, the color came and flooded her with beauty. A pair of colors: lively orange and gaudy purple. Then, reluctantly, Lafanu smothered that rainbow of pleasure to keep from being heard in the neighboring rooms. Was it wrong, what she'd done? She didn't know and didn't want to know. But she had every intention of repeating the miracle. Afterward she fell into an untroubled sleep, with the smell of herself in her nostrils.

———

IN THE MORNING, they had to leave and get back on the road; off to Livorno, as someone said, "to embrace the world." And there the two women and their courier plunged into the Livornese atmosphere, to which Arabs, Turks, Armenians, Circassians, Greeks, and Jews had all contributed. Once upon a time in Livorno, there had been a fortress, galleys, and an extravagant number of slaves.

Lafanu knew nothing in regard to the slaves of Livorno.

Nor did Henrietta know anything about them. She did, however, know all about the local cafés. She wanted to take a seat in one of the spots recommended in *Murray's Handbook*, one of those suitable for ladies, but suddenly she saw an acquaintance walking down the street. She shouted like a madwoman, waving both hands: "Colin! Colin Marriefield!" And the man, a portly gentleman with a blond beard and a sparse mustache, turned around. *Fifty years old and not aging well*, Lafanu thought. *Belly too big, bags under the eyes likewise.* But he had a nice smile. Colin and Henrietta conversed intensely for at least ten minutes, leaving Lafanu and the courier to their own devices. Then came the time for introductions. "This is Lodovico, our courier and guide, and she's Lafanu, my little negress. I pay all her bills."

Lafanu could hardly believe her ears. She couldn't tell whether she was more wounded than amazed, or the reverse.

Henrietta bit her lip. She hadn't introduced her protégée very well. She'd let herself get carried away just to dazzle this acquaintance of hers, who smelled of London. She knew she'd made a mistake, but it wouldn't have been in her nature ever to admit her fault. She smiled and tried to rescue the situation. "She is the famous Lafanu Brown. You've probably read about her in one of our English newspapers— even *The Times* dedicated a paragraph to her."

The man nodded. "Yes, I've read some of the articles, you know I support your cause," he said in a whisper. And then, with greater assurance: "I read Frederick Bailey's piece about her in the *Statesman*. He mounted a valiant defense of her case."

No one had spoken Frederick's name in her presence since her arrival in Italy. And now, not far from ships so much like slave ships, his name had been evoked. Lafanu felt weak in the knees, but she smiled and resisted. In embarrassing moments, she didn't know how to do anything else. She bowed to Mr. Marriefield. Then she bowed again.

"Have you seen the Moors yet, Miss Brown?" Marriefield asked her.

"The Moors? No!" Lafanu stammered in great agitation.

"I shall escort you to them."

They walked past docks, crates of fish, cheerful girls in Turkish-style turbans, and old Jews smoking pipes, until they came to the monument for which the city was famous. "The white man on top is Ferdinando, Grand Duke of Tuscany," Marriefield said. "The stone's so white you can hardly see his eyes."

Below him, finely carved and fixed forever in bronze, were four men, prisoners, bending low, chained and bound. Slaves of the Grand Duke. A single tuft of hair on each of their heads. Their torsos naked. Their manhood hidden by folds of cloth.

"That one, the African? Everyone calls him Morgiano."

His face was the same as Frederick's.

Lafanu took out her sketchbook and went to work. She made a great many sketches, her strokes decisive, terse, almost desperate.

She hadn't yet finished when Henrietta called her to order. "We're tired and hungry." But Lafanu was completely absorbed by Morgiano's suffering beauty. And she remembered the faces of all the fugitives, the ex-slaves she'd seen in Salenius. People who had abandoned the slaveholding South to embrace the freedom of the North. Lafanu had seen them trudging into Salenius, limping, with shackles on their feet they hadn't yet been able to liberate themselves from. They were weeping, crying out in pain. And

then someone from the free black community or some abolitionist would run to bring them water. And smelling salts. Also an embrace. And now Lafanu felt herself spurred on by the same desire. She wanted to climb up on that monument and hug those four prisoners. One of them was terribly old. *Where did they take you from?* He looked like a Turk or an Arab. He was covered with wrinkles. Overcome by weariness. Lafanu would have liked to reinvigorate him with a kiss on the mouth.

"I didn't know there were slaves in Italy," she said to Marriefield.

"Indeed there were, and how. Slaves of all colors. Even English slaves. They used them to row their galleys."

This news, like a blow to the head, left her stunned. Nobody had ever told her this about Italy. There was not so much as a nod to the subject in the Murray guides. Lafanu was perplexed. Then they dragged her away to get something to eat, but she didn't touch any food. She'd lost her appetite.

The following day, they were ready for the next leg of their journey. They couldn't deviate from their travel plan; they had to follow it and arrive in Rome at the scheduled time. They were expected. A woman named Georgina Harris had written to Henrietta Callam, "Everyone greatly wishes to meet your protégée. And those of us who are artists and reside

in Rome—we just can't wait to see her." Lafanu, who didn't know she was so anticipated, applied herself to enjoying the scenery.

Lucca restored her spirit. And Pisa lit her up with wonder. Henrietta, for her part, found Pisa distinctly overvalued. "There's nothing there. It seems to me like a tract of deadwood and swampland. And they dare to call this a city?" But to Lafanu, Pisa was brilliant. With its leaning tower, the Piazza dei Miracoli looked like the silvery icing Baby Sue used to decorate her famous pies. Among the crowd in the vast square, she thought she recognized someone. Was that possible? She knew nobody but Henrietta in the entire country. She peered into the throng and caught a quick glimpse of a familiar thatch of blond hair. But then it vanished, as elusive as a gecko. To distract herself from that thatch, which she hadn't been able to get a fix on, Lafanu started drawing towers, frills, wayfarers, children, dogs, birds, sky—that enormous spectacle of nearly perfect beauty.

The courier, however, recalled the ladies to their commitments. They had to leave. They were so close to Florence... "We'll be able to rest there, finally," he concluded.

Henrietta Callam exploded in a snort: "I can't. I really just can't." Like a river in torrent, she poured forth a flood she'd been holding back for a long time, ever since Turin, in fact. "I must see a little civilization.

This Italy is so uncivilized. These Italians are such barbarians. And I intend to fire Lodovico as soon as we get to Florence and get someone else for us, someone with less nonsense in his head. Have you seen how he looks at girls? It's obscene. Nothing like the martyrs for the cause I've supported all these years. These Italians are very disconcerting. But you'll see, Florence is so English, it's almost like home. I've been assured of that by my friend Mildred, who has lived there for years."

In the face of this rant, which continued even after they were in the carriage, Lafanu preferred to remain silent.

Crossings

XIV

The message came at three in the morning. It was from Alexandria. Time zones remained an enigma to her.

I had gotten up to pee. I was taking probiotics for a tiresome bladder infection, triggered by stress, and most of my time was spent going to the bathroom.

"I finally know what I'm going to wear to my wedding," the first message said. Then came a second, longer one: "A wide-skirted dress in dark green velvet, topped with a short-sleeved jacket trimmed in front with copper-colored beads. That will be my wedding outfit. I didn't want to get married in white, a color that stamps us with a fragility I don't feel I have. And do you know who inspired me?"

I wrote back immediately, even though the reply was obvious: "You're getting married in the same dress Lafanu had made for her entrance into Rome."

"Right. She's guiding my steps now. As she guides yours."

A few minutes later, I got another text message. This one was from Lul, Binti's doctor. The woman who repaired minds. I opened the photograph she sent me. It was Binti. Smiling and showing her big, dazzlingly white teeth. Bright eyes, wrinkled nose.

The doctor's message read, "Today Binti laughed so hard she had to hold her sides after I told her one of our traditional stories, one of those with a lot of irony and a moral at the end. She especially liked the closing moral: We must be happy. Then she sat down next to me at the table and ate a little rice and meat. They didn't break her completely, our Binti."

My heart did a joyous somersault inside my chest, and I spent the rest of the night wide awake, vibrating with hope.

THE ROAD TO FLORENCE seemed to have been drawn by a mad cartographer. It was full of bends and turns, little hills and swampy ground, and around it stretched an expanse of ilexes and cypresses. And the people, in their humble work clothes, looked to Lafanu like so many reflections of a Leonardo or a Michelangelo.

"It's our expectations that confound us. We see the Tuscan countryside through the eyes of artists who have painted it," Lizzie Manson wrote in the letter sent general delivery and which Lafanu had retrieved at the post office in Pisa.

She opened the letter and read it at once. It sounded as though, now that the Civil War was over,

everything in Salenius had to be rebuilt, especially the heart and soul of the people.

Mulland has reopened his store. Marilay is still working with him there, but she's going blind. They say it's the result of her illness. Perhaps, but there's a general air of woe hanging over the city. And I'm having trouble finding pupils. Rebels like me are out of fashion. In a year or so, I may go to live with my niece in Baltimore. She'll take me to the opera, and I shall be able to hear the music of the divine Mozart. And when I'm too old, she'll keep me from dribbling soup on myself the way old people often do.

It was strange to read such sad words from Lizzie. Years had passed since the last time she and Lafanu had seen each other, and an ocean separated them, but Lizzie was still the person to whom Lafanu felt the closest, along with Baby Sue.

"Think of me, my dear pupil," the letter closed. "Think of me hard, the way I think of you."

IN THE CARRIAGE, the young woman took Tiberio Baldazzi's creased and crumpled pages from her purse. She hadn't looked at them for weeks. She'd forgotten, as if distracted and overwhelmed by all the

anomalous beauty that Italy exhibited every meter of the way.

Of Firenze, you will see the naked skeleton. The walls have been knocked down, and the city will look to you like a flayed bird. It has been so long since I saw her, my dear, sweet Firenze. The melancholy city where I was born, where I took my first steps, where I was happy, where I was betrayed. Firenze, which is now our capital. Firenze, which, like Dante, I shall perhaps never see again. I am an exile, rejected by the Nation I helped to create. Like Mazzini, by cruel devils rejected, reviled, impoverished in this frigid England. But Firenze, even though stripped of her walls, is still Firenze. My friends there told me about the muffled explosions that demolished, in that strange spring of 1865, the ancient ring that held the city in its embrace. They told me about the sound, which echoed from all the surrounding hills. And about the subdued lamentations of the Florentines, who saw themselves exposed, within a minute, in all their nakedness. The walls, the much-beloved walls, were no longer there. You will not see them, Miss Brown, except for their scattered remains. But if you follow my suggestions, Firenze will open her heart to you all the same. We Florentines do not love foreigners, because from the beginning,

those who come have always wished to take for themselves something of our soul. But we can be tolerant. Do not expect us to smile. We are rather inclined to the inappropriate witticism, we know how to embarrass, and we feel no regret for our harshness. In the rest of Italy—Italy, the country to which we gave our language—we are held in contempt. We are not among the favorites of the kingdom. But without us, this kingdom would have no soul. And so please heed my words, Miss Brown. Read well every line of these shabby notes. And if you do so, I promise you wonders! I shall reveal to you the hidden treasures of that city where the sì *is not only heard, it is also bathed in the waters of our* blessèd *Arno.*

And so it was that Tiberio Baldazzi, after Lodovico was let go, became Lafanu's eyes during her Florentine sojourn. Via Panzani, Via dè Tornabuoni, Via dei Servi, Via San Sebastiano, the reek of the old market, the vastness of Florence Cathedral, the restrained composure of Palazzo Vecchio, the sensuality of Michelangelo's *David*. And then the claustrophobia of the little streets, some of them even narrower than the streets of Genoa.

Lafanu and Henrietta didn't stay in a hotel but in a noble palazzo with a breathtaking view of Brunelleschi's dome. The owner of the house, Mildred Trenton,

was an old friend of Henrietta's. They had grown up together, living in the same county, gazing up at the same sky. But then Mildred had married a sculptor based in Florence. Because, she said, "The artistic life here is among the most intense anywhere. All the young artists choose Florence or Rome for their training. And my beloved Albert always has one or two apprentices around. If you could see, dear Henrietta, how they revere him. And with a gesture, a wave of his hand, he determines their whole existence." Mildred was always talking about Albert, who, on the few occasions when he was in the house, limited himself to sporadic mumbling. Lafanu had almost never heard the sound of his voice. Moreover, his sculptures failed to make much of an impression on her. She found them tremendously second-rate, but of course she kept that to herself.

It was in that house that Lafanu and Henrietta attended their first real soiree since leaving England. Henrietta was jubilant. She said, "This is the ideal I was looking for: You can enjoy Italy while at the same time staying in England." That evening, a large number of expatriates came to pay their respects to their hostess's London guest. Artists, yes, but not solely: There were opportunistic politicos, lawyers, merchants, veteran academicians, widows, vicars on leave. To all of them, Henrietta displayed Lafanu Brown like a trophy. For the occasion,

the young woman was wearing a striped dress with a pleated collar. She made a little curtsy and then avoided looking the people she met in the face. She didn't want to see the flash of disapproval in their eyes. She wouldn't have stood for it.

But—because hatred can be felt on the skin—she sensed that not all of the guests were happy to see her in that circle.

"Pay no attention to their ugly mugs," a woman said. At first glance, Lafanu guessed she was about the same age as her former tutor Lizzie Manson. Lafanu smiled again, mechanically. She had nothing to say to this unknown person. But the woman insisted on having a conversation.

"Don't you find good old Albert's sculptures abominable? They're so . . . how shall I say it . . . paltry. If only he'd let himself go and follow his inspiration. But nobody here has the nerve to do that." This elicited yet another smile from Lafanu, who couldn't manage to utter a sound.

"Forgive me, I'm jabbering away, and you, you poor thing, you must think I'm crazy . . . I *will* have that effect."

And the lady burst into laughter so loud that it turned several heads.

"I'm embarrassing you, am I not? Admit it, Miss Brown. I do it to everyone. It's my defect, but it's also an asset. It's how I became friends with your tutor

Lizzie Manson. I'm Harriet . . . the famous Harriet, and I'd like to show you the real Florence."

Was this the Harriet she'd heard so much about?

Soft body, round arms, outsized bosom, chubby face, lips as big as Lafanu's, all topped by her golden hair, which she had gathered into an elegant chignon. Her manners were refined, her style relaxed. And she herself so welcoming.

"Come with me tomorrow to the English Cemetery. I want to bring some flowers to my sweet friend Elizabeth Barrett Browning. Her absence is still unbearable to me. You ought to read Elizabeth's long poem *Casa Guidi Windows*, it's so perfect in its essential—"

"It's my Bible," Lafanu murmured, almost moved. "Together with Madame de Staël's novel *Corinne*."

"Elizabeth would have liked you, my girl. You have an open manner that would surely have conquered my poetess friend. I'll have my carriage come for you rather early tomorrow morning. Be ready."

Tiberio Baldazzi had included that cemetery in his notes. He'd written, "Along those flowery boulevards, one breathes the air of revolution."

Lafanu wore a dark, austere dress and a camel-colored cloak for her visit to the cemetery.

Harriet told her about the pleasant place with meticulous precision. "Life flows inside the bones of these dead," she said. Then she started walking among the graves, greeting her departed friends.

"Here are my adored Fanny and Theodosia. They left us a few scant months ago to lie here so sweetly in their eternal sleep. And there beside them is the resting place of Theodosia's father, Joseph Garrow. Just a few meters away, you can see the graves of other members of their family. They're all here, as if gathered for Christmas dinner. I don't know why, but I always imagine them smiling."

The two women strolled around slowly beneath the cypresses; openings in the foliage allowed the visitors to glimpse the beauty of Giotto's Campanile and the dome of Santa Maria Novella church. The sounds of Florence, however, seemed far away.

"I've never understood why we all insist on calling it the English Cemetery when it's the Swiss who look after it. And besides, there aren't only English people buried here, there are many of our fellow Americans. And people of other nationalities could claim to be entitled to a plot here."

Then she began to name graves, pointing them out at such a rapid rate that Lafanu had difficulty following her.

"These people are buried here because the Catholics didn't want them in their consecrated ground. See over there, those are Protestant graves, and behind is a Jewish section, and here . . . right here, where the sod is raised . . . there's a handful of atheists, and farther to the left, some Freemasons. There

are Anglicans, and there are Baptists like me. Nobody is turned away. Suicides have found fresh earth to welcome them. As well as exiles, stillborn babies, and adults so strangled by debts they didn't have so much as a penny to put toward a grave. There are syphilitics, tuberculosis victims, people who died of sheer melancholy or were killed by romantic passion. Here are people who were servants in noble houses, chambermaids, whores, pimps. Here are some just rulers. And also some slaves . . . whom nobody dares to mention."

"Slaves?"

"That's right. Only twenty years ago there were still a lot of them around. Slavery never really ended, not even in Europe. In America, it caused a bloody war and inflicted great suffering on the people in bondage. You know something about that, dear Lafanu, you saw so many poor wretches in Salenius, running to escape their masters' clutches. What an intolerable spectacle that suffering was! But the wickedness of men was bestial in Europe too, don't think otherwise."

Lafanu resolutely took out her drawing book. "I'd like to make a few sketches—may I?"

"May? Must. One breathes art in this place. The dead will be overjoyed."

And so there reappears in the girl's sketchbooks the decisive, terse line with which, for some time

now, she has been interpreting the world. Ever since she landed in Italy, that line has become even darker, more baroque.

The way she held her pen was different too. The hesitation that had frozen her in Salenius was gone; now she felt she was part of the drawing. Nothing seemed alien to her anymore. She trembled, and she wondered if that was the sensation a real artist feels. Then she concentrated and filled every corner of her sketchbook with funerary urns and sarcophagi. And then, in sequence, little obelisks, pyramids, scarab beetles with long horns, hourglasses . . .

"The snake that's biting its own tail, what is that?" she asked, curious.

"It's an Ouroboros. It symbolizes eternal time, the infinite," Harriet replied.

Lafanu didn't sketch it. She didn't like snakes.

"The Ouroboros is a symbol present in ancient Egyptian culture, among others," Harriet said before being interrupted by a brief but harsh coughing fit. Then she went on: "Like the serpent, the woman who lies in this tomb not far from Elizabeth's is Egyptian, or rather, Nubian. She's the most well-known slave in the cemetery."

"What language is *that*?" asked Lafanu, staring amazed at the strange letters on the tomb.

"It's Russian. I know the language. For a while, in my childhood, now so far away, I lived in the austere

land of the Russians, because my father was the English ambassador."

Her hand, covered by a pink glove, gently stroked the stone of the unknown woman's grave.

"What does the writing say?" Lafanu asked, compelled by an anxiety she couldn't explain.

"It tells about her life. There on that white marble cross, the Russian Orthodox cross, it says she was a black slave brought to Europe from Nubia at the age of fourteen by the famous archaeological expedition Jean-François Champollion and his friend Ippolito Rosellini made to Egypt in 1829. Later she became a free person and was baptized into the Orthodox religion. They called her Nadezhda, which means 'Hope.' But..."

"But what?"

"But when she was a slave, her name was Kalima. One of your fellow Americans gave me that bit of information, a certain Frederick Bailey."

Lafanu's heart skipped a beat.

"Mr.... Mr. Bailey was here?" she asked in surprise.

"Yes, both he and his wife, such a sweet-natured, silent woman. He didn't want to leave, he said, they'd fallen in love with Florence. Do you know Bailey?"

How could she lie? Lafanu swallowed and said, "Yes, I know him. A truly good man."

"A real gentleman! He and Elizabeth had a correspondence. My poor Elizabeth, destroyed by laudanum...I've heard that Bailey's wife is ill too, and they say it's serious. May God protect her and spare her."

Lafanu felt almost as though she might faint.

"Are you not well, Miss Brown?"

"No, I mean, don't worry. Too much emotion. I'd like to see Elizabeth."

"She's very close, we just have to turn here and walk a bit...And there's Elizabeth, in a tomb suspended in air. Dancing with the light of this splendid morning."

Lafanu Brown knelt before the white grave of the author of *Casa Guidi Windows*. She murmured, like a prayer, "She stood for tolerance and liberty."

"She loved your people very much. She wanted you to be free," said Harriet.

But Lafanu paid practically no attention to those words. She was there to say a prayer to Heaven and the future, and she desired no interference. "The arc of the moral universe is long, but it bends toward justice," she whispered.

"Odd," Harriet replied. "Those were the very words that Frederick Bailey used. He said the exact same thing."

Lafanu smiled. She knew that the love which still linked them had prompted both of them to use those words.

Crossings

XV

The girl was right there in front of me, giving me a
look like an angry, wounded animal. She seemed to
find her wooden chair uncomfortable. She moved in
little jerks, clearly annoyed, making it obvious that
her rage could barely be contained. And that if she
was angry at the world, she had good reason to be.
"Because the system fucks us Black folks."

Her Tuscan accent, in all its weighty purity, ex-
panded into the big room. And to go with her accent,
the girl, whose name was Uarda, deployed a range
of body language developed during the centuries in
which the Guelfs and the Ghibellines were beating
the shit out of one another. The daughter of a Ghana-
ian mother and a Nigerian father, while still a child at
home she had already absorbed the contradictions in

what her mother would say to her father every time they quarreled: "You Nigerians kicked us Ghanaians out in the 1980s, and sooner or later your Nigerian ass is going to get kicked out of my house." They didn't quarrel often, but when it happened, it was as if the first African world war had broken out. And Uarda never knew whose side to take. Sometimes she wore the colors of the flag of Ghana, other times the colors of the Nigerian flag. "But then, when I was thirteen or so, I decided that both nations could go fuck themselves, and I embraced Pan-Africanism. I belong to Mama Africa, period. The rest is bullshit. And I can't waste time on bullshit."

"What about Italy? What about Florence?"

"That's only one possible scenario, the stage I act on. If you want to know, I feel I'm purely and simply myself. Me. The other stuff, the qualifiers—Italian, Nigerian, Ghanaian, Florentine—those are just labels for others to use. I'm a flowing river. And that's enough for me. If it's not enough for other people, fuck 'em."

I liked the way Uarda worked. She was one of the first artists I was considering for what Alexandria and I had named the Lafanu Brown Project, at the heart of which would be the young artists called on to confront the multicolored worlds of the painter from Salenius. Alexandria had already seen several potential participants, but the only one she'd really liked

was a young man from Chicago whose work superimposed images of America's past slavery on images of its present segregation. I'd seen some of his pictures too, and they were excellent, but aside from him, there wasn't much. We wanted six artists from various parts of the world. Italy had to be represented, and we were expressly interested in African Italians, for reasons that included sending a political signal to a country that was showing itself not only insensitive to the plight of migrants and their children but cruel to the point of savagery.

Uarda was perfect. Enza, a dear friend of mine, had talked to me about her. Enza was an archaeologist and a brilliant professor at Sapienza University of Rome. She was the one who tipped me off to the best books to read, the best series to watch, the funniest YouTube videos, and she often discovered artists before I did. Uarda had sprung onto the scene as a Web phenomenon before she ever picked up a paintbrush. She had talent to burn. She sang beautifully, she'd written scenarios for some short films, she'd acted in TV dramas. But what interested me was her series of metropolitan portraits called Bitch Power, in which former prostitutes take back their lives and freedom. It was something that touched the soul. When I saw those images, I thought Uarda had to be part of our project.

Lafanu would have liked her, I was sure of that.

THERE WERE RATS all over the place. They had gnawed on the wainscoting, on Lafanu's canvases and brushes, and on Henrietta's clothes, which hung limply from the velvet-upholstered armchair. The blasted creatures were scurrying everywhere, in every corner of the room in the cold, damp house, the only one they'd found in the crowded city of Rome.

Henrietta screamed.

Their little Italian servant screamed as well. "I want my mama!"

She too had been all they could find on that dreary November day, and they'd taken her into their service. Her name was Emma; she came from Montefiascone, a country town. Emma was fourteen and had

never worked in her life. This was her first job, and she was totally unprepared to cope with an emergency of the present kind.

"You have to help me, Emma!" Lafanu shouted. "We must dress the signora and get out of here. Quickly! Before these rats infect us with their germs. They could be carrying diseases."

Henrietta was terrified. This Rome for which she had undertaken such a long journey was proving a hard nut to crack. And to think that Mildred had warned her. "It's impossible to find a decent place to live in Rome unless you have protectors or acquaintances there. Ask Catherine to help you." But Henrietta was proud, she wanted to succeed on her own. For the moment, however, these filthy accommodations were all she'd been able to come up with.

When she'd realized that those horrible, hairy beasts had invaded her bedroom, Henrietta had begun to scream and call out to her traveling companion at the top of her lungs. "Lafanu, save me!" she begged.

Lafanu was never very sure about how she'd managed, in the midst of all that delirium, to call the attendant, get their trunks loaded onto the carriage, and drag out Emma and Henrietta, who was still in her nightdress.

"Did you know?" Lafanu asked the attendant in vexation. "About the rats, I mean."

"It's been ten years since anybody rented that little palazzo. When you all arrived, the lady who owns it jumped for joy. I'm afraid the English signora won't see her deposit again."

Lafanu decided not to translate any of this for Henrietta, who had already reached her limit of endurance. She ordered the attendant, who turned into a coach driver for the occasion, to take them to Mrs. Pennywise's establishment at Via di Ripetta 32.

It was a pensione, a boardinghouse, highly recommended in Tiberio Baldazzi's "guide" as a place to stay when first getting to know the capital. "Signora Pennywise is very respectable, she has large, clean rooms and a select clientele. Tell her I sent you," Baldazzi had written.

When they knocked on her door in the middle of the night, all three of them looking the worse for wear, Baldazzi's name worked as a passe-partout.

"Something unexpected happened."

Emma, the little servant, said with a grimace of disgust, "Rats, so many rats."

"Oh, you poor things," the woman said sympathetically. "They swindled you. What scoundrels these Romans are. I apologize in the name of the city. Not everyone's like that, but you *do* have to be careful. They take advantage of gullible foreign women who love antiques. You should have looked up at the beams. Never rent any place in Rome without first

taking a good look at the beams. If they're rotten, you'd best run away."

For that first night, Mrs. Pennywise gave her new tenants a little room to sleep in. "Tomorrow I'll take down your particulars and lodge you in some airy rooms with big windows. You won't regret coming here."

Henrietta said "Thank you" in a drawling voice, leaning on Lafanu every step of the way, as if the breath of life had gone from her.

"How long has the lady been in this state?"

"Ever since we set foot in Rome. This business of finding a place to live is exhausting her," Lafanu said disconsolately. "We've already been through three. We left the first two because of the musicians outside."

"The street singers are a disaster, but you'll stop paying attention to them before too long." And then, with a smile, Mrs. Pennywise added that Rome was a melancholy city. "She needs to sing to keep from wallowing in sorrow."

"Sorrow?"

"Why shouldn't she be sorry? How would you feel if you'd lost an empire?"

TWO WEEKS HAD PASSED since their arrival in Rome, and Lafanu Brown still hadn't seen anything

of the city. No basilica, no obelisk, no square, no fountain. And to think, how her heart had filled with expectation when she glimpsed the dome of St. Peter's through the branches of a tree as they drove into the city. The last stretch of their way—through Radicofani, Acquapendente, Montefiascone, Viterbo, Ronciglione, La Storta—had been rather arduous. Steep bumps and abysmal holes made the roads a torment, and the carriage wheels had sunk several times into unexpected craters. The horses were exhausted too. In Montefiascone, about seventy miles north of Rome, the women had been warned about the presence of bandits along the rest of their route and had felt compelled to add two more men to their company as guards.

Nevertheless, the difficult journey had fortified Lafanu's spirit. In Florence, she'd been smothered by requests for portraits and by Henrietta Callam's social bulimia. Lafanu had greatly feared that all those tea parties, art openings, elegant dinners, and gala lunches would cause Henrietta to forget their original plan, namely to go to Rome and live there for a while.

Lafanu could see that Florence had changed her traveling companion. It had made her nostalgic for her homeland. As if the city of Firenze, with its river and hills, were only a pale reflection of her own Great Britain. All those English rituals had brought

to maturity in her the idea of abbreviating the torture of their Italian travels, which had already tired her out. She told everyone, "This brutal Italian sun has ruined my lily-white complexion. I look almost as black as Lafanu." She was, of course, exaggerating; her skin had only turned a little pinker, but now her rejection of Italy was underway.

One day she had even mentioned it to Lafanu: "I'm thinking about shortening our stay here."

Lafanu was in despair. They hadn't even reached Rome yet, and this woman on whom her life depended was already talking about returning to England. But Lafanu had learned to be cautious. She limited herself to smiling and saying, "We can't leave Italy without seeing Michelangelo's *Last Judgment*."

Fortunately, Henrietta had allowed herself to be persuaded.

IN THE END, the days in Mrs. Pennywise's pensione had turned out to be perfect. Henrietta decided not to leave her room. Mrs. Pennywise, an inexhaustible source of local gossip, spoiled and coddled her. In the midst of their chattering, the two women discovered that they were from the same county in England and had mutual acquaintances.

Emma, on the other hand, was gone, abruptly fired by Henrietta. Lafanu, who was as poor as the

girl, could do nothing to help her. She confined herself to giving the child a few pats on the shoulder as she walked her to the city gate known as the Porta del Popolo.

Emperor Trajan and his troops had left the city through that gate when they set out to conquer Dacia, and Lafanu and Henrietta had entered through it when they arrived in Rome two weeks previously. A torrential rain had rendered the ground muddy, and all around, having appeared from who knew where, were croaking frogs. The carriage lurched along. The sun was low on the horizon, but the day's dying light was still illuminating the streets with its last beams. What a thrill for Lafanu to see, even in that dim sunset, the red granite obelisk in the center of Piazza del Popolo that all her favorite writers, both men and women, talked about!

For the first time, she found herself disagreeing with her Corinne. The urban landscape before her eyes wasn't banal, it didn't seem that the same could be found in every European city; on the contrary, the vast piazza looked like an enchanted stage, while the graceful statues placed all around resembled a paying, demanding audience. And on the Pincian Hill overlooking the square were other people, another audience. How splendid it was to see Rome and Romans strolling about in their charming lace dresses, their handsomely embroidered bow ties. Somehow,

the place was so deliciously *lacquered* that nothing could equal it. On nights when the moon was full ghosts kept appointments there—or at least, so the Romans said.

One day, in the middle of that very piazza, Lafanu saw, not far from the obelisk, none other than Hillary McKenzie.

At first, all Lafanu glimpsed of Hillary was a flash of yellow that merged with the intense light of the city; then something in the way she moved her hand recalled to Lafanu's memory a gesture she'd seen Hillary make on the many occasions when she attempted to silence her raging mother.

Lafanu didn't move toward her, limiting herself to calling out her name a single time. There was always the possibility that the young woman wouldn't want to exchange greetings with her. Lafanu was, after all, still black. And it was the mother who was the abolitionist, not Hillary, whose attention was always focused on some fetching soldier or a new fur coat. Upon hearing her name pronounced in the pungent mountain accent that Lafanu had never completely lost, Hillary felt something inside, like a surge of hot blood. She looked around and saw Lafanu. Her face broadened in an expression of wonderment, and then she started running toward her.

"Is it really you?" she asked, incredulous.

"It's really me," Lafanu said, a little tentatively.

She held out her hand to Hillary, but the proffered shake never took place. Hillary wasn't made for such formalities. She was a carnal woman, given to embracing, to violations of etiquette. And in the middle of that Roman piazza, a white woman and a black woman hugged each other like sisters.

It was Hillary who squeezed tight, and Lafanu who received her fundamentally unexpected demonstrations of affection; she and Hillary hadn't had much to say to each other in Salenius.

"Finally, a friend! It turns out Mama and I don't know a single person in Rome!"

"Bathsheba's here?"

"She is, and she needs your help."

Lafanu noticed right away that Hillary had changed. She no longer talked about soldiers, gentlemen, rascals, or her transitory romances. Every trace of mischievousness in her had disappeared. And a worry wrinkle had furrowed her formerly smooth brow. Even her voice now sounded more serious. Hillary had become an adult, but it wasn't only that. There was a composure, a poise in her manner, and a certain sobriety even in her use of words.

"We had to leave Salenius when the Civil War broke out. We were in England, then Paris, then with some relatives in Edinburgh, but my mother's condition got dramatically worse, and she was advised to go to Italy. Where, I must point out, we have yet to

see sunshine. I have managed to take only one walk, in Pisa, in the big Piazza dei Miracoli."

"The two of you were in Pisa?"

Lafanu remembered the flashing apparition that had struck her eyes in Pisa a few weeks previously... their paths had probably crossed that morning.

"Mama has changed, she's not the strong woman you remember, Lafanu. She's so fragile, she might break from one moment to the next, and I... I couldn't bear it. If something should happen to her, I wouldn't survive it."

They were walking down Via del Corso, and several northern European gentlemen obsequiously greeted Hillary while altogether ignoring Lafanu, whom they took for her slave. Hillary responded courteously, nodding her head, but did nothing more.

The Hillary whom Lafanu used to know would have flung herself into an inappropriate conversation with those young men and created a scandal in the public square, laughing unbecomingly and driving Bathsheba out of her mind.

But only after they entered a little Renaissance palazzo did Lafanu understand how serious the situation was. And how immense Hillary's grief.

BATHSHEBA HAD PUT ON some raggedy clothes, and there was a bottle of brandy on the table. She wasn't

shouting, and she wasn't flying into a rage. Her eyes were fixed on the wall in front of her, which she'd soiled with food and spit. There was a smell of urine in the room.

"I have someone wash her every day," Hillary said. "I pay a sturdy Italian woman handsomely, and together we try to keep Mama away from the bottle. She cooperates for a day or two and goes back to being the woman we know. But then she leaves the house and heads straight for some drinks. I'm desperate. There's no place left for us to hide, and if her brother finds out about her, he'll seize everything we have. I don't see how we can keep her condition a secret."

Then the young woman burst into a long fit of weeping, like the lament of a fawn when death is near.

"I'll come and help you tomorrow, and from then on," Lafanu said decisively. She spoke almost without thinking, spurred on by a strange affection for that woman, who had caused her torment but at the same time given her the freedom to be what she wanted to be. Under the affection, however, there was also the subtle satisfaction of seeing her in need.

"You'll come? You'll really come to us, Lafanu? That would be . . ."

"Would be what?"

"Pure joy."

"For me too." Lafanu laid an arm around Hillary's shoulders, and Hillary gripped her hand

desperately. The two women had concluded an unspoken agreement.

LAFANU FLED from Mrs. Pennywise's pensione by night, like a thief. She couldn't betray Hillary's secret. She had time to write Henrietta a letter of apology for her abrupt departure:

> *I am grateful to you for everything you have*
> *done for me. For the wonderful years in England.*
> *For having supported my art and believed in*
> *my talent. But it happens that my help has been*
> *requested elsewhere. And I cannot be insensible to*
> *the siren call of affection. Now you will not be able*
> *to understand me. You will hate me, you will think I*
> *am an ingrate. But I ask you only for a year's time,*
> *a year of silence about my behavior. After a year*
> *has passed, I shall contact you again, with a letter*
> *that will clear everything up. The time I have spent*
> *with you, these fabulous years together, have been*
> *precious to me. You protected me when I needed*
> *protection. And you believed in my art. The por-*
> *trait I painted of you just before we left England,*
> *the one that's all pink and lilac, is one of my best*
> *pictures. And you are a perfect model. I have prom-*
> *ised myself—and we talked about it in the past few*
> *days—to do a another good portrait of you soon,*

with the Roman countryside as background. It will be a stylized painting, to be sure, but filled with everything I am learning from the classics during this wonderful journey, which I would never have undertaken without you. I am not an exploiter, I know how much I owe you. And every time my hands move quickly over a canvas, I think about you with joy and gratitude. Without you, Mrs. Callam, no Muse would have breathed her ardent breath onto my puny, callow hands. I would still be in London, in the trap laid by the horrible Mr. Harwell of the American legation, who didn't want me as his fellow citizen. I shall always remember how hard you fought for me in that situation. But you must not regret your kindness now that a greater duty calls me away. I cannot run from my responsibilities. I need not witness your dismay to understand how awful it will be at first, and how bitter your resentment toward me. But I have learned to know you, Mrs. Callam. You are a loyal woman, and I know you will let me have a year. And if, at the end of this year, I fail to reveal to you the secret of my apparently capricious behavior, you will be authorized to make minced meat of me in every respectable social or cultural gathering.

A year, Mrs. Callam. I ask you for only a year. And I implore you not to speak of this flight of mine to anyone.

When Henrietta read the letter, she flew into a rage, but she complied with Lafanu's request. And she returned to London, more than happy to leave Italy, with which she had never been able to establish a rapport. She really was the loyal woman Lafanu had imagined her to be; she didn't speak of her for a year. Her lips were sealed, even though she very much regretted not having that portrait of herself against the background of the Roman Campagna. "It would have looked splendid in my drawing room on St. James's Street."

Lafanu Brown spent that year taking care of Bathsheba McKenzie.

She was more devoted to her than ever before.

Outside, Rome was waiting for Lafanu. But she had shut herself up in that nearly sunless apartment with Bathsheba, her former mentor, now almost unrecognizable to the eyes of the world.

As well as to Lafanu's own.

Bathsheba was so thin that she looked like a feather. And at this point, Lafanu was much stronger than she.

In the course of that year, it was Lafanu who gave the servants orders concerning the meals that the signora should eat. But before taking the reins of the house in hand, Lafanu made all the bottles of brandy that Bathsheba had hidden around the apartment disappear. And all the bottles of perfume too, which

Bathsheba knocked back indiscriminately in the absence of cognac. Lafanu obliged her old guardian to follow a diet of thick soups and large portions of risotto. Meat once a week, fish on Fridays, beans and grains on the other days. In fits of pique, Bathsheba would refuse the food or vomit it up. Lafanu, however, didn't give up. "Vomit as much as you like. But you're not getting so much as a drop of brandy from me, Bathsheba." By now she was calling her by her first name, as if they were old friends.

The older woman snarled at her and bared her teeth. And once Lafanu did something she would never have allowed herself to do in the past: She stuck out her tongue.

But when Bathsheba appeared calm, Lafanu told her everything she had in her heart.

"If you only knew how often I had to hide the bottle from my aunt. But she would always find it again. My aunt was already dead, already done for. Maybe that was the reason why, even though she still looked young and beautiful, she turned me over to you. She wanted to save me from her fate. But the price I paid for that salvation was that I would never see her again. Now I couldn't bear the thought of not seeing you again, Bathsheba. Do you understand me? Now that I've found you, I don't want to lose you again. I love you, damn it! And in spite of the differences between us and that odious arrogance of yours, which

comes with being a rich white lady, I know you love me too. A lot."

But Bathsheba didn't speak. She never spoke.

Months passed, and Lafanu still hadn't seen very much of Rome. She good-naturedly scolded Bathsheba for what she, Lafanu, was missing.

"How long is it going to take you to get well, dear Sheba? Hillary's life is in suspension too, and it's all your fault. You can't do this to a girl. She's beautiful, and so brilliant. Don't you think she deserves to have a fiancé?"

And it was then—five months after the girl had moved into their apartment, on a side street off Via del Corso—that Lafanu finally heard Bathsheba's voice again. "So do you," she said.

"So do I what?"

"Deserve to have a fiancé. That Frederick Bailey was a perfect choice. I've never understood why you refused him."

Lafanu burst into joyous laughter. It was so typical of Bathsheba: Mute for months, and then the first thing she said had the flavor of a reproach!

In the seventh month, the two women went out for a walk. They didn't go far, only to Piazza del Popolo to see the carriages. Every day, they added a few meters to their itinerary. And eventually, slowly, they climbed the Pincian Hill. Then they changed direction and went to Piazza di Spagna, then to the

Trevi Fountain, then to smell the odor of fish in the vicinity of the Pyramid of Cestius; they ventured into the intricate streets of the Centro Storico, the historic city center, skirted the Forum, admired Trajan's Column, and at last entered the Colosseum. Finally, from day to day, Bathsheba seemed to be getting better. And it was in those little streets, as narrow as an inexperienced young girl's hips, that Bathsheba blurted out a confession: "My marriage almost killed me. And I made my daughter expiate the hatred I felt for her father. I hated Hillary so. In this, I, Lizzie Manson, and all the others were despicable. We married not for love but because we were obliged to do so."

Then silence, for minutes on end.

Lafanu didn't want to force her. She spoke to her about the landscape, the colors of Rome that she wanted to capture in her future canvases, "when you are well."

She told her things like: "This is where young Romans play at chasing each other under the arches. And when they catch each other they kiss in the moonlight. I think I heard that in a poem. Or maybe I heard it at the flower shop. The guy is such a gabber."

And they laughed. They thought for a while about those young Romans looking for love where gladiators once slit each other's throats before the emperor.

Under those arches, which during the day were so blindingly bright, Bathsheba asked, "Was I a bad mother?"

"Yes, Sheba," Lafanu sighed, then she added, "But you can still make up for it if you want to. Hillary loves you."

"And you love us. That is a gift. And there was a time when I called you nigger. How stupid I was . . ." And a tear, sudden, fleeting, slithered down her cheek.

Lafanu changed the subject, but she was glad to have seen that lone teardrop on Bathsheba's cheek. Bathsheba never cried.

"There are lots of new weeds on that arch. And look there, a red flower growing out of that crack. Oh, if only I had my sketchbook!"

"Tomorrow, you start drawing, young lady." It was the first order out of Bathsheba's mouth in such a long time. An order that did not accept no for an answer, just like old times.

Lafanu smiled. The old lioness was on her way back. Christmas was not far off. In a couple of months, she would write to Henrietta Callam. Finally, she would tell her everything. And maybe, with time, Henrietta would even forgive her.

Crossings

XVI

After that smile, there was no other improvement in Binti's life for months on end. Dr. Lul wrote to me faithfully about my cousin's condition.

> *I want to be sincere with you, there are no visible signs of improvement. Binti eats very little, vomits frequently, her body is covered with pink boils, and she still doesn't talk. She walks and that's it, with a slow, exasperating step. She does none of the activities. Doesn't sing, talk, or scream. It is as though she were stuck in that desert. At least the others scream during the night, let loose their ghosts. Your cousin screams in silence. It is an agonizing spectacle, her mouth opens wide, her eyes dilate, you expect a scream . . . but*

nothing leaves her lips. Nothing but a stone-cold silence. Binti is also hostile to me. She spits on me. Scratches me, if she can. Lets me know I'm not wanted. That getting better doesn't matter to her, that I might as well go away. She is one of the most difficult patients I have ever had in my long career. But I will not give up so easily. I'll find a way to get through that membrane of hers. Binti has decided to keep life on the outside, but I won't allow her to do that. She cannot let her soul be stolen by what happened to her . . .

I clicked off the doctor's message with more anger than pain. Anger for the destiny that had decided to torment Binti. Just as it had decided more than a century ago to torment the fragile body of Lafanu Brown.

HILLARY HADN'T BEEN HOME for days. She'd gone to visit friends in Florence.

And in the last few months she hadn't spent much time at home. Lafanu recalled one of the last conversations they'd had, right there in the living room.

"I can't handle her absence, Lafanu," Hillary said, speaking of her mother. "So I'm going to get away from here with my daughter, at least for a while." And then, after a long sigh, "I can't stand being in this house without her. And if I sold it?"

Lafanu said nothing, and then muttered, "It's yours, Hillary, you can do whatever you want with it."

"You'd still have your studio. I wouldn't touch that for all the world."

"That's yours, too. You can dispose of it as you wish."

"My mother provided for your income, you know, and I wouldn't want to leave you alone, but . . ."

But then she didn't finish her sentence and let the subject drop.

Hillary, wrapped in her swishing gown, went over to the center window.

"It's too noisy here," she said. "Via della Frezza used to be a tomb. Not a peep. Just a few carriages, the minstrels, and the bells from the nearby churches. Now it's a constant buzzing. Unbearable. I hate it!"

Lafanu was silent.

"This is not my Rome." Hillary sighed.

"Things change" was Lafanu's only comment.

"But it's not fair for Rome to change, it can't do this to us. What's happened to all of the picturesque that she lavished on us? Can it really be that it's all being shattered by this unholy din? I'm just glad that mother didn't live to see more of this havoc."

Lafanu nodded faintly, to not seem impolite.

Hillary felt authorized to go on and continued her monologue.

"I don't recognize anything anymore, I don't identify with anything . . . Oh, Lafanu, I hate this Rome with all its identical apartment buildings! And then these streets so wide they just about swallow you up, what's the point? And these Romans who have suddenly become so arrogant, as though they actually believed they're European? I want my old Rome

back, those narrow streets, those dark alleys, those cobblestones that ruined your satin shoes, and those accommodating Romans who instantly bowed to you like servants. Oh, I'd be so glad to go back to our little happy colony."

She wasn't the only one who saw it that way. Even the Murray guides, with their fire-red covers, found all those changes reprehensible and advised visiting foreigners that much of what they had read in the beloved novels had been destroyed by the demolishing fury of the self-styled Italian state whose delusions of grandeur had transformed the capital of the world into a small provincial town.

Hillary was standing near the window with the same attitude of reflection that Bathsheba had in moments when an important decision was looming. And she confessed to Lafanu that in recent months she had come to the decision to go back to America, to Salenius. "I've raised a daughter in Europe, I don't want her to become decadent like this flaccid continent. I want her to have a good dose of sound American principles. Like the ones I grew up with. And this 1887 seems to me like the right year to go back. It's a nice number. That feels good when you say it."

Lafanu smiled. And for a second she had a flash of the young girl of long ago, little Hillary with her wavy blond hair, who had an uncontainable passion for military uniforms and disreputable young men. That

girl who, by pure luck, had not ruined her reputation and who had almost sent her mother to the asylum.

Now Hillary was a mature woman, who talked about sound American principles.

"If you want to come back with me, keep in mind that my house is your house. I will never abandon you. My mother always had you in her thoughts, even if you always insisted on giving back the money when you could, but mother left you an income and I too want to leave you something."

Lafanu thanked her and said, "I'll think about it."

AND NOW, instead of the thoughtful Hillary of a few weeks ago, standing by that same living room window was Concetta. She was stuffing cucumbers into the interstices of the louvered shutters and sprinkling everything with apple vinegar.

"Ants hate vinegar," she said.

And then she smiled. That smile that Lafanu had seen for the first time in February 1870. It was the early days of Carnival and a seventeen-year-old Concetta, newly arrived from Agrigento, or as she was quick to emphasize "in the vicinity," was helping her clean her studio.

Lafanu was very happy that day. She had finally succeeded, after a lot of effort, in getting her atelier onto the list of commercial art studios in the city. Just

three years earlier her efforts had been in vain. She had customers, commissions, but she was substantially ignored by the society that counted. And in the civil, artistic, commercial guide of the city of Rome—another of the important guidebooks—her name was missing.

But in 1870 the studio of the Negress of Rome, as it had been rebaptized by a local journalist, was considered to be on a par with the other sixty-six ateliers operating in the city, some sixteen of which were in the area around Via della Frezza. They were almost all sculpture studios, because in Rome sculpture was in fashion. The sculptors corralled their customers directly in the souvenir shops in Via Condotti. Tourists adored that chaotic street. Dusty antiquated shopwindows, modern mosaics peddled as antiques, fakes sold as authentic masterpieces. And those foreign wayfarers, a bit unwary and a bit naive, filled their pockets and purses to overflowing. Deep down, they all wanted to be hoodwinked. That was part of the adventure.

After Via Condotti it was easy for artists to blandish and ingratiate themselves to the customer of the moment with gab, flattery, and promises of nighttime visits to the Forum. And between a quote from Cicero and one from Catullus, which, naturally, the hapless traveler was clueless to decipher, it was a snap to get them to commission a bust of a likeness

of Marcus Aurelius or Tiberius. Lafanu was disgusted by those fraudulent tactics, by those unsavory, vulgar approaches. And in her early years in Rome, difficult years for her career, she tried to make her work speak for her. Certainly, like everyone else, she had to bow to commissions. The money came in handy, not least because it gave her a certain independence from Bathsheba, who kept on telling her, "Don't you worry about money as long as I'm here." But her presence weighed on Lafanu. She loved her, but Bathsheba still belonged to the master race. And more than once, even after her convalescence, she had tried to have her say about Lafanu's artistic production. Every time, Lafanu was annoyed by her invasiveness. And she often complained about it in her letters to Lizzie Manson.

Lizzie didn't last long in Baltimore.

"It wasn't time yet," she had written to Lafanu, "to take my oars out of the water. In Baltimore, I felt like I was fit to be put in a coffin and that helped me more than anything to understand that I am alive and that my students, whether they be few or many, need me." Lafanu needed her, too. And it was not rare in their correspondence for Lafanu to write: "But why don't you come to Italy, Mrs. Manson? We would be perfectly content, and Bethsheba always asks me about you, she misses you dearly."

Lizzie would answer: "You have to keep Bathsheba out of it, you are the one who commands the

brushes, not her. You have to give your art the free-
dom it deserves, and then you'll see how it flies."

Lafanu swallowed her saliva.

That word shook her down to her soul.

Could an artist pressed by commissions be free?

IN THOSE YEARS when she had to think about her
career, Lafanu had neglected her sketchbooks. And
she had devoted herself, like everyone, to portrait se-
ries of the most improbable subjects. With time, her
commissions increased and her reputation, despite
all the obstacles, was growing. But the art world of
Rome was ruthless. It did not forgive the success of
neophytes. And it was not rare for someone who had
smiled at her in public to later stab her in the back
with a series of carefully honed scimitars. Low blows
were the daily bread of the art world. And Lafanu
was quick to become the target, more than others, of
everyone's envy. It was said that she was disagreeable,
irascible, violent, that she smelled, that she ground
her teeth, that she was incapable of discretion.

"She treats her customers abominably," one of
her painter colleagues said, and a sculptor spread
a rumor that young Lafanu was a witch. "She hates
whites and more than one of her customers has
gone back to their pension assailed by malarial fever
and all kinds of hexes." A black aura was gathering

around Lafanu's head. But she didn't relent. And she tried to make her work the best it could be. She became irritated only when she read that an old friend of Bathsheba McKenzie's, who had visited them just two weeks earlier, had written horrible things about Bathsheba while in her own home. She had called her a hag, an old witch, and had insinuated that a woman who paid a negress to splatter canvases must not be completely sound of mind. About Lafanu, on the other hand, she had said what so many were fond of saying behind her back. But to see it written in black and white by that Henry Chapman, self-styled writer of moral pamphlets, had a certain effect on her.

He was not the first to have devoted space to her in his pamphlets, but he was certainly the one who annoyed her most.

When Bathsheba read the article she roared with laughter.

"They wanted to destroy you and instead they created you, my dear." And then she added naughtily, "Now you'll see how many come to your studio just to have a look at you. To touch your skin. To get a glimpse of the Negress of Rome. We'll be drowning in commissions."

CARNIVAL ALWAYS BROUGHT a large array of foreigners to Rome. And those were the days when the

artists' studios were jam-packed. On that day in February 1870, when storm clouds were threatening to burst, a rousing crowd gathered in front of the door to Via della Frezza 56. There was a constant coming and going of artists, curiosity seekers, wayfarers, and pilgrims. There were even a few ragged and hungry beggars for whom Lafanu always kept an apple and a hunk of bread in her supply cabinet.

Lafanu was fairly agitated herself. That very morning, at breakfast, she had received a letter announcing the visit, for just before lunch, of Diana Cleveland. That was a name well-known and feared among American artists in Europe. It was she who decreed an artist's success or her miserable extinction from the circles that counted. And in those days, her feet, clad in cavalry boots that gave her a touch of virility, were planted in a Rome about to become the capital.

It wouldn't be long before the city was annexed to the Kingdom of Italy.

But at least for the foreigners, who almost never took an interest in Italian current affairs, everything was still wrapped in the mists of the thickest fog. For many expatriates in the arts it was more important to know the movements of Diana Cleveland than those of Pope Pius IX. Because it was Cleveland who, with one word, could change the course of a career.

That morning after reading the letter, Lafanu's hand was shaking a little. She was alone. Bathsheba

and Hillary were in Pisa visiting a friend. And she was there in Via della Frezza with the new cleaning lady, Concetta, whom she had to train. Her plan had been to keep the studio closed that day while she instructed the new maid, but the letter had changed everything. She had to find a dress suited to the special occasion and somehow get her hair, frizzier than ever from the humidity, under control.

She felt exhausted. The last she few days she had worked against her will on the portrait of that disgusting Mr. Mosely, on whose bovine face she read a deep contempt for herself, but work is work, and she had laid down a rule never to respond to provocations. But when she had to give a little rosy color to that pockmarked skin, "that you must hide in the portrait because I'm paying you and I demand to have what I pay for," Lafanu had asked herself if she was doing the right thing.

It had been two years now since she opened the studio. And she had understood immediately that the competition in Rome was intense. Her rivals were Stacey Morley, Miss Olga Stebbins, the veteran Carol Whitney, and Mr. Horace Cushman. She couldn't give in.

They were the ones who denigrated her the most. They who wanted the negress exposed to public derision.

They would certainly be dying of envy on hearing that Diana Cleveland would be coming to her studio at lunchtime.

To hers, not theirs. Just the thought of it was already a great victory.

LAFANU DECIDED to wear a two-piece outfit of blue faille with a bodice closed by buttons down the front. It was not a work outfit but she certainly couldn't welcome Mrs. Cleveland in her usual beige overalls. Sometimes a little theater was necessary to impress people. And Lafanu, ever since she had become the owner of a studio, had pulled out all the stops. She was taking her new role very seriously.

Diana Cleveland was not at all how she imagined she would be. She was cheery, down-to-earth, with a ready wit and the glint in her eye of a mischievous little girl. Contrary to what Lafanu had been told, there was nothing monstrous or mean about her. Her face was rather ordinary and her straight-as-spaghetti hair had none of that touch of exuberance that Lafanu was expecting to see in a woman so talked about. That day, she was wearing one of those impossible outfits that made women look like poplar trees. The corset was so tight that the journalist's already thin figure was magically transformed into a laurel leaf.

She was lively and spontaneous. The first impression was what counted for her.

Lafanu had prepared a speech to recite with all the right words, well arranged and lined up like little tin soldiers. But she was soon forced to drop the whole thing. There was no need for it. Diana Cleveland wanted to see her at work.

"I'll sit here quietly and watch you. If you don't mind," she said.

Lafanu shook her head, petrified by a request that she hadn't contemplated. She was sorry her easel was occupied by the portrait of that doughy-faced, bleary-eyed Mr. Mosely, gawking at her from under that mass of fuzz covering his cranium. If only she'd had a better portrait available, she would have shown her with some virtuoso strokes of her brush how high her art could fly! But she had no choice. She had no other material at hand. She had to content herself with the porcine eyes of Mr. Mosely to help her stupefy the journalist.

In the meantime, Diana Cleveland had found herself a corner from which to observe Lafanu, not too far away from the threshold of the studio, where the coming and going of tourists and curiosity seekers was still in progress.

"Do you always have this constant flow of customers?"

"They're not all customers, sometimes they come in just to look at me. And it's Carnival. Rome is more crowded than usual."

"Ah, I see, they come to look at you."

And it was then that Lafanu, to overcome her embarrassment at being observed by that journalist who would determine her future, began to talk. About her work, her interests, her reading. Naturally, she talked about Corinne, her Corinne, whose exploits she tried, however clumsily, to imitate. "She gave me all my love for beauty. At times it feels like I'm looking at this city through her eyes full of innocence and virtue." She avoided saying that, in the same book, the sterility of Nelvil's gaze upset her. The male protagonist had been odious to her right from his initial appearance. Ah, so much Britannic pomposity! So much arrogance! Furthermore, how dare that two-bit Scotsman mistreat her sweet Corinne, not consider her worthy of him just because she was a half blood? What was it about the Italy flowing in Corinne's blood that didn't measure up to the Scotland racing through Nelvil's veins?

Diana Cleveland was struck by that cultivated literary disquisition about a book that she, too, had obviously loved. And by now she was completely taken with the Negress of Rome, about whom she had heard talk even in Venice, where she lived six months a year.

All the same, she maintained her cynical scowl. And despite her admiration for Lafanu Brown, she didn't, for even a minute, relax her scrutiny, until she finally burst out with "How in the world do you put up with all these customers, for example that woman over there who is handling that canvas as though it were a piece of fabric on sale at an outdoor market? I would kill her. I must confess that I would surely become violent."

Lafanu was also alarmed by that woman and by her touching the painting. The portrait of Countess Maniscalchi was one of the best she had done in recent months. She could not allow anyone to ruin it.

She took a quick look around. There were eight people in the studio, including Diana Cleveland and Concetta. Most of them were standing behind her, intent on observing the paintings. There were both men and women. Upper-middle and high class, as could be seen from their fashionable dress. One of the men impressed her with his broad shoulders. She wasn't able to see his face. She almost felt a thrill, looking at those big shoulders. The woman, on the other hand, the one who was touching the painting with her black-gloved hands, was showing her profile. She had a full face, excessively round. What to do?

Diana Cleveland was observing her. Then she said, again, "I would lose my patience with that one there."

"If I lost mine, Miss Cleveland, I'd burn all my bridges. How could I pretend to sell my works if I didn't welcome warmly those who come to visit my studio?"

"But even when people are rude and ill-mannered like that woman who touches everything she sees?"

"Her, too," Lafanu Brown replied with a smile, and then she added, "I'll show you how I manage to untangle the knots with my visitors."

And she quickly made her way over to the woman who was still touching the canvas.

She immediately took note of her dress. It was sophisticated. So out of line with that overly full face the woman was cursed with.

Lafanu tried to interpret the expression on her face and realized that the woman seemed rather glum.

That gloominess, that full face, those evasive eyes, that affected refinement of her wardrobe, all seemed strangely familiar to her. But where the devil had she seen her before? At one of Bathsheba's charity dinners, perhaps? After all, it was only on such occasions that Lafanu crossed paths with the capricious upper classes.

She stared at the woman from a distance, but then a giant shadow clouded her view. Lafanu looked up in surprise and saw in front of her the man with the enormous shoulders she had noted earlier. Her unease turned to terror.

Meanwhile, the woman had left without Lafanu managing to decipher her face. The man was still looming over her.

"My wife doesn't know that this is your studio, Miss Brown," he said to her in a grim voice.

Lafanu was confused by the timbre of his voice. As though she already knew him.

"Perhaps you didn't recognize her. But you, Miss Brown, attended the same college as my wife in America, Coberlin."

And in an instant the past poured over her. Those classmates that barely spoke to her. And who, when she happened to run into them in the hallways, muttered "that nigger smells," "get washed," or "Oh God, I'm going to throw up, how disgusting."

"I'm going to say hello to her," Lafanu said mechanically to that man she didn't know.

"My wife doesn't know that this is your studio, Miss Brown. She doesn't know anything. It was I, miss, who dragged her here, to Rome, to this Via della Frezza."

Lafanu gave him a puzzled look. "You?"

"I wanted to apologize to you, Miss Brown. That was my only purpose in coming here. That night . . . when . . . they did . . . that night after the opera . . . in 1859, you remember? When they humiliated you. You see, I was with a group of boys waiting outside for the opera to end to see our girlfriends, yes, we considered them ours, to . . . well, to caress them with our

eyes, dream of their kisses. Then, however, we saw you come out of the theater and almost immediately some girls, panting breathlessly, came running down from their opera boxes and told us to 'give that nigger a good lesson, she thinks she can go to the opera with white girls.' My future wife was also part of the group. I have always been in love with her. And I got behind all the others. But I want to assure you, Miss Brown, that I had no part in the violence. Not me, even though she forced me to go there, to look on. I love her, and I was afraid she wouldn't marry me if I refused to do what she told me . . . Maybe you don't understand. But I loved her so much, I still love her. Even if she's a witch, but . . . That night I should have intervened to stop them. But I didn't, and my remorse torments me every night."

"I don't understand you. You were there that night at Coberlin? I don't understand . . . who are you?"

The man, despite his imposing stature, trembled.

"I cannot stay here any longer, Miss Brown. But please forgive me, if you can, I beg you."

He hurried out of the studio and joined the woman. He wrapped his arm around her shoulders so she couldn't turn toward Lafanu, who had run to the door. Then he turned and cast Lafanu a parting look full of pain and guilt.

And in an instant, that couple who came right out of Lafanu's past, disappeared into the mists of a Rome preparing itself to celebrate Carnival.

Crossings

XVII

The colored artist, the Negress of Rome, our little black face . . . That's what the locals and the expatriates called Lafanu Brown.

"Little black face, like the old fascist song?" I asked Alexandria, incredulous.

"So it seems," she answered sleepily.

It was one of our weekly Skype calls. We spoke very little about ourselves, mostly Alexandria gave me the latest news about her upcoming wedding. She was in the "I hate my future in-laws" phase, and I let her blow off steam. Then, to amuse her I told her about my experiences as a single Black woman with a big butt in a country under a size 12 dictatorship. "Men in Italy, be they white or Black," I said, disconsolate, "have been bamboozled by years of Berlusconian TV.

They're looking for little girls, but in the meantime we've become women!"

"That's not fair, come on . . . whatever happened to the Italian Latin lover? When I was young I thought all Italian men were like Rossano Brazzi in *Three Coins in the Fountain.*"

"You got it! Nowadays they're all tattooed like pirates, too bad they've got tiny little hearts like Bambi."

"I'm hearing a little resentment . . ."

"No, no. By now, my ex, that 'I can't live with a sick woman,' I've erased him."

"Can you erase a person? Even a rat like him?" Alexandria asked me.

"Maybe not," I replied, sincerely. "But by now I'm over it. I've digested the end of our story so well that I wish him the best of luck with his new girlfriend. Sure, if I happen to see him on the street, I'll run him over with my electric motorbike. That way, at least, it'll be an ecological homicide!"

Laughter. Then, as usual, we went on to talk about her, our Lafanu, the mysterious angel that bound us together. We were disappointed with the artists that we had found in our search. Apart from Uarda and a few others, they were all pretty tame. "Too tied to their brand and to jumping through the right hoops. No spirit of adventure," I said. "Contemporary art is becoming standardized even when it comes to protest."

"Maybe we shouldn't be looking for professional artists," Alexandria said. "You remember what Lafanu said about some of her colleagues?"

"Sure I remember. She was always writing to Lizzie Manson that they seemed more interested in appearances than substance."

We ended up talking about the Lafanu exhibition for the Biennale. Alexandria was dubious about exhibiting a painting that I actually liked a lot. It showed a line of Garibaldians taken prisoner by the Papal State. They are beaten, raggedy, suffering. And two faces stand out from the rest of the line: one of a young man with red hair and the other of an old guy with a handlebar mustache. They're not relatives but you could feel in that shared pain an elective affinity, which Lafanu had captured with fast, concentric brushstrokes. Everything was nuanced, almost impalpable, but precisely because of that, so sharp. We knew a lot about the painting and about the episode that inspired it. Our source was Rebecca Wilton, also a painter, today almost unknown, who had gone to Rome before her marriage to get some training and breathe in the classics. She specialized in landscapes with ruins. A few of her paintings can still be viewed in some provincial American museums. Like many expatriates, Rebecca Wilton was not at all interested in Roman current events. For her, as for others, Rome was a backdrop. But sometimes history

is too pressing and even those who were not directly involved can't help but watch it unfold. That was true in November 1867. Lafanu was still caught up in the "illness" of Bathsheba McKenzie but had started to let herself be seen in artistic circles. And her dark skin had immediately given her a sudden fame. On November 3rd of that year, French and Papal troops defeated Garabaldi's red shirts at Mentana. It was a slaughter for the Garibaldians.

Thirty-two dead and a hundred and forty wounded for the Papal troops. For the Garibaldians the outcome was very heavy, some hundred and fifty dead, two hundred and twenty wounded, and seventeen hundred prisoners. Many said that it wasn't the French that defeated them but the chassepot, thin rifles that shot lethal bullets; they caused little blood loss but bones were reduced to fragments. When the French entered Rome in triumph, crowds of people lined the streets to watch. Among the crowd was Lafanu Brown. And it is Rebecca Wilton who writes to her family that "the colored artist was very upset by that foreign presence. I had seen her in society, with her frank, benevolent face. She seemed to me to be a sweet, serene person. And even before the appearance of those troops she smiled at me amiably. Don't laugh at me, but even negroes know how to be gentle and civilized. But her face changed at the sight of the French soldiers. I saw her wrinkle her brow, tighten

her jaw. And when I asked her, 'In your view, Miss Brown, where are these troops going?' she answered me with a brusque 'They can all go to hell, damn them, that's the place for invaders.' We spoke in English, luckily no one understood us. We were surrounded by frightened Italians. Then, without saying goodbye, I saw her head off into the crowd. When we met again in society neither of us raised the subject. We smiled at each other as usual. As if nothing had happened."

There were just three Risorgimento paintings by Lafanu Brown: that one of the Garibaldians taken prisoner at Mentana; a portrait of a young Garibaldian; and another portrait, on commission, in memory of Margaret Fuller.

"For Lafanu, politics was very important," Alexandria said.

"Because of Frederick?" I asked.

We had a tough time saying that name, as though the hurt it had provoked in our beloved also hurt us.

"Yes, but not only. In those French soldiers, the invaders of Rome, she also saw the Yankees who had exterminated her people. Let's not forget that Lafanu was Black but she was also Native American."

"But Frederick . . ."

"Frederick had given her, even though it was long ago, the courage to express herself politically. That's why I, who have been studying her for years, think her three Risorgimento paintings are so important.

Because even you and I, through Lafanu, are doing politics."

That's when the light turned on for me. I decided— and who knows why I hadn't thought of it before—to go to Mogadishu. I would find our artists there: among those who had failed the *tahrib*, among those who had been rejected at the searing-hot borders of Europe.

I told Alexandria. "I'll take Uarda with me. That girl is smart. And maybe there we'll find what we're missing."

Alexandria shouted out with joy, "Lafanu would have loved this idea!"

ALONG WITH EVERYONE ELSE, Lafanu Brown, together with the stalwarts Bathsheba and Hillary McKenzie, escaped from Rome in the spring of 1870.

It was uncertainty more than fear that spurred the movement of the expatriates toward the countryside, toward the Castelli Romani, toward an elsewhere. The city was about to become the capital of the realm.

The pope, by now everyone was saying it, had to give up the scepter of power. Coats were turning, customs were changing, things were being done differently. Newfangled patriots were popping up everywhere, shouting *Viva l'Italia!* with hands on hearts and eyes fixed in reverential stares. It was time to

genuflect to new masters. And so, even in its most secret alcoves, Rome was adorning itself in the tricolored flag.

But some, who knew Rome down to the depths, wisely advised, "Don't think for a moment that the church is dead. She'll take back in spades all that's been taken from her."

And in spades, as it turned out, the church started making deals. Together with the fading, income-hungry aristocracy, the purple-clad cardinals were the first to speculate on lands and to sell them for their weight in gold to the Italian state. They were the first to make Rome the capital into capital for themselves.

Amid all that hustle and bustle, the only ones left on the sidelines were the foreigners. They were not prepared to accept all the disruption that the city's new status brought with it. "Certainly, the Italians have a right to their capital, but . . ." But they selfishly thought that they, too, held some rights to the city. Indeed, perhaps even more rights than those filthy stinking Italians. The right to quiet, for example, or to the glorious picturesque that Rome offered copiously at every sunset. Lafanu herself was not ready to renounce the serenity that the city had managed to provide her in those years.

That spring of 1870, the eve of her departure for the Castelli Romani, was for her a time of deliveries. The studio absorbed every minute of her time. As

Bathsheba had predicted, Diana Cleveland's article had tripled her small volume of sales. Finally, after so many sacrifices, her art was producing income, so that she was no longer totally dependent on Bathsheba. She worked without pause to satisfy those who commissioned portraits or sketches from her. And her imminent departure from the city forced her to work even at night to meet the deadlines for delivery.

Her customers must be satisfied. Her customers must be happy. Everything had to be delivered before she loaded her trunks onto the carriage. Otherwise, she wouldn't be able to abandon herself to the beauties of the Castelli Romani and to that pure, bracing air that Goethe had praised in his writings.

LUCKILY, even with those time constraints, Lafanu managed to carve out some free time for herself. She was fond of walking in the city and she was dying to complete a work that was all her own and that she deeply cared about. She had realized during her long walks that Rome was a forest. That all those crumbling ruins were home to numerous enchanting beasts, some in flesh and blood, others in stone and marble. It was not unusual to find a stray cat between your feet, or worse, a rat. And it seemed that in almost every house you walked by there was a wet-nosed,

watery-eyed dog, offering tender affection to pass-
ersby. Rome was a triumph of crows, seagulls, bats,
wolves, and lions. The rivers were ruled by nutria and
the skies by cormorants. The city nursed by a wolf
was a crossroads of civilization and nature, barbar-
ity and perfection. Lafanu was attracted by that wild
side of the Eternal City, virtually enthralled by it. She
saw in Rome a reflection of the high plateau where
she was born, where she lived with the Chippewa.
There was something about Rome that reminded her
of the sacred mountains of her childhood.

And so, maybe out of homesickness or maybe
simply out of wonder, Lafanu began to fill her sketch-
books with portraits of that city of wild animals. For
months, she had been devoting her free time, what
little she had, to this peculiar project. It gave her joy.
When she could, she ran from one part of the city
to another, drawing animals, enticing them out of
their hiding places, reveling in their wildness. Some
were crouched under capitals, others boldly winked
at her from a fountain. She wasn't bothered by their
sneers and she tamed them with her skillful use of
chiaroscuro and precise pencil strokes. And there,
showing themselves off in her sketchbook, were the
armadillo from Bernini's Fountain of the Four Riv-
ers, the horses of the Dioscuri Fountain near the
Quirinale Palace, the tightrope-walking turtles
of the fountain in Piazza Mattei, the bees on the

Bernini family's coat of arms, the lions from Piazza del Popolo.

But then a dark specter emerged and upset her plans.

THE SPECTER PLUMMETED into her life while she was intent on doing a quick sketch of a dog that was on a bas-relief under the portico of the basilica of San Lorenzo in Lucina. It was a dog in mourning, attached to the skirts of its mistress, Clelia Severini, dead at the age of nineteen. The animal was pressing against the girl's body to keep her from going away. To prevent Hades from taking her as a trophy. He was the emblem of unbearable pain. He barked, squealed, growled, moaned, and implored his mistress to stay, or at least to take him away with her. There was everything in that dog: fidelity, love, respect, admiration. That bas-relief by Pietro Tenerani, completed just forty-five years ago, deeply moved Lafanu.

While she was concentrated on drawing, an opaque glare flashed across her eyes. She was bent over the page, but something passed through her iris and pupil. A specter, which from some unspecified place in that piazza was reverberating to draw attention to itself. Lafanu was incredibly quick to close her sketchbook and turn her gaze toward the phantom figure. She saw it, already in the distance, with its

curls dancing on the architecture of an animalesque Rome.

Lafanu thought she recognized the woman who had come to her studio a few days before. Her former college classmate. She who had helped to ruin her life.

She couldn't get a good look at her face. But she could see her hips swaying back and forth in rhythm as she ran. "It's almost certainly her," Lafanu thought. "Damn her."

She wanted to catch up to her, to talk to her, to understand, finally . . .

"Why me? Why did you have to choose me to hurt that night?"

She hadn't been sleeping well since she had seen that woman and the man with the massive shoulders in her studio. During the night, she screamed in the silence of a pain she didn't know how to express. She decided to follow the specter.

But it was fast, damned fast, and it was going down the avenue, which the piazza opened onto, with long strides. Lafanu struggled to keep up with that rabid, self-assured gait.

The specter was getting farther away and forced Lafanu to wedge her tall figure into those alleyways that turned the city into an intricate labyrinth. She was breathless. She was just about to give up the crazy chase that she couldn't figure out where it was taking her, when she intercepted the gaze of

the elephant in Piazza della Minerva, which urged her not to let up, to confront that specter and erase the past once and for all. So Lafanu continued on the wild chase, slithering like a lizard along the side of the Pantheon, that solemn temple of a thousand virtues. The specter, however, wouldn't let her catch up to it and even stepped up its pace to leave her behind. So it knew it was being followed? But at Sant'Eustachio, Lafanu almost caught hold of the specter that tormented her. She was close, so close that she could see its every gesture. Right then the specter was looking up at a point on the facade of the church of Sant'Eustachio. Lafanu looked up too and saw the head of a ferocious stag with a cross between its horns. A flash blinded her. For an instant that seemed endless to her, the ground around her started spinning. She remembered what her aunt, down in the valley of the Chippewa, used to say about stags. "They are the ones who bring daylight to the Earth. They transport the Sun in their horns. Don't you see how they lean toward the sky? It's there that life runs its course, that life decides." And she warned her: "Don't keep your eyes on those fated horns or they will burn out and your destiny will vanish." But Lafanu was stubborn, she wanted to see the beacon in those horns. And the specter was so close by now. It was a question of seconds, the time had come to confront it.

They hurtled down alleys and disconnected streets, and finally, in a narrow side street, Lafanu caught up to the fatal phantom. She grabbed her by the shoulders. The specter remained immobile, without turning around. Lafanu, with her fists closed tight, started striking her on the back and neck. "Damn you," she shouted. But that phrase was a trifle compared to what she felt. Dancing inside her was a mad desire to spill blood. She wanted to annihilate her, that hateful specter, just like *they* had once annihilated her at Coberlin. She wanted to take her scalp and offer it up to the gods.

"Slut," she repeated in an indistinct, hoarse murmur. The woman, who was now covering her head with her arms, was wearing a strange beige dress, similar to the one Lafanu wore when she was painting. Maybe she had stolen it from her? She struck her again, two slashing blows, and the woman fell to the ground.

Then she heard a voice in her head: "Stop it, Lafanu, you're chasing your ghosts. They'll take you to Hell if you don't let go of them."

Who had spoken?

Lafanu was deaf to every appeal.

With all the force she had in her body she landed a kick in the ribs of the phantom figure lying on the ground, and then she landed another, carefully aimed. And then another, and another, and another, and still another...

After all those blows, a ray of sunlight illuminated that alleyway. There was no one on the ground. Neither man, nor woman, nor animal.

No one.

Lafanu looked at her hands. And it was terror when she saw the blood on them.

The specter was none other than herself.

She had been chasing a ghost.

Crossings

XVIII

It was a long trip, but not as exhausting as I thought it would be. To get to Mogadishu we had to pass through Turkey, and for two hours, Uarda and I made the rounds of the duty-free shops at the Ankara airport, replete with pottery vases and religious souvenirs. In one of the many bars, we had a kebab that Uarda found not very spicy.

"On the street where I live I've got Vladimir the Romanian who learned how to make a kebab that's so good people in Florence stand in line to get one."

I laughed. "The world is all mixed up now from every point of view. Romanians are making kebabs and the Turks are making goulash."

When she was finished eating, Uarda pulled a book out of her pack and started reading. "A crime

novel. Because they're relaxing and they don't make me think. And this P. D. James is really good. She's an ace at the psycho thriller!" I nodded. I liked P. D. James a lot, too, she was the Jane Austen of crime novels and she helped me to not think about life problems. I envied Uarda for having thought of outfitting herself with a P. D. James for support. I, on the other hand, hadn't brought anything along, just my Mac and Lafanu's papers. By now I read nothing else, I practically lived with her 24-7. At times I got so confused I found myself thinking I was Lafanu.

"That happens to me, too," Alexandria had reassured me. "We follow her every breath. It's inevitable."

After a while, Uarda fell asleep with the book in her lap. Looking at her, I thought that our trip, with our strong passports, was so simple for us. A few stamps, the turnstiles to pass through, and there we were, inside the bubble of the privileged.

But for Binti, and all those carrying a weak passport, there was only barbed wire, militarized borders, the fear of losing their bodies, even worse, the certainty that something irreparable would happen. They set out on their journeys in terror. Because the nightmare arrived every damn time.

And Binti was still trapped inside her half-completed journey.

How was it going to affect me, seeing the cousin I loved so much for the first time in those conditions?

And me, the cousin from rich Europe, what effect would I have on her?

We were separated by geography. By our passports. I was protected, she was not.

I wonder if similar thoughts passed through Lafanu's mind when she was on that steamship from Salenius to Europe. It was a voyage of the privileged that she had made with her heart aflutter. In the letters that she wrote from Liverpool to Lizzie Manson and Mulland Trevor she talked about her excitement for the voyage that she had yearned to make for so long, mixed with the fear of unpleasant encounters, and finally, relief, given that everything had gone well. But about what happened on the bridge she had talked only with Lizzie Manson. "Baby Sue gave me a lock of her hair. She said to me, 'Throw it in the water. Into that ocean as bleak as the night, where my sister and my mother were also thrown. I don't know how I survived seeing how they suffered under the weight of those horrible men. It's not human to see your own mother or your sister humiliated in that way. I didn't see them die. Their bodies were filled with the breath of too many men, and after they had their fun, they threw them to the sharks. They died under the weight of those beasts, but I know that they're there. They have created another life in that sea. I sometimes see them in my dreams. They're cooking manioc and dancing like they used to in the village. In the

ocean, there are lots of women, lots of men. Their bodies have been transformed; they no longer have hands, but scales. Only when they dance do I recognize the people they used to be. They have become fish with rebellious, frizzy hair. But they don't know what happened to their loved ones. They don't know that America turned out to be worse than that ship. Sometimes in my dreams, I see a shadow of worry on their faces, and I know they're thinking of us. If you can, Lafanu, throw this lock of my hair to my mother and sister. Whisper in their ears that I'm doing fine and that the Goddess has taken care of us, of me, and of you, of everyone.'"

Baby Sue was not the only one to ask Lafanu to throw locks of hair into the Atlantic. Many people, even from nearby counties, had heard about her upcoming voyage and had begged her to let their ancestors know "that we're fine. That we're still struggling."

In London, settled in the home of Henrietta Callam, Lafanu confessed to Lizzie Manson, "I don't know how many locks of hair I threw into that ocean. The ocean took them in. And I swear, you'll take me for crazy, but I felt someone, maybe our Goddess, caress my cheek and whisper to me: 'You did the right thing, Lafanu Brown.' So they said."

The Goddess . . . Lafanu named her often in her letters to Lizzie Manson. Who was she? Alexandria couldn't imagine. She had made some hypotheses

but other researchers had rejected them. For Alexandria, the Goddess was a native divinity. For René Bérgere, from the Sorbonne, there was no doubt that Lafanu was referring to Yemanja. Roberta Bolton of New York University, on the other hand, was dubious about both ideas.

"We may never know," I said to Alexandria. "But for Lafanu she was important. Maybe she was just a guardian angel she turned to when she was worried."

"Could be," Alexandria said to me, and then added with a laugh, "By now you too are officially one of the soul sisters of Lafanu Brown. You're trying to reason like she did. Welcome to the club, my friend."

MIDMORNING, Lizzie Manson asked her new maid to make her a strong cup of tea with a slice of lemon. She was upset. A wave of confusion had been troubling her heart for hours and she wanted to squelch it with something invigorating. It was Sunday and, fortunately, she didn't have any students to tutor. No Plato to inculcate, no Chaucer to interpret. She was on her own, with no commitments. Free to close her eyes and dream.

For more than a year now, her garden, once arid and measly, had turned into a forest of climbing plants and capricious flowers, which her neighbors always looked on with a touch of suspicion and, occasionally, admiration.

All thanks to Derma. It was she, the new all-around handywoman, who had worked the miracle. She came from rural Missouri, but the hard life she had suffered there (the marks of hunger were still visible in her sunken cheeks) had not robbed her of her sense of beauty. Thanks to Derma, the house, Lizzie's same little house on Thirty-Ninth Street, notwithstanding its cramped tiny rooms, shone like a mirror, brighter than the sun. Every object was polished to a T, every tile sparkling clean.

But it was in the garden that Derma had done what Lizzie defined without hesitation as an astonishing job. Already on her second day, the girl, just eighteen, was on her knees pulling out weeds and battling parasites with her bare hands. Then she got herself some rakes and hoes, and with the grim determination of a general, set about tilling the soil, giving each clod a new life to cling to. They were days of pitched battles, which Derma won through extraordinary effort. Many of the plants were dead and were sacrificed to beauty. But others arrived to replace them. Derma got Lizzie to give her some small change she used to buy them at a nursery that sold them at good prices. She had succeeded in making that garden almost as luxuriant as the tropical forests of South America. From time to time, Lizzie even saw her talking with the flowers. "She must be a little crazy," she said to

herself. Then she noticed that the flowers grew bigger and stronger after those chats.

Now it was just so pleasant to sit in that garden and loaf. It was the only place that she could regenerate herself and work through all the things that weighed on her. And it was there that she often read her correspondence.

Lizzie was waiting for her tea. Hands closed tight and brow furrowed. Her worries wouldn't let her breathe. On her lap was a newspaper that she didn't usually read, which had been delivered that morning. It had been a struggle to find one, but Derma, who had made friends with some of the neighbors' servants, had managed to procure a copy. It was a newspaper for negroes, and reading it made Lizzie almost feel she was an intruder. But she had to. There was, or so she had been told, an editorial signed by Frederick Bailey which, according to the gossip she had heard, intimately concerned her.

Lizzie looked toward the inside of the house and saw Derma hovering over the stove.

"Oh, sweetheart!" she thought. "She's also making me those toasted sandwiches I like so much. Wonderful girl."

She closed her eyes, squeezing them tight in satisfaction, as she had done when she was little. The thought that Derma was in the world made her smile. But the newspaper and that article by Frederick

Bailey (damn you!) were still there to stifle her. No sooner than it had appeared, her smile vanished.

She had met Frederick on the occasion of the small exhibition that Salenius had organized to celebrate its Civil War heroes. Lizzie had been one of the organizers. Theirs was obviously a small town, nowhere near the caliber of Boston, Philadelphia, Baltimore, or Atlanta. Yet Salenius was teeming with art lovers. Over time, the town had produced some sophisticated artists, who had brought glory to the county. It was preeminently a city of sculptors, and that was the era of celebratory monuments and portrait busts. Every city wanted to celebrate its heroes, exhibiting their noble figures in the public squares for the benefit of posterity. Men who had given their blood and lives for their country, whose names were already inexorably sinking into oblivion. Commissions flourished everywhere. Studios all over the nation were working busily. Many works were being commissioned to artists living abroad, especially in Italy, where sculptors were not only numerous but ready to satisfy any request, embellishing it all with the prized marble of Carrara.

Lizzie was on the committee that Salenius had named to organize a celebratory exhibition. She had been called for her expertise, and this was a source of pride for her because she could finally stake her claim to a leading role in the world of the arts and

display her deep knowledge, which, in Salenius, was without equal. Her prestige made it easy for her to select the artists she most admired for the exhibition, first among them, her former student and now friend Lafanu Brown. To be sure, it hadn't been easy convincing the committee of her choice. The first objection was "We haven't planned to have a section dedicated to negroes"; and the second, "Dear Lizzie, we can't open our exhibition with a work by that girl. That would be, how should I put it, inopportune."

There was a lot of resistance. Not least because no one on that committee embraced the abolitionist ideas of Roland Perkins.

But Lizzie didn't give in. "If you don't want her, you'll have to do without me, too!" She knew that they, having no expertise, would never be able to organize an exhibition on their own. Lizzie was the only one in town who had that capability.

They conceded. Lizzie Manson's ultimatum had thrown them into a panic. They knew very well that they couldn't replace her and so they agreed that Lafanu, too, could show one of her works—"no more than one, and on condition that her presence remain . . . shall we say . . . invisible."

Lizzie agreed. The important thing was that they let her show. The work would speak for itself.

Like today, on the day of the show's inauguration, which everyone in Salenius pompously called

the National Exhibition, even though it wasn't, Lizzie had asked Derma to make her some strong tea. And when the girl brought it to her, she burned her tongue because she drank it in a rush, throwing it back like it was Scotch whisky. So off she went, with her scalded tongue, to that exhibition where she was finally in a leading role.

The works, especially the sculptures, were mostly portraits of men who had distinguished themselves on the battlefields. All painfully the same. Serious gaze, sweaty forehead, mouth shut, eyes close together, thick beard. Their names were Homer, Charles, Andrew, or Douglas and they were the opaque heroes of a historical period too close to the present to be displaying the skeletons in the closet.

Only two paintings were selected. The first was by a New Yorker, a certain Mike Rodney, whose grandmother was from Salenius. He had painted a Minerva in combat who walked across the battlefields with a slow, measured pace. A painting whose classicism seemed arbitrary and cloying. Lizzie didn't want to take that painting but someone on the committee had vouched for Rodney, saying, "We cannot leave out those who, like Mike Rodney, actually fought in the war." The other painting, naturally, was by Lafanu. Lizzie had commissioned it, telling her explicitly, "This will be your triumphant return to Salenius." Ignoring everything that the committee had tried

to impose on her, she insisted on her former student being present at the inauguration. But Lafanu had declined the invitation. "I still don't feel up to it," and she had added, "perhaps some time in the future I'll be able to come back to America," which sounded like a lie to both of them.

Lizzie had told her that they were unable to pay her but the show would open the doors for her to the American market. "This could be a clamorous success." Lafanu had already had a lot of commissions from her stepmother country. Everyone wanted a painting by the Negress of Rome. After that article by Diana Cleveland, Lafanu's success had become nearly unmanageable. Lizzie knew how much work Lafanu had but she didn't want to miss the chance to bring, if not Lafanu herself, at least one of her works to Salenius. Partly, to give her the space that she deserved in that society, which had not always treated her with white gloves, and partly because she, Lizzie, as Lafanu's former teacher, would shine in her reflection.

They were childish thoughts. But despite herself, she was motivated by them, given that she was growing old. And so she asked Lafanu, with the same authoritarian tone from when they were teacher and student, "to make a hagiographic painting of Barry Maddow, our war hero." Maddow was venerated in Salenius as much as the Madonna in Italy. He had

not survived the wounds inflicted by the enemy, but his distinguished performance on the battlefield had earned him commemorative medals and state honors. Salenius was proud of his blond curls, his gentlemanly comportment, and his heroic death that had placed him among the ranks of patron saints.

Lafanu obeyed without discussion.

Now Lizzie was sitting in her garden, the exhibition had ended days ago, and she felt totally at sea. To calm herself she drank down two large cups of tea. Always attentive to her moods, Derma had politely taken her leave. Lizzie didn't have the courage to open the newspaper on her lap. She already imagined what was written there. She was certain that inside that newspaper she would find insults and anger.

No, she didn't have the courage yet.

That damn Bailey!

SOMEBODY ON THE COMMITTEE, perhaps precisely because there was a work by Lafanu in the show, or simply because many of them had known and loved Bailey during his long stay in the city many years before, had invited the now celebrated activist to say a few words during the opening ceremonies. Bailey had accepted. But when he arrived at the town hall where the event was about to take place, two guards stopped him from entering, accosting him with a "Where do

you think you're going, longhair?" Frederick was dressed with his usual impeccable elegance. For the occasion, he had a gardenia peeking out of his jacket pocket. "So, some cat ate your tongue, nigger?" The two of them were sniggering, and the one with the puffy face took him by the arm with the intention of roughing him up. It would have ended in a fight if Mr. Arthur Rowling hadn't passed by just then, one of the committee members who had most wanted Bailey to inaugurate the exhibition. "Fools, what are you doing? Take your hands off our honored guest right this minute." The guards, who knew very well how much Rowling counted in the city, let go of Bailey's arm and bowed to the gravelly voice of that man they feared. He, too, had been a hero in the Civil War, a friend of Lincoln, and like so many who had fought in that war, he was highly respected in the city. The guards apologized to Bailey, albeit through clenched teeth, almost growling, to which he responded with a defiant stare; then with a regal step he followed Rowling to the distinguished visitors' gallery.

That's when Lizzie Manson saw him.

It had been years since the two had last met, ever since Lafanu's departure for Europe. Lizzie was left practically paralyzed under Bailey's magnetic gaze as he, without so much as a hint of a kiss on the hand, said only, bowing his head slightly, "I find you in fine

fettle, Mrs. Manson," to which Lizzie responded with an equally simple: "I too, Mr. Bailey." Throughout the whole ceremony, however, Lizzie couldn't take her eyes off him. He was different. His features were more mature, his hair frizzier, his arms more muscular. His build seemed more massive, more solid. It was as though the Bailey of years past, thinner and less robust, had been replaced by a man more conscious of his mission in the world. His charming gaze was still the same, but while during the time of his relationship with Lafanu, Bailey had only a mustache that was barely visible on his sculptured visage, now a full beard enveloped his resolute chin. It was as a though his physical presence was following in the wake of his progressively advancing political life.

Above all else, Bailey was a man who had made himself heard after the Civil War. And even though, as always, there were those who were critical of him, he had never retreated an inch from his mission, which was to do good for his people. To break the chains that had been wrapped around their feet. But along with this struggle, Bailey claimed for himself and for the others a new way of being Americans, a way that was inclusive and that would not exclude anyone anymore. He had traveled that big country up and down, from Atlanta to Washington, and he had understood that, despite everything, he, too, belonged to that land of promises and dreams. There

was something messianic in his words. Something that went beyond politics.

Over the years, Lizzie Manson had read him with respect. But now that she found herself just a few feet away from him, other thoughts were filling her head, certainly not politics. She wondered what Bailey would say when he saw the painting by Lafanu Brown, which had been installed in the east wing of the building, along with a statue of Diana the Hunter by a certain Milford Pritchett. So she offered to accompany him "to see the wonders that we have brought together here." They walked through corridors, admired busts, reveled in the perfection of some putti that glorified the war. He spoke very little. He was observing. And Lizzie was intimidated. They had been enemies once. Because of Lafanu. She had thoroughly detested him, saw in him the undoing of all of her efforts on behalf of the girl. He would drag her away from her dream and imprison her in a marriage. Now, listening to him breathe with such vigor, hardly saying a word, filled her with an inexplicable anxiety. But she tried to ignore it, and continued pointing out to him names, works, the reasons why the committee had chosen one work rather than another . . .

When they got to the east wing, Lizzie deliberately ignored the statue by Milford Pritchett to direct Bailey's attention to the painting hanging on the wall. "This was done by Lafanu Brown, whom

we both have had the opportunity to know well." Her voice trembled as she said Lafanu's name and then she looked timidly at Frederick, who was staring at the painting with severity. Barry Maddow, the local hero who was its subject, was astride a horse with a bellicose attitude, almost like a young Napoleon. His features were idealized, the horse decorated in the manner of an eighteenth-century war, the background landscape more like Tuscany than the arid terrain of North Carolina, where Maddow had died. But there was considerable grace in the execution, a certain majesty that the committee had very much appreciated. They had also liked the chromatic contrasts, worthy of Caravaggio, which Lafanu had used to highlight the whiteness of the horse against the dense darkness of the war that loomed all around it. Lizzie was pleased with that painting, which was now attracting crowds of curious viewers. Noting the contented faces of the visitors, she was satisfied. Then, however, she returned to Frederick's stare: His eyes were ice, as though he wished to pull the local hero off his horse and beat him to death.

"Did Lafanu go to Italy to paint hokum? She didn't marry me so she could do this? It is so common. Can't you see that, Mrs. Manson?"

Lizzie flared. "You are profoundly unjust, Mr. Bailey. This is a painting done on commission and Lafanu did exactly what the committee asked her to do."

"Commission? She was supposed to conquer the art world, to go to Rome to become the best, and now she's living off commissions? Off the charity of white folks?"

"You're being unfair," Lizzie replied, irate. "Lafanu is making her way in the difficult world of art. She has to accept commissions. And with regard to her artistic merit, I wholeheartedly disagree with your assessment. This painting is technically perfect. From the time when I was her teacher, Lafanu has not only made progress but she has amply outdone me. She has outdone anyone in Rome and anywhere else in the world with the pretense of taking brushes in hand. I'll grant you that this painting is excessively neoclassical. But that is exactly what we asked her to do."

"I understand very little of what you're saying. I don't know a damn thing about technique or light or color. I am a man born under a palm tree, the son of woman who was enslaved . . . because we are not slaves, we were bound to enslavement . . . and deep down I am a simple man. I only know how to distinguish if something is beautiful or ugly. To you, my criterion is no doubt primitive. But it is utterly sincere. And this painting is ugly."

"Ugly?"

"Soulless."

"How dare you!" Lizzie exploded.

"I dare, Mrs. Manson, because I loved Lafanu, to the point of madness. And now I can't stand the thought that she left me to paint something that anyone would be able to do after a minimal amount of practice."

"What are you saying?"

"Beyond that, it's as though she had forgotten she is a negress. Where are we in this picture? Where are her oppressed people? A picture like this, in which a white man, hoisted atop a white horse, is glorifying himself and his master race, makes me nauseous. Lafanu left me for this? I can't bear it, Mrs. Manson. Not all commissions are to be accepted. And it was wrong of you to commission Lafanu to do something like this. You are not helping her this way."

Lizzie was dumbfounded by those words so full of rancor. She would have liked to rebut. She would have liked to tell Frederick just how much Lafanu was fighting for her freedom. That in order to have a free art, first you had to be free of material needs. That compromising oneself sometimes was the fate of many artists. That she was quite sure that her former student's talent was still there, in those Caravaggian colors, in her techniques that mixed the Baroque with the Renaissance. Lafanu had talent to spare, about that Lizzie had no doubt. She would have liked to tell Bailey that Lafanu had not forgotten she was a negro, on the contrary, she was proud of it. That by

her very existence Lafanu was advancing the cause of her people's struggle. Having her own studio, being a recognized talent, receiving commissions, and being interviewed about her art were certainly not things to be overlooked. Her struggle to emerge was something she was doing not for herself alone but for everybody. Every time she took a step forward, she could feel a multitude advancing behind her.

Lizzie wanted to say all of this to Frederick Bailey. But she could hardly manage to breathe.

So again it was Frederick who spoke first to say, "Here, we negroes are in the trenches. It's too convenient to run away. Lafanu Brown was a coward to leave America. She could have stayed here with me, together we could have done it, fought side by side, but instead she ran away to Italy and now she has sold herself completely. It disgusts me to think that I once loved her."

"She hasn't sold herself to anyone. She didn't run away. She just protected herself. She followed her dream," Lizzie shot back, icily.

"That's what you say, Mrs. Manson," and with a forced bow Frederick Bailey took his leave from her and from that conversation that was becoming less and less civil.

Lizzie remained in the center of the room, trembling.

"What do I say to Lafanu?"

———

NOW LIZZIE WAS AT HOME, sitting in her wicker armchair admiring the begonias. But the memory of that afternoon at the National Exhibition was still quite vivid. Still sitting on her lap was *The Fielding Herald*, the African American newspaper that Derma had managed with great effort to get a copy of and that Lizzie still couldn't manage to read. It was there that Frederick Bailey had published his account of the event, and there, or so she had been told by the members of the committee, "he had torn her former student to pieces." But then they had reassured her: "Nobody reads that negro rag. That Bailey really treated us abominably. To think that everyone says he is such a well-mannered and personable man. All that animosity is simply shocking."

WHILE LIZZIE WAS TRYING to deal with Frederick Bailey's anger, Bathsheba McKenzie, along with her daughter, Hillary, and Lafanu Brown, had fled the dog days of Rome to take refuge in the peace and quiet and cool air of the Castelli Romani.

Actually, both mother and daughter were worried for Lafanu. The girl was loafing around with her feet dragging and a dull look on her face. On the eve of their departure, as their trunks were being loaded

on the carriage, Hillary noticed Lafanu's bandaged hands and the cuts and bruises on her arms. The two women were worried, but they didn't let it show. "We'll deal with it once we get to the Castelli," they told each other. Now the important thing was to leave Rome. The city was bustling and even the expatriates had noticed that something was going on. For many of them, Italian political battles were a kind of constant background noise that it was better to ignore. The struggles for independence had been classified as skirmishes and even when the tension was palpable, there were many who attributed all of that fuss to the Italian penchant for melodrama.

"Nothing ever happens here," the city's American and English residents were fond of saying, "but then that nothing makes a lot of noise. The Italians are hot-blooded, such children. Always up to some shenanigans or other."

But in that spring and summer of 1870, the background noise had turned into a roar. Nobody, not even those who sympathized with the Kingdom of Italy, wanted to find themselves in the middle of a battle. Nobody knew if the pope would resist the Savoy dynasty with arms or only with contempt. Naturally, none of the expatriates wanted to be there to find out in person. So, among the foreign residents, there was a generalized heading for the hills. Some went toward Florence, those who could to Venice, if not all the way

to spend the summer in the countryside of France. For some, the mountain resorts were the most attractive. They looked north, although there was no shortage of those who opted instead to take advantage of the opportunity to explore the unknown south, either Sicily, of which they had heard such wonders, or Naples with its air of Bourbon decadence, where they could regenerate their tired limbs with long walks in the country and early-morning swims.

It was Bathsheba who chose the Castelli Romani and who said to Hillary and Lafanu, "I've found a delightful pension near Marino, immersed in the countryside and full of boarders who will be falling all over each other to spoil and refresh us." Bathsheba didn't like to travel. She had long since tired of running up and down and across the peninsula, and now her farthest journeys took her to Tuscany to visit some old friends and get her fill of social gossip, with which the expatriate community was never stingy. She was feeling especially lazy. Moreover, her friend Diane Abbott had sung the praises of the wonders of Marino and the pension run by the De Marco sisters.

Two weeks had already gone by when Hillary received a letter from Lizzie Manson in Salenius.

She was in the dining room and had just finished a tasty treat of some pastries filled with Abelarda De Marco's homemade blackberry jelly. She was always among the last to have breakfast. Her mother

and Lafanu were early risers. And she, who had never been one, now had another reason to delay her appearance at the breakfast table: Matthew Hastings, who had attracted her attention from the very first day. He was a bit gruff but he also had some adorable ways about him. Besides, he had a very good job in Holland and she had never been to Holland, and maybe it was even a nice place to live. Mr. Hastings was in Italy to heal from a bout of pneumonia, which had struck him unawares the previous winter. He was a latecomer to breakfast, too. Hillary, dressed to the nines, was there waiting for him, with a desire to go for a swim in his sea-green eyes. But that morning he was later than usual. And it was during that long wait that the letter from Salenius had arrived.

Hillary opened the envelope in a rush. Curious. She found a missive written in minuscule characters, and then a clipping from a newspaper. She started reading the article. When she finished she was devastated. Just at that moment Matthew came in, dandily attired, with a big smile and a rose for her. Hillary was so confused. She grabbed the rose heedlessly. Then, regretting the brusqueness of her gesture, whispered, "You must excuse me, my head . . ." And she told him she had to go walk a little, alone, and if he was available it would be nice to have lunch together. The man, stunned by the flowery scent of the girl's perfume, nodded almost unconsciously.

And Hillary was able to run off to look for Lafanu. She was sure she knew where to find her at that hour of the day.

Marino was not an easy city to get around in. Its steep climbs and sudden descents were a tough test for sightseers. But that charming town to the south of Rome was an authentic wonder. Not only had the De Marcos' pension brought to town a numerous group of expatriates who enjoyed the charms of nature without even lifting a finger in the pension's ample garden, but vestiges of the glorious past were also there to seduce travelers in search of characteristic views in which to immerse themselves. Like few other cities, Marino had been crossed by history. It had been a military outpost, a holiday resort for the nobility, and an important commercial crossroads for the economy of the Castelli. Tourists had discovered it only recently. With its basilicas, little convents and monasteries, and aristocratic villas, the city was a spectacle for the eyes. Hillary knew that Lafanu spent every morning going around discovering new angles and slices of the town. What worried Bathsheba and, therefore, also Hillary, was that Lafanu always went off without her beloved sketchbook. Since the day she left Rome she had stopped drawing. And Hillary had discovered that with every day that passed the scratches on Lafanu's arms were growing larger.

Her mother was a fatalist. Hillary was convinced that the good air of Marino would heal Lafanu. But they had been there for two weeks now and there were no signs of change in Lafanu's spirit. She needed something to shake her up.

And now Hillary had in hand that newspaper, which might be just what she needed. She had to find Lafanu and show it to her. She quickly left the pension and headed briskly up the hill.

AS ON EVERY OTHER DAY, Lafanu was in front of the fountain next to Palazzo Colonna with a rose in hand. She was not alone. All around her were townspeople involved in their daily routines. There was also a man with a pointed white beard and a glint in his eye who was looking at her with the firm intention of starting up a conversation. Lafanu had seen him briefly at the pension. Although they had not been introduced, she knew from Bathsheba (on whom nothing about the boarders at the De Marco sisters' pension was lost) that he was a sculptor, Horace Silver, with a well-attended studio in Florence. Silver was wearing an extravagant checkered jacket. Lafanu had never seen a man wear anything like it; perhaps it came from Paris like all offbeat fashion of the time. Once she would have laughed at a man primped up like that, but for weeks now her mouth

had not managed to widen into a smile. Her eyes were still stuck on the sight of the man with the massive shoulders. She had told herself that she should forget about it. That going to Marino would be good for her. Getting away from Rome, from the pressure and envy of the little circle of expatriates, might do her good. Now that envy scared her. They all hated her just because Diana Cleveland had been generous with her praise for her. That meant more commissions, more money, more fame. She knew that. The envy was part of the game. But now it scared her. What if they, too, got the idea to treat her badly?

It was getting harder and harder to cast off the shadowy figures that besieged her every day. Especially at night, before going to bed, there were so many hands trying to strangle her. Phantom hands that she struggled to escape. Every night there were punches and muffled screams. As she had been taught by Daisy the Irish girl at Coberlin, every night Lafanu Brown died in silence. Only to realize that often her hands were bleeding. Every night in Marino the bruises and cuts she had inflicted on herself in Rome, by punching that wall, reopened and started bleeding.

The man, Horace Silver, was looking at her with a vague air of pity. Had he sensed her torment? But he wasn't able to speak to her because she, annoyed, pointed her eyes in the opposite direction.

And just then Hillary arrived like a fury, with a newspaper clipping in hand. "Lafanu, this is all about you!" When Lafanu read the name Bailey, she nearly forgot about everything else.

She read the whole thing quickly. Her head was spinning. She felt sick. She was stunned, even more than offended. There was plenty to take offense at. Frederick, the man she had never stopped loving, was reprimanding her for having forgotten that African blood flowed in her veins, and accusing her of leaving behind her people and her mission. Then, how badly he had treated the portrait of that poor Barry Maddow whose belly had been split wide open by the Confederates! Lafanu had drawn on the heroism she had seen in paintings by Delacroix. Nonetheless, there was a sobriety in that work of hers which Frederick had failed to grasp. And then, to accuse her of being a coward ... What was she supposed to do? Get herself beaten again like at Coberlin? What harm was done by those who tried to follow their dreams? What harm was done by those who left their homeland? She worked harder for the black cause living in Rome than thousands of others who had prostituted themselves to the white people who financed their political careers. Who did Frederick Bailey think he was? Hadn't he, like so many others, built his fame thanks to the benevolence of Perkins and the other supporters of the cause? Besides, she worked ... she worked hard. How

could Bailey dare to berate her as though she were some capricious little girl? She didn't need that badly written editorial to tell her that commissions often took time and space away from her creativity, she knew that on her own. But an artist could not always choose her subjects. She could fashion them in line with her own approach, but commissions were necessary for survival. Artists were not rich. For a black artist like her the obstacles were even greater.

How dare Bailey define her as not black enough, how could he?

Lafanu was beside herself. Her well-combed curls held tight in a bun looked like they were about to explode rebelliously into the air. Her hands were so agitated they were twitching every which way. Even the phantoms that had been assailing her had decided to disappear. She only had room for rage.

Hillary looked on at the scene with satisfaction. That editorial was just what they needed. "I'll be able to tell Mother that something has finally broken through that cloud of gloom that had descended on dear Lafanu."

The curious eyes of Horace Silver were also looking at Lafanu, and he suddenly decided to speak.

"Have you just received some terrible news?"

"More or less," Lafanu grumbled rudely.

"I'm sorry to hear that," the man said. "Like everyone else, I read the article about you by Diana

Cleveland. She is a dear friend of mine and I know she is not easily enthused. Indeed, friends as we are, she detests my work. She has always spoken badly of it without hesitation!"

"And you're still friends?"

"Well, yes. I know that someday I'll show her how wrong she is about my work."

"But how do you tolerate—"

"Because one must be patient with friends sometimes. They don't always understand the paths we take."

Lafanu remained silent. Then she picked up the rose that she had let fall to the ground. She laid it at the base of the fountain and Silver spoke to her again.

"I've been wondering for days now. It's not the first time I've seen you leave a rose here . . . and I don't understand."

Lafanu laughed softly. "Did you really not notice?" she said, looking him straight in the eye. "Please take a better look . . . can't you see that these four people chained to the pole and held in slavery are my ancestors?"

Silver noticed for the first time the four blacks twisted into unnatural poses and chained to the column. By now, it had been several days that every so often he took a walk around the fountain and he had never realized that those four people were prisoners.

"They are not slaves, they have been bound to enslavement. And that woman looks so much like me . . . don't you two agree?"

Hillary caressed Lafanu's wounded hands. "As soon as these heal, you have to draw them. A drawing of something like this would be the perfect response to Mr. Bailey's distasteful outbursts. Don't you think?"

Lafanu, finally freed from her ghosts, looked at her with gratitude. That was such a good idea.

Crossings

XIX

Yellow. Then red. Yellow again, and red again. That's how Somalia looked to me in those first few days. Land of drought, exuberance, and incense. Plastic had occupied all the trees. And Turkish flags illuminated my field of vision as it extended outward from the road that went from the airport to the city. In those early days my hotel room was invaded by relatives, people I often didn't know and who didn't know me. We had a handful of names in common and we hurled them at each other like whirling Frisbees. During the invasion, Uarda stayed in her room tied to her computer. She always had something to do, something to write. On the fourth day, she seemed a little annoyed.

"Are we going to spend our fifteen days shut inside here?"

I promised her that the next day we'd go to see Dr. Lul, at the Rajo ("hope" in Somali) center, where my cousin had been for almost a year now.

I woke up with my heart racing, a knot of emotions in my stomach. I was afraid I wouldn't recognize my beloved little cousin, that I would see in her only the horror she had been through.

During the long taxi ride to the center I didn't say a word. Uarda understood that I was upset and at one point, she took my hand and squeezed it tight. That contact was enough to make me feel a little better.

When we got there, we took a look around. The center was painted in pastel colors. As diaphanous as a hummingbird beating its wings. I knocked on the door of the doctor's office. Despite the fatigue in her face, she welcomed us with a smile and pointed to her degree hanging on the wall, of which she was very proud. "I studied at the Sapienza in Rome, I'm glad that my old university in now the best in world for ancient languages and the classics. I wanted to study Cicero, you know, and then my aunts convinced me to study medicine. 'An African doesn't study Latin,' they said." She sighed.

"They did right," I said, selfishly.

"You think so? I'm not so sure. Now I would be like Mary Beard, writing books, going around Rome

on a bicycle . . . have you seen her documentary *Meet
the Romans*? Extraordinary, you can find the whole
thing on YouTube. At times, I dream of living a life
like that."

I like Mary Beard a lot, too, but I doubted that
a person, even someone special like her, could go
around Rome on a bicycle without risking her life.
Anyway, the doctor was letting her hair down with
us. "I allow myself to complain with you because in
front of my patients, who I call cotenants, I can't.
They need to see me strong. There are days I can't
manage that, but I try very hard. But now, come with
me, I'll take you to Binti. At this time of day, all the
guests are in the garden."

She led the way. In the garden, the "cotenants"
were drawing. They were there in their multicolored
veils and dazzling blouses to greet the sun, and us,
the strangers who had come to eavesdrop on their
lives.

Uarda and I were also wearing veils and heavy tu-
nics. We weren't used to dressing that way and we
were sweating like mad under them. Uarda, irri-
tated, scratched her head repeatedly.

None of the patients raised their heads. The only
one to look at us, or to give us the impression of doing
so, was the baobab that dominated the center of the
courtyard. In the shade of its fronds a girl was bent
over a sheet of paper, drawing. As if responding to

some silent call, she suddenly lifted her head and our eyes met. It was she, Binti, my beloved cousin. I felt my heart beating stronger.

Then she immediately lowered her eyes.

"Yesterday a boy came to visit her," the doctor said to me point-blank. "Bilal."

"And . . . ?"

"He asked her to marry him."

I was already imagining what Binti's response might have been.

"She shook her head, as I expected," Dr. Lul said. "The boy was really crushed. I advised him to wait, if he really wants her."

I looked down at my cousin, bent over her paper again. And I sensed that poor Bilal was no longer part of her destiny. Even if Binti's journey had failed, the die had been cast for her. There wasn't going to be any wedding.

I couldn't make myself go closer to her. I noticed that now and again Binti raised her head a little to shoot me a glance, and every time I died inside to think that this girl was my little Binti, the girl who, picture after picture, I had watched grow up from far away. I felt she was a part of me more than people in Rome whom I saw every day. We could spend hours talking about nothing via Skype, and then in the last few minutes tell each other what really mattered. I missed that playful Binti so much, and probably Bilal,

who loved that Binti, missed her as well. But that journey had ruined everything. Nothing would ever be the same. I had to accept that our relationship would change. The world had come between us. Binti had been imprisoned in a nightmare. A change was inevitable.

Meanwhile Uarda was enchanted as she watched those "Welwel" loonies, as the doctor called them with sincere affection.

"They're good. They look like a bunch of dark-skinned Rembrandts!"

I took a breath, summoned my courage, and went over to my cousin. She kept her eyes lowered but she perceived my presence. She stopped drawing and held out the paper to me. I nearly collapsed from amazement. There was a woman chained to a pole who was breaking the chains. She was crying and on her lap was a passport.

Then suddenly Binti took my hand and kissed it, as young girls do in our country to pay homage to their elders. It was her way of welcoming me. I bent over, looked into those fearful eyes, and held her close to my chest. We remained in that embrace for a long time.

And so it was that instead of the fifteen days we had planned, Uarda and I, ever more enamored of Dr.

Lul's loonies, stayed in Mogadishu for two months. During that time I tried in every way possible to find a solution that would allow me to take my cousin to the Venice Biennale. Alexandria and I produced documents upon documents, each with an untold number of attachments. Even the private sponsors helped us out. We wanted to take Binti to Europe as a representative of all the artists we had selected. Every morning we made phone calls, wrote e-mails, and churned out new documents. Because what we had all agreed on—Alexandria, Uarda, and I—was to exhibit the girls and boys that Dr. Lul treated in her center. Many of those patients had attempted the *tahrib*, the journey to Europe, and they had stopped halfway because the violence was impossible to bear or simply because they had been forcibly repatriated. They were people traumatized by unspeakable violence.

Uarda, as her name itself suggests, flowered like a rose among those wounded souls. Her art, powerful and impassioned, had finally found in that context an outlet for putting herself in service to humanity. She directed their work, gave advice, but without any arrogance or effrontery. She was who she was, a young woman from central Italy in search of herself, part Ghanaian and part Nigerian. Binti talked to Uarda a lot. She was a little afraid of me, maybe because she thought I might judge her, but with Uarda she felt free. She confided to Uarda that she had always been

fond of Bilal but that by now their time had come and gone. "He needs a real wife, *Nag run, Nag.* A real woman."

"And don't you feel like a real woman?" Uarda asked her.

"I don't want to be one anymore. I want to go back to being a girl. I want to laugh again. And I'll get married when I've done everything I've dreamed of doing."

In those words, I heard an echo of what Lafanu Brown had done.

ROME DIDN'T SEEM any different than usual in that tepid October of 1870. Same purple-clad cardinals, same hubbub of common people, same trash distributed equitably on the streets. Even the alleyways were the same as always, narrow and cramped. While the piazzas, on first glance, seemed even more regal. It was the same Rome, yes! It promised paradise even though it knew darn well it was hell. It was the Rome where Corinne the half blood had loved her cruel Nelvil. And it was the Rome where Beatrice Cenci had been beheaded by an unjust power that hated women. But it was also in that Rome, at times malevolent and at times farcical, that Lafanu Brown was looking for vindication.

As soon as she got back to Via della Frezza, La-
fanu shut herself in her studio, not even pausing to
catch her breath. She announced herself to no one,
neither to her neighbors nor to Concetta. Bathsheba
and Hillary, seeing her feisty mood, preferred to leave
her in peace.

Instead, the two women tried to understand
what was happening in the new capital city. It was
so strange for the expatriates—and Bathsheba and
Hillary were certainly no exception—to be taking
an interest in Italian affairs. They had been accus-
tomed to the pope, to the slow pace of the cardinals,
to the stale ritual that was so amusing to them. They
thought that nothing would ever change in that city
where even boredom was eternal.

At first, both Bathsheba and Hillary had asked
about the breach of Porta Pia. It was there that the
bersaglieri, the king's elite light infantry, had broken
through the defenses and occupied the papal state on
behalf of Italy. Hillary was the curious one.

"Were the soldiers handsome?" she asked eagerly,
and the thought of those men in uniform made her
heart skip a beat. But all it took was a scowl from her
mother to remind her that Matthew Hastings had
proposed on a sunny afternoon in the main piazza of
Marino and she had agreed to become his wife. The
wedding was set to happen in the spring, probably

in Holland, or if his mother insisted, at the family's estate in Yorkshire. Hastings was the good catch that Hillary had been looking for. Now her future was assured. She wouldn't have to worry anymore about running out of money or becoming a spinster. Ah, what a relief! So her mother's glowering look was enough to get her back in line. And, given that politics bored her to death, she pulled out another topic of conversation about which all the expatriates in Rome had been talking for days.

"I hear Vivianne Remy is in town, is that right? The famous Vivianne Remy."

The expats, who couldn't wait to gossip, poured a river of words over Bathsheba and Hillary.

"She's had a commission from Congress for a sculpture."

"Can you believe it? The Congress of the nation, of our beautiful nation, America."

"We saw her on the Corso and she's really as beautiful as they say."

"No, she's even more beautiful than what they tell us."

"She's here to take a look at some blocks of Carrara marble."

"When she's not in Rome, where she's taken possession of a palazzo near the Spanish Steps, she wanders around Tuscany."

"They say she's studying Michelangelo's *David* in Florence."

"She'd like to achieve that same measure of nobility."

"But we haven't told you what statue she is supposed to sculpt! None other than the bust of our beloved and dearly departed Abraham Lincoln, may he rest in peace!"

"Don't get us wrong, now, but we think she's far too young for such a prestigious role."

"What's more, she's a woman . . . it seems blasphemous to us that they've given a woman a commission that calls for a much stronger set of hands—masculine hands, just to be clear."

"Don't take us for naysayers, but there are a lot of us who believe that she got this commission more for her good looks than for her talent."

"We're not saying she's not talented, of course."

"But, well, let's just say she's not talented enough."

"And now Congress . . . can you believe it?"

In Rome, all the talk was about her, Vivianne Remy. That was enough to make the expatriates forget that Rome was changing. The king was about to arrive and they would all have to get used to him. But for now the little shrimp could wait, Vivianne Remy was

center stage. Vivianne, who shone like a star in the firmament of gossip.

"I'd give anything, dear daughter," Bathsheba said to Hillary, "to be able to meet this Vivianne. The more they hate her the more I love her. We could even become friends, who knows . . ." That fleeting thought made her smile.

While Bathsheba and Hillary were conspiring about how they could meet Vivianne Remy, Lafanu was shut in her studio planning her new piece. She, too, had received a commission, from the organizing committee of the 1873 Boston Fine Arts Exhibition. The letter had arrived a few days before she left Marino. It read: "We have admired your work for some time, Miss Brown, and we have seen in Salenius the magnificent portrait of the hero Barry Maddow, which you executed with so much grace. We would like to ask you to do something analogous for our exhibition. It would be an honor to have you as one of our artists. A great honor because we committee members have been for a long time, since well before the Civil War, active in the negro question. You would be our only negro artist and we would give you an important place so that all of our citizens can see your work and admire it as we do." Lafanu had accepted the invitation, motivated in part by a healthy spirit of vindication that had blossomed in her since she read the article by Bailey. Every time she recalled those

words, it made her blood boil. How dare he? She had transcribed his words in great big letters on several sheets of paper and then tacked them up on the walls of her studio. She didn't want to forget them. Only by hating Bailey, every day, with tenacity, could she nurture the hope of turning those words on their head with a work that the world would judge to be simply magnificent.

THE CHOICE OF SUBJECT was not easy. Riding in the carriage, as the wheels rumbled over the uneven terrain between Marino and Rome, lots of images went through her mind. War heroes, abolitionists who had done so much for the negro cause, ancestral legends, and even figures from classical mythology. A Diana, or better, a Venus or an Ariadne abandoned by Theseus might constitute a great attraction for the audience at a big exhibition in the United States. Of course, those themes wouldn't impress Frederick Bailey. He would consider it submissive art, her talent once again exploited to satisfy the requests of whites. Lafanu could even borrow from the ideas that were coming down from France. Make daily life the object of minute observation and then reproduce on canvas only its impression. At that point, everything was legitimate: a child's face, a village festival, a rickety bridge, water lilies, peasants exhausted by

laboring in the fields. But there was one risk in that kind of operation. Even though she lived in Europe, Lafanu was still an American. And America was not ready for those novel techniques in which art showed the ephemeral aspects of life so clearly. Lafanu was learning a lot from the French, but to follow them in everything meant betraying the expectations not only of those who had commissioned the work but also her own. Above all, she wanted to be sincere in her art; she wanted to show herself for what she truly was: a painter in Rome who quenched her thirst for new techniques without forgetting the teachings of the Baroque. A traditionalist, but nonetheless consistent with her own personal approach.

It was then, thinking of Bernini and Borromini, of Caravaggio and Artemisia, that an idea came to her. She was alone in her studio, sitting cross-legged on the cold floor, and she remembered when, years ago, she had entered for the first time the Church of St. Ignatius of Loyola, along with Bathsheba who was not yet completely cured from her dependence on alcohol. Lafanu didn't know much about that place, but she understood that it was always a good idea to enter the churches of Rome because there was always a chance that something unexpected would happen.

Immediately, still on the threshold, the women were invaded by color. The frescoed ceiling by the

Jesuit Andrea Pozzo, with its innumerable figures, blinded them, it was so strikingly beautiful. The trompe l'oeil dome that the painter had designed so minutely enchanted them. Everything about that ceiling was wonderful. In that church, which, thanks to the play of perspectives, seemed to contain a second church, Lafanu realized how lucky she was to be there, in the middle of that earthly paradise. Inside that paradise, she found someone who looked like her. It was Bathsheba who noticed the regal figure that seemed to be looking right at them with a certain curiosity.

"That woman up there looks just like you, Lafanu," she said with a voice somewhere between laughter and tears. "Yes, it's really you. So then, you didn't just come to Rome, my dear, you have come back."

Then Lafanu also looked up at the black figure overhead and, indeed, it seemed like she was observing them. Lafanu and Andrea Pozzo's creation had the same black skin, the same frizzy hair, and the same posture, sober and controlled. The figure was clearly an icon of Africa. She was the personification of the continent that Lafanu's paternal ancestors had come from. Lafanu glanced at the figure's foot, sticking out of her red tunic; it was so beautiful. A foot yearning for some movement.

The memory of that first encounter with Pozzo's Africa prompted her decision for the Boston

exhibition. "I'll do Africa, too," she said to herself, "and I'll do it my way."

She got up off the floor and rushed out. She had to sew a new canvas and prepare her brushes.

LAFANU WORKED day and night on her Africa. She painted a piece and then undid it, painted again and undid it again. An unquiet Penelope, increasingly angry with herself. Her anger intensified a hundred-fold when her eye fell on one of those words that Frederick Bailey had thrown at her like lightning bolts. The more she looked at them, the more her stomach tied up in knots. Often, in the solitude of that studio, which she had closed to the public, she screamed at that man she had once loved. But it wasn't only her work on the painting that was upsetting Lafanu. Ever since her return from Marino, her ghosts had come back, too. She was scared. She wanted to give up everything. Run naked through the streets of Rome and have herself interned where they kept the crazies. She didn't want to think anymore. She wanted someone to get Coberlin out of her head. But then those words of Frederick's, so hastily stuck up on the wall, saved her. When those ghosts started crowding around her too closely, all she had to do was take a look at those pages on the wall. Her anger vanquished her fear, her thirst for vindication got the better of

the ghosts, which did not want to leave her alone even for a minute.

Lafanu was on the verge of madness. She painted day and night. But it was as though her brushstrokes were askew. They had no soul. Her Africa was lifeless, it was merely a slavish copy of what Andrea Pozzo had done, and this upset her. She tried adding some new colors to the tunic, to the shell that served as the throne, to the script *Africa*, which flashed before her eyes like a threat. But brushstroke after brushstroke, she was getting nowhere.

As she was sinking deeper and deeper into desperation, Hillary came into the studio. This was a frenetic time for Hillary. She had only a few months left before the wedding and she wanted to be perfect. She spent much of her day going around town ordering dresses, hats, blouses, skirts, and slips appropriate for the honeymoon suite. Naturally, at the top of her list of her priorities was a wedding dress, and she had come to Lafanu's studio now to ask if she would design it for her. Lafanu had designed a lot of dresses for Hillary and her patterns were so perfect that the tailors only had to copy them.

Only Lafanu could design the dress of her dreams.

When Hillary burst into the studio, she found Lafanu with her back turned, working away intently.

Hillary looked at the painting. Her gaze was penetrating, severe. It was then that she pronounced the

words that surprised Lafanu, who would never have expected Hillary to be so acute.

"Poor woman. Even she, in the end, looks like the slaves we saw in Marino. They were chained to a pole, while she has been chained to a shell. Look at her face . . . there's a dark future awaiting her. Who are you going to paint around her? What will they be doing? It would be so wonderful if you could liberate her . . ."

For a whole minute Lafanu couldn't manage even to move. She couldn't tell what had paralyzed her like that, whether it was realizing that Hillary was so sharp or that she was so blind.

Yes, she had to liberate her. Africa had to be freed, and all of her children, too.

She let her brushes drop to the floor, turned, and threw her arms around Hillary's neck. An embrace so tight as to make her say, "You'll break me in half, Lafanu!" But Lafanu couldn't contain her joy over having other eyes to see with. Her eyes had not been enough. But now that Hillary had arrived . . . now everything was clear to her.

"I have to sew another canvas," she said out loud.

And Hillary, who didn't quite understand what had happened, smiled.

IF HAD BEEN UP TO HER, Lafanu would have never left her studio, but one Thursday in November Bath-

sheba forced her to don an elegant dress and accompany her to a lunch at Villa Pensierini, a Renaissance country villa on the outskirts of Rome.

The villa, like many others, was about to be sold. The new Kingdom of Italy was hungry for land, where it could build modern roads and mark the contrast between its dynamism and the immobility of the old papal state. Even the train station that Pius IX had inaugurated would be undergoing further restructuring. It would all be done in an efficient and timely manner, but at the expense of the breathtaking views, the uncontaminated gardens of the villas, and the beauty of the landscape. That's why the lunch at Villa Pensierini was so important. It was a sad celebration that the expatriate community didn't want to miss. Not exactly a funeral but a sort of ritual of consolation for the thousands of changes that were coming to the city. Villa Pensierini had been purchased some time ago by Katherine and Andrew Chapel and, after their death, it had passed down to their son, Lawrence, and his wife, Mary. "But the Italian state has offered us a lot of money to buy it. And we, as you know, are not exactly rolling in dough. My father-in-law's debts have nearly done us in." Mary had pushed her husband, a noted lover of the arts, particularly of sculpture, to sell the villa and return to the homeland. Lawrence had bowed to his wife's wishes, their debts had

forced him to do what he would never have wanted. Mary conceded her husband one last party in their villa, which was soon to be torn down. The whole community of expatriates had been invited.

Naturally, the main attraction at the party was Vivianne Remy. She was the prize to which everyone aspired. She was gorgeous as usual, breathtakingly so. Next to her, every other woman disappeared. What a dress she was wearing! For Lafanu it was strange to see her in person. Before now, she had only seen a banal portrait of her in the studio of one of her rival artists, a friend of the sculptress, in which Vivianne was dressed in the typical costume of the women of Albano. But her skin was too white to pass for an Italian. Besides, the painting had a slew of defects that Lafanu found not only unpardonable but that gave the woman's likeness an opacity she did not have.

Bathsheba dragged Lafanu before the famous sculptress. But even before she could open her mouth, Lafanu was overwhelmed by what she saw behind the woman.

Bathsheba was all involved in the formalities of the introduction, and Vivianne Remy, well-mannered person that she was, was nodding politely in Lafanu's direction, but Lafanu was lost. She curtsied, her movements following precisely the rules of social etiquette. Even the few words she pronounced were

sensible and soaked with formality. But Lafanu was completely taken by what she saw behind Vivianne's back. Frederick Bailey was staring at her, his eyes full of fire and animosity.

For an instant, Lafanu felt she was about to die.

Crossings

XX

Baratto Hall was filled to overflowing. For the occasion, a big screen had been set up in the university courtyard. After a short greeting from the chancellor and vice-chancellor of Ca' Foscari, it was the artists' turn to speak. Alexandria and I had decided it was right that they themselves take the floor to present their works in advance, those same works that Venice would see just a few hours later. Unfortunately, we could only have them appear on the screen, the Italian government had not granted any of them a visa to attend the exhibition, at which their work was to be the main attraction. We had tried everything to obtain visas for at least two of them. I wanted Binti, while Uarda and Alexandria were completely enamored of the plastic fish by Omar Hagi, a boy who,

like my cousin, had arrived at Dr. Lul's center after a journey to Europe gone awry. But the refusal had been ferocious and immediate, their bodies considered an immigration risk, bodies for which the Italian state wanted no responsibility. What anger I felt for that fortress Europe that denied mobility to young people like Binti and Omar, young people who were ingenious and talented. If any Charlotte from Düsseldorf or Pierre from Bordeaux could jump at their pleasure from one border to another—as was only right—why were Binti and Omar, who were the same age and had the same aspirations, denied entry? My thoughts turned to Omar, a fisherman son of a fisherman, who candidly recounted: "In my father's day, the sea was teeming with fish, but today ships come from the farthest parts of Asia and, besides sucking up all our fish, they're also ruining the ecosystem. I can't count the number of dead fish and sea turtles I've had to pull, belly-up, from our ocean!" Omar had left home because the fish were getting scarce and the only other work opportunity for a fisherman like him was to become a pirate. "When our government collapsed, our coast guard, the *badaadinta badda*, vanished. And for a while we replaced them. But after seeing all those foreign ships rob us of everything, including our souls, a lot of us became *burcad badeed*, pirates. I tried to escape that destiny, but I couldn't get anywhere else. I wanted to

go to Sweden, they told me you could be a fisher-
man there. But I couldn't even get anywhere close to
Sweden. And then I got lost."

In Baratto Hall the screen was being filled by
his smile. There was Omar, there was my Binti, and
there were all the others: Abdi, Jasmine, Asha Deer,
Yousuf, Fardosa Honey, Hussein, Gimale, Fawzia,
Sohan. They told about their lives, the pain and suf-
fering, the rapes, the wounds, the scars, the number
that was sometimes tattooed on the arms of women
as though they were cows. Then, without losing any of
their tenderness, they talked about Lafanu Brown, of
the work they had done with Uarda on the artworks
of that woman of the past whom they didn't know and
whom they now loved like a sister.

And then Binti came on the screen again, her lu-
minous face lighting up every dark corner of the room.
A face that was finally serene. In the video, my cousin
was walking slowly, like a knowing turtle. Then she
pointed to a canvas: It was a big collage of photos,
newspapers, silhouettes, shadows. In the center was
an airplane preparing for takeoff, and a girl, Binti
herself, along with some other people, smiling as she
prepared to embark.

Her voice explained in English: "We found this
backdrop in an old abandoned photography studio. It
was in really bad shape. We brought it 'home' to Aunt
Lul's, our doctor, removed all the dust, painted a blue

sky, the plane with the colors of Somali Airlines, the airline company that Somalia had before the war, and then we made our silhouettes, the way we really are or the way we are in our dreams. This is us as we're getting on the plane. Us and our smiles with the right to travel. This is our work of art. Our work of art is this dream of ours, to be treated like normal people. Our dream is taking a plane and not having to get lost in the desert with the traffickers."

The video, which Uarda had shot with great skill, ended with a chorus of "I am Lafanu Brown," perhaps rather obvious as a slogan, but it resounded in that hall like a bullet. "I am Lafanu Brown. We are all Lafanu Brown."

On the second day of the conference, three days before the inauguration of the exhibition, it was Alexandria's turn to speak. I, as a good curator, preferred to stay in the wings.

Alexandria was almost as emotional as the day she was married—after all, the memory was still fresh. She was a raging river, as nervous as a schoolgirl. She started off recounting how her professor in the art department of Salenius University had worked to bring together the initial nucleus of the Brown collection and how, over time, she too had joined in that treasure hunt against time and against

forgetting. She told of all the obstacles she had come up against. With funds from the university, they had acquired portraits from private collectors, searching through the basements and attics of heirs who didn't even know who their ancestors were. To raise more funds, the department had made alliances with public museums, applied to funding programs for ethnic minorities, and appealed to private sponsors who supported female empowerment. Many portraits by Lafanu Brown had been found in the United States. Thanks to the archive of the letters of Silvia Peruzzi, which had been donated to the university, it was easy to identify the clients. Other material had come from the Vatican. In general, thanks again to Silvia Peruzzi, everything that had remained in Rome had been tracked down. Numerous nativity scenes had been uncovered in the Vatican, and in the Jesuit collection in the Vatican, they had found *Woman in Chains* and all the sketchbooks. Other discoveries, however, had been made by chance. In an old saloon, in a museum in Arkansas, in the home of an African American family in Illinois . . . Alexandria illustrated that impossible search with style and determination. She knew that there was a lot that was still missing, but the essential things were with us: along with the paintings were her sketchbooks, in which Lafanu Brown had in fact sketched her whole life, the life of an American Black woman in Italy.

She wasn't the only one, Alexandria concluded, but she was surely one of the most tenacious and brilliant Black women artists of the nineteenth century.

"A woman who traveled alone, when traveling for women in general and above all for Black women, was impossible. A self-made woman, activist, painter, but also a pioneer of modernity. Lafanu Brown suffered a lot, but she held up under all the blows that life dealt her."

Alexandria's voice was breaking. I was overwhelmed, too.

I thought of Lafanu who had lost her sense of taste. I thought of my cousin Binti and her vomiting. Forced to . . . forced to put up with everything. But they had picked themselves up and fought back. They hadn't lived perfect lives. But they'd had a life.

I squeezed my hands into fists to keep from crying. And Alexandria also held back the tears that would have devastated us.

She went on with her presentation. And I was proud of her.

SILENCE. No movement in the house. No breathing. Finally, Lafanu Brown was alone in the big apartment on Via della Frezza. Alone. With the rooms all for herself, and all the time in the world at her disposal.

She hadn't been alone in years. She'd wandered from one place to another, but always in the company of Bathsheba and Henrietta. Now she was alone. She liked it. She even felt electrified by it.

The house was empty. She could hear her footsteps reverberating in the hallway. In that December of 1870, they had all left Rome. Bathsheba and Hillary to Yorkshire to meet the family of Matthew Hastings, and Concetta to Agrigento to care for her sick mother.

Lafanu had given her the money for the journey.

"Don't you worry, Concetta, you'll pay me back. Now, your mother needs you. Come on, get moving, go to her."

Probably Concetta would never be able to pay her back that amount of money, but at least she didn't feel like she was asking for charity. And Lafanu, who had experienced charity personally, knew well how important it was not to be humiliated in a time of need. This was a time for that respect that she had not always had from her benefactresses.

The respect that made you feel still human.

"**WHAT WILL YOU DO** for Christmas all alone, Lafanu?" Hillary asked her on the eve of her departure for Great Britain. "Why don't you come with us? Yorkshire is splendid, so green, you'll love it, we'll have a wonderful time, the three of us together. Like always."

But Lafanu turned her down.

"I'm fine here, Hillary. Besides, I have to finish the painting for the exhibition."

"But it's almost Christmas, Lafanu."

"I know," she answered seraphically.

"And nobody celebrates Christmas alone. Come on, come with us."

"Maybe later, when you and Matthew are married. Afterward . . . maybe."

She was evasive. She knew quite well that her presence would not make things easier for Hillary with her Yorkshire in-laws. They would surely react badly on seeing her and her black skin. "If they see me they might even cancel the wedding." Besides, the idea of having some time alone in Rome didn't bother her at all. She would finally be able to experience a quieter Rome. With Bathsheba around it was impossible to live peacefully, willy-nilly she involved you in the hustle and bustle of her social life, there was no way to out of it. Bathsheba wanted to make up for all the years she had lost when she was a prisoner of fine liqueurs. But that December, Lafanu wanted to vanish from the high society that animated Rome, and it was a blessing for her that both mother and daughter had been invited to Yorkshire. A little time by herself was just what she needed. She wanted to stay at home lounging comfortably in an armchair. To think and to paint. And when she felt the need for a change of scene she would walk along the river and look at the boatmen.

STILL AND ALL, there was also another side to her wish to stay away from the salons. The reason was clear to both Hillary and Bathsheba: Lafanu had learned that Frederick Bailey was going to be married again. Perhaps that was also why she wanted

some space for herself. She wanted to cry over that despicable man whom she still loved.

It was Lizzie Manson who had let her in on the gossip, in one of her letters, long and as thick as rice pudding.

All Lizzie knew about Helen Bright was that she was beautiful, rich, and white.

"Blindingly white," she had written. And then she was a widow, "like Frederick." They had fallen in love at the home of Ronald Perkins . . . "Who else?"

Helen Bright was already one of Frederick's admirers. For his part, he had read a political screed of hers that he liked very much.

He had decided to write to her. "I admire your use of every single word, every single comma, every single outburst. Your passion for the cause swept me off my feet."

They both had the same vision. They were against the system, but neither of them would ever be against America. *God bless America!*

"Don't take my words the wrong way, dear, but those two have the same vision of life, death, love, and struggle. They are kindred spirits. And their friendship has for a long time not gone beyond the limits of decency." Lizzie had also heard it said that Helen's father had thrown her out of the house when he learned of her firm intention to marry Bailey. There had been gossip, dismay. A black man and a white woman

together was inconceivable. "That's why Frederick left America. They have a plan, or at least that's what people are saying. To get married in Europe. In Paris, probably, or in Germany. For now, Perkins has taken Helen under his wing. As long as the waters are stirring and until people get distracted by some other gossip, she'll be protected by good old Perkins."

LAFANU WAS ALONE. Alone with her thoughts, and with Bailey's contempt for her work still clinging to her. And now this news that he would be getting married . . . God, it was too much to take!

She remembered, and it was a vivid memory because it was recent, the look in his eyes, glimpsed behind the back of Vivianne Remy at Villa Pensierini. That icy stare had torn her apart. Then he had immediately turned his back on her, with an animosity that Lafanu felt she didn't deserve, and left the party. It was evident that he found her presence intolerable.

Now Lafanu didn't even know if Bailey had left Rome or was still there. There was no way for her to find out without Bathsheba and Hillary . . . but stop thinking about Bailey, she said to herself. Enough already!

She tried to distract herself with everything around her. Christmas was just a few days away and, in line with tradition, the apartment in Via della

Frezza was riddled with blasts of cold air. The furniture accumulated helter-skelter over the years had transformed the living room into a warehouse of antiques, however elegant. "As soon as Bathsheba gets back I'll tell her to have some of this stuff removed, otherwise we risk tripping over something every other minute." But, despite all that, she was fond of slaloming her way through all of that old furniture.

Her days were measured out in a consoling monotony. In the morning, she would go walking aimlessly around the city and after lunch (it was she who did the shopping at the market and the cooking) she shut herself in the studio to work off all the anxiety that Bailey had dumped on her. Then, when she got too agitated, she went out again. The destination of her pilgrimages was the river. The Tiber was so full of life. It slithered its way through the city like a green snake out to discover the world. Rome was a city where everything led to the river. From the little boats to the short descents, made of steep stairways, that precipitated into those turbid, rumbling waters. Lafanu liked to make drawings of the river ports in her sketchbook, and then the brightly colored houses that looked out directly over the Tiber and recalled the suspended structures that Baby Sue was always telling her about, those old African houses "that we lived in before the men from the nearby tribe came to get us, tie us up, and sell us to the whites."

And then there were all those people who lived on the river. Industrious as ants, frenetically going about their daily routines; customs and uses that the marine population had borrowed from the ancients.

YEARS LATER, she would write to Lizzie that the old life on the river was coming to an end right in those years in which Rome was becoming Italy's capital, "swallowed up by the aspirations to modernity of the Kingdom of Italy, which had decided arbitrarily to separate a people, the people of Rome, from their river." But the great walls that the king and his engineers decided to build would not arrive until many years later. In that December of 1870, the Tiber in the area around the port of Ripetta was still in part as it looked in Piranesi's drawings from a century earlier. Boats, pedestrian traffic, the church of San Girolamo degli Schiavoni dominating the scene, the curved staircases, and the beautiful fountain, where exhausted mules found water to placate their infinite fatigue. Lafanu was enchanted by that world of fishermen, who continued to catch fish to be sold at nearby markets. Now the port was in ruins. But despite its rundown condition, the dock was for Lafanu one of the most breathtaking views in the city. She often went down to the river for inspiration, always intent on drawing quick sketches of boatmen and

wayfarers. Out of her hands came a multiform peo-
ple made up of pitcher-carrying women and children
covered with mud. A people made of water that La-
fanu studied for later use in her canvases.

And it was down by the river, at the port of Ripetta,
just a few days before Christmas, that her attention
was captured by a mule that was in a fit of rage, right
there next to the boats. There was no way to stop its
fury. Usually mules are docile animals, almost with-
out demands for this world that has given them birth
to exploit them. Lafanu, especially back in Salenius,
had seen a number of mules whipped to bleeding
without batting an eyelash. But this mule was differ-
ent. It was kicking up a storm. Its coat was bristling
under a blanket of fear, which Lafanu was powerless
to explain. She pulled out her sketchbook and drew
it. All she needed was a few lines and curves. Nothing
extraordinary. Then, with quick motion of her hand,
she also rendered the scene in which the mule had
decided to stage his rebellion against fate.

It wasn't until she got home that Lafanu took a
look at what she had drawn. It was afternoon. Rome
was preparing to celebrate the birth of the Child by
keeping vigil on Christmas Eve with plates of fried
fish and almond crisps, and then on Christmas Day
by filling its belly with chicory soup, boiled capon,
and meat casserole. Meanwhile, Lafanu was sitting
back in her armchair, in her housedress, her pantry

half empty, looking at the sketch she had done. The mule was still there, carrying the burden of all that fear. Its eyes were a picture of terror. Then Lafanu noticed the river. Impetuous as it had never been before and high, too high. Lafanu had never seen it so high. She began to tremble. The mule's expression quickly became her own.

She couldn't know this, but in Val Tiberina and Val di Chiana, in Tuscany, it had been pouring rain for days. People had been forced to abandon their shabby farmhouses. The rain had destroyed trees, ruined crops, flooded the dens of hibernating animals, and swept away entire villages. Not to mention the people who died. But Rome still didn't know that it was raining hard in those parts. The river was swelling. And Lafanu, on Christmas Day, went again to Ripetta to look at the water level. She was worried. Ripetta was deserted. There was a strange silence looming over the riverfront houses that was out of tune with the Christmas atmosphere in the rest of the city.

Lafanu headed back home slowly, pensively, and went into her studio. She had interrupted her work on the painting, an interruption that was all Bailey's fault for distracting her with his presence and his wedding plans. Bailey, whom she couldn't manage to forget. The new canvas was enthroned, uncompleted, on her easel. In the center was a woman with short, frizzy hair, naked. She was standing on a seashell,

with chains still visible around her wrists. Chains that had been broken by the wind, or by the woman herself. That young woman, standing on the shell, was all there was. Around her, the background was still missing. Lafanu wasn't sure what color to use for the waters that were supposed to represent the Atlantic, in which black people had been locked up in chains. She wanted a grim color for those malevolent waters. She had to succeed in creating more contrast between the darkness of the sea and the luminosity of the girl's smile. She wanted to call that painting *Forever Free*, "because," she thought, "we won't always live our lives in chains. One day we too will liberate ourselves from fear."

She cared deeply about that painting. She took it down from the easel and carried it upstairs, into the house. Where it would be safe.

WHEN THE RAIN STARTED, on Saint Stephen's Day, Rome was stuffed with food. Bellies were full and brains were numb. The city didn't notice that the river was rising. In a daze, Lafanu was looking out her window. She was alone and tired. For the whole day, she had been trying to get all of her tools and artworks to safety. But it was a titanic undertaking. To do it, she had taken off her dress, because she was constantly tripping over her skirt. In the end she

decided, and who cared if it was scandalous, to remain in her blouse and bloomers. That way she was more at ease and could move about more freely. She managed to carry most of her things from the studio upstairs into the apartment.

When the river overflowed its banks, on December 28, there was shouting in the street. The people had been caught by surprise and now they were screaming their dismay. The water spared no one. In no time at all, everywhere—from the Ghetto to the Spanish Steps, including Via del Corso, the Pantheon, and Ripetta—was flooded. Like squirrels, people were climbing up onto the roofs of their buildings. Lafanu was shaking as she looked out on that disaster from her window and praying for the water not to reach the upper floors, otherwise she would be lost. She clung to her painting, trembling from the cold. The rain kept coming down. The water in the street was rising higher and higher. In an instant, Rome turned into Venice. Water was pouring out of every little opening. The only hope for anyone who hadn't found shelter, or at least a pole to grab on to, was to pray for a speedy death because drowning is slow and painful.

Lafanu was hungry and her pantry was empty. She was also feeling cold, and covered herself in a thick shawl. She was afraid to let go of the painting. "We're going to die together, my dear," she said to the figure in the painting. "I will not leave you

alone." She fell asleep, exhausted, in the throes of cold drafts and fear.

The next day, she woke up to the sound of a voice calling her name. It was a strong voice, deep, but raspy from fatigue. A voice that had something familiar about it.

Lafanu looked out the window, and she couldn't believe her eyes. Maybe hunger was playing tricks on her. She saw Frederick Bailey waving from a tiny boat.

"I'm carrying some supplies for you, Miss Brown."

Even at a time like this, Frederick respected the formalities. He had never called her Lafanu.

He struggled to make it through the window, and when he finally managed to get his feet on the floor, Lafanu noticed that he was drenched.

"Wait a minute, Mr. Bailey," she said, "I'll get you something to dry yourself. Take your shoes off. Otherwise you'll get a terrible cold. And those knee socks as well."

Lafanu didn't have any men's clothes, so she gave him a long cloth, one that she used to cover her canvases or the furniture, to wrap himself in.

Frederick took off his clothes and covered himself with the cloth as though he were an ancient warrior from some lost dynasty. Lafanu hurried to collect his clothes and hung them up to dry. She was moving so fast she forgot that she was still in her nightshirt and bloomers.

When she realized it, it was too late, he was already looking at her with a smile. So she grabbed another cloth and covered herself as well as she could. Then she started looking though the supplies that Frederick had brought.

"Oh, may God bless you, Mr. Bailey! Cheese and bead, some fennel, and pasta . . ."

And she took a big bite of bread. She was famished.

"I haven't eaten for two days."

"I figured that, Miss Brown. That's why I got here as soon as I could."

FOR FREDERICK BAILEY, Rome had been torture. Seeing Lafanu Brown at Villa Pensierini, though not unexpected, had been painful. She was even more beautiful than he had remembered. A little softer perhaps, but with those eyes that still shone with a light that had always charmed him. Helen's eyes were bright, too, but more tenuous. Avoid excess. That was his motto, and that was why their imminent union, which by now the whole world knew about, was based more on respect than passion. In Helen, Frederick felt he had found an ally. She would help him to be even more the man devoted to the cause that he had always planned to be. But the light in Lafanu's eyes threw him off-balance. It was difficult to grasp, and he knew that that light could not shine only for him.

It was a light that, willingly or not, she had to share with those who loved her art. Now she was there before him, with her kinky hair all ruffled. With a blouse that showed her nipples peeking through, firm from the cold. That ingenuous attitude of hers was so sensual, despite her looking like someone who'd had to face the apocalypse all alone. "Damn it, I should have come sooner," Bailey said to himself. But his pride had held him back. To think that he had spotted her a number of times on the backstreets of the city. One day he had even followed her. Lafanu was walking swiftly, nervously. When she stopped, it was almost an automatic gesture for her to pull a sketchbook out of her bag and make a quick sketch of the scene, which he was unable to see. She was always dressed in a subdued, elegant manner. Frederick noticed how much the city was her home by now. She was greeted by the storekeepers, by the women out on their balconies beating their laundry, by the greengrocers, by the children playing on the cobblestones. Ultimately, to the people of Rome she was a Roman like them. It was only when she walked past the studios of her fellow American artists that Frederick noticed the animosity reserved for her presence. But Lafanu obviously knew the acrimony directed at her by those Americans and she just walked straight ahead. Frederick would have liked to stop her to chat. There were so many times that he had been close enough almost to

touch her with a finger. But there was always something that stopped him. He knew he couldn't marry Helen if he didn't free himself from the ghost of Lafanu. But seeing her, confronting her, fighting if necessary, terrorized him. He knew that if he didn't look her square in the eyes, no future was possible for him. He didn't want what had happened with Menilla, his first wife, to happen again; those times when he was making love with her and thinking of Lafanu.

His hosts in Rome—he was staying with a family from Boston, the Gils, who were also associated with the school of Ronald Perkins—told him not to do anything foolish, but he, gesturing indignantly, replied, "I'm a good swimmer," lying about his real talents. Then he set out on the adventure of finding a boat to take him to Lafanu.

He had climbed up the side of the building like a monkey after hoisting the food up to the window with a rope that Lafanu had thrown him. Now here he was, a man standing before a woman.

A man standing before the woman he loved.

LAFANU IS PENSIVE. Her pen is suspended over the paper. She asks herself if it's really necessary to tell Ulisse everything. A lot of the story is yet to be told and her time is running out. Before long, Ulisse will come back to her and demand an answer.

It's then that Lafanu does something inexplicable. She rips up the last few pages and leaves the house. She makes her way toward the Janiculum. She needs to breathe a little and get back in touch with the world, and she is dying to eat a dish of vanilla ice cream.

What she doesn't want to tell Ulisse is how Frederick had embraced her from behind and kissed her neck. Her mouth was still full of bread and cheese. She had grumbled something but he kept kissing her, with an energy that sent chills down her back. More than the kisses, what struck her was the way he was embracing her. Powerfully, as though she were his anchor of salvation. It felt like a steel grip. She searched for his mouth avidly. Frederick had slipped off his shirt, it didn't matter that they were sweaty, ruffled, a little dirty, and exhausted. They had found each other. They didn't want to miss their chance.

THE NEXT MORNING, Frederick got up before Lafanu and, wrapped in the cloth, went to recover his clothes, which, in that chaos of drawing tools, canvases, and easels, Lafanu had put next to the window to dry. He stopped in front of a canvas that Lafanu had not quite completely covered with a cloth similar to the one in which he had wrapped his loins. Curious, he brushed aside the cloth and found himself in

front of the woman that Lafanu had been painting. The woman with her bare breasts and short hair who was looking out at the world with an air of defiance. Frederick couldn't have known that in that woman's gaze Lafanu had brought together all the gazes of all the women she had known. There was the determination of Baby Sue, the passion of Lucy, the stubbornness of Bathsheba, the exuberance of Henrietta, the pragmatism of Lizzie, the gentleness of Harriet, the affliction of Marilay, and the innocence of Timma. Underlying all of those gazes there was also her own, which was still fighting off the shadows and did not want to give satisfaction to those who wanted to break her. The woman was standing on a seashell, proud of her skin, a black Venus. On her wrists, those broken chains that the young woman displayed with pride. *Forever Free.*

"It's missing the sky," Lafanu's voice reached him from behind. "I still don't know what color to make it."

"Don't ever quit, Lafanu," said Frederick, enraptured. Then, haltingly, he added, "I have been so unfair to your art."

"You're going away, aren't you?"

Frederick was shaking. "What else can I do?" If only she would ask him to stay. If only she would create a space for him in her life, he would stay. He would leave everything for her. He told her, "I could leave everything for you."

Lafanu slapped his face, playfully. "Woe to you if you do. You are Frederick Bailey. The world cannot do without you. It needs you."

He smiled at her, and again his mouth went looking for her mouth. They returned to the bed that they had just left, a star-studded sky to lose themselves in. The shadows of Coberlin were swept away by all of that light.

SHE DOESN'T TELL ULISSE about that late December of 1870. She doesn't tell him about the embraces, about the endless kisses. She writes only: "Frederick Bailey married Helen Bright one year later in Paris. My present to my old companion in the struggle and his new companion was a painting that I was supposed to send to an exhibition, *Forever Free*. One of my paintings I am most proud of. For the exhibition I replaced it with another painting that I will show you. It is called *Woman in Chains*, and it is inspired by a strange fountain that I had the opportunity to see in Marino."

Crossings

XXI

From: Binti Warsame Bwarsi@gmail.com
Date: Sat Dec 7 2019 11:26
Subject: Becoming a cartoonist
To: The star of Pun <puntmainoffice@punt.com>

It's Binti, your Binti. Just a quick message. Attached you'll find my first cartoon for the *Star of Nairobi*. They say they like the stroke of my pen. It's modern. You wouldn't recognize the characters, they're local politicians, and they're also pretty stupid. But the editor says I have a touch of sarcasm and irony that the paper can use. They're restructuring right now and they can really use someone like me. I'm also studying Chinese. If you live in Kenya it's essential.

The future, at least around here, will be Chinese. That's what everybody is saying. And you wouldn't believe how many Chinese are already here! There's a cartoonist, Michael Soi, whom I suggest you look for on social media, and that's all he talks about. He has a strip he calls *China Loves Africa*. And it's fantastic. The other day he did a cartoon called *Miss Africa*, where Miss Africa is obviously Chinese, while second and third place go to two Africans with kinky hair and black skin. Soi is irreverent, politically incorrect. And that's how I want to be, too. But Chinese certainly is a beautiful language. Everybody should learn it. Naturally, dear cousin, I'm also still working for that German NGO that contacted the doctor after the Biennale. They're working in a lot of countries now. They say that Dr. Lul is a model to be followed. That they never paid much attention to the traumas suffered by migrants and that it was a big mistake. And they're right. Whether people make it or not, their psyches are compromised. By now all of our heads are fried. After detention centers, traffickers, and violent attacks, we cannot be okay. We need a Lul here and in the West to get us back to normal. I'm part of the team and they are paying for my psychology courses because the cause needs somebody like

me. And I'm starting to believe that part of my work can also be helping others. So there it is, I'm giving it all I've got in drawing, Chinese, and psychology.

I'm doing everything I can to survive, dear cousin. I won't give up!

But some nights it's really tough. I'm surrounded by mean-spirited shadows. They won't let me breathe. But then I drive them away with willpower and my drawing.

Dr. Lul says I should make a complete comic book. For now, I don't have the strength for that. I'm satisfied with posting my cartoons on the Internet and collaborating with a newspaper or two.

I've had a lot of contacts for projects that are more or less promising.

Some NGOs have asked me to provide an endorsement for their campaigns to convince people not to migrate. Here in Somalia, you know, we call the journey *tahrib*, in other places they call it *backway*, and I know better than anyone else how dangerous it is. They say that Libya is a black hole. That you can never get out of there. I don't really know, I never even made it to Libya. They sunk their teeth into me on the way. But listen, dear cousin, you tell me what's the sense of going into villages to tell people

not to leave. I could never say that to someone my age. Why do they want to take from us what they—whites, Westerners, the ones with the strong passports—have? They can travel the world far and wide. And instead they want us to stay put. Are they afraid to be contaminated by our Black blood? Is that what the whites in the West are afraid of? You live there, you tell me. That's why I say no to the NGOs. I don't think it's a good idea to tell young people: "Hey, you're African, you're a loser, so stay in your own country, the world doesn't want you." What kind of message is that?

Aren't we supposed to fight to fulfill our desires? Lafanu migrated, and then when she got to a place she liked, she stayed there.

So that's it, I'd like to have a world where we Africans have the chance to move around. Some of us want to study, see the world, change the way we live. Then, along with that, I wish that no one here in Africa—I say Africa as an example, I know you always point out that Africa is made up of fifty-four countries—should be forced to leave because there's no work or opportunities for the future. They should also defend their right to stay.

Now you're going to say, "You're turning into a politico." A bit, yes. I really want to change

society. A little like Lafanu Brown did. I think
about her a lot. Lafanu and I were both mo-
tivated by the desire to know. She wanted to
make it to Rome, and I wanted to make it to
Paris, where the real cartoonists are. I would
really have liked to see the Eiffel Tower. But
who's going to give us a visa?

Yesterday I took a virtual tour of the city
with the Mac you bought me last month—by the
way, thanks, dear cousin, for the awesome pres-
ent you gave me—and I fell in love with it.

One day, cousin, when the world changes,
take me to Paris. Now that I've reemerged from
the black hole the traffickers drove me into,
Paris has got to be a part of my life.

Say hello to Alexandria for me and give her
my best wishes for the baby that's on the way. Is
it a boy or a girl? Because if it's a girl she has to
name her Lafanu. I insist. Tell her I said so.

Say hello to Uarda, though I'll probably beat
you to it . . . she and I text on WhatsApp all the
time. Well, cousin, here's a kiss for you, a big
kiss, and please always be the wonderful person
you are. I love you, Leila.

<div style="text-align: right">Your Binti</div>

EPILOGUE

I IMAGINE you're just about to lose your patience with me, Signor Barbieri."

Ulisse was speechless. Concetta had accompanied him into the sitting room. Outside, a light breeze was making the pine needles flutter and inside the apartment on Via della Frezza the woman he was in love with, Lafanu Brown, still hadn't given him the answer he'd been waiting to hear for six months.

"You want a yes, you want a no, in short an answer. You'll have it. I'm a woman who keeps her word. But first I would like to take a walk with you."

"And the answer?" Ulisse's voice came out in a whisper on the verge of desperation.

"The answer will come." Lafanu was cryptic. "But let me get my mantle on."

Concetta came out of nowhere. "Here is your wrap, milady."

Lafanu reproached her playfully, "You know I'm not a lady, I'm just Lafanu Brown."

Ulisse looked at Concetta with his blue eyes. He was hoping to see in the maid's eyes the answer that Lafanu wasn't revealing. *Can I nurture some hope?* his sad eyes almost seemed to plead. But Concetta was an imperturbable mask of silence.

"I'm ready," said Lafanu with an unusually shrill voice.

Ulisse observed her. He found her so lovely, with that black skin illuminated by the radiant sunlight streaming through the window.

Lafanu's eyes were staring at a point on the wall. Beyond that wall, beyond that sitting room, was the mahogany desk that she had been bent over for six months, writing on those pages of mock parchment. There, at that desk, Lafanu Brown had relived her whole life. Now she didn't have the courage to give all of those pages full of herself to Ulisse. She was afraid of filling him up with words.

She looked at him. He was thinner, his face more gaunt, his beard fuller.

She went over to him and, with the audacity of a country woman, caressed his hands.

Then she said, "I'm ready . . . ready to begin a new journey."

Ulisse smiled, and almost without breathing said, "Me, too."

AUTHOR'S NOTE

The Making of *The Color Line*

The city of Salem, Massachusetts, is just fifteen miles
from Boston. Its name evokes fog, sinister land-
scapes, mystery. What we know about Salem is that
it went down in history for its horrifying witch tri-
als of 1692. It is no coincidence that many of us have
memories of one or more of the many horror movies,
thrillers, or fantasy films that have been set there,
movies like *Hocus Pocus* or *The Crucible*. Moreover,
Salem is the city of Nathaniel Hawthorne's *The Scar-
let Letter*, the city of the stigma, of the big letter *A*.

For one reason or another, we all, unfortunately,
have a rather stereotypical vision of this city, which
even today leads us to associate it with our favorite
Halloween parties or even trash tourism in search
of zombies. Happily, however, Salem's history is rich

with many other things beyond the witches. For example, Salem was an important maritime center, a place of commerce with the Far East, perfumes, harrowing adventures, and fiery passions. What's more, the city has given birth to illustrious citizens, including Hawthorne.

Of all the famous Salemites, the most important for me (and for the book that you have in hand) is Sarah Parker Remond, midwife, human rights activist, feminist, and a highly cultivated woman. A Black woman who tried to be free when it was difficult for Blacks (and for women) in America and elsewhere to be free. Sarah was born in Salem and died in Rome on December 13, 1894, at age sixty-eight, in a hospital that no longer exists, the hospital of Sant'Antonio. She was buried in the Non-Catholic Cemetery just five rows beneath the tomb of the poet August von Goethe, son of the more famous Johann Wolfgang Goethe. Subsequently, her body was moved to an ossuary. Today, in the Non-Catholic Cemetery, there is only a commemorative plaque. But I feel that Sarah's spirit is lingering in some way among these white stone graves. It seems I can almost see her soul running through this landscape dominated by the Pyramid of Cestius and the towering cypress trees. Though she no longer has a grave, I know that Sarah is resting in this illustrious cemetery, along with Keats, Shelley, Gregory Corso, and Antonio Gramsci.

But Rome forgets that she once had among her citizenry, already in the nineteenth century, a Black woman who fought strenuously for the rights of her people, for the rights of the Black people of America.

I discovered Sarah's story thanks to a friend. I never imagined that such a talented and resolute woman had lived in and loved my hometown. A Black woman and a feminist. But my friend Cristina Vuerich, who shares my passion for Brazilian music and Caetano Veloso, knew all about Sarah Parker Remond. She sent me a picture of her, adding, "Why don't you write a novel about her?" I remember looking at that picture attentively. There was Sarah, even though I still didn't know that was her name, with a Victorian-style dress, high-necked and austere. In that image, she seemed very much like the character Miss Rottenmeier, the acid-tongued, severe governess of the cartoon series *Heidi* (I confess I've always been more well versed in Miyazaki's cartoon version than the book by Johanna Spyri). Anyway, her gaze, though just as severe as Miss Rottenmeier's, inspired trust.

Everything about her was placid. Those soft arms resting on her feather-like body, those full cheeks, that fleshy mouth even though it was shut tight in an unnatural silence. I don't know why, but she gave me the idea of a woman who knew how to assert herself when needed. Naturally, I asked Cristina for more

information about that picture and she gave me a quick rundown of everything she knew about Sarah. Activist parents, free Blacks from Salem, in the front lines against racism, well educated, committed, well read. Cristina had given me the essentials.

For days, I tried to imagine that woman, who had left the United States, first for England and then for Italy, striding, free, on the streets of nineteenth-century Rome. I saw myself in her as though I were looking in a mirror. So I set out like a bloodhound, following her tracks through the city. Cristina had told me that Sarah had been buried in the Non-Catholic Cemetery, and I started finding myself in that area more and more often almost by chance. There was no trace of her left there apart from the plaque, but just knowing that her name was there in the midst of all the others filled me with joy.

It was at the cemetery that I asked myself for the first time if Sarah Parker Remond knew Edmonia Lewis. She was my other obsession. I had discovered her existence years earlier, thanks to the Twitter account @medievalpoc, which for many of its subscribers, including yours truly, had become a drug. Whoever managed the account simply posted images of paintings and sculptures from the Middle Ages to today whose protagonists were men and women of African descent (and sometimes with other roots). Once I'd discovered it, I was inundated daily with

images of pages, bondswomen, slaves, and ambassadors, who stared at me from my computer screen. Their ebony skin shined on me and my eyes were filled with masterpieces that went from Vittore Carpaccio to Hieronymus Bosch, and from Peter Paul Rubens to Rosalba Carriera and a slew of others that it's hard for me to name here in these few lines.

Some of those paintings, like Carpaccio's *Miracle of the Relic of the Cross at the Ponte di Rialto* (or *The Healing of the Madman*), the center of which features a magnificent gondolier of African descent, elegantly dressed in red, I already knew. I had seen and admired the gondolier in the gallery of the Accademia in Venice. But other paintings were a revelation, like the one by an anonymous painter, which showed what life was like in Chafariz d'El Rey, in the Alfama district of Lisbon, around 1570 to 1580. The *Chafariz d'El Rey* painting, which is part of the Berardo Collection, was a great discovery for me. Every inch of the canvas is occupied by an exorbitant number of Black figures, who are not (mind you!) imaginary but real residents of sixteenth-century Lisbon. Some are slaves, others musicians; some of the women pictured are governesses, others are shown in their free time launching languid glances toward nearby men in the hope of arranging a matrimony or a night of pleasure. Off to the side, you can see a Black boy who, like in a Laurel and Hardy movie, has a bucket turned upside down on his

head. Then, majestic, there is a knight with a beautiful mantle and a thoroughbred horse. Hundreds of figures. For the most part, Black: Europeans, Afro-Europeans. Just this one painting was enough to make me understand how long and complex the Black presence in Europe has been.

How I wished I had seen that painting when I was a troubled adolescent in school. In the years when, out on the streets, they called me "little black face," like the fascist song from the 1930s, or simply "dirty nigger," without bothering to beat around the bush. I also wished I had seen that painting when distinguished professors told me that Blacks had no history. That, in effect, we had come down from nothing and we were destined to remain nothing in the present and beyond, in the grave. I wished I had seen when I was a teenager the paintings that, thanks to my account and the books I consulted (among them the monumental, multivolume work *The Image of the Black in Western Art*, published by Harvard University Press), I was now discovering. I would have loved to have said, "The father of Russian literature, Aleksandr Sergeyevich Pushkin, was of African descent," or "Alexandre Dumas, the author of *The Three Musketeers* and *The Count of Monte Cristo*, looks like the twin brother of the rock star Prince." I would have loved to cite those examples of excellence to make myself feel better, then

shout out, "We do not come from nothing like you're always telling us."

As an adolescent, models help you keep from going under. Unfortunately, I did not have that chance. The history I was taught in school rarely offered a global perspective with all of its interrelationships. We were taught the history of Italy as though the country were isolated from the rest of the world (and not in the middle of the Mediterranean with all of its complexity), and nothing was said to us about the thousands of contaminations that trade and conquests had brought to the peninsula. So as an adult I tried to fill in the gaps and I became omnivorous because it was the only real option for surviving in a world falsely described as monotone. Thanks to these Black stars, as they were called by the French soccer player Lilian Thuram in his best-selling book, *My Black Stars: From Lucy to Barack Obama*, I was able to illuminate my Afro-Italian firmament, however belatedly.

But let's get back to Edmonia Lewis. As I mentioned before, the first time I saw her was on @medievalpoc. I still didn't know that I was looking at one of the few pictures of the American sculptress. She was wearing a mantle, a long dress, a fez. Her eyes were not looking at the camera but passed over and above it, with elegance. In the photograph, Edmonia was looking beyond us. Everything about that picture was sweet and delicate, as though she wished

to show us not only her strength but also her fragility. I read a lot of books about Edmonia. I learned that, like Amy in *Little Women*, she too had gone to Italy to become a great artist. Not an easy life, always looking for money, growing tension with her patrons, the desire to spread her wings and fly, economic hardship, and then, finally, success. Edmonia struggled to break through and, in the end, she made it. When I saw the picture of Sarah Parker Remond, I wondered if those two free Black women had known each other in that Rome only recently become the capital of the realm. Actually, their paths did cross. When the famous writer and activist Frederick Douglass came to Rome with his wife, both of them met him. Edmonia was his official guide and she took the Douglass family for walks along the streets of the historic city center. They captured my imagination, and even now that the novel is finished, I find myself dreaming about these three Blacks—Edmonia, Sarah, and Frederick—walking around Rome. Three Blacks, three Americans, three people who had changed the world with their determination, strolling around the Eternal City. Happy and free.

But did the city know about them? That was the question that tormented me. Did the city know about their freedom?

Rome is a city that I often like to define as a big wedding cake. Just like a cake, the city is made of

superimposed layers. In every layer an epoch, an event, a handful of famous and less famous people. Then each layer has its stones, its arches, its Corinthian capitals, its views, and its sunsets. In each of its layers, Rome hides all of this and much more. Right before your eyes, you see rolling out like a carpet the wonders of the ancient empire of Augustus, skyscraping medieval towers, the marvels of the Renaissance, the enchantment of the Baroque.

Amid all this stratification, and this is the wonder of Rome, there often pops out something unexpected. For example, these two freely strolling Black women came out of the top hat of Rome. They had come expressly to crown their dreams: one to become a midwife, the other a sculptress. And Rome, and Italy in general, had gratified them. Because the Rome of that epoch knew how to make itself loved, knew how to welcome, it was curious.

For those two women, however, Rome—and this must be emphasized with a certain degree of fervor—also had another meaning. In the United States, both of them had been victims of aggression. Edmonia had been beaten (some biographies imply that she was also raped, but we have no solid evidence about the episode) outside of the college she was attending, and Sarah had been thrown down the stairs of an opera house just as the performance she had come to see was about to begin. The theater was packed and

Sarah was punished, like the future Rosa Parks, because she didn't want to give up her seat for a white person. She wanted to remain seated there, it was her right. She had paid for her ticket just like everybody else. And she did not move from her seat. To make her get up they had to do her physical harm, serious harm. So the specter of violence against the so-called other (in his *Between the World and Me*, Ta-Nehisi Coates, a great contemporary African American writer, speaks, not coincidentally, of the fear of losing your body) led both women to leave their own country (a country that until the end of the Civil War did not even consider Blacks to be citizens) and find another, where they could finally feel free, finally themselves.

It filled me with pride, as well as surprise, to learn that two Black women had felt free in, of all places, Italy, a country that today has turned nasty toward those considered "other" and has let itself sink into an unhappiness that fosters cruelty. This climate of racism and distrust slowly brought me to the decision to write a book about these two women, to offer the country a different perspective. Rather than an actual biography, I opted for a novel, creating a character, my Lafanu Brown, who contains both Sarah and Edmonia, without being either of them.

Along the way, I found many "friends" who led me to undertake the writing. One book that helped me greatly in making the decision to write this

novel, you could almost say it threw me into the arms of this story, was *Being Arab* by the Lebanese journalist Samir Kassir, who was assassinated in 2005. His story, apparently so distant from the nineteenth-century world of Sarah and Edmonia, helped me to see Italy in a mirror image. Kassir's book does not talk about Italy, but in clear and never irreverent language it tries to explain to readers the state of mind of Arab countries prior to the fall of the great dictatorships, before the revolutions and the current restorations. An Arab world, therefore, suffocated by the various Assads, Mubaraks, Ben Alis, or Omar al-Bashirs. A world where young people were unemployed and isolated. An immobile world that inevitably reminded me of the Italy in which I was living. An Italy badly aged, afraid, without work and unable to visualize the future. An Italy where foreigners were being persecuted and young people marginalized (and forced to emigrate). An Italy without children, which was no longer able to see its own beauty and uniqueness. I have always loved the country where I was born, but seeing it become mean and turn in on itself pained me. When I discovered that two women (Black women!), Edmonia Lewis and Sarah Parker Remond, had chosen it as the place of their freedom, my eyes literally filled with tears from emotion.

The Italy of that time was synonymous with welcoming, dreams, and opportunity, not hatred.

Moreover, Edmonia and Sarah were two voyagers, two Black women who had set out to cross the ocean (that same ocean that had seen so many Blacks in chains) and go to foreign cities. Black women who, with their bodies, had burned through frontiers and prejudices. It was inevitable for me, both in the ideation of the novel and the writing of it, to think of what was happening in the contemporary Mediterranean, between Europe and Africa. People dying on rubber rafts or in Libyan prison camps, people who were denied visas, who were denied a legal journey with a passport and a suitcase.

In the 1970s, when my parents came to Italy from Somalia, they came on an airplane; no rubber rafts. The city of Rome, they always told me, was full of African students, so elegant in their jackets and starched shirts and ties that all the girls fell in love with them on the spot. Students who were studying medicine, engineering, or architecture. Young men like the ones that Pier Paolo Pasolini had encountered in his *Notes Towards an African Orestes*. Measured words, in their eyes the desire for future. In those days, you could come and go legally. Migration was not the only possible choice. People could stay here for a while, study, and go back home. Do seasonal work. Fall in love. And, why not, be tourists. Is it so strange to think of an African as a tourist?

But Africa today has been deprived of rights, and mobility is denied to those who are born there—not only mobility toward Europe but even mobility within Africa. Since 1989 it has become difficult (more like impossible) for Africans to move. In 1989, in one part of the world, in Berlin, a wall came down and we all hoped for the end of history described by Francis Fukuyama, or we simply yearned for a world without borders. But then in another part of the world there was a clampdown on rights, which we all failed to notice until it was too late. It all happened so suddenly. People who just a few years earlier were boarding airplanes now became dangerous bodies, an immigration risk. Bodies to control, to marginalize, on which to perpetrate policies of separation. And so it was that I understood (like everyone, with time) that the Berlin Wall had reappeared in the Mediterranean, effectively creating class-A citizens, to whom every government permitted travel thanks to their strong passports, and class-B citizens, who were de facto denied the right to travel. People whose bodies, in order to move from one part of the world to another, had to let themselves be tortured, broken, raped. Bodies that ended up first in a prison camp and then on rubber rafts that might or might not make it across the sea.

This apartheid was and still is my obsession. Therefore, when I encountered these two free Black

women in Rome, Edmonia and Sarah, I wanted to tell their stories. Two women who not only traveled but who also dreamed of being everything they wanted to be.

To write this book I began, a little like Giacomo Leopardi, by studying like crazy and somewhat haphazardly. The first step was consulting books about the Grand Tour, because in a certain sense the journey made by Sarah and Edmonia was inscribed in that framework. Numerous essays, among them the most enjoyable ones by Attilio Brilli, were illuminating. Then I read novels and accounts. Slowly I began to see my country through the eyes of Charles Dickens, Johann Wolfgang Goethe, Edith Wharton, Henry James, E. M. Forster, Stendhal, Lord Byron, Percy Bysshe Shelley, and Mary Shelley.

One of the most surprising books I read was *The Marble Faun* by Hawthorne, a book with a slow, meandering rhythm, and for a contemporary reader also a source of irritation. We would like to get straight to the heart of the matter, to the psychological motivation, but the author doesn't let us. He takes us by the hand and leads us through a dark Rome where, from time to time, like a ray of sunlight, a daisy springs forth. Then there is nothing for us to do but surrender, put ourselves with some difficulty in the shoes of someone who lived in that faraway time, and try to look at Rome for the first time.

I was born in Rome and still live there, but to write the novel I had to unlearn everything I know. I had to walk through the city with the eyes of others. In this, the characters of *The Marble Faun* were extremely helpful. The mysterious Miriam (a woman mysterious also in her origins, probably with Black blood in her veins), the honest Kenyon, and the determined (and in her way, adventurous) Hilda helped me understand what the foreigners on the Grand Tour were seeking in the Eternal City: the picturesque, exactly like Donatello, the Tuscan Donatello, naive, effeminate, and an enchanter; the Italian character in Hawthorne's book. A picturesque, which, like Donatello himself, might conceal more than one dark side. Italy was the possibility for a different life, but also the fear of being overwhelmed by a surge of energy difficult to control for the Puritan soul of a country still too young, as was the United States in the nineteenth century. Roman fever, as malaria was called back then, might be nesting everywhere. Death was waiting in ambush everywhere. Hawthorne says this very clearly: "fever walks arm in arm with you, and death awaits you at the end of the dim vista."

It is a slow book, *The Marble Faun*, moralizing and, at bottom, full of stereotypes, but for me it was fundamental. Reading it, I understood that for some Italy is a matter of survival. It is no coincidence that the two female protagonists of *The Marble Faun* are

artists. Two women who have chosen a precise identity that was in some measure unconventional. Hilda, for example, is described like this:

> *This young American girl was an example of the freedom of life which it is possible for a female artist to enjoy at Rome. She dwelt in her tower, as free to descend into the corrupted atmosphere of the city beneath, as one of her companion doves to fly downward into the street;—all alone, perfectly independent, under her own sole guardianship, unless watched over by the Virgin, whose shrine she tended; doing what she liked without a suspicion or a shadow upon the snowy whiteness of her fame. The customs of artist life bestow such liberty upon the sex, which is elsewhere restricted within so much narrower limits . . .*

Hawthorne had known such women in Rome. The character of Hilda was likely inspired by two real women. One was Louisa Lander, an American sculptress, very worldly and uninhibited, described by Hawthorne in his travel notebooks as strong, independent, free beyond all decency. Perhaps this excessive freedom cooled their relationship, which at the beginning of their acquaintance must have been at the very least cordial, seeing that the woman had sculpted a bust of the writer. But Hawthorne,

despite his *Scarlet Letter*, remained a Puritan. The other woman was Harriet Hosmer, whom Hawthorne found to be absolutely unconventional. She liked to dress as a man and was very unrestrained. Oddly enough, in the journey through this Rome previously unknown to me, the names chase after each other like rabbits: Harriet was a friend of Edmonia, the woman who, along with Sarah, inspired me in the creation of my protagonist, Lafanu Brown. Rome suddenly appeared to me in a different light. Harriet, along with Margaret Foley, Emma Stebbins, Anne Whitney, the actress Charlotte Cushman, and Edmonia Lewis—the Black of the group, the Negress of Rome—had created a sort of female club, a sisterhood of understanding and freedom that was possible only in the capital. So much so that Henry James, a writer who in any case wanted to keep women on the margins, set his sights on this group of women (probably free even in their sexual habits), not sparing himself nor us a tasteless remark about Edmonia's black skin. He defined her, maliciously, as very different from the white marble that she worked with as a sculptress. "One of the sisterhood was a negress, whose color, picturesquely contrasting with that of her plastic material [white marble], was the pleading agent of her fame" (Harry Henderson and Albert Henderson, *The Indomitable Spirit of Edmonia Lewis: A Narrative Biography*).

Henry James aside (I admit that the books and notes from his journeys to Italy were quite useful for me, as was his *Portrait of a Lady*, which I reread with great pleasure, despite the author's latent misogyny that I had to fight my way through), the discovery of a Rome that bestowed freedom on women is the image that helped me to write the novel. All the women in the book, some more, some less, are struggling against a patriarchy that is keeping them down. Love is impossible without freedom, that is the idea of the protagonists of my book. And they do what they can. Some fight to love men, others fight to love women, others embrace a solitude not imposed but chosen. I have tried to give the women of the book the same freedom enjoyed by Louisa Lander and Harriet Hosmer, and that was enjoyed especially by Edmonia Lewis and Sarah Parker Remond.

I live in a very different Rome. Suffocated by neglect and bureaucracy. A Rome that looks for scapegoats to salve its conscience. A Rome where the buses break down or catch fire. Where poverty and psychological distress are on the rise. A Rome that imprisons and does not liberate. But writing this book has helped me to understand that beneath the ashes of this contemporary disaster, Rome still has a chance to make it, to be reborn. If I have been able to give Sarah and Edmonia a new life, maybe the city can also give one to itself.

Through the biographies of Sarah (Sirpa Salenius, *An Abolitionist Abroad*) and Edmonia (Kirsten Pai Buick, *Child of the Fire: Mary Edmonia Lewis and the Problem of Art History's Black and Indian Subject*; Harry Henderson with Romare Bearden, *The Indomitable Spirit of Edmonia Lewis: A Narrative Biography*; and *Forever Free: Oltre la barriera del colore* by Luisa Cetti, essential for Edmonia's Roman years), not only have I slipped myself into the veins of these sisters of mine from the past but I have tried to live in my Rome through their Rome of freedom. My Lafanu is not Sarah or Edmonia. I fused them, I have made them into one character unbound from the real-life women. Even though some elements (having suffered an assault, falling in love with Italy, the burden of having to be dependent on wealthy and substantially spoiled women) persist in Lafanu, who compared to the two women who have become my obsession is certainly more timid and at times more confused.

I really liked making the site visits for the book. My city is a treasure trove, and every place you go, you discover something. Going to see the places of Edmonia and Sarah was almost like going on a treasure hunt. It is no coincidence that Via della Frezza, where Edmonia actually lived, has become a central location in the novel, where Lafanu balances the accounts of her life. Today, Via della Frezza, despite the bustling crowds on Via del Corso (which is right

next to it) with its daily grind, has remained a nice quiet street.

This is a novel of places, as were the novels I read, and especially the accounts of the Grand Tour. Rome, but also Florence, Venice, and Marino, are places that are described, well-known, admired. But there is an Italy that is unseen, the one where the dark presence emerges from a painting or a sculpture. The one in which images of slavery are mixed up with images of nineteenth-century colonialism. In a certain sense, the presence of the Black protagonist amplifies this "Black lady" at the center of a story made of slavery and chains that is not well-known here. It is no coincidence that the Four Moors Fountain in Marino is a catalyzing center of the novel. Marino, a small town near Rome, tells a story of slavery and piracy that is studied only superficially in school, with no deep analysis, a history about which, today, no one asks why. But there they are, the Black women chained to the fountain, to tell us that no one is innocent in history. That to avoid repeating it, you must at least know about it.

Those women of the 1600s, chained to the fountain in perpetuity, speak to us about what is happening today to migrants. I hope that one day the curriculum in Italian schools will no longer be so heavily Eurocentric (at times white-centric), but that sooner or later, the schools will broaden their scope to include

the world and its interrelationships. Rather than fearing this past of exchanges and co-penetrations, a country like Italy, at the center of the Mediterranean, and for a long time at the center of history, should embrace it, pinning it on its chest like a medal. To the question *Are Italians White?* (the title of a wonderful book by Jennifer Guglielmo and Salvatore Salerno), respond with a proud "No, we are not white. We are a mixed breed. Born of a medley of genes and ethnicities." That is why I have written this book astride of history, because history teaches us that there are no monotints and that every one of us is made of the sum of our experiences and of the experiences of those who preceded and generated us.

The book concludes an ideal trilogy, a journey that began in 2008 with the novel *Oltre Babilonia* (*Beyond Babylon*) and continued with *Adua* in 2016. In my head, I call it "the trilogy of colonial violence." I wanted to investigate what happens to people when a violence that is not only sexual but also systemic traverses their bodies. Violence that in these books, make no mistake, has its identity card: patriarchal, colonial violence. In all three books, the female protagonists are looking for an escape route from the depression that envelops them. I did not set out to write a trilogy. I thought that writing trilogies was a prerogative reserved to the genre of fantasy, to the *Harry Potters*, *Game of Thrones*, and *Mists of Avalon*. Actually, I

understood, and it became as clear as day for me as I was writing this book, that my three novels were tied together by this theme. It is not coincidental. We live in an age when violence is continual and bodies are exposed to the voyeuristic gaze of an avaricious society (I'm thinking of the migrants tortured in Libya and then forced to undertake gruesome journeys in the desert and across the sea). Those bodies are in need not of exposure but only of an embrace, just laws, and a friendly hand. My protagonists, though different from one another, find themselves thanks to the stubborn desire to be someone despite it all. Lafanu Brown, like Adua (from the novel *Adua*) and like Zuhra (from *Beyond Babylon*), finds within herself the resources to start over. Art saves her, but she is also saved by opening her heart to Ulisse Barbieri, a man no longer seen as an enemy but as an ear that listens. An ally. Not least because the violence that traverses Lafanu Brown is not only male violence but a systemic violence of a society against those who are singled out as different.

Having gotten to this point, I want to reveal that this novel, like its predecessor, is connected in its opening scene to the Termini train station. Adua ends in the Piazza dei Cinquecento, where a new cycle begins for her; in *The Color Line*, instead, I recount who the five hundred were that gave the piazza its name: the Italian soldiers killed in Dogali, the site

of a battle between a colonizing Italy and an East Africa that defended itself against the aggression. This version of mine is based on the dates reported by Angelo Del Boca in *Gli italiani in Africa orientale* (The Italians in East Africa). Here, however, a small caveat is in order. Those of you who have read *Pleasure* by Gabriele D'Annunzio will say, "Here you're mistaken. D'Annunzio says that the news of the massacre arrived in Rome on February 2." True enough. But Del Boca writes instead in his monumental work on the history of colonialism that it was February 1, and I have preferred to follow the lead of the historical source.

The title of my book is a tribute (direct citation) to W. E. B. Du Bois. The color line still divides, but for Lafanu Brown it also takes on another meaning. It is the line of her art, the line of her emancipation.

I would also like to say a word about the cover. My thanks to the publisher and especially to Giulia Ichino and Antonio Franchini for accepting my suggestion. I wanted an evocative image that spoke not only of that past but also about our dystopian present. That is how I encountered the work of Ayana V. Jackson. A work that literally takes your breath away with its immense beauty and great intelligence. The artist, who works on colonial cages and on the pervasiveness of that history on bodies today (like those of yesterday), succeeds in making her portraits the

scream of a global revolt, the scream of those who do not want to be subjugated anymore.

For that reason, I deeply wanted to have one of her works as the cover. The world of African artists is so rich and varied. And this is my way of dedicating the novel to all those sister artists scattered around the word, a sisterhood that gives me so much energy.

There are many people I would like to thank. I hope I am able to remember them all.

First of all, my family. These have been difficult years of illnesses and separations. My father left us when this novel was in progress. Even though Papà is no longer with us in body, he lives in us and in our memories. As his daughter, I know how much he gave me and how much my writing owes to him. I always listened to his words, his endless stories. Papà lived through the twentieth century and all its horrors, the twentieth century and its sparkle. And of that twentieth century (another epoch that we should have our children study more in school) I have brought with me into this novel, which moves back and forth between the nineteenth and twenty-first centuries, the possibility for a future despite the hardships. It was my father who told me about colonialism. It is no coincidence that I decided to open the narrative with the massacre at Dogali. In fact, often when we speak

of colonialism we think only of Mussolini and fascism. To be sure, fascist colonialism was ferocious, but the nineteenth-century version was no less deranged. Now I can reveal it: Ulisse Barbieri, the name of one of the characters in the novel, is a name that I borrowed from an Italian anarchist, poet, and playwright of pure genius, a convinced anti-colonialist and free spirit from Mantua, who for reasons internal to the novel I transformed into a native of Puglia. The phrase that he says to the crowd when Lafanu faints in his arms is really his.

I have to thank Papà, and I will thank him every day for as long as I live, for giving me the eyes to see history outside of the fences where it is usually corralled.

I thank the rest of my family as well. I send them all a big hug. They have helped me a lot in this period. Thanks to my mother; my mother number two (that's what I call my aunt), Halima; my brothers Abdul and Mohammed. Thanks to my cousin Nura and my two cousins Zahra and Sofia, thanks to all my nieces and nephews. I thank all of them for the great affection that they give me always.

Next I would thank Biblioteca Goffredo Mameli in Via del Pigneto and all of its splendid librarians: Angela, Anna Maria, Arianna, Daniela, Laura, Lucia, Luciana, Luisa, and Manuela. I roamed their shelves for months, months, and months. They helped me,

like the true angels that they are, to find many of the novels that I read. They pulled put some real jewels whose existence I never suspected. And always, especially in those times when I was feeling lost, they gave me a smile. Those who have a neighborhood library have a treasure, an enormous treasure. Thank you, Biblioteca Goffredo Mameli. Without you, Lafanu would never have been born.

Then I would like to thank Giuseppe Ieroli. We share a love for Jane Austen. He knows everything there is to know about Jane Austen (and Emily Dickinson), and emerging myself in Austen through his eyes was really useful. This is not a Jane Austen–type novel but the supreme lesson of the rigor of her writing is something I always kept in mind while I was writing.

I want to thank Cristina Vuerich. She literally pushed me to write, with that photo she sent me on Messenger.

Thanks to Sara Antonelli for reading in advance.

Thanks to Nicola Labanca and Alessandro Triulzi for their enlightening comments on nineteenth-century Italian colonialism.

I also want to thank two dear friends from Venice: Carla Toffolo and Waris Ali Omar Osman, fabulous mother and daughter. They helped to catch the true spirit of Venice and many pages I wrote at night while I was their guest with their super cat, Filo, keeping

me company. For me, Venice will always be tied to their faces of pure light.

In addition, I would like to thank the entire city of Venice. I was one of the fellows at the International Center for Humanities and Social Change of Ca' Foscari University and it was a lovely and rich experience, for which I have to thank first of all Shaul Bassi, the director of the center and a friend. He allowed me to experience things in Venice that I have never experienced anywhere else. And this makes me say that Venice is unique, but its survival depends on all of us. So let's not let it die. Thanks again, Shaul. I want to take this opportunity to thank those who orbit around and are part of Ca' Foscari University: Alessandro Casellato, Alessandro Cinquegrani, Flavio Gregori, Pia Masiero, Barbara del Mercato, Antonio Montefusco, Ricciarda Ricorda, and Simon Levi Sullam. Experiencing Venice not as a tourist but with an inside view helped me to put into this novel of many cities an unusual slice of Venice. And yes, Ricciarda, thank you, thank you, thank you for dragging me to see Veronese in San Sebastiano. That was a turning point. I was really stuck in a chapter and from there the whole skein of the novel unraveled, melted like snow in sunlight. It was a very important moment in the life of this novel.

I also want to thank Ruth Ben-Ghiat, Rino Bianchi (whose splendid photographs you'll see in the book), Anna Caputo, Leila El Houssi, Esther Elisha,

Valentina Farinaccio, Elvira Frosini, Giulia Frova, Helena Janeczek, Gabriella Kuruvilla, Tahar Lamri, Paolo Massari, Adil Mauro, Francesca Melandri, Karim Metref, Michela Monferrini, Chiara Nielsen, Paolo di Paolo, Pina Piccolo, Dagmar Reichhardt, Enza Spinapolice, Maurizio Taloni, Daniele Timpano, the team of *Future* (a book of Afro-Italian women's voices that I edited for Effequ, in a certain sense *The Color Line* is dedicated to all of you sisters) . . . thanks for supporting me, taking care of me, for being there, for lending me books or only your ears.

I thank the Italian publisher Bompiani for their support.

I want to thank Piergiorgio Nicolazzini (and his staff) for the work and passion that they put into the publishing of my books.

Then a thank-you as big as a house to Alessandro Portelli. If I write, I owe it to him, who has always believed in the writing of us Afro-Italian women and has always supported us. His essays were fundamental to the writing of this novel. Over the years, his expertise in African American literature has allowed me to acquire a deep knowledge of it. Without Sandro I would not have had the courage to pick up a pen or cling to the keyboard of a computer.

Furthermore, I want to take this opportunity to advise my readers that what you have in hand is not a classic historical novel. At times, I think of it as a

fantasy novel with a historical basis. To tell the story of Edmonia Lewis and Sarah Parker Remond I have had to betray them, exaggerate some traits (the story of the Trevors' general store is tied to Sarah's biography, but in the book it becomes something different, larger, and more complex compared to her father's business) or move others to behind the scenes. For example, the American Civil War is offstage because I was interested in presenting the epoch and the consequences it could have on my protagonist. Moreover, and I want to make this clear, Frederick Bailey is not Frederick Douglass, even though I used the same first name. He was the inspiration, but Frederick Bailey is much more fragile and at times ambiguous. Douglass, on the other hand, was a complex thinker on a well-marked path, with a courage that my character recalls but cannot fully embrace.

I also want to add something else that I consider fundamental. Although I've written about an African American woman, this is not an African American novel. I do not aim to imitate America. From the very beginning, my intention has been to construct a story that speaks of Italy, a story, therefore, that taken all together, is an African Italian story, because I, the author, am an African Italian. It is a dialogue with America, but from my indigenous point of view.

So if some African American happens to take this book in hand I want to clarify that this is not cultural

appropriation but the construction of a bridge character, whose journey shines a light on Italy, my country. It is not by chance that the novel's other, contemporary part is related to my other country, Somalia.

Finally, I want to close with an appeal, almost a prayer. According to the statistics, tourists come to Rome one time and never come back. It is becoming a city that repels those who come to have an experience or those immigrants who are looking for a city where they can make a new life. Rome has become a city from which to escape, a city not to go back to. It repels both citizens and foreigners. Instead, for Edmonia Lewis and Sarah Parker Remond, it succeeded in becoming home. Let us return; this is my prayer to constructing a city (but I'd say a country) in which people can live happily and see their rights respected.

Let us also say enough to this apartheid traveling that creates rankings of A-, B-, and C-class travelers. We have to restore the right to travel and mobility. Barbed wire and walls shut some people out and other people in. They create inequalities and death. We can no longer permit it.

And then, naturally, there is the final thank-you. As is only logical, it is all for them. Thank you, Edmonia Lewis. Thank you, Sarah Parker Remond.

And thank you, Rome. I know you will shine once again.

US IN STONE

Photographs by Rino Bianchi

The Four Moors Fountain in Marino was built in 1632 after a design by Sergio Ventura to commemorate the victory of the pontifical fleet led by Admiral Marcantonio Colonna in the Battle of Lepanto (1571). Leila and Lafanu both stop to observe with anguish the slaves chained to the base of the column of white marble.

Who knows if on one of her Venetian journeys Lafanu might have been able to imagine that one of the patrician palaces looking over the canals would become the meeting place for students coming from all over the world. In the photos, Baratto Hall of Ca' Foscari University in Venice is where the inauguration of Leila's exhibition is held. Certainly, however, Lafanu was struck by the "elegant gondolier" of the *Miracle of the Relic of the Cross at the Ponte de Rialto* by Vittore Carpaccio. The painting is conserved today in the Gallery of the Accademia in Venice.

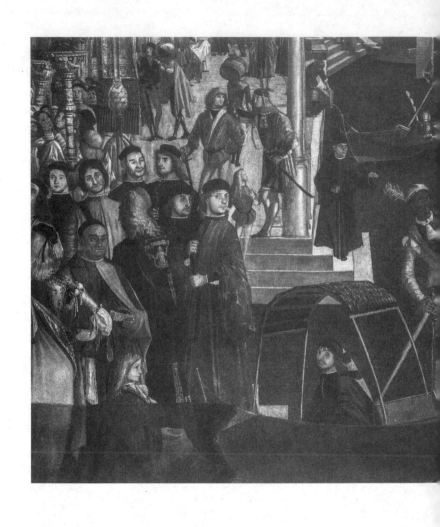

On these pages images of the Monument of the Four Moors, built between the end of the sixteenth and the beginning of the seventeenth centuries in Livorno. Lafanu encounters it on her journey.

The tomb of Nadezhda De Santis in the English Cemetery in Florence, where Lafanu crosses the path of her Nubian sister.

The bas-relief memorial to Clelia Severini in San Lo-
renzo in Lucina, in Rome (1825). The sculptor Pietro Tene-
rani represented on this slab of white marble the final
farewell of a young daughter to her parents, inserting
into the scene the poignant figure of the little dog that so
moves Lafanu.

Memory in stone of the extraordinary flood of the
Tiber in December 1870, when the waters of the river rose
to a height of more than fifty-five feet . . . and when Lafanu
looks out her window to see Frederick Bailey coming to
rescue her.